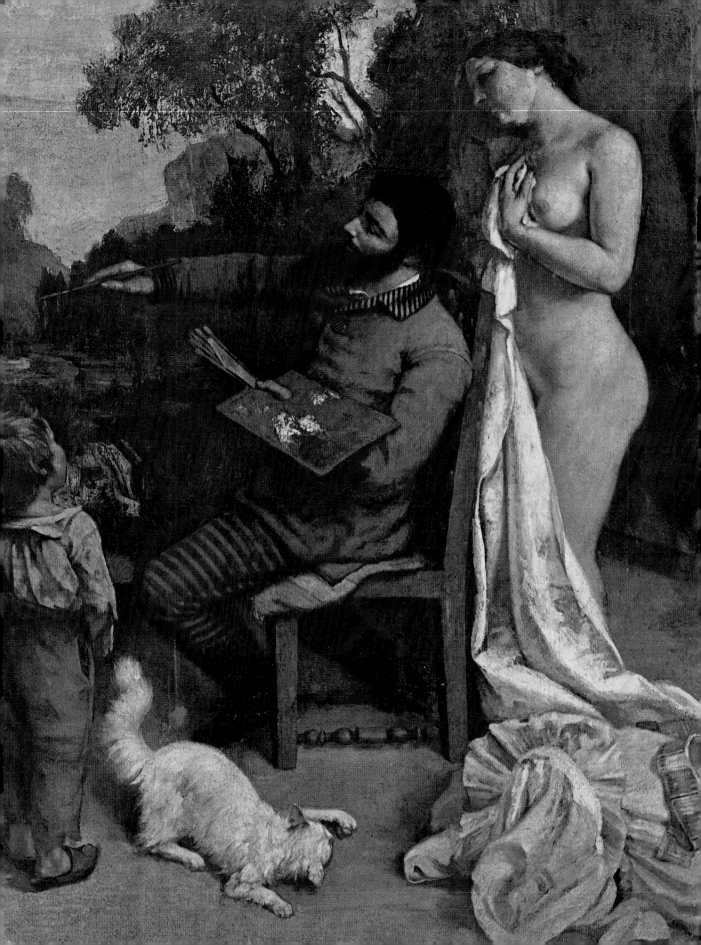

Woman as Sex Object

Studies in Erotic Art, 1730-1970

Edited by Thomas B. Hess and Linda Nochlin

Allen Lane

Left: Courbet portrays himself
at the easel, with a posing
nude behind him as an element
of his artistic life, in his
huge allegorical painting
The Studio (detail). Louvre.

First published in the United States in 1972
by Newsweek

First published in Great Britain in 1973
Allen Lane

A Division of Penguin Books Ltd
21 John Street
London WC1

ISBN 0 7139 0662 6

Printed in the United States

Contents

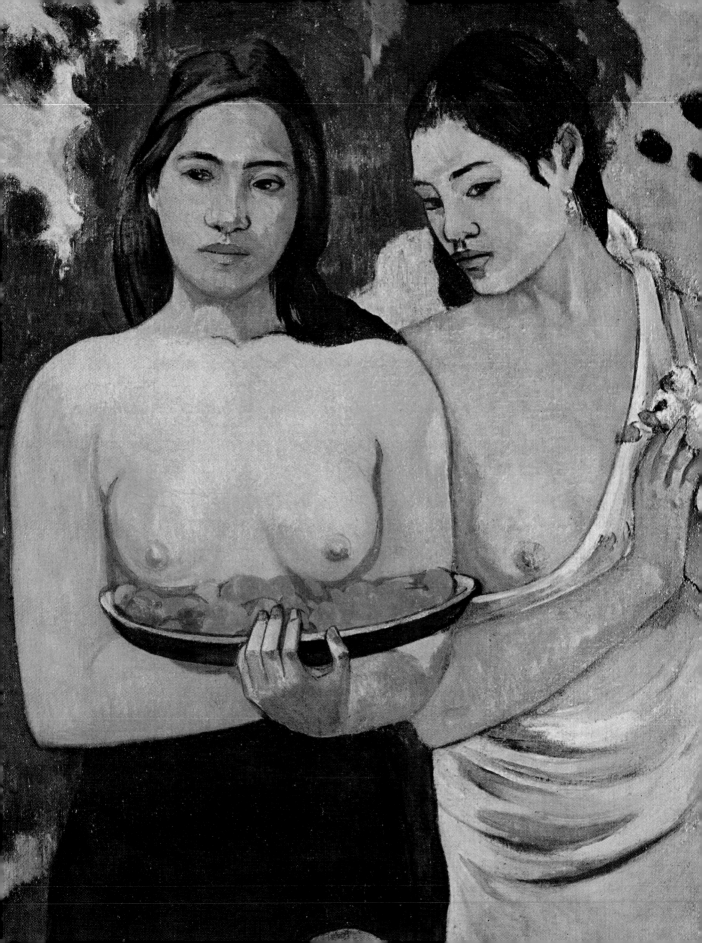

Eroticism and Female Imagery in Nineteenth-Century Art

Author: Linda Nochlin is professor of art history at Vassar and a specialist in 19th-century French art. Her most recent book is *Realism,* Penguin, 1971; a book on Courbet is in preparation.

Considering how much of Western art deals with themes that are overtly or covertly erotic, it is surprising how little serious attention has been paid to the specifically erotic implications of art works by scholars and critics.[1] While the psycho-sexual development of artists has been thoroughly investigated, mainly by psychiatrists, since the time of Freud, no similar interest has been shown in the erotic content of their works, unless, as is the case with certain Surrealist examples, it is simply too obvious to ignore. Even in the latter case, the approach to the erotic is generally descriptive and psychological, rather than analytic and directed towards investigation of the socially determined concomitants and conventions of erotic imagery in different art groups during different periods.

It would seem that the world of erotic imagery is no more controlled by mere personal fantasy *in vacuo* than any other type of imagery in art. It is precisely in the nineteenth century–at a time when older prototypes and motifs were transformed by new needs and motivations–that the social basis of sexual myth stands out in clearest relief from the apparently "personal" erotic imagery of individual artists.

Certain conventions of eroticism are so deeply ingrained that one scarcely bothers to think of them: one is that the very term "erotic art" is understood to imply the specification "erotic-for-men." The very title of this investigation–"Eroticism and Female Imagery"–is actually redundant. There really *is* no erotic art in the nineteenth century which does *not* involve the image of women, and precious little before or after. The notion that erotic imagery is created out of male needs and desires even encompasses the relatively minor category of art created for or by homosexuals; it has always been *male* homesexuals who are taken into consideration, from Antiquity through Andy Warhol. Even in the case of art with Lesbian themes, men were considered to be the audience: Courbet painted his scandalous *Sleep* not for a *femme damnée* of the time, but rather for the former Turkish ambassador, Khalil Bey, who no doubt felt as invigorated by the spectacle of two voluptuous female nudes locked in each other's arms as he had by the delectably realistic *bas ventre* Courbet had previously executed to his specifications. As far as one knows, there simply exists no art, and certainly no high art, in the nineteenth century, based upon women's erotic needs, wishes or fantasies. Whether the erotic object be breast or buttocks, shoes or corsets, a matter of pose or of prototype, the imagery of sexual delight or provocation has always been created *about* women for men's enjoyment, by men.

Gauguin transmutes the breast-as-flower metaphor into high art in *Tahitian Women with Mango Blossoms,* 1889, 37 inches high. Metropolitan Museum, New York.

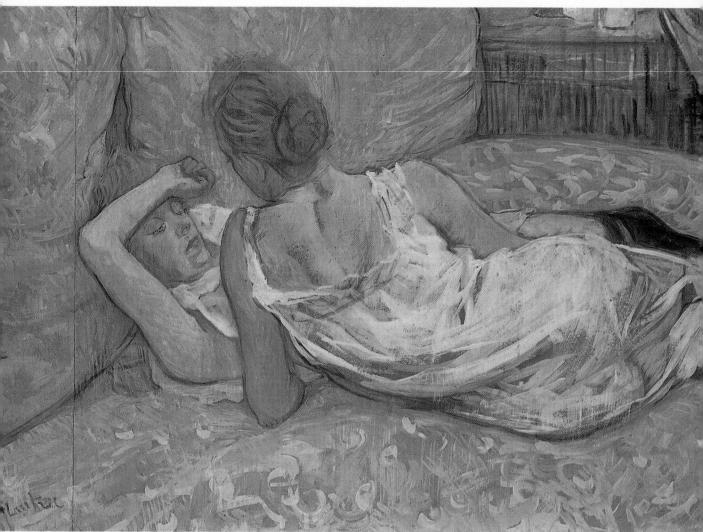

Toulouse-Lautrec brothel scene:
Abandonment, 1895. Private coll.

This is, of course, not the result of some calculated plot on the part of men, but merely a reflection in the realm of art of woman's lack of her own erotic territory on the map of nineteenth-century reality. Man is not only the subject of all erotic predicates, but the customer for all erotic products as well, and the customer is always right. Controlling both sex and art, he and his fantasies conditioned the world of erotic imagination as well. Thus there seems to be no conceivable outlet for the expression of women's viewpoint in nineteenth-century art, even in the realm of pure fantasy.

This lack of a women's viewpoint in erotica is not merely a corollary of the fact that nineteenth-century art "mirrored" reality. It is obvious that there could have been no equivalent of Degas' or Lautrec's realistic and objective brothel scenes[2] painted by women and populated by men, given the non-existence of such accommodations for feminine sexual needs. Women were never even permitted to *dream* about such things, much less bring them to life on canvas. Equally unthinkable would be such an egregiously unrealistic erotopia as the *Turkish Bath,* populated by sloe-eyed, close-pressed, languid youths, and painted by an

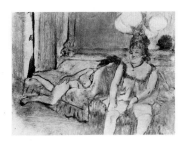

Degas brothel scene: *Rest,*
ca. 1879, monotype in black
ink, 6¼ inches high.
Collection Pablo Picasso.

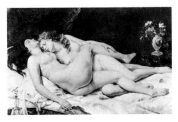

Courbet's notorious *Sleep,* 1866,
painted not for a lesbian
audience, but for the delectation
of a Turkish ambassador (see
colorplate on page 77).

octogenarian Mme. Ingres. Those who have no country have no lan-
guage. Women have no imagery available–no accepted public language
to hand–with which to express their particular viewpoint. And of course,
one of the major elements involved in any successful language system
is that it can be universally understood, so that its tropes have a certain
mobility and elasticity, as it were–they can rise from the lowest levels
of popular parlance to the highest peaks of great art.

While certainly low on the scale of artistic merit, a nineteenth-century
photograph like *Achetez des Pommes* nevertheless embodies one of the
prime *topoi* of erotic imagery: comparison of the desirable body with
ripe fruit, or more specifically, the likening of a woman's breasts to
apples. *Achetez des Pommes* represents this image on the lowest level,
to be sure, but the fruit or flower-breast metaphor can move easily
up into higher esthetic realms: in Gauguin's *Tahitian Women with Mango
Blossoms*, 1899, the breasts of the women are obviously likened to both
fruit and flower. As Wayne Andersen points out: "Gauguin used this
image in Tahiti because the charm of it fitted in with his surroundings,
and with his favorite myths about the Promised Land. In *Tahitian Women
with Flowers*, a noble-featured Tahitian girl holds a tray of flowers beneath
her bosom; the lushness of the presentation causes the breasts to appear
as cornucopias from which all good things flow . . ."[3]

In the case of Cézanne, Meyer Schapiro has devoted an entire article,
"The Apples of Cézanne,"[4] to a convincing demonstration of the central-
ity of what one might call the apple-female sexuality syndrome in the
artist's oeuvre. Prof. Schapiro places the breast-apple metaphor in the
context both of Western cultural history and of Cézanne's psychological
development. There is obviously a time-honored connection, dignified
by the sanction of high culture, between fruit and women's inviting
nudity: apples and breasts have been associated from the time of Theoc-
ritus' pastoral verse down to Zola's eroticized paean to fruit in *Le Ventre
de Paris*. Cézanne's *Amorous Shepherd* is convincingly interpreted in the
light of this time-honored association by Prof. Schapiro. Thus, despite
the laughable triviality of *Achetez des Pommes* and its ilk as images, the
echoes of a grand, universal and time-honored metaphor still reverberate
in them. In any case, man's erotic association of inviting fruit and a
succulent, inviting area of the female body lends itself easily to artistic
elevation: sanctioned by tradition and prototype, it may be raised to
the level of the archetypal though it may indeed also sink to the level
of the ridiculous.

No similar sanctions exist for the association of fruit with male sexuality,
exemplified in a modern counterpart of *Achetez des Pommes* titled *Achetez
des Bananes*."[5] While there may indeed be a rich underground feminine
lore linking food–specifically bananas–with the male organ, such imagery
remains firmly in the realm of private discourse, embodied in smirks
and titters rather than works of art. Even today, the food-penis metaphor
has no upward mobility, so to speak. While Sylvia Plath may compare–
disappointedly–the male organ to turkey giblets, and Dr. William Rubin
may describe–disapprovingly–the penis of the impotent male as "limp

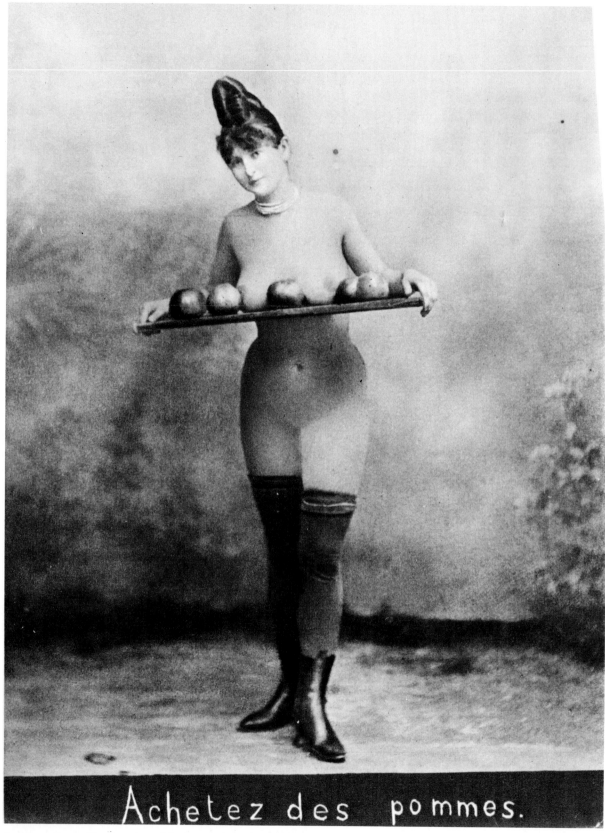

Achetez des pommes.

A mass-audience, "low" version of the breasts-as-apples metaphor:
Buy Some Apples, from a late 19th-century popular French magazine.

What happens when traditional erotic symbols change sex?
Buy Some Bananas, 1972, photograph by Linda Nochlin.

Rare example of delicious male
odalisque: Sylvia Sleigh's *Philip
Golub Reclining,* 1972.
Lerner-Misrachi gallery, N.Y.

as a noodle," or to return to the banana metaphor, Philip Roth may
nickname the heroine of *Portnoy's Complaint* "The Monkey," the linking
of the male organ to food is always a figure of meiosis–an image of
scorn, belittlement or derision: it lowers and denigrates rather than
elevates and universalizes the subject of the metaphor.

In the nineteenth century, and still today, the very idea–much less
an available public imagery–of the male body as a source of gentle,
inviting satisfaction for women's erotic needs, demands and daydreams
is almost unheard of, and again not because of some "male-chauvinist"
plot in the arts, but because of the total situation existing between men
and women in society as a whole. The male image is one of power,
possession and domination, the female one of submission, passivity and
availability. The very language of love-making attests to this, as does
the erotic imagery of the visual arts. Indeed, as John Berger has astutely
pointed out, the female nude of tradition can hardly call her sexuality
her own. Says Berger: "I am in front of a typical European nude. She
is painted with extreme sensuous emphasis. Yet her sexuality is only
superficially manifest in her actions or her own expression; in a compar-
able figure within other art traditions this would not be so. Why? Because
for Europe, ownership is primary. The painting's sexuality is manifest
not in what it shows but in the owner-spectator's (mine in this case)
right to see her naked. Her nakedness is not a function of her sexuality
but of the sexuality of those who have access to the picture. In the
majority of European nudes there is a close parallel with the passivity
which is endemic to prostitution."[6] One might add that the passivity
implicit to the imagery of the naked woman in Western art is a function

Apples associated with nudity and love: Cézanne's *The Amorous Shepherd*, ca. 1883-85, 20¼ inches high. Present owner unknown.

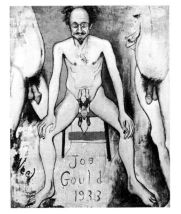

Alice Neel's *Joe Gould*, 1933. Owned by the artist.

not merely of the attitude of the owner-spectator, but that of the artist-creator himself: indeed the myth of Pygmalion, revived in the nineteenth century, admirably embodies the notion of the artist as sexually dominant creator: man–the artist–fashioning from inert matter an ideal erotic object for himself, a woman cut to the very pattern of his desires.

There are, happily, signs of change which go beyond such ephemera as the male nude fold-out popular in a magazine a few months ago. Years ago, Alice Neel, in her spectacular nude portrait of Joe Gould, took a step in the right direction. Sylvia Sleigh wittily reversed the conventional artist and model motif in her recent *Philip Golub Reclining*, representing a heavy-lidded male odalisque, recumbent against the foil of her own alert verticality. Miriam Schapiro furnished the miniature artist's studio in *Womanhouse* (in Los Angeles, winter-spring 1972) not only with a nude male model, but a still-life of bananas as well.

The growing power of woman in the politics of both sex and art is bound to revolutionize the realm of erotic representation. With the advent of more women directors, the film will have to reshape its current erotic clichés into more viable, less one-sided sexual imagery. All this still remains largely in the future. To borrow a phrase from Erica Jong's *Fruits and Vegetables*, a collection of poems which itself is a sign of the times in the freshness of its fruit imagery, "The poem about bananas has not yet been written."[7]

[1] Two noteworthy exceptions in the recent literature immediately spring to mind: *Studies in Erotic Art*, sponsored by the Institute for Sex Research of Indiana University, edited by Theodore Bowie and Cornelia V. Christenson, containing articles by Bowie himself, Otto J. Brendel, Paul H. Gebbard, Robert Rosenblum and Leo Steinberg; and Donald Posner's illuminating and convincing "Caravaggio's Homo-Erotic Early Works" which appeared in the Autumn 1971 *Art Quarterly*.

[2] One can of course question to what extent such highly charged subjects could ever be considered "realistic" or "objective" in the nineteenth century, or at any time for that matter.

[3] Wayne Andersen, *Gauguin's Paradise Lost*, New York, 1971, p.247.

[4] Meyer Schapiro, *The Avant-Garde (Art News Annual XXXIV)*, New York, 1968, pp.34-53.

[5] Created by the author with the sympathetic co-operation of the male model at Vassar College.

[6] John Berger, "The Past Seen from a Possible Future," *Selected Essays and Articles*, Penguin, 1972, p.215.

[7] Erica Jong, *Fruits and Vegetables*, New York, 1968, p.13. The poem continues: "Southerners worry a lot about bananas. Their skin. And nearly everyone worries about the size of bananas, as if that had anything to do with flavor. Small bananas are sometimes quite sweet. But bananas are like poets: they only want to be told how great they are. Green bananas want to be told they're ripe. According to Freud, girls envy bananas. In America chocolate syrup and whipped cream have been known to enhance the flavor of bananas. This is called a *banana split.*"

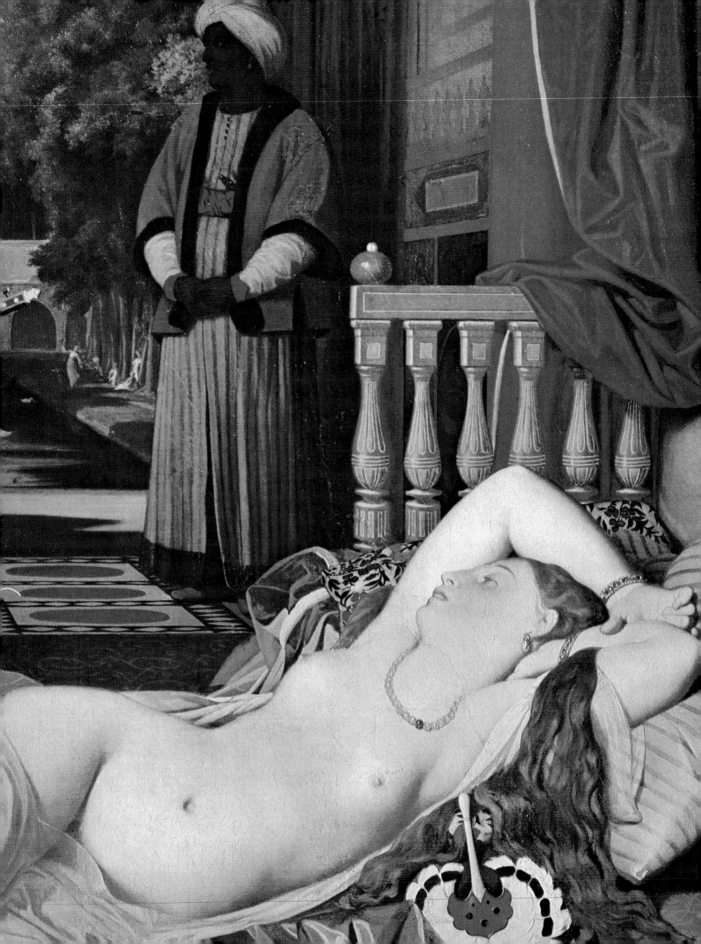

Ingres and
the Erotic Intellect

Author: John L. Connolly, Jr.
is Assistant Professor of Art
at Reed College, Portland, Ore.

In 1834, Jean-Dominique Ingres received a commission from Ferdinand duc d'Orléans for a painting whose theme was to be *Antiochus and Stratonice*. In December, 1834 Ingres journeyed to Rome where he labored on the painting for six years, delivering it to Ferdinand in 1840.[1] Though the theme of this masterwork has often been explored,[2] the original purpose of the painting as revealed through its key details has escaped scholarly explication. It is proposed, therefore, to identify those details which establish the portrayal of *Antiochus and Stratonics* as the allegorical representation of the painting's patron, Ferdinand duc d'Orléans, and of his beloved wife, Hélène de Mecklembourg-Schwerin. Moreover, it will be suggested that this painting, described by Robert Rosenblum as an "erotically complex drama,"[3] is in fact the quintessential representation of Ingres' particular conception of the erotic.

Prior to an examination of the painting, it is essential to survey Ingres' images which might be called erotic, and to consider briefly their relationship to erotic art in general. In Western art, erotic images have been created almost exclusively for a male audience, and may be divided into two broad categories: depictions in which figures act out a sexual performance, and those wherein figures are accompanied by clichés or are so posed as to suggest a potential amatory exchange between the depicted and the spectator. In each case the spectator is, willingly or not, a voyeur, with the image ready grist for the mill of his sexual fantasies. Ingres' paintings which invite the label "erotic" belong to the second category and are almost exclusively depictions of nude female figures. Though these paintings may appear to invite an imagined encounter between the image and the viewer, it will be found that they generate erotic power precisely because they elude the imagination's hot embrace.

The most blatantly erotic images to issue from the master's atelier are those gathered today in a collection housed in the Musée Ingres;[4] of apparently uneven quality, these drawings have been attributed to Ingres' hand and identified as copies of sixteenth-century prints and drawings. While Ingres made sketch copies of all manner of objects and pictures, he was not inclined to create images as specific in their description of sexual encounters as may be found in this collection. It must be realized that in the context of Ingres' oeuvre these are study copies, exercises, not inventions. Perhaps the most explicitly erotic image to come from Ingres' easel was the *Sleeper of Naples,* acquired by Murat, King of Naples in 1809, to disappear with Murat's downfall in 1815.

Ingres: *Odalisque with a Slave* (detail left), 1842, 30 inches high. Walters Gallery, Baltimore. [See footnote 8]

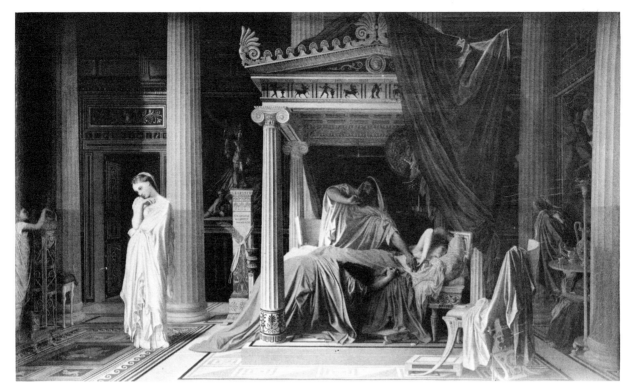

Ingres: *Antiochus and Stratonice,*
1840, 22½ inches high,
commissioned by Ferdinand
duc d'Orléans in 1834.
Musée Condé, Chantilly.

The image has survived through copies and its reappearance in the 1851 *Zeus and Antiope.*[5] The sleeping, receptively posed figure is discovered by a presumed male audience as by Zeus: tranquil, available and unresisting. Yet there is a subtle shift in the thrust of the later painting's meaning; whereas the spectator is the master of the Sleeper, Antiope is the possession of mythic time. Led to Antiope by Eros, Zeus has not yet known the mortal; we are witness to the arousal, not the satisfaction of passion.

It is tempting to see the *Bather of Valpinçon* in the same light as the *Sleeper of Naples,* a passive sex object presented to a male audience. Signed and dated 1808, this *Bather* was a deeply personal expression, the means by which the youthful *pensionnaire* to the Villa Medici expressed the success of his Roman education and his commitment to the creation of melodious visions. The *Bather* is not simply the representation of an idealized female body, it is the personification of sound. To the young artist who once had to choose between his violin and his pencil, the ethereal image held immense and enduring importance. This modest, elegant, thin-enamel personification exists in a drapery-hushed interior, the absolute silence gently broken by a minute splashing font. But a single personal feature is revealed to the spectator: the bather's ear, tuned perfectly to the harmony of her private world. The pure sound of the falling water and its sensual reception mark this painting as an allegory of the sense of hearing. The spectator lured to the vision of a beautiful woman discovers late that he stands before a remote entity—the untouchable realm of sound.

Four drawings after Giulio
Romano and other late
Renaissance sources. Collection
of unedited drawings, Ingres be-
quest. Musée Ingres, Montauban.

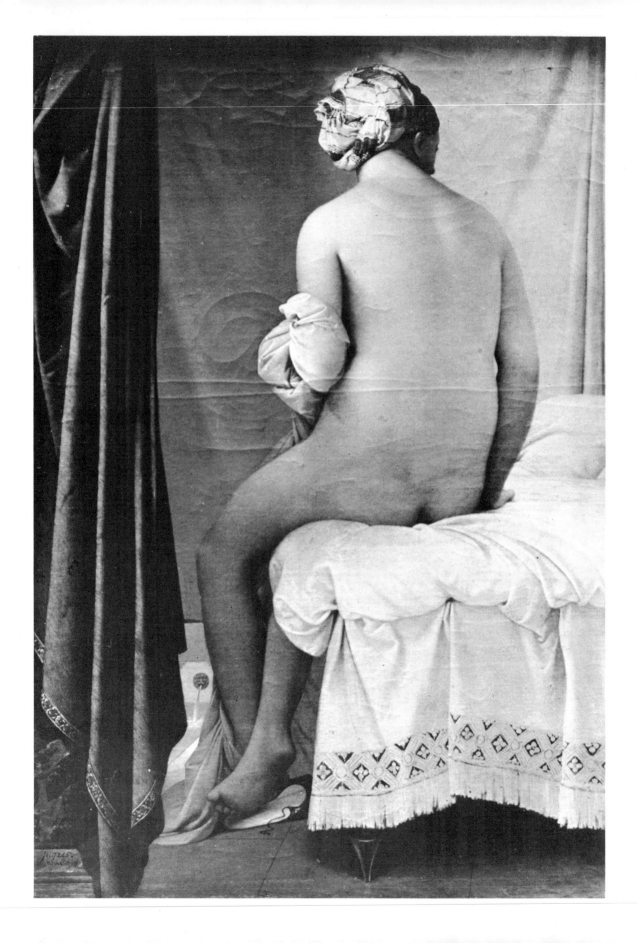

Ingres: Drawing for his lost
Sleeper of Naples, 1808,
6 inches high. Musée Ingres.

Ingres: Study for *Sleeper of Naples*,
1808, 11¾ inches high. Victoria
& Albert Museum, London.

Zeus and Antiope, 1851,
12⅝ inches high. Louvre.

Bather of Valpinçon, 1808,
56⅝ inches high. Louvre.

tightly compressed image than the preparatory grisaille in New York's Metropolitan Museum.[6] The grisaille, however, contains a particularly fascinating detail, the vestige of a program intended to depict the five senses. In the lower right corner there are two rapidly brushed circles, the sketch location of a water-spout; the *Grande Odalisque* was once intended to enjoy the same refreshing sound as the *Valpinçon Bather.* This detail was fully represented in two prints of the *Odalisque* which were published in 1851,[7] where may be seen a water-spout in the lower right corner, emptying into a square-cornered pool, and to the left of the pool a rather stilted, arbitrary still-life of drink and fruit. The presence today of overpainting in the *Grande Odalisque* in the lower right corner and center foreground suggests that these details were once present, and that they were painted out because they cluttered the pristine clarity of the *mise-en-scène*.[7a] It is proposed that it was once possible to read the details of the Odalisque thus: the censer represented the sense of smell; the font, hearing; the hand which gathers jewel-metal-fabric and feather, the sense of touch; the still-life, the sense of taste; the odalisque's steady gaze the sense of sight. The *Grande Odalisque* failed to attain its desired programatic completeness; frustrated in the attempt to harmoniously resolve narrative with image, Ingres returned to the drawing board to create, in 1828, *La Petite Baigneuse.*

Once again the artist attacked the problem of allegorically depicting the senses. Reading the painting from left to right: the censer by the pool again represents the sense of smell; the tambourine player and the font with basin—located at the *Bather's* ear level—the sense of hearing; the hair-dresser personifies touch; the waterpipe to the Bather's right, taste. These senses are gathered in the closed world of the harem, a world seen exclusively by its owner. The spectator is therefore the possessor of all that he sees, and thereby the bringer of the fifth sense—sight—to the painting's program. This was an ingenious though not completely felicitous solution and Ingres must have realized that as he returned to the problem in the *Odalisque with a Slave.*[8]

By the time Ingres began this painting, he had been inventing and experimenting with representations of the senses for 20 years; but here, in 1839, he found the perfect program to wed image and narrative. It has already been suggested that there are four senses explicitly symbolized in the painting:[9] the hookah, with its mouthpiece coiled invitingly

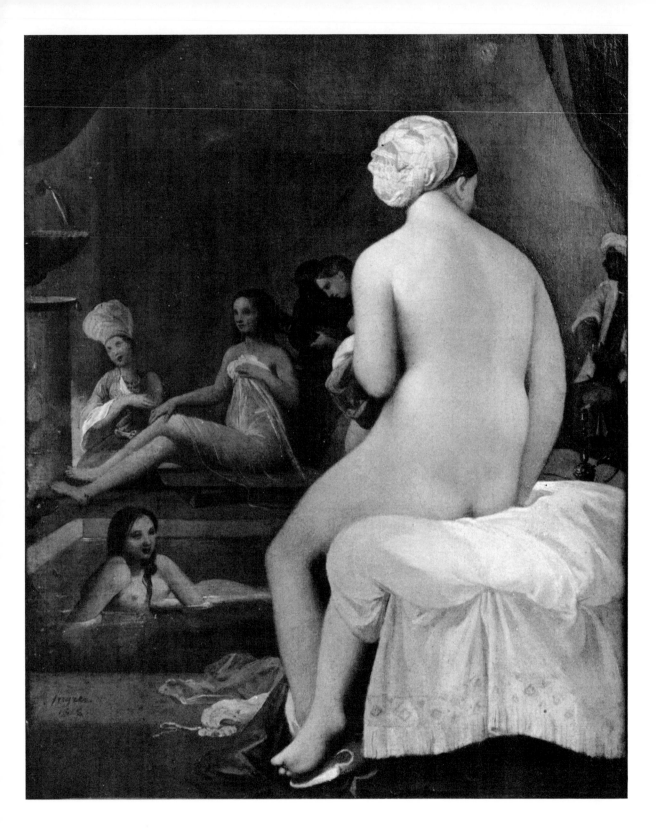

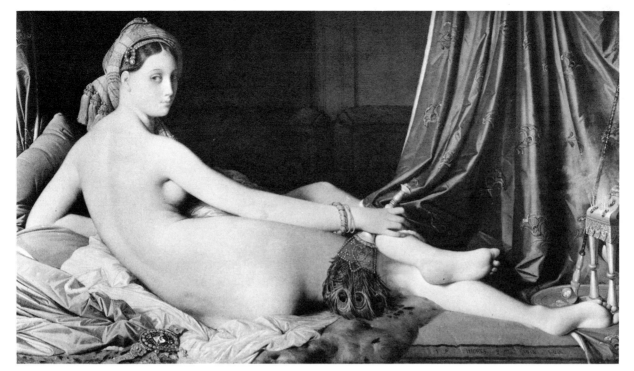

Ingres: *Grande Odalisque,*
1814, 35⅞ inches high.
Louvre, Paris.

La Petite Baigneuse, 1828,
13¾ inches high. Louvre.

toward the spectator, represents taste; the smoking censer, smell; the multi-jetted fountain symbolizes hearing; the fingered strings of the musical instrument, the sense of touch. As in the *Petite Baigneuse* the sense of sight appears at first glance to be missing, but the sense of sight is symbolized by the curious helmet in the lower left corner. Ingres borrowed this helmet from seventeenth-century Persian miniatures of the Shiraz School, which illustrated the tale of Khosru and Shirin, a love poem by Nizami. In these miniatures, Shirin is shown as having removed her robes and helmet to bathe in a mountainside pool; while bathing, Shirin was seen for the first time by Prince Khosru who had the good fortune to happen by at the right moment. Though the scene appears with variation in the miniatures, the shape of the helmet and the drapery covering the lower half of Shirin's body remain constant, to reappear in Ingres' painting as direct quotations. Though popularly called an Odalisque or a Sultana, Ingres thought of this figure as a Bather, in the tradition of her predecessors in his own oeuvre, and like the image of Shirin. Garbed as Shirin and in possession of that princess' helmet, the figure alludes to that moment in time when the princess was first seen by the prince. As we behold this bather, we are Khosru who sees Shirin for the first time, and we are thereby the bringer of sight to this allegory of the senses.

Once we recognize the allusion to Nizami's poem, we realize that we may but sense this vision of loveliness. This bather, like the bathers before her, is unpossessable, unknowable in a worldly sense. She and her sisters belong not to the material world and its representation, but to the spiritual world of form. Though there is an obvious temptation to view the harem as Rowlandson did,[10] an endlessly titillating tale of an Arabian knight, Ingres' harems represent, in an Aristotelian sense, the variety of sensory experience. Only in ignorance may we find these

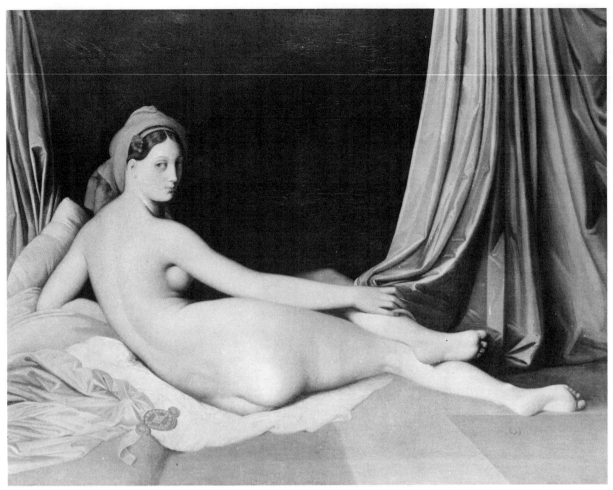

Grande Odalisque, grisaille,
with a water spout indicated
at lower right. Metropolitan.

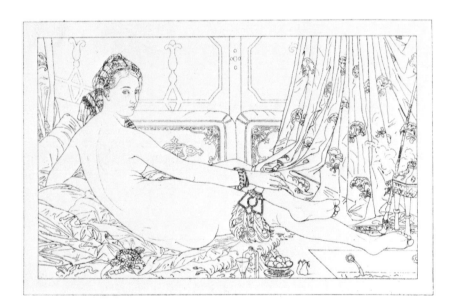

A. de Reveil's 1851 engraving
of *Grande Odalisque,* with water
spout clearly represented.

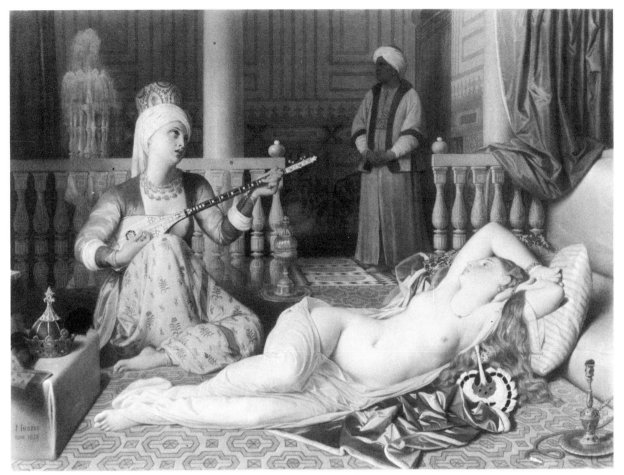

Ingres: *Odalisque with a Slave,*
1839, 28½ inches high.
Fogg Museum, Cambridge, Mass.

images to be tastefully displayed erotic morsels. Ingres' concept of what constituted eroticism centered on his expectation that an educated spectator would embrace the erotic image with his intellect no less fervently than with his senses. For this reason, the erotic images which Ingres created are fully erotic only to those who recognize that the clichés accompanying the primary image covertly contradict its overt message. To Ingres, the erotic was that which is recognizable and desirable, but known to be unattainable, and therefore all the more desirable.

The monumental *Bain Turc* is just such a painting.[11] To the uninitiated it is a hedonistic wallow; but to those who suspend disbelief to discover the artist's intent it is the masterpiece of a lifetime search to create an allegory of the senses wherein the spectator is the living personification of sight. All of the other senses are represented twice, once in the foreground and again in the background. The still-life of drink and sweetmeats recalls that of the *Grande Odalisque.* The *Bather of Valpinçon* appears with a musical instrument, seated on a scarf which has a decorative border composed of floral motifs and a parrot. This is an especially interesting detail as this bird was common to allegories of the senses in post-Renaissance art, but rare to the French nineteenth century. Indeed, one of the few parrots to appear as the sense of hearing is that in Manet's *Woman with a Parrot,* where it is joined by the invitingly peeled orange, the fragrant violets, the fingered ribbon and a monocle,

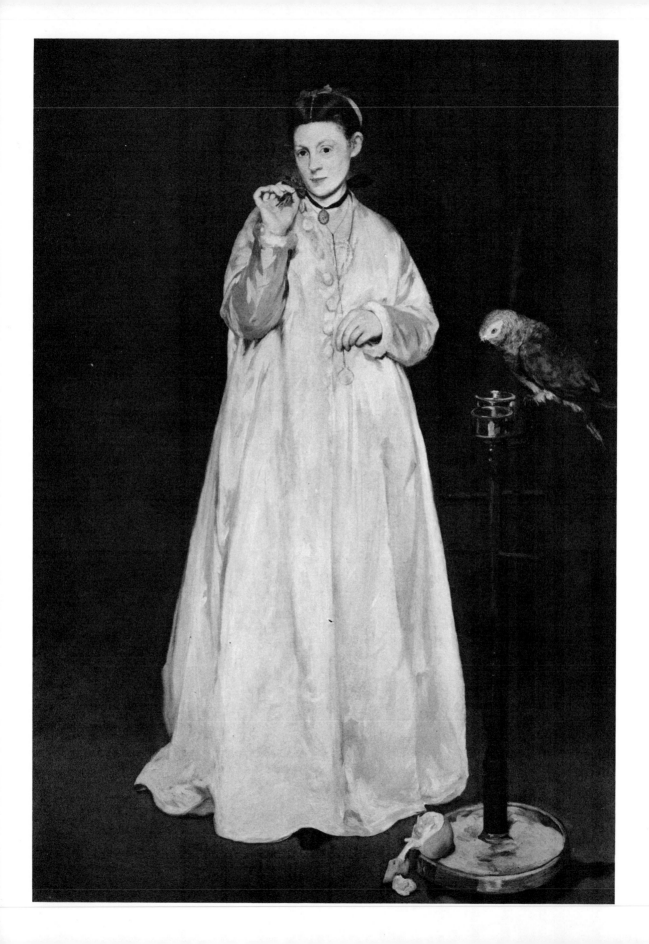

to constitute an essay on the five senses. To return to the bath, it confronts the spectator with no less than 25 pneumatic ladies who amuse themselves by petty diversions of the harem. Ingres, not noted for his humor, seriously expected the figures to the right of the Valpinçon figure to be understood as the sense of touch, or feeling [see cover], as it is so labeled in a refreshingly bawdy print by Rowlandson.[12] Behind these embracing figures, a harem beauty's hair is being perfumed by a censer.

Against the back wall of the bath a frieze of figures is divided into three groups: at the left, bathers sway and dance to the rhythm of the tambourine; in the center food and drink are being consumed; to the right some harem girls amuse themselves by tickling the cheek of a sleeping companion. A censer by the side of the pool perfumes the distant reaches of the bath and completes the allegorical representation of the senses. Though we sense an erotic delight, the intellect is reminded that the image is beyond the possibility of our erotic experience. This was precisely the predicament which nearly cost Antiochus his life, in the legend of *Stratonice*.

As the story from the Seleucid dynasty has it, Antiochus fell in love with his beautiful young stepmother, Stratonice. Unwilling to violate the sanctity of his father's marriage, and bound by honor to keep his love a secret, Antiochus was nearly destroyed by the frustration of his passion. One day, while the court physician was taking the dying Antiochus's pulse, Stratonice entered his bedchamber. The sudden acceleration of the prince's heartbeat told the doctor the nature of the malady; he advised the king, who magnanimously dissolved his own marriage and allowed Antiochus and Stratonice to marry. Ingres first approached the narrative in a drawing of 1809,[13] wherein the moment of discovery is portrayed. A rather somnambulant Stratonice has entered the chamber and paused to languorously fondle the prince's bedpost, distracting not only the doctor but also the prince's armor: the helmet abruptly turns toward the stepmother and the spear stands alertly to attention. The simple intention of this drawing and the canvas delivered to Ferdinand was the illustration of suffering caused by the frustration of erotic desire: in short, Ingres' particular conception of the erotic. Antiochus has seen Stratonice as the answer to his secret longings, and realizing that she cannot be his, desires her all the more.

The painting had a secret meaning for Ferdinand duc d'Orléans and his bride, Hélène de Mecklembourg-Schwerin; it was an allegory of Hélène's arrival in France and her discovery of true love in the person of Ferdinand. The painting metaphorically suggested the presence of a passionate romance behind what had in fact been a state-arranged marriage. Hélène, a Lutheran princess from an obscure and indigent German court, was picked for Ferdinand by the Cabinet des Tuileries. Though the bride was known for her bearing and charm, and the prince was a popular figure, the match was an affair of state–not of the heart. The painting allegorically describes Antiochus-Ferdinand as consumed by the fever of erotic desire but remaining honorably silent, to be saved by a compassionate state which granted him the hand of

Manet's "essay" on the five senses: *Woman with a Parrot*, 1886, 72⅞ inches high. Metropolitan Museum, New York.

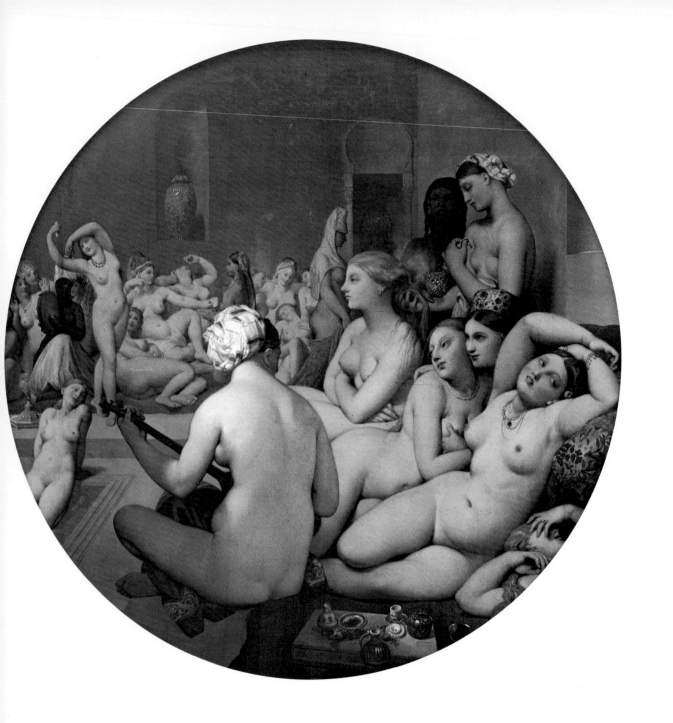

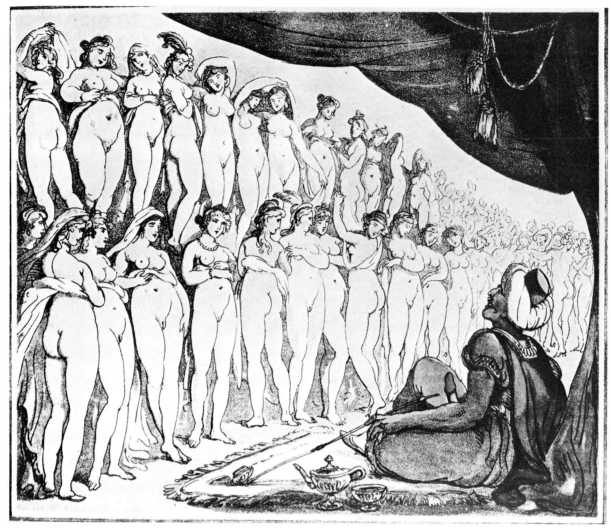

Rowlandson's *Harem,*
probably after 1812.

Ingres: *Le Bain Turc,* 1863,
42½ inches high. Louvre.

Stratonice-Hélène. The painting suggests that the state bowed to the
wishes of the prince–in France as in antiquity, and that Ferdinand had
desired Hélène from afar. Though examination of the details which
allude to the virtues of the prince must await later study, note can be
made of the floor decoration at Stratonice's feet and the overdoor paint-
ing above her. Both of these details were drawn from the publication
of Sir William Hamilton's collection of antique vases.[14]

At her feet is the sphinx, guardian of time, flanked by figured panels
which represent signs of the zodiac. Below the sphinx is the image of
Leo, a rampant lion; above is that of a bull, the representation of Taurus.
The time alluded to is therefore the days between May 20 and July
24–that is, the time of Hélène's arrival in France, her wedding at Fon-
tainebleau and her public reception in Paris. The overdoor decoration
was drawn from an Apulian volute-crater in Hamilton's collection which
also provided the model for the canopy above Antiochus' couch. This
image was described in an accompanying text to be the representation
of Helen, the sister of Castor and Pollux. Stratonice therefore stands
in the time of Hélène's advent and before the portal of Hélène's future,
testimony to the erotic power of a woman to influence the course of

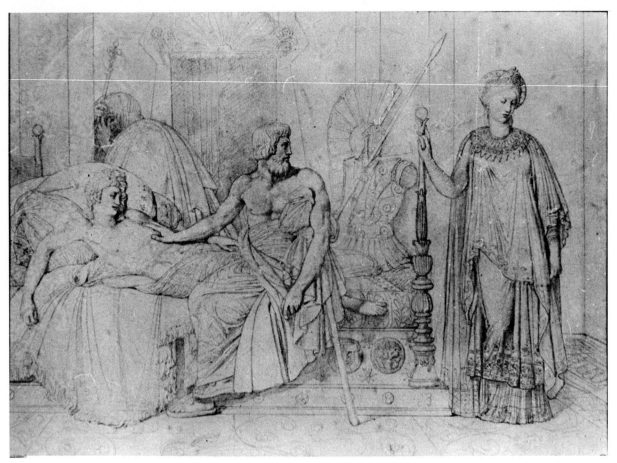

Ingres' first approach, in
1809, to the narrative of
Antiochus and Stratonice,
lead point drawing. Louvre.

history. Though this may cast Hélène in the role of a sex object, and
portray Ferdinand as a royal chauvinist boar, that was passion's protocol
in 1840.

The author is profoundly grateful to Prof. John McCoubrey of the University of Pennsyl-
vania for his generous observations on and criticism of Ingres research in progress.

[1]The painting with its pendant, H. P. Delaroche's *L'Assassinat du duc de Guise*, are now
in the Musée Condé, Chantilly. The Delaroche is signed and dated 1834, the Ingres,
1840. The relationship of the two will be considered in my forthcoming study of Ingres'
four extant paintings on the "Antiochus and Stratonice" theme.
[2]Most notably: H. Lemonnier, "A Propos de la 'Stratonice' d'Ingres", *Revue de l'Art Ancien
et Moderne, XXXV*, 1914, pp. 81-90; W. Deonna, "Ingres et l'imitation de l'antique," *Pages
d'Art*, Dec. 1921, pp. 373-374; W. Stechow, "'The Love of Antiochus with Faire Stratonica'
In Art," *Art Bulletin, XXVII*, 1945, 221 f.; W. Stechow, "The Love of Antiochus with Faire
Stratonica," *Bulletin du Musée National de Varsovie, V*, 1964, 11 f.; A. Mongan, "Ingres
and the Antique," *Journal of the Warburg and Courtauld Institute, X*, 1947, 1 f.; N. Schlénoff,
Ingres, ses sources littéraires, Paris 1956, 100, 237f.; H. Francis, "Antiochus and Stratonice,"
Bulletin of the Cleveland Museum of Art, LV, 1968, 103 f. See also: Georges Wildenstein,
Ingres, London, 1954, p.211, no. 232.
[3]Robert Rosenblum, *Ingres*, New York, 1967, p. 146.
[4]Louis Dunand, "Les dessins dits 'secrets' légués par Ingres au Musée de Montauban,"
Bulletin du Musée Ingres, XXIII, 1968, 27 f.
[5]Hans Naef, "*La Dormeuse de Naples:* un dessin inédit d'Ingres," *Revue de l'Art*, 1968, 102
f.; for illustration of the *Sleeper*, variations on the theme, and the *Zeus and Antiope*, see:
Wildenstein, *op. cit.*, pp. 173, 222.
[6]Wildenstein, *op. cit.*, p. 181.
[7]See A. Magimel, *Oeuvres de J. A. Ingres, gravées . . .par A. Réveil*, Paris, 1851, pl. 31; *L'Artiste,*

VI, no. 11, 1851, p. 177.

[7a]Two impasto concentric circles may be seen beneath the surface which represents a blue cushion, located exactly as they are in the grisaille version.

[8]Hans Naef, *"Odalisque à l'Esclave," Fogg Art Museum Acquistions Bulletin,* 1968, 80 f.; Prof. Naef suggests that the Walter's *Odalisque* (reproduced on p. 16, 17) is an authorized copy of the Fogg *Odalisque* by Paul Flandrin. Though space will not allow discussion of the role of master and assistant in the production of Ingres' oeuvre, Ingres' control over the concept and execution of the Walters' painting must be recognized. The painting bears the master's signature and conveys his genius, but its meaning is a thing apart from that of the Fogg *Odalisque.* Whereas the addition of pool and trees strengthens the allusion to Nizami's poem, the substitution of slippers for the censer removes this painting from the category of paintings of the senses.

[9]The author presented a brief discussion of the *Odalisque à l'Esclave* in a paper titled "Ingres and Allegory"; delivered in the January, 1970, College Art Association meeting. The sources for and probable meaning of the Fogg Odalisque will be discussed in a future study.

[10]Kurt von Meier, *The Forbidden Erotica of Thomas Rowlandson,* Los Angeles, 1970, pp. 119, 135.

[11]Hélène Toussaint, *Le Bain turc d'Ingres,* Paris, 1971.

[12]von Meier, *op. cit.,* p. 59. When this essay was submitted for publication, the author was of the impression that these harem beauties were depicted as embracing and fondling one another. Continued study of preparatory drawings has led to the conclusion that the woman nearest the Valpincon figure is represented as cupping her breast in her left hand. It is noted that Ingres accepted for the final version a pose which could be variously interpreted; the image is at once the portrayal of modesty and sensuality. The sense of touch must be symbolized, as in the *Petite Baigneuse,* by the girl perfuming the hair of the woman above and to the right of the Valpinçon figure, her fingers intertwined in flaxen locks.

[13]The date of 1809 is suggested as a probable *terminus ante quem* for the Louvre drawing as it would appear that the *Stratonice* by Guillemot was admired by Ingres, who may have seen the print after his painting in Landon's *Salon* (I, 1808, p.109)

[14]d'Hancarville, *Greek, Roman and Etruscan Vases in the Collection of Sir Wm. Hamilton Esq.,* 4 vols., Naples, 1766-1767.

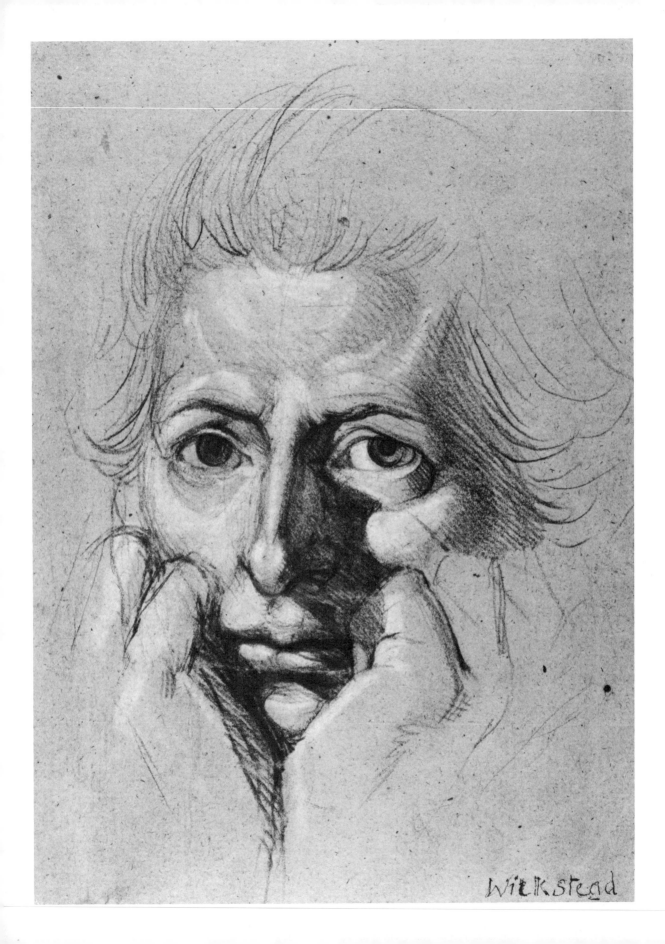

Wickstead

Henry Fuseli's 'Nightmare': Eroticism or Pornography?

Author: Marcia Allentuck, Associate Professor of English and Art History at City University of New York, currently has a research fellowship in Landscape Architecture from Harvard.

Henry Fuseli's valedictory lecture before the Royal Academy in 1825, shortly before his death, and virtually 44 years after the first known version of *The Nightmare,* emphasized his abiding faith in an artistic autonomy independent of the doctrines of academies: "No genuine work of art ever was or ever can be produced, but for its own sake; if the artist does not conceive to please himself, he will never finish to please the world."[1] The polarity inherent in this statement was further emphasized in Fuseli's conclusion: "All depends on the character of the time in which an artist lives, and on the motive of his exertions."

I should like to consider one aspect of this stated polarity: "the motive" of Fuseli's "exertions," as I construe them to bear upon *The Nightmare.* Limits of space do not permit me to deal with the fascinating question of all of the known versions of this picture, or of its probable sources, literary and artistic, and its plausible analogues among works both by Fuseli and other artists except in the most glancing and peripheral manner. I will confine myself to the version of *The Nightmare* which was exhibited in 1782 at the Royal Academy in Fuseli's forty-second year; it is now at the Detroit Institute of Arts. An engraving of this version hung on the walls of Freud's study. It is, I believe, possessed of the greatest emotional density and the most charged ambience of any of the surviving versions, thus offering the richest opportunities for explication. Not merely *épatant,* not merely a work of contrived sensationalism, it is arrestingly evocative, truly a masterpiece of psychosexual projection.

But to return for a moment to Fuseli's polarities of "the character of the time" and "the motive" of the "artist's exertions". It should be understood that I do not rule out the possibility of viewing *The Nightmare* as a splendid example of a work quite of "the character of the time" if we understand this phrase in an art-historical sense. It can be regarded as the result of Fuseli's assimilation and forwarding of such contemporary theoretical preoccupations as expressive pathognomy versus structural physiognomy in Lavater's context; or the pregnant moment, in Shaftesbury's or Lessing's context, the moment which was, in Fuseli's words, "the middle moment, the moment of suspense," which combines "the traces of the past, the energy of the present and a glimpse of the future."[2] It can even be enjoyed as Fuseli's private joke, as a lapsed Protestant minister, against martyrology in art–or Fuseli's smack at, his travesty of, the works of high historical seriousness by artists such as Poussin and Gavin Hamilton, whose concern to convey an *exemplum virtutis,* a

Henry Fuseli: *Self-Portrait,* ca. 1790, crayon and white chalk. Victoria & Albert Museum, London.

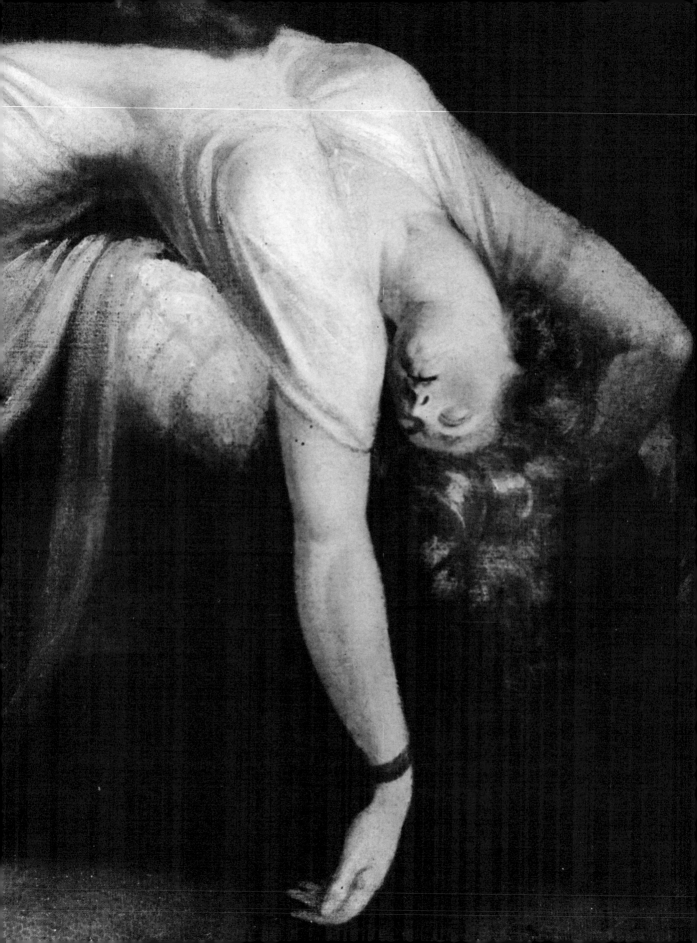

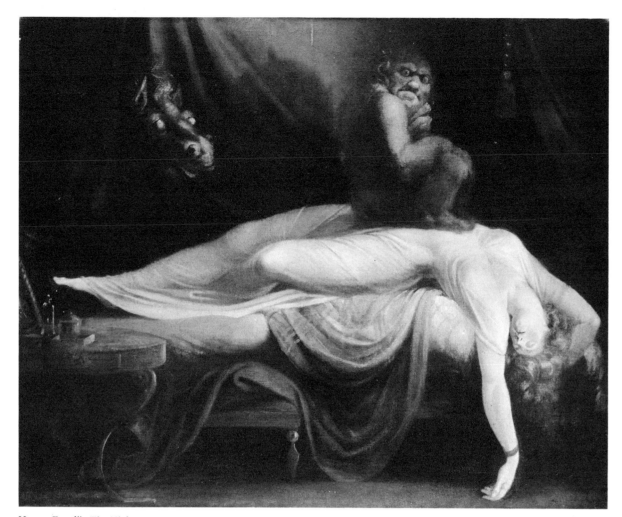

Henry Fuseli's *The Nightmare,*
40 inches high, exhibited at the
Royal Academy, London, 1782,
detail left.
Detroit Institute of Arts.

kind of secularized *pietà* amid dishevelled bedclothes and peering spectators, had a palpable effect upon Fuseli's own works in the historical and dramatic modes. Most significant of all, perhaps, with regard to the "character of the time" and its preoccupations, *The Nightmare* can be apprehended as an arresting embodiment of the components and strategies of the sublime in the radical Burkean sense–of the mind thrown back upon itself during an ineffable pain-pleasure experience, in a context of physical danger, darkness, terror and human solitude. The richly flowing draperies; the delicately fashioned dressing-table, whose oval and curves vibrate to the female form; the still-life upon it containing a mirror, with an erect sinuous support, a mirror which may be used for other confrontations than mere empirical authentications of order in dress and countenance; the well-tempered jars which may contain cosmetics–or lubricants and aphrodisiacs–all of these accessories enhance the contrast between the familiarly known and the strangely ominous which is the nature of the sublime. The *Umwelt* renders the subtleties of terror and not the mechanics of horror, and estrangement is enhanced by the use of objects of hard, physical reality, precisely detailed. Here again Fuseli is our best commentator in his Royal Academy *Lectures:*

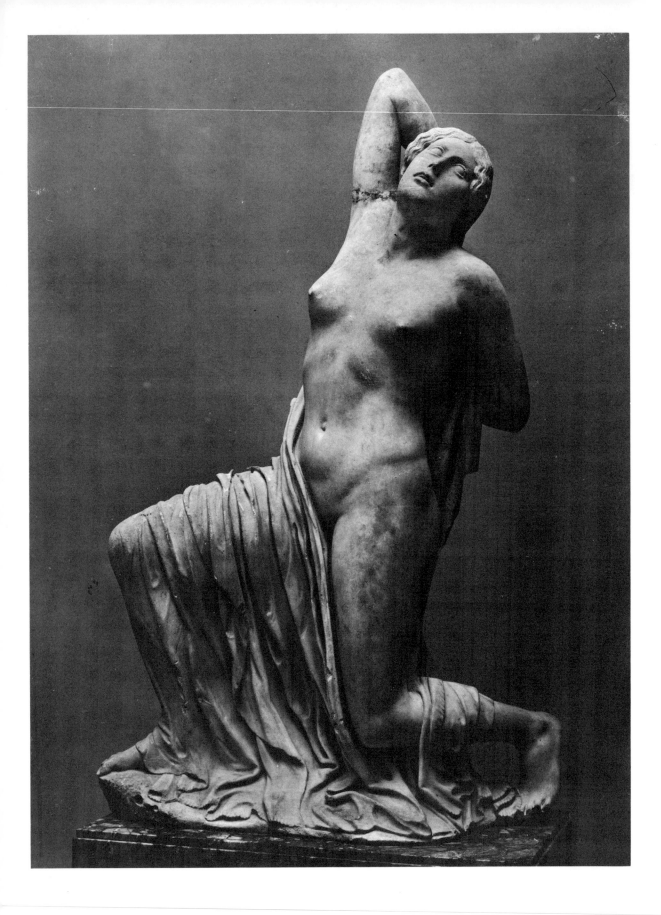

Maenad, after Skopas, marble,
4th century B.C.
Skulpturen-Sammlung, Dresden.

Daughter of Niobe, marble,
Greek, 5th century B.C.
Thermae museum, Rome.

"By the choice and scenery of the background we are frequently enabled to judge how far a painter entered into his subject, whether he understood its nature . . .what passion it was calculated to rouse . . .it acts, invigorates, assists the subject, and claims attention . . ."[3]

The Nightmare, then, is of its time on a host of levels, and is not necessarily such a remarkably prescient exercise in the subconscious and the Surreal as so many of its discussants have claimed. But "the motive" of Fuseli's "exertions," its private dimensions relative to this picture, cannot be so patly delineated. One might equate biographical facts as far as we know them with *The Nightmare* and conceivably regard it as an emblematic transcription of Fuseli's private life. But such an approach would be reductive if applied to so various and complex an artist, so provocative and challenging a picture. I shall forsake *Schaffensvorgang,* and use Fuseli's own words in another R.A. *Lecture:* "The first demand on every work of art is that it constitute one whole, that it fully pronounce its own meaning."[4]

The Nightmare fully pronounces its own meaning and that meaning has to do with eroticism and female imagery. To be sure, it is but one of Fuseli's numerous works which offer insights both esthetic and cognitive into human sexual life, in the dual areas of realistic representation and fantastic projection. Many women have found the generic use of the term *homo eroticus* to cover their own range of responses unjust; here I am concerned with *femina erotica,* and her peculiar and distinctly unmistakable responses to sexual consummation. By using eroticism, whether with studied calculation or felicitous instinct, to mediate between theoretical art-historical assumptions–the public aspect of *The Nightmare*–and purely feminine subjective experience–its private aspect–Fuseli transcended the topical and rose to the archetypal. For eroticism is an area in which the public and the private perennially converge, with varying degrees of conflict, diversity, enigma, absurdity and even, occasionally, fulfillment. "*C'est toujours la chose génitale,*" maintained Freud's mentor, Charcot, "*toujours, toujours, toujours.*"

Is *The Nightmare,* then, overtly and dominantly erotic, or only subtly and associatively so? Do erotic motifs obliterate or even eclipse all others? So far as eroticism in art goes, it is assuredly at first glance an understated, rather than an obtrusive or flagrant rendering. The scholar avid for sexual symbols can find them in the erect ears of the horse and goblin, the protruding eyes of these creatures (truly examples of *concupiscentia oculorum*), the leg of the stool balanced by the tassel of the drapery, and so on. But the painting lacks the corroborative details (other paintings by Fuseli do possess them) of an explicit act of sexual copulation; it depicts no manipulative or exhibitionist genital activity, either homo- or heterosexual; no picturesque landscapes of tufts of pubic hair or phalluses in varying heights of tumescence, nor even frantic intertwinings of unclothed extremities fortified by energetic penumbra of lines.

Even its title diverts one from the picture's eroticism, from what is actually happening, for it can be read literally as a nightmare, not, to use a classical distinction, as a *somnium,* but as a *visium* or even an *insom-*

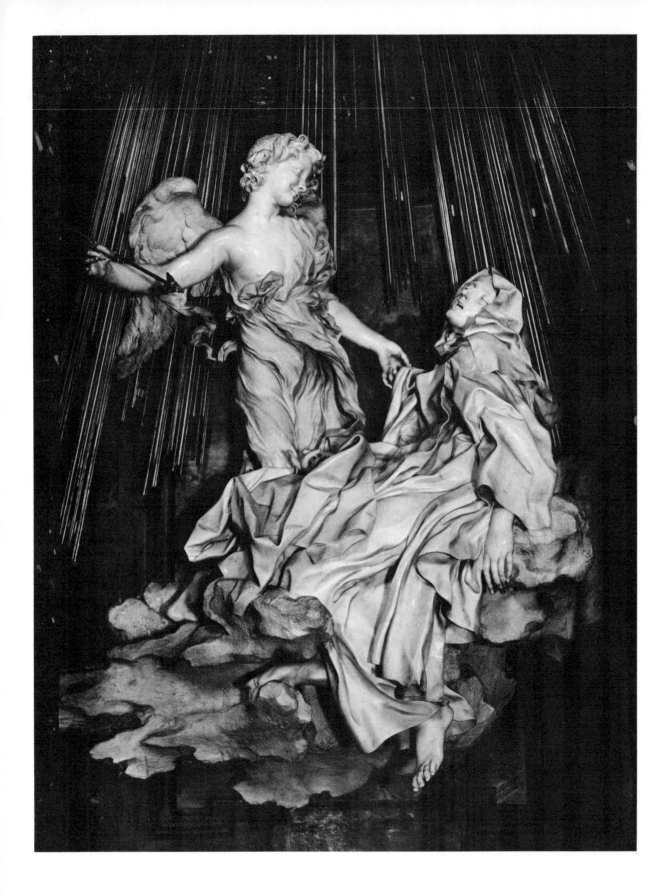

nium, with a perfectly acceptable tradition behind it, from the ancients such as Plato and Macrobius to the moderns such as Freud and Ernest Jones. The female figure, apparently invested with suffocating dread of real or hallucinatory agents, simultaneously gripped by panic and paralysis, is no stranger to folklore, in literature or art. Nor is the equation of these agents–the spectral, voyeuristic horse and the contorted and supposedly causative ape-goblin–with the male libido and, in the case of the latter, with its more lubricious aspects. The *general* sexual connotations of the painting were not unremarked by Fuseli's contemporaries. After his friend Erasmus Darwin saw the preliminary drawing he wrote of the "love-wilder'd Maid" over whose "fair limbs . . .convulsive tremors fleet," and Fuseli's mortal enemy, the droning Rev. R.A. Bromley, a natural Victorian born too soon, incensed at the picture's enormous popularity–we recall that Allan Cunningham in the early nineteenth century wrote that "perhaps no single picture ever made a greater impression in this country"[5]–dubbed Fuseli a "libertine of painting."[6]

But in Fuseli's *Nightmare,* does the artist give us an etiology of the experience? A nightmare triggered by what? A nightmare before´ or after the fact of the picture? Edgar Allan Poe, in *The Fall of the House of Usher,* wrote of "the certainly glowing yet too concrete reveries of Fuseli." Here is the key: the picture speaks a clear language.

For I submit that, in the rhetorical sense, the *topos* of the picture is *not* a nightmare, but a female orgasm, one not in the excitement or peak phases, but in the very beginning of the resolution phase. The distinguished British psychologist, J.A. Hadfield, has written recently in *Dreams and Dreaming,* a study remarkably free from the jargon of the schools, that "terrifying nightmares of the monster type are particularly liable to occur as the result of a sexual orgasm, for an orgasm overwhelms the whole personality."[7] In Hadfield's view, a young and relatively inexperienced woman is particularly vulnerable, for her sexuality may still be repressed and her orgasms may occur spontaneously in sleep as a result of a fantasy pattern, rather than as a result of tactile auto-eroticism. She has not yet learned, in Hadfield's words, to "control . . .those passions which therefore appear as overwhelming and sometimes destructive forces coming to overmaster" her. She is "carried away" by a monster, an enfranchiser of her desires, and the instrument, from her vantage point, of both her pain and her pleasure. While there is no visible evidence in *The Nightmare* that the female is prurient, mindless, usable or depersonalized–no evidence, that is, that she is a pornographic image, there is material aplenty for regarding the direfully squatting incubus as such. He is decidedly pornographic: overtly lascivious, he solicits the spectator with a smug, grotesque, bestial sneer, while exhibiting his swollen, contorted shape. Yet observe the monster's position –nightmare folklore would have him squatting and "riding" directly on the female's chest. But Fuseli has so placed him that he is actually on her abdomen, tipped back towards her *mons veneris.*

Mark also the inflections of the female's position and the contradictions in her pose between mass and line, between movement and stasis, a

Bernini: *St. Teresa in Ecstasy,* marble. Cornaro Chapel, S. Maria della Vittoria, Rome.

perfect example of Fuseli's stated apprehension, in his R.A. *Lectures*, of the "picturesque effect and powerful contrasts" of the "nature of a dream," as well as of his contention that "the forms of virtue are erect, the forms of pleasure undulate."[8] Clear, bounding outlines move with easy transitions throughout and along the figure, through the cascading hair, the drapery and the furniture. Observe her left side, which at first glance appears relatively relaxed, even slack or languorous. The well-groomed and modestly adorned hand which, if it were striving for orgasmic peak might be contorted into a fist (as it is in the case of the female in one of Marcantonio Raimondi's engravings of Giulio Romano's illustrations to Aretino's *Sonnetti Lussuriosi*, which Fuseli knew), now rests upon the rug. The elongated left thigh of round, firm flesh is not actually on the bed but slightly elevated. Its generous proportions are revealed and enhanced by superb rendering of the drapery (here certainly an accomplice of nudity) in which there are no encumbering folds, and whose animating luminosity passes over the shining expanse of surface like a caressing hand terminating between the cloth's subtle inner modulation of swelling and subsiding between the thighs. No better commentary can be found on Fuseli's handling of this drapery which makes the form intelligible, than in his own translation (1765) of J.J. Wincklemann's *Gedanken:* "The smaller foldings spring gradually from the larger ones and within them are lost again, with a noble freedom ...drapery clasped the body and discovered the shape" (pp. 28-29).

The female's right side balances the left; the tension of the left thigh slightly elevated above the bed is reflected in the straining forward of the right foot. The almost torpid left hand, however, makes a remarkable contrast to the flexed right hand flung backwards–what is it doing within the private recesses of her gleaming and splendidly dishevelled hair? These balances and contradictions are unified centrally at the small curve of her waist–for her back is clearly arched as if she is straining upwards for perhaps the last time. Her breasts are distinctly in a detumescent state; there are no engorged nipples visible in what is a quite detailed painting–merely gentle curves.

The thrown-back head and the raised right arm suggest the ritualization of two general classical sources so unmistakably that one must acknowledge them even within the limits of this paper: that is, the Niobid position suggesting psychological pain or anguish, and the Maenad position, symbolizing ecstasy and pleasure. Like the eyes of Bernini's *Teresa*, the female's eyes here are hooded and inward-turning, and the full mouth above the dimpled chin opened, perhaps to emit final groans of pleasure. Along the female's somewhat swollen face is the suggestion of the measles-like rash characteristic of the last stages of orgasm among many women, a most interesting contrast to the dark blood-reds used for the draperies and parts of the coverings. "Color," asserted Fuseli in his R.A. *Lectures*, is "an organ of expression...the minister of the passions...the herald of energy and character."[9]

We have, then, in the female of *The Nightmare*, not the frightened victim, the degraded pornotopic female, but the eroticized one, the

enjoyer and not the tortured, with, in William Blake's words, "the lineaments of gratified desire." We remember that Blake reserved this description for harlots and lamented its absence in wives. Fuseli never declared himself on this subject, but, in view of his praise of Correggio for a "voluptuous sensibility of...mind,"[10] it is doubtful whether he would have acceded to Blake's fragmentizing of the female erotic experience, or, indeed, to Goya's contention in *Capricho* 43 that "that sleep of reason produces monsters." For Fuseli, dreams and nightmares were not destroyers of reality but the gateways to it, and his most suggestive aphorism on art began with the revolutionary observation that "one of the most unexplored regions of art [is] dreams . . . "[11]

I am indebted to Cornelia Christenson, Trustee of the Kinsey Institute and biographer of Dr. Alfred Kinsey, for many stimulating exchanges of ideas about this painting and related subjects during my research visits to Indiana University.

[1] All references to Fuseli's written works will be to the following edition: John Knowles, ed., *The Life and Writings of Henry Fuseli* . . ., 3 vols., London, 1831. The present quotation is from Knowles, III, pp. 54 ff.
[2] Knowles, III, pp. 82, 94.
[3] Knowles, II, p. 224.
[4] Knowles, II, p. 190.
[5] Allan Cunningham, *Lives of the Most Eminent British Painters* . . ., 2d ed., II, London, 1830, p. 290.
[6] Erasmus Darwin, *The Botanic Garden, Part II, The Loves of the Plants,* London, 1791, pp. 97-98, and Knowles, I, p. 183.
[7] Middlesex, England (Penguin Books), 1951, pp. 189 ff.
[8] Knowles, II, p. 197 and III, p. 135.
[9] Knowles, II, pp. 33, 255, 334.
[10] Knowles, II, p. 105.
[11] Knowles, III, p. 145.

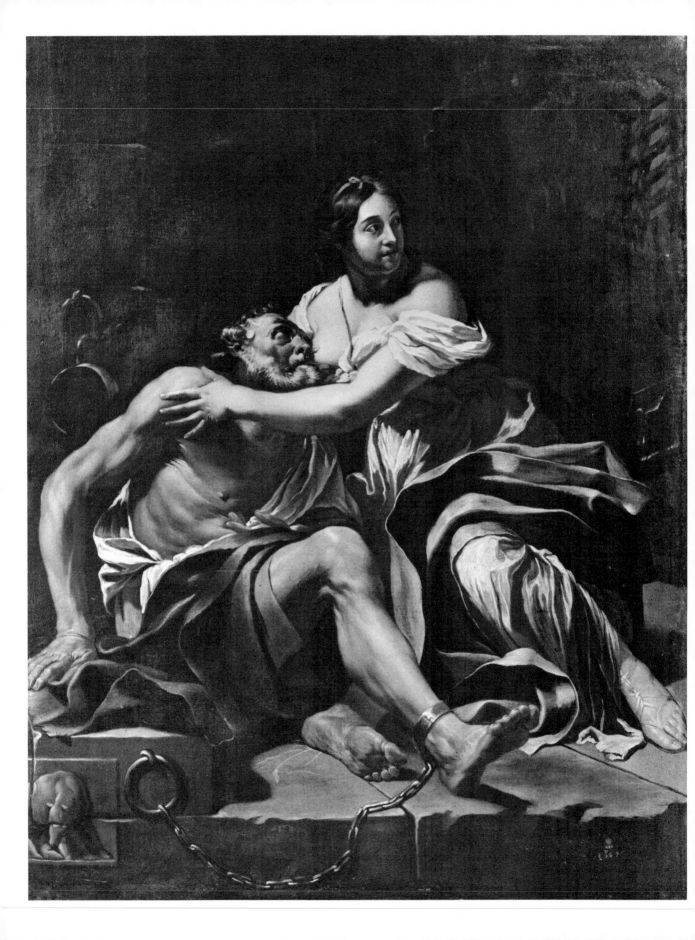

Caritas Romana after 1760:
Some Romantic Lactations

Author: Robert Rosenblum, professor at the Institute of Fine Arts, N.Y.U., is the author of books on Ingres, Cubism, Romantic painting and Frank Stella

For us today, decades after Krafft-Ebing and Freud, it is probably all too easy to invent psychosexual explanations for the long and continuous life of the strange legend which Renaissance humanists called "Caritas Romana."[1] As recounted first by classical writers such as Pliny the Elder (VIII, 36, 121-122), Hyginus (CCLIV, 3) and, in two versions, Valerius Maximus (V, 4, 7 and V, 4, ext. 1), the story of Roman Charity concerns a daughter whose father–or, in some cases, mother–was imprisoned for a crime and left to die of starvation, but whose uncommon courage and devotion inspired her to visit the prison and stealthily to sustain her parent's life with milk from her own breast. Although the sophistication of 20th-century erotic sensibilities may read into this bizarre legend everything from incestuous desire to gerontophilia, from infantile oral sexuality to sado-masochism, the ancient authors and artists who recorded this tale and illustrated it on the walls of Pompeii seemed to consider it a high-minded and edifying drama which exemplified rare filial virtue rather than perverse sexual behavior. Such a moralizing interpretation continued into the Middle Ages, when Boccaccio, in his *De claris Mulieribus* (LXIII), repeated the classical anecdote as an example of feminine heroism, and when 15th-century manuscript illuminators elegantly illustrated, with doll-house prisons, his text.[2] And in the Renaissance as well, when classical accounts of the story were re-examined, the noble aspects of the theme were maintained, often to so ideal and classicizing a degree that we are hardly aware of the story's odd components.

But as Western psychology became more complex, so too did interpretations of Caritas Romana. Thus, in the 17th century, when the theme surged in popularity, it was frequently given a new pathos and carnality, whether in the works of famous masters like Rubens or obscure ones like Louis Dubois, who, with perhaps unconscious wit, paralleled this scene of unusual human lactation with one of an equally unusual animal lactation, the suckling of Romulus and Remus by a she-wolf, as represented in a bas-relief on the prison floor. However, it is not until the dawn of the Romantic movement, that is, from the 1760s on, that the classical story begins to acquire the fullest spectrum of new inflections that can share, in emotional range, everything from the sacrificial heroism of the French Revolution to the exploratory sexuality of the Marquis de Sade, and that can even create anecdotal variations which relocate the theme in quite unclassical milieux.

Already at the Salon of 1765, such tremors may be felt. Unlike a

A Baroque version of *Caritas Romana,* painted by Louis Dubois in 1696. Saint-Lô museum.

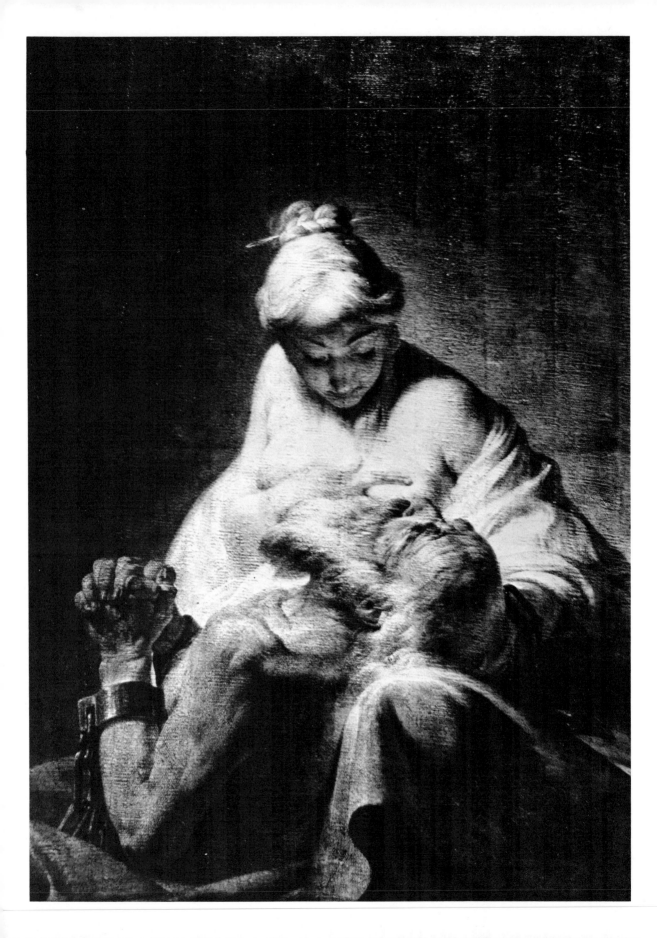

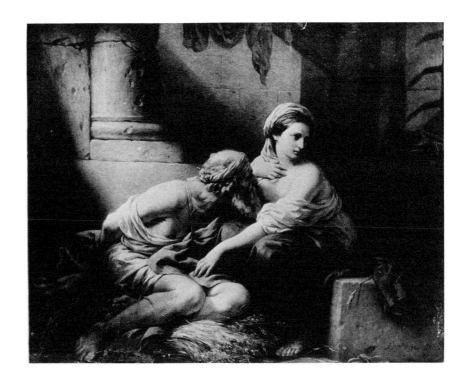

Louis-Jean-François Lagrenée the Elder's *Roman Charity,* exhibited at the Salon of 1765. Musée des Augustins, Toulouse.

relatively conventional version of the theme exhibited there by Louis-Jean-François Lagrenée the Elder,[3] one by the ambitious animal painter, Jean-Jacques Bachelier, invests the father and daughter with an aura of intimacy and eroticism that can almost be confounded with the incestuous theme of Lot and his daughters, so popular in the Rococo period. In Bachelier's painting, the brawny old man, his shackled hands raised almost in prayer, seems to be receiving, as if in a saintly vision, an erotic angel of mercy in the form of a blonde Rococo maiden, his very daughter, who relieves his supine desperation with the succor of her full breasts. It may indeed have been this prominence of a woman in a dominant, crypto-sexual role that inspired a Dutch woman artist of the late 18th century, Gertrude de Pélichy, to copy, with only minor variations, Bachelier's painting.[4]

Somewhat more chaste, if no less intense in its intimacy, is a British version of Caritas Romana by Johann Zoffany. Although undated, its exploitation of the lachrymal potential provided by a withering old man, a pious daughter and a gloomy prison would seem to locate it somewhere in the new sentimentalizing current of British art of the 1770s and 1780s, where it could keep company with such extremes of family despair as Wright of Derby's *Dead Soldier* of 1789, in which a widow on the battlefield mourns her husband and nurses her pitiful baby at the same time, or with such investigations of prison horror as found in literary sources (Reynolds' *Ugolino*, 1773, illustrating Dante's spine-chilling narrative of an old man's incarceration with his children in the Tower of Famine) or in contemporary philanthropic experience (Wheatley's painting of 1787 that commemorates the reformer John Howard relieving the misery of British prisoners).

But if the earliest generations of Romantic artists and spectators liked to wallow in the tears shed over uncommon suffering, they also liked to take courage in demonstrations of no less uncommon heroism. In

Intimacy and eroticism mix in J.-J. Bachelier's *Roman Charity,* shown in the Salon of 1765. Ecole des Beaux-Arts, Paris.

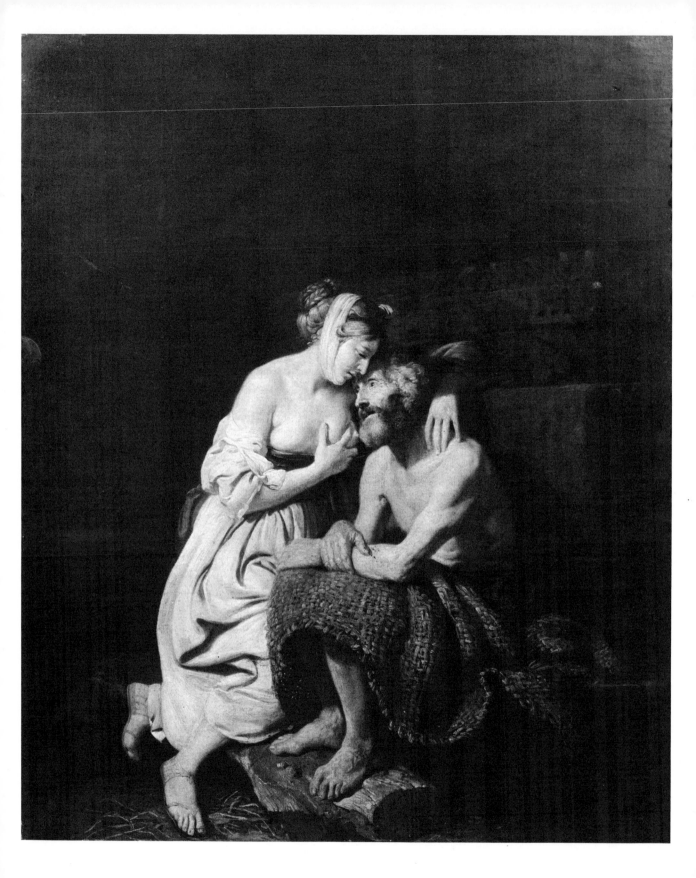

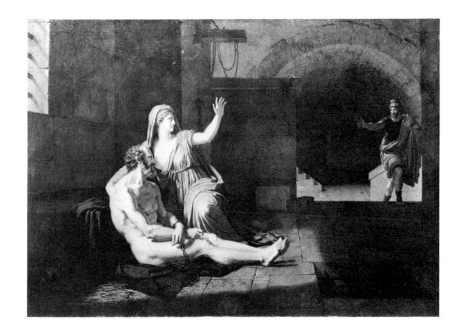

Neo-Classical ideal of feminine nobility: François-Xavier Fabre's *Caritas Romana*, 1800, includes the Roman jailer mentioned by Pliny. Dayton Art Institute.

France in particular, the late eighteenth century produced an enormous gallery of pictorial and sculptural heroes and, more to our point, heroines, whose courageous behavior, recorded in the annals of history, was to inspire so many Frenchmen and Frenchwomen at the time of the Revolution. Heroic women were especially sought out as new subjects, witness for example two enormous paintings exhibited at the Salon of 1781, which celebrated the decisive intervention of a woman on both a classical and a medieval battlefield: Vincent's painting of Hersilia intercepting the combat of the Romans and the Sabines with a plea for reconciliation, and Le Barbier's painting of Jeanne Hachette striding, like Delacroix's Liberty at the barricades, through the bloody siege of Beauvais (1472) to remove the enemy's flag from a horrifying pile of male corpses. Little wonder, then, that the feminine heroism exemplified by the Caritas Romana story could take on a fresh relevance in France, especially since it also permitted the presentation of a prison interior, a milieu of gloom, tragedy and sacrifice that often corresponded with such chilling contemporaneity to the noble and ignoble sacrifices of the Revolutionary years.

The fullest and finest combination of these themes of ideal feminine nobility and the lugubrious ambiance of a prison is found in a Caritas Romana by Francois-Xavier Fabre, a painting executed in Rome in 1800. Dramatically speaking, it amplifies the usual restriction to parent and daughter with the narrative assistance of Pliny the Elder and Valerius Maximus; for both these writers tell of how the daughter was observed performing these astonishing filial duties and how, in generous recognition of this noble deed, the parent was released. Indeed, Pliny the Elder even goes on to say that a Temple of Filial Affection was erected on the prison site (now that of the Theater of Marcellus). Thus Fabre sets the scene at the moment when a Roman jailor is literally and figuratively on the threshold of discovery, a moment of dramatic terror that resonates through the funereal, neo-Caravaggesque gloom of these somber prison chambers and vaults, so reminiscent of the Athenian prison which David had envisioned in 1787 as the background for Socrates' own sacrifice.

Johann Zoffany's *Roman Charity* reflects the sentimentalizing trend of British art in the late 18th century. National Gallery of Victoria, Melbourne.

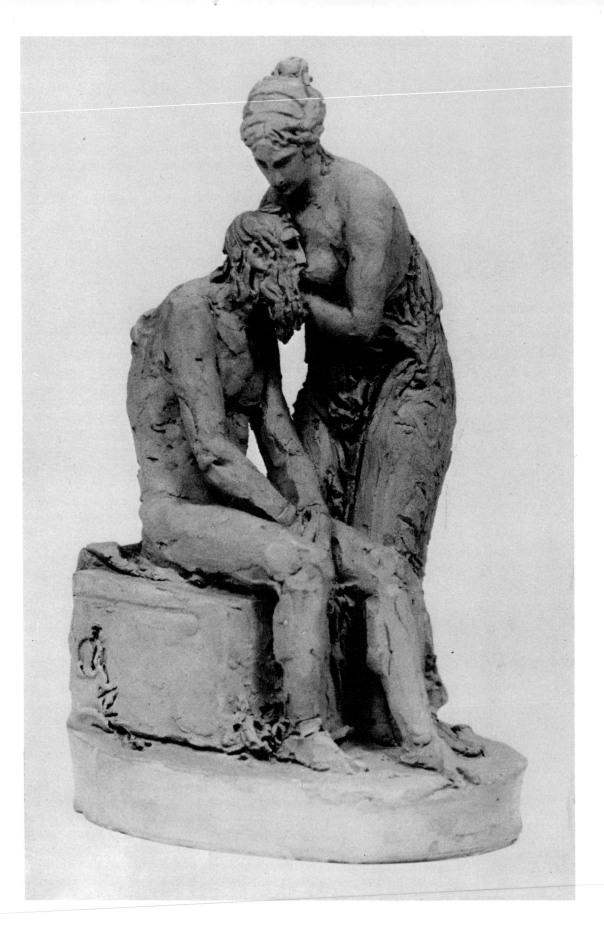

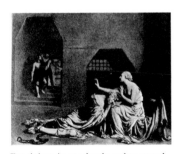

Eroticism is modestly submerged in a German version of *Roman Charity,* ca. 1800, by Gottlieb Schick. Coll. Schaefer, Schweinfurt.

It is telling, too, that in the same year Fabre executed this painting, 1800, the Paris Salon exhibited for the first time an illustration to Dante's Ugolino by a certain Fortuné Dufau, a work that evokes precisely the same mood of the horrors of incarceration and starvation, except that there, the hope for survival is gruesomely transformed from the mother's milk of the prisoner's daughter to the very flesh of the prisoner's children, who offer themselves to save their father's life.

The Neo-Classic nobility in the heroic profiles and ideal gestures of Fabre's father and daughter was matched as well in French sculpture of the period, although in three dimensions, there could be only a minimum of prison ambiance and narrative intrigue. Thus, in Joseph-Charles Marin's terra-cotta interpretation, ca. 1800, we concentrate exclusively on the grave and pathetic juxtaposition of a tragic old man and a loyal daughter, a filial core that found another classical counterpart in Marin's pendant to this work, Oedipus and Antigone, an analogous example of a daughter whose extreme fidelity inspired her to follow her father into banishment. That Marin conceived these two classical daughters and fathers as pendants suggests that he may have used as his literary source the *Fabulae* of Hyginus, for this Roman writer mentions Antigone and Oedipus as a parallel in memorable filial devotion to the Caritas Romana daughter and father, whom he names Xanthippe and Mycon (as opposed to Valerius Maximus, who called them Pero and Cimon, names generally repeated in Renaissance and Baroque versions of the theme). Indeed, the increasing classical erudition of the late eighteenth century even disclosed that the tradition of representing Caritas Romana as a father and daughter was incorrect, for in fact Pliny's account is of an imprisoned mother, and Valerius Maximus tells the story twice, once as an event which occurred among the Romans (in this case a mother) and once among foreigners, presumably Greeks (in this case a father, Cimon). Already at the Salon of 1791, Jean-Charles-Nicaise Perrin exhibited the maternal version of the story (the painting seems to be lost), and again at the Salon of 1801, Etienne-Barthélemy Garnier, referring to Valerius Maximus, exhibited another maternal version (the painting is in ruinous state at the Musée, Pont-de-Vaux), which elicited a critic's praise for finally correcting the error of the paternal tradition *(Examen des ouvrages modernes de peinture, sculpture...,* Paris, An IX, pp. 54-55). Nevertheless, for reasons that may demand psychosexual speculation, the tradition of the father was never really usurped by the maternal variant pointed out by Neo-Classical learning, especially since the story of Caritas Romana with a male parent was equally supported by classical texts. Thus the paternal tradition continued into the early nineteenth century, in France and in other countries where artists responded to a theme that could veil an erotic motif under the pall of a dungeon and the light of daughterly virtue.

When, in fact, Caritas Romana was treated by foreign artists under French inspiration, the erotic component was often modestly submerged. Such is the case in a painting of ca. 1800 by the Stuttgart artist, Gottlieb Schick, a student of David's at the turn of the century; for here, in

Joseph-Charles Marin's version of *Roman Charity,* ca. 1800, terra cotta. Besançon museum.

Charles Lemire the Elder's *Roman Charity,* from an engraving in C. P. Landon, *Salon de 1812,* Paris.

the primitivizing architecture of an almost Mycenean prison, the jailors discover not a nursing but a sleeping father, his draperies and flesh, like those of his daughter, carved of the chilliest pictorial marble. Such is the case, too, in a recently rediscovered American version of the subject by Rembrandt Peale, a painting of 1811 that was again inspired by French precedent, the artist having just returned from a second visit to Paris.[5] Peale's version, exhibited with great critical success in Philadelphia in the spring of 1812 (although it was accused by the Russian Vice-Consul Paul Svinin of being a plagiarism from Gérard's now lost version of the subject, first shown at the Salon of 1791, seems to be the only American treatment of the theme; and, not unexpectedly in a country that was soon to be embarrassed by the public exhibition in 1814 of the French-trained John Vanderlyn's *Ariadne,* it slurs over the actual act of breast-feeding by having the father–modeled, according to tradition, after the artist's own illustrious artist-father, Charles Willson Peale–avert not only his mouth but his gaze from his daughter's discreetly covered breast. And needless to say, in the most famous English dramatization of the story–Arthur Murphy's immensely popular play, *The Grecian Daughter* (which remained a staple of the Anglo-Saxon theatrical repertory for at least 50 years after its London premiere in 1772)–the suckling of the dethroned and imprisoned King of Sicily, Evander, by his noble daughter, Euphrasia, is an offstage event, recounted by an astonished guard, Philotas.[6]

Even in France, the theme was given a bit more propriety as well as pathos by the introduction of an infant among the dramatis personae, a grandparental variant that, given the daughter's lactiferous condition, was thoroughly plausible. Such an unhappy trio was presented by Charles Lemire the Elder at the Salon of 1812, but hardly in so startling a compositional scheme as that by a French-trained Italian artist,

A newly rediscovered Rembrandt Peale, *The Roman Daughter,* 1811, appears to be the only known American treatment of the theme. Coll. Donald D. Webster, on loan

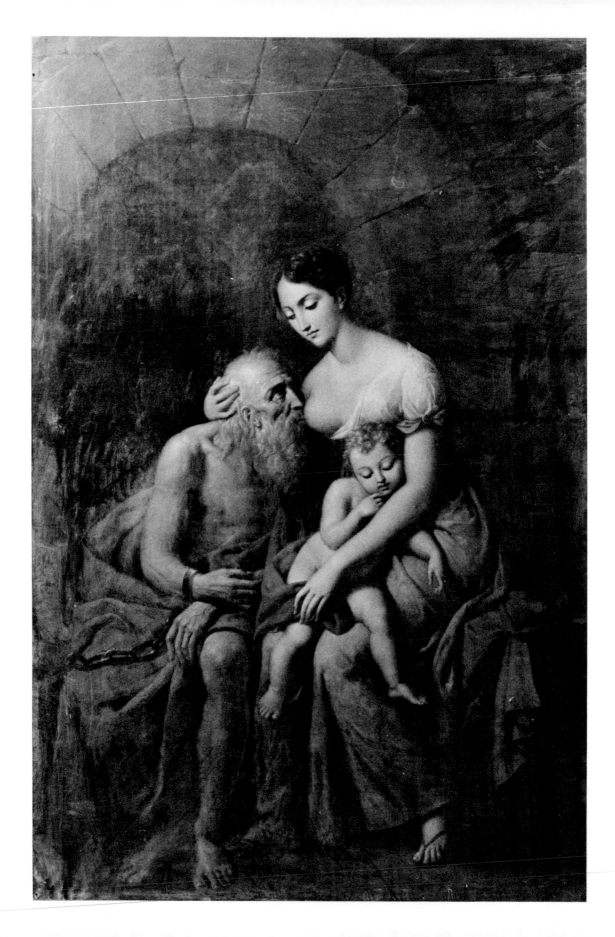

Gioacchino Serangeli, in a painting of 1824 that offers one of the most bizarre deductions ever made from the archetypal premise of Raphael's Holy Family group, *La Belle Jardinière*. (Still more ironically, this emotionally and erotically complex family trio was given an overtly pornographic, if somewhat poignant twist by the Hungarian mid-nineteenth-century artist of sentimental genre, Mihály Zichy, who pictured, on a bed and a crib, a man copulating with a woman who, at the same time, is nursing her infant.)

Yet even these interpretations of Caritas Romana were prosaic by comparison with the most lofty ruminations inspired by the theme, those by Lord Byron in four stanzas (CXLVIII-CLI) in the Fourth Canto (first published in 1818) of his epic *Childe Harold's Pilgrimage*. Meditating upon the ancient sites of Rome, this most Romantic of tourists, after musing upon the Pantheon, spies a dungeon, in whose "dim drear light" he conjures up the vision of Caritas Romana, a ghost of ancient virtue that is dimly reflected in Richard Westall's engraved illustration for the 1822 French edition of the *Oeuvres de Lord Byron* (Pichot trans., II, p. 219). The gloomy Gothic setting provided by Westall is not fortuitous; for according to legend, Caritas Romana took place at a site upon which was ultimately erected the medieval church of S. Nicola in Carcere, still standing in Rome today, and Byron was clearly aware of this association.[7] Childe Harold marvels, above all, at the reversal of roles between youth and old age, between parent and child in this curious lactation; and although today, a student of Byron's complex sexuality might find that it was the prominence of incestuous desire in the poet's life that gave the Caritas Romana motif a special fascination, Childe Harold himself declares that even "the starry fable of the milky way" does not have this story's purity.

Byron's Romantic voyages, in which remote monuments evoke distant memories as in a dream and are then poeticized into universal symbols, found even stranger counterparts in an interpretation of Caritas Romana perfectly attuned to the Romantic fascination for the exotic world of the American Indian, who so often seemed to represent living examples of that nobility and virtue which, in the civilized world, had expired with the more stoical Greeks and Romans. Indian women in particular were described as embodying a heroism especially foreign to eighteenth-century ladies, who could hardly have matched the courageous fidelity of, say, the Indian widow who, in Wright of Derby's painting of 1783-85, follows stoical custom by waiting for the first full moon after her warrior-husband's death and then seating herself under a tree hung with his trophies for a full 24 hours, no matter how malevolent the weather. Nor could they have matched the maternal virtues extolled in Guillaume-Thomas Raynal's *Histoire philosophique et politique des établissemens et du commerce des Européens dans les Deux-Indes* (IV, Geneva, 1780, pp. 22-23), which tells of how Indian women love their children so much that they sometimes nurse them until the age of six or seven and how they are often so moved by the death of a child that, at times, six months after such a loss, an unhappy Indian couple will mourn at the tomb of their

A child is introduced into the "Roman Charity" theme by the Italian Giaocchino Serangeli, 1824. Chambéry museum.

Childe Harold meditating on a
vision of Caritas Romana, in
Richard Westall's engraving
from a French edition of
Byron's works, Paris, 1822.

Maternal virtues of the Noble
Savage: Jean-Jacques-François Le
Barbier's *Canadian Indians at
Their Infant's Grave,* exhibited
at Salon of 1781. Rouen museum.

J. M. Moreau le j.^{ne} inv. Helman Sculp. 1776

ah couet!, dis-nous donc si tu veux mourir quel
ami tu nous laisse.

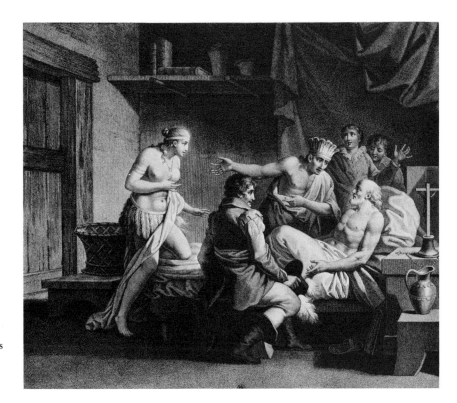

Jean-Jacques-François Le Barbier's *The Sublime Loyalty of the Cacique Henri,* engraved by Mariagé for Marmontel's *Les Incas.*

Caritas Indiana: Jean-Michel Moreau the Younger's *The Illness of Las Casas,* engraving for J. F. Marmontel's *Les Incas,* Paris, 1777.

infant and the mother will let her milk flow upon it. Such a funereal lactation was actually illustrated by Jean-Jacques-François Le Barbier for the Salon of 1781 in a painting whose display of elemental grief, noble savages and mother's milk corresponds closely to Rousseau's own explorations of natural feeling among uncorrupted people and of the virtues of breast-feeding. But if one critic in 1781 complained that it was preposterous for Le Barbier to go all the way to the Iroquois to learn lessons in virtue *(Galamatias anti-critique des tableaux du Salon...,* Neufchatel, 1781, p. 28), his was a minority view. Indeed, the late eighteenth century even provided a curiously exact translation of the Caritas Romana theme to the New World, thanks to Jean-Francois Marmontel's account of the Spanish conquest of Peru, *Les Incas* (1777). In this lengthy pastiche of history and legend, the story is told (Chapter XLIII) of how the early sixteenth-century Spanish missionary and historian, Bartolomé de Las Casas, was taken sick in the New World and needed mother's milk to restore his health. So beloved was the humanitarian Las Casas by the natives, that a cacique named Henri proposed that his own wife, who had just lost an infant and who, as in Le Barbier's painting, had been covering the grave with mother's milk, provide the cure. Although Las Casas at first demurred, the Indian's wife persuaded him that if her husband would give his blood for him, why should she not give her milk? This scene of what might be called "Caritas Indiana" was first illustrated by Jean-Michel Moreau the Younger in 1776 for the first edition of Marmontel's book, and offers an odd combination of traditions that range from, in Christian terms, scenes of extreme unction and of medieval representations of the Miracle of the Virgin (whose milk heals a dying man)[8] to, in exotic terms, the feathery costumes of, say, an 18th-century production of Rameau's *Les*

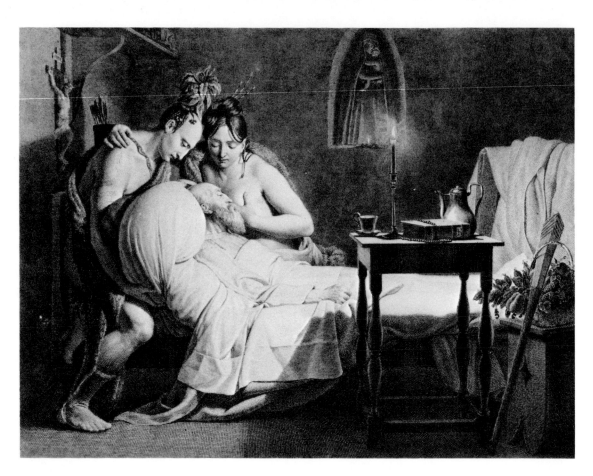

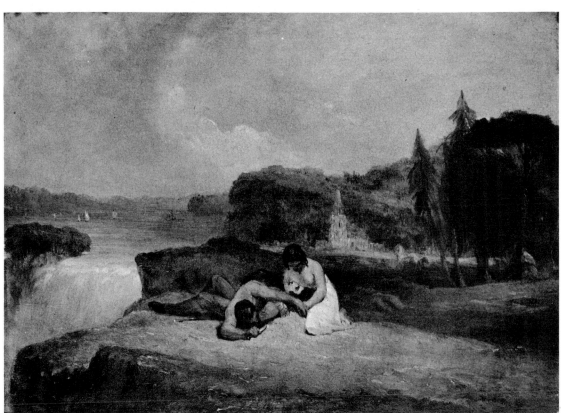

Louis Hersent's *The Illness of Las Casas,* exhibited at the Salons of 1808 and 1814, in an engraving by Pierre Adam, dated 1823.

Indes Galantes to, in classical terms, the appearance of the *femme totale,* Stratonice, at the foot of the bed where her love-sick step-son, Antiochus, languishes. This tale of Indian lactation *in extremis* obviously appealed to Romantic imaginations, for it was soon illustrated again by Le Barbier in an undated engraving (probably of the 1780s) which removes all of Moreau's late Rococo flutter in favor of a Davidian solemnity and planar clarity that even uncross the legs of Moreau's Pizarro, who, seated in the foreground, witnesses this touching scene. And this veneration of an Indian angel of mercy continued into the early nineteenth century, when Louis Hersent painted a more dramatically distilled version of the story that was exhibited at both the Salons of 1808[9] and 1814 and again, in an engraving by Pierre Adam, at the Salon of 1824. Hersent's attraction to pathos-ridden Indian themes was already apparent at the 1806 Salon where he exhibited both a scene of Indian burial practice (an aerial tomb) and, two years before Girodet's famous painting of 1808, an illustration to Chateaubriand's account of the death of Atala. In his treatment of the Las Casas legend, he reduces the dramatis personae to three, bathes this greater intimacy in a mysterious, neo-Caravaggesque candlelight, assures the chastity of the Indian wife by locating her right arm firmly around her husband's shoulder, and adds a variety of would-be authentic New World detail, from the Spanish Colonial Virgin and Child in the niche to the native paraphernalia of oar, exotic cashews, quill and feather headdresses and tattoos. Typical of the mobility of the Romantic imagination, this theme of New World charity could even be transposed to contemporary experience, witness an undated painting by the British artist George Jones, which, in the tradition of Copley's *Watson and the Shark,* records a cliff-hanging event in the life of a patron who served in the war of 1812.[10] In this case, the story is of Sir John Moryllion Wilson, who, during the Battle of Chippawa (1814), was wounded, left for dead, taken prisoner and attached by a knife-bearing Indian whom he killed. He was then suckled back to life by an Indian woman in a setting whose inclusion of the top of Niagara Falls gives it a touch of sublimity and topographical accuracy.

If the Caritas Romana theme *per se* found perhaps no more extravagantly dramatic variation than this in the Romantic era, the more general motif of lactation could provide similar flights of pathetic fancy. Appropriately, women artists of the period invented tearful variations on the theme of breast-feeding, a subject that, from the time of Rousseau and Greuze, had gained great popularity as an image of maternal joy, both charitable and sensual.[11] Thus, at the 1804 Salon, Mlle. Henriette Lorimier exhibited a painting of a young mother who, unable to continue nursing her own infant, is obliged to give him to a she-goat. This surrogate lactation, a sentimental variant upon such well-known illustrations as Poussin's of the legend of Jupiter's being nurtured by the goat Amalthea, produces in turn sad maternal meditations, which were in fact articulated by an anonymous Salon critic who not only soliloquized the mother's jealousy of the goat's happiness, but claimed, in a lucid statement of

Niagara Falls is included in George Jones's *Sir John Moryllion Wilson and the Chippewa Indians,* depicting an incident in the War of 1812. Art market, London.

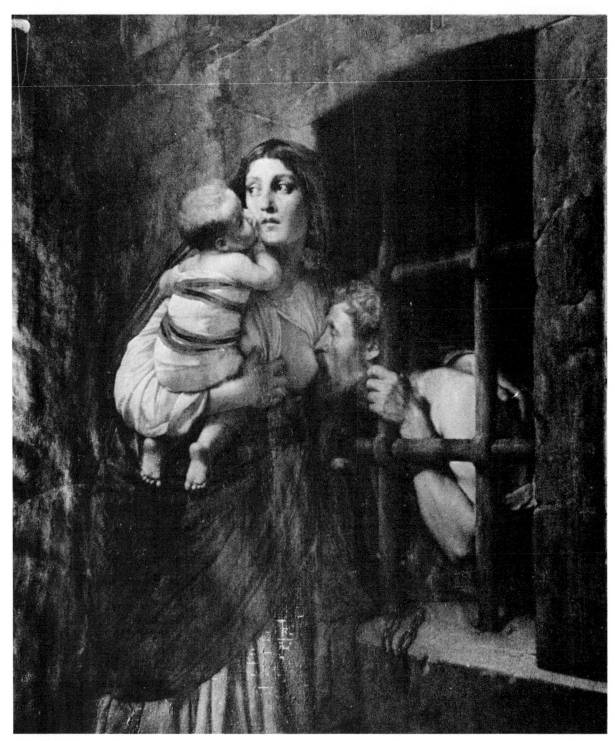

A Realist's interpretation:
Jules Lefebvre's *Roman Charity*,
Salon of 1864. Melun museum.

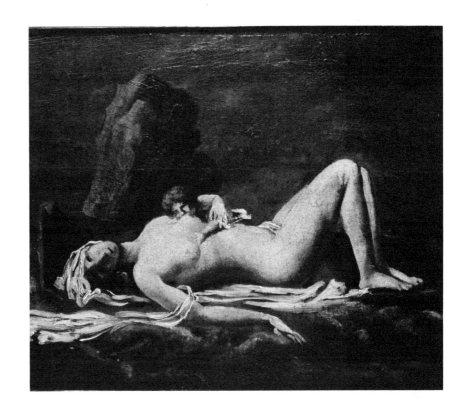

Extreme of Romantic pathos:
Constance Mayer's *The Shipwreck,*
ca. 1821. Musée Magnin, Dijon.

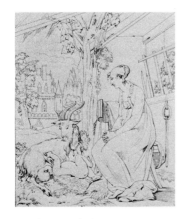

Henriette Lorimier: *A Young Woman Having Her Child Nursed by a Goat,* Salon of 1804; from an engraving in C.P. Landon, *Annales du Musée et de l'Ecole Moderne des Beaux Arts,* Paris, 1805.

male chauvinism, that the painting is thoroughly worthy of a woman, i.e., it demonstrates tenderness, sensibility and the fulfillment of duties (*Lettres impartiales sur les expositions de l'An XIII,* Paris, 1804, p. 17).

Far more tragic a lactation was one painted ca. 1821 by the ill-fated mistress of Prud'hon, Constance Mayer, whose suicide in 1822 must have turned her lover's own painted images of happy maternity into bitter fantasies. In an extreme of Romantic pathos that harks back to a motif from Poussin's *Plague of Ashdod* and that reflects the shipwreck imagery that reached its climax in the *Raft of the Medusa* of 1819, Mlle. Mayer envisioned the ultimate horror of the corpse of a nude mother, washed up on a rocky shore, and a live baby who seeks milk at this dead breast. It was a theme to be aggrandized by no less an artist than Delacroix, who explored the same morbid and heartbreaking motif in the righthand corner of his *Scenes from the Massacre at Chios* at the Salon of 1824.

Inevitably, the welling forces of the Realist view in mid-nineteenth-century art undermined the conviction with which Romantic artists could resurrect and vary the uncommon pathos of the Caritas Romana story, although to be sure, academic artists, such as Jules Lefebvre, could continue as late as the Salon of 1864 to provide a literal reprise of the classical theme. Yet in the context of Courbet's and Manet's new pictorial prose, a dramatic fantasy upon the joys and sorrows of a lactating Roman daughter could carry less and less conviction; and in the later nineteenth and early twentieth century, the lactation theme was relocated in a more commonplace world. Women artists again were drawn to this subject, from Mary Cassatt, who recorded it with a certain primness that countered its potential sentiment and sensuality, to Paula Modersohn-Becker, who venerated the theme in many images of nursing

Prison scene from the film, *Futz,*
1969, directed by Tom O'Horgan.

earth-mothers who brought up to primitivist date the traditions of Rousseau and the pre-Romantic eighteenth century.

But if the story of Caritas Romana seems to have faded from twentieth-century art, it does, at least, have some literary survival in our time; for as Panofsky once pointed out in a breathtaking, one-sentence history of the subject,[12] it occurred not only in De Maupassant's very short story, *Idylle* (where, in an episode of poignant symbiosis, an Italian peasant woman who produces too much milk, embarrassedly asks a stranger to relieve her and he in turn admits, after doing this favor, that he had been starving), as well as in the final scene of *The Grapes of Wrath* (where another nursing earth-mother saves an old man who is starving). Indeed, even the year of Steinbeck's novel, 1939, does not mark the final demise of Caritas Romana, for as recently as 1969 it was revived in its most perverse form to date. In the underground film *Futz,* directed by Tom O'Horgan and based upon a LaMama Troupe stage production of Rochelle Owen's script, there was included, among assorted scenes of bestiality and sadism in a Dogpatch world, the lubriciously bare-breasted prison visit of a mother to a son condemned to death for murder[13]. Characteristically for our time, the Romantic heritage of the Marquis de Sade is rivaling the no less Romantic heritage of Jean-Jacques Rousseau.

*Research on a topic which, like this one, is at once wide in range and esoteric in detail inevitably accumulates many debts of gratitude for assorted clues and photograph-hunting. I should like to thank here: Françoise Baudson, Peter von Blanckenhagen, Jacques de Caso, William Gerdts, Anne Coffin Hanson, Wilbur Hunter, Annie-Claire Lussiez, Jacques Manoury, Jean-Patrice Marandel, Pierre Rosenberg and Mary Webster.

[1]The prominence of Caritas Romana illustrations in Western art has inspired at least

three iconographic histories, of which the most recent is: Edmund Braun, "Caritas Romana," in Otto Schmitt, ed., *Reallexikon der deutschen Kunstgeschichte,* III, Stuttgart, 1954, cols. 355-60. This is preceded by Andor Pigler, "Valerius Maximus és az újkori kép-zömüvészetek," in *Petrovics Elek Emlékkönyv* [*Hommage à Alexis Petrovics*], Budapest, 1934, pp. 87-108 (text in Hungarian with French summary, "Valère Maxime et l'iconographie des temps modernes," pp. 213-16); and Adolphe de Ceuleneer, "La Charité romaine dans la littérature et dans l'art," *Annales de l'Académie Royale d'Archéologie de Belgique,* LXVII, Antwerp, 1919, where the legend is also discussed in the context of non-Western cultures. All the above studies, however, assume that the theme had virtually expired by the late 18th century, at exactly the point where my own study begins. For a lengthy list of Renaissance and Baroque examples of the theme, see also A. Pigler, *Barockthemen,* II, Budapest, 1956, pp. 284-92.

[2]See Millard Meiss, *French Painting in the Time of Jean de Berry (The Late Fourteenth Century and the Patronage of the Duke),* London, 1967, p. 128.

[3]The painting actually exhibited at the Salon may, in fact, not be the version in Toulouse, but a variant in Leningrad (Academy of Fine Arts).

[4]Illustrated in Pigler, *op. cit.,* II, p. 289.

[5]Wilbur Hunter, Director of the Peale Museum, Baltimore, was especially generous in supplying me with the results of his own research on this painting.

[6]William Gerdts was kind enough to call this play (as well as Peale's painting) to my attention. For more information about it, see Howard Hunter Dunbar, *The Dramatic Career of Arthur Murphy,* New York, 1946, Chap. 11, where Murphy's literary and visual sources are also discussed. It is worth noting, in terms of the popularity of the motif in the Romantic period, that Murphy's play may be related to two earlier Continental dramatizations of the story by Pierre-Laurent Buirette du Belloy *(Zelmire,* 1762) and Pietro Metastasio *(Issipile,* 1732), both of which in turn provided the basis for later opera libretti.

[7]For a contemporaneous discussion, see John Hobhouse, *Historical Illustrations of the Fourth Canto of Childe Harold . . .,* London, 1818, pp. 295-300.

[8]This medieval theme of the *Virgo Lactifera* is discussed in Meiss, *loc. cit.*

[9]Although the painting does not seem to be listed in the 1808 Salon catalogue, it is nevertheless included in C.P. Landon, *Salon de 1808 (Annales du Musée . . .),* II, Paris, 1808, pp. 36-7.

[10]My account depends upon that handed down with the painting and kindly provided me by the Leger Galleries, London.

[11]This topic has been fascinatingly explored by Carol Duncan in "Happy Mothers and Other New Ideas in French Art," a paper presented at the meeting of the College Art Association, January 28, 1972.

[12]Erwin Panofsky, *Early Netherlandish Painting,* Cambridge, 1953,). p. 53.

[13]The film is discussed and illustrated in a review kindly called to my attention by Jacques de Caso: Jason McCloskey, "Futz," *After Dark,* XI, Dec. 1969, pp. 21-22.

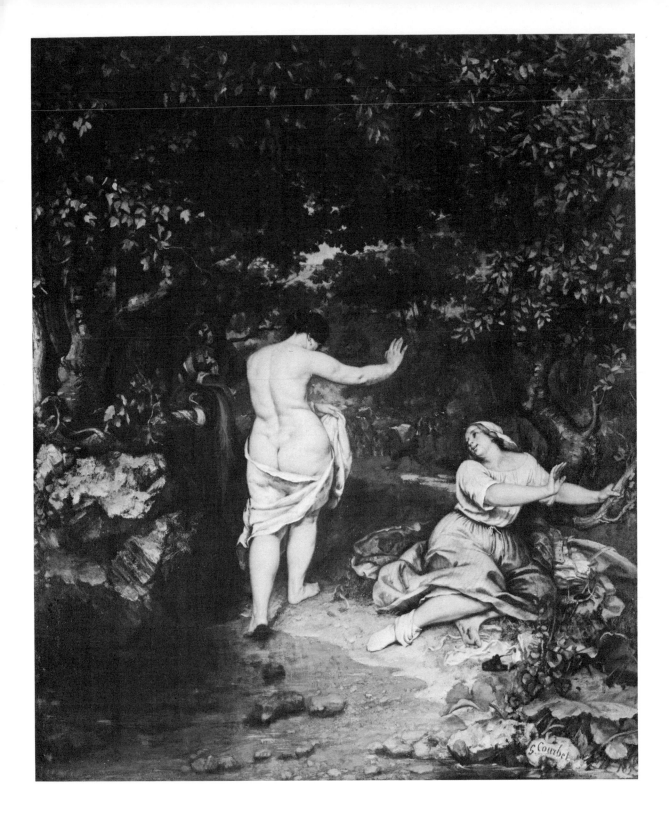

By Beatrice Farwell

Courbet's 'Baigneuses' and the Rhetorical Feminine Image

Author: Beatrice Farwell teaches at the University of California, Santa Barbara. She has written on Delacroix and Manet, and is now preparing a college text on Manet and the nude.

"I was amazed at the strength and relief of his principal picture–but what a picture! What a subject to choose!...what are the two figures supposed to mean? A fat woman, backview, and completely naked except for a carelessly painted rag over the lower part of the buttocks, is stepping out of a little puddle scarcely deep enough for a foot-bath. She is making some meaningless gesture, and another woman, presumably her maid, is sitting on the ground taking off her shoes and stockings. You see the stockings; one of them, I think, is only half-removed. There seems to be some exchange of thought between the two figures, but it is quite unintelligible. . ."[1]

Thus Eugène Delacroix expressed his baffled reaction at the Salon to Courbet's *Baigneuses* in his *Journal* on April 15, 1853. What was his criterion for "meaning"? Gestures of the sort Courbet has given the bathers generally occur in Delacroix's own art as expressions of emotional reaction to some dramatic element of the theme he treats–as they do in much previous art in the grand manner, from Greuze on back to Tintoretto and Titian. Courbet's plump and rustic bather, however, neither grieves nor languishes, nor is she confronted with anything more dramatic than her clothes and her maid. According to the standards we may assume he applied, Delacroix was right. But Courbet must have meant something. I believe what he meant to do was to dress up a subject drawn from quite another sector of tradition so that it would look like high art in the grand manner. The hybrid result, an aggressively realist nude in what looks like a classical situation, succeeded well enough to hide its true source and obscure its meaning.

The theme of bathing nudes in landscape is common enough in the imagery of both classical and Christian art. Witness the prevalence of baths of Diana and toilets of Venus, attended by maids usually distinguished from their Olympian mistresses by being either clothed or black (or both), in which the figures are monumental, the gestures broad and the setting frequently sylvan. In Biblical themes such as the chaste Susannah approached by the Elders, or the toilet of Bathsheba calculated to tempt King David, where nudity has a more pointed meaning and the setting is not necessarily an outdoor one, an element of contemporaneity and hence realism creeps in by way of setting or the maid's costume, or even in the treatment of the principal nude body, as in Rembrandt. Courbet's picture, while it corresponds inconographically neither to the classical nor the Biblical tradition, nevertheless owes its traditional look to the familiarity of such works, especially Italian ones,

Courbet's *The Bathers*, 1853, aroused a public scandal when shown at the Salon of that year. Musée Fabre, Montpellier.

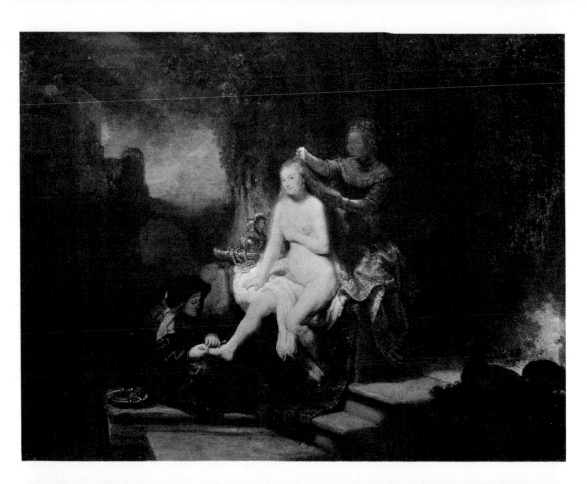

where noble histrionic gesture abounds. And since Courbet had already become known to his contemporaries as the depictor of the "real" rather than the "ideal," Salon-goers like Emperor Napoleon III and Empress Eugénie treated his picture with predictable contempt, but without surprise, as the subject at least must have seemed a "normal" one at the Salon.[2] Despite his words protesting the subject, Delacroix's reaction was essentially the same as the Emperor's, though considerably more refined.

In his manifesto of 1855, Courbet said he wished "to draw forth from a complete acquaintance with tradition," and "to be in a position to translate the customs, the ideas, the appearance of my epoch."[3] It seems that he was already practicing these preachments in 1853. The tradition on which he drew, however, was not a simple matter, and its history needs tracing. The great *Baigneuses* arose neither out of the iconography of the classical nude bather, nor from that of the Biblical heroines of the Renaissance and the Baroque, but from the latter tradition's subsequent transformation into the anonymous and the contemporary during the eighteenth century–a period with which Courbet's imagery has more contact than at first meets the eye.

The Biblical theme in Rembrandt's *The Toilet of Bathsheba*, 1643, is treated with contemporary realism. Metropolitan Museum.

Mistress and maid in the eighteenth century lost their Biblical meaning in certain works of Watteau, who introduced intimacy for its own sake as a theme for high art. The maid who formerly prepared Bathsheba for the seduction of King David now prepared her anonymous mistress for a tryst with some equally anonymous gentleman, and the theme became a type, in which the mistress may or may not be nude, and the maid never is. An exotic example by Joseph Vernet, *A Greek Woman after the Bath,* includes the Oriental note frequently encountered in erotica of the age of Turkish invasions and Lady Mary Wortley Montagu, as well as the theme of black maid paying homage to white beauty in an age of colonialism. It is worth noting that at least the maids in Vernet's picture are integrated, as they are in Rembrandt's.

The element of homage and the rhetorical character of the type had appeared already by 1733, as exemplified in Nattier's *Mlle. de Clermont at the Bath* in the Wallace Collection. This lady, a daughter of the Prince de Condé, was immortalized by her contemporaries as the heroine of a romance spun around a tragic love affair and secret marriage of her youth, which accounts for the unusual departure from the anonymity of genre in this work, while at the same time the picture puts a contemporary individual into the role of a type. Mlle. de Clermont's adoring maids include both the Oriental and the black–a third world domestic staff. One of them (at the lower left), if reversed, seems to form a prototype for Courbet's maid in the *Baigneuses,* whose pose suggests ecstatic admiration of the mistress, though meaning has been removed from the gesture of her hands by adaptation: the turbaned eighteenth-century figure displays her mistress' necklace, while Courbet's rustic maid grasps a branch with one hand and suggests with the other the view of a luminous wonder that we cannot see. The erotic role of Nattier's royal princess is expressed more by the servants than by her own heroic bearing–the

Mistress and maid: Joseph Vernet's *A Greek Woman after the Bath.* 1755. Collection S.K.H. Prinz von Hannover.

exposed breast of the maid draping the towels strikes this Rococo note.

The more such iconography becomes genre, the more erotic becomes its content. In France in the eighteenth century a whole class of engravings arose, deriving from paintings made for a private market, in which women are seen in intimate moments of bath or toilet, some observed by peeping Toms in works bordering on the pornographic, some leaving all the voyeurism to the viewer of the print. As in comic operas of the day, the maids are frequent accessories to the schemes of suitors, not only providing for unchaperoned encounters and the like, but revealing their mistress' charms at the bath by withdrawing window curtains at strategic moments. A painting by Pater of ca. 1730, in the Wallace Collection (a significant repository for works of this sort collected by a nineteenth-century Englishman living in Paris), shows such a scene with no less than five maids assisting their mistress from the tub while a sixth pulls back the curtain for the eagerly waiting lover [see David Kunzle's essay in this volume for a detail from this work]. Called *The Bath* as a painting, in its engraved version the title, *Pleasure of Summer*, reinforces its character as genre. The reduction to genre of formerly heroic subject matter is seen also in the type of the cross-legged bather. Mlle. de Clermont's pose may be remotely connected with a sixteenth-century type that originated with Raphael and was disseminated in an engraving by the ubiquitous Marcantonio Raimondi, a bathing Venus who dries a foot that is crossed over the other knee. This pose may be found among bathing nymphs throughout the seventeenth century, and by the eighteenth the gesture is just as apt to be concerned with putting on, or more likely taking off, stockings.

A subtle transformation comes over the style of this sort of print with the turn of the nineteenth century. If in the Baudouin, one maid turns her back on the spectator and both concentrate their attention on the business of getting their *petite madame* safely out of the tub, in "pop" engravings and eventually lithographs of the Neo-Classical and Romantic periods the maid seems deliberately to display her mistress, or even to turn rhetorically to the viewer as though for the approval of a customer, and indeed the image by this time may be seen to have degenerated to a representation of the woman who bestows her charms for a price. In this process of transformation the number of maids is generally reduced to one and eventually none.

With the rise of the cheaper and more popular medium of lithography (introduced into France in the first decade of the nineteenth century), such images seem designed more and more to satisfy a growing mass market for erotica, sometimes with lesbian overtones in the relation between the two female figures–an idea apparently much enjoyed by men, and one which turns up frequently in the high literature of the period as well. While Achille Devéria was perhaps the most accomplished artist to work in this genre, one of its most faithful practitioners whose name was also known to Salon-goers was Octave Tassaert (1800-1874), painter of scenes both religious and libertine, who won the praise of Baudelaire and the custom of Dumas fils. His pot-boiling lithographs,

Jean-Marc Nattier's *Mlle. Clermont at the Bath*, 1733. The royal princess is surrounded by maids in ecstatic admiration. The Wallace Collection, London.

Left: Anonymous 18th-century
French engraving, *Curiosity*,
with a Peeping Tom at window.

Maids as accessories: *The Bath,*
18th-century engraving by
Baudouin, a pupil of Boucher.

dating from the 1830s and '40s, provide imagery of an infinite number
of moments in the dressing and undressing of girls–girls who now seem
definitely to be *grisettes*, having no maids, rather than the heroines of
eighteenth-century aristocratic society with which their type began. These
girls are forever putting on or taking off stockings, and there can be
little doubt that the high-minded Delacroix's expression of distaste over
the maid's stockings in the *Baigneuses* bears some relation to an acquain-
tance with this type of vulgar print. The motif of stockings on an otherwise
naked woman, symbol of low-down sin and lust, continues through the
nineteenth century, through Toulouse-Lautrec and Bonnard, to the Ger-
man Expressionists. Courbet himself made a feature of stockings in
several pictures, among them his rustic version of the cross-legged Venus
seen from an unusual and revealing angle that reinforces the nature
and meaning of the pose–a pose used also by Constantin Guys in depicting
the mores of Parisian prostitutes of the Second Empire and documented
as well in photographs.

This brings us to the problem of producing evidence that Courbet
knew and consciously responded to the popular genre of the salacious
lithograph. Meyer Schapiro and Linda Nochlin have been the pioneers
in demonstrating popular sources for Courbet,[4] and the case of *The
Meeting* (Musée Fabre, Montpellier), 1854, and its derivation from a
popular woodcut of the Wandering Jew found among the *images d'Épinal*,
is now well known. Prof. Nochlin has also shown, in an article on the
Toilette de la Mariée (Smith College Museum of Art, Northampton, Mass.),
that Courbet in the mid-'50s was surely cognizant of the popular and

Left: Tassaert's *First Moments of Dressing: The Garter,* ca. 1835, from lithograph by de Frey

Neo-Classic erotics: Noël Blaizot's *Noon,* or *The Bath,* ca. 1815.

frequently lithographed scenes of the customs of rural or lower-class weddings and the erotic games surrounding them.[5] These themes, like the maid and mistress prints, also go back to eighteenth-century genre engravings. In Courbet's art of the following decade, besides the *Woman with White Stockings,* there is the famous lesbian image of *Sleep (Le Sommeil,* Petit Palais, Paris), 1866, for which there is a close prototype in a lithograph by Achille Devéria,[6] and a figural prototype for the sleeping brunette in a painting by Octave Tassaert on a theme which occurs also in libertine lithographs. The blond-brunette polarity of Courbet's painting reflects the black-white polarity not only of maid and mistress, but of specifically lesbian imagery of the period as seen in a painting by Jules-Robert Auguste (Delacroix's "Monsieur Auguste") in the Louvre, representing an entwined pair of female nudes, one black and one white.[7] Courbet's title *Le Sommeil* and its preceding but less known pendant *Le Reveil* (formerly Gerstenberg Collection, Berlin, now lost), correspond to familiar titles for pendants among the popular lithographs by such artists as Devéria in the '30s and by later followers. Traditional matching girl-watching themes with titles like *Le Sommeil* and *Le Reveil* or *Le Coucher* and *Le Lever (Sleep* and *Awakening,* or *Going to Bed* and *Getting Up)* were even echoed by Degas among his libertine monotypes on themes of life in a Parisian brothel.[8] It is perhaps not too much to suggest that the entire output of intimate bathing scenes by Degas, and those by Manet as well, were inspired by this tradition of "bather" prints.

Courbet's *Baigneuses* is his first mature and ambitious work on a theme that even hints at the erotic. When he was still a young Romantic,

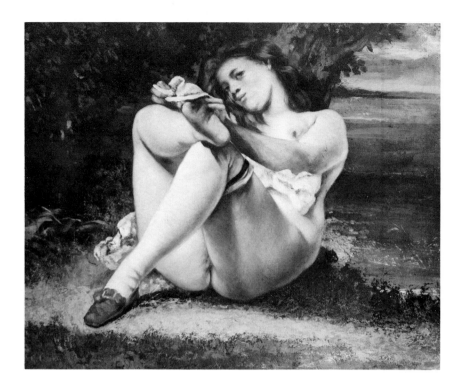

Gustave Courbet's *Woman with White Stockings,* 1861. ©The Barnes Foundation, Merion, Pa.

Achille Devéria's *Stepping out of the Bath,* lithograph, ca. 1830.

the subject of Lot and his daughters had attracted him enough to attempt this perverse Biblical theme–something he never tried again. But in 1844 he also painted *The Hammock.* This girl with her bodice undone may of course have been inspired directly by Victor Hugo's ballad, *Sara la Baigneuse,* which evokes a picture of the amorous daydreams of an Oriental peasant girl in a hammock, but it is equally possible, if not more so, that it was derived instead from the imagery this popular work inspired once it had been set to music.[9] From the 1830s until well into the 1860s there appears a whole series of images of girls in hammocks, some clothed and some nude, some made as music covers, some merely as prints, a considerable number specifically titled *Sara la Baigneuse,* of which one was created by Octave Tassaert–but in 1856, too late to account for Courbet's *Hammock.* (Tassaert's version was influential however; Fantin-Latour copied it quite exactly in a lithograph, and an anonymous parody of it represents the Empress Eugénie as a nude but not particularly chaste Susannah.)

Going as far back as *the Swing* of Fragonard, girls in hammocks seem to have had wide appeal as erotica. Whether Hugo derived his Sara from visual imagery I do not know, but his poem certainly served as the basis for early examples of a new feature of the erotic print: its removal of the female figure from the intimacy of the boudoir (to which it had retired in the eighteenth century) back to the natural outdoor setting where hammocks belong, while retaining its "genre" characteristics as contemporary play-girl and caterer to erotic fantasy. That is to say, the nude female did not automatically resume the status of goddess or Biblical heroine on returning to the out-of-doors. This shift appears to have taken place in the early 1850s, when a new type of erotic lithograph made its appearance: pairs of nude girls in woodland settings, sometimes with hammocks, always with fashionable coiffures

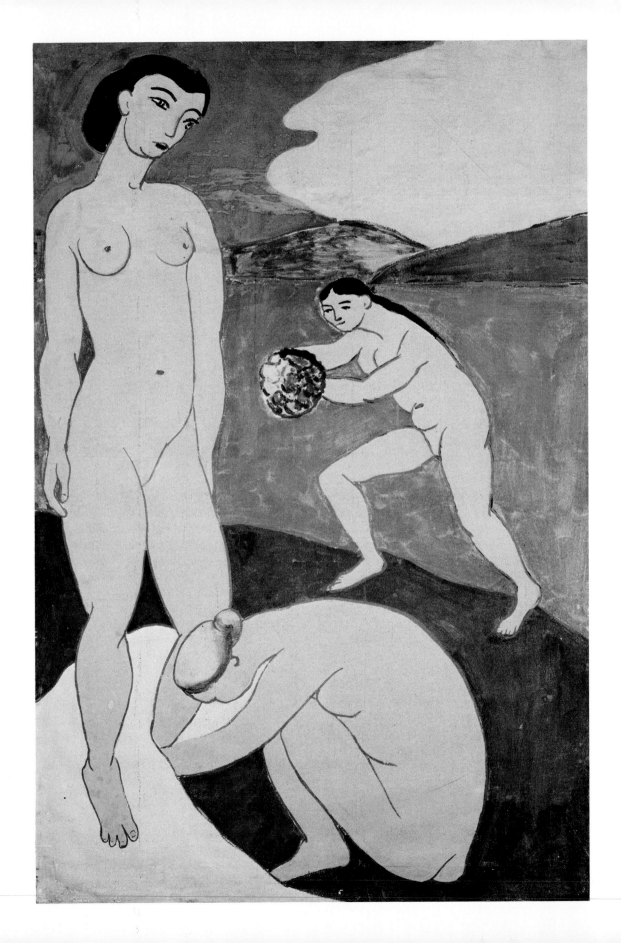

Charles Bargue's lithograph *The Hammock,* 1850-51, is typical of the mid-19th-century erotic print with an outdoor setting.

Bargue's lithograph of *The Bathers,* ca. 1850, from an album titled "Nymphs of the Seine."

Matisse's *Le Luxe II,* 1906, State Museum, Copenhagen.

that facilitate dating, and, since they are paired, often with the hint of lesbianism seen in earlier prints. Sometimes they are enjoying a cigarette, which marks them as *lorettes* on an outing, small-time prostitutes, in which role they amuse by seeming deliciously but inappropriately to play the goddesses and nature-spirits of antiquity for the fine-art-nourished imaginations of nineteenth-century gentlemen. These prints appeared by the hundreds, in albums titled *Sylphides, Nymphs of the Seine* and other likely epithets. The examples reproduced date from 1850-51, earlier than Courbet's *Baigneuses* by a couple of years. I really do not know whether Courbet's picture represents a reflection of this type of print, though I believe its relationship to the earlier bathing print tradition is secure. The rhetorical bather admired by the rhetorical maid is however typically an indoor image. That Courbet put it out of doors may be connected with the mass outdoor movement, contemporaneous with his picture, of the nude image in lithographic erotica, a genre in which the painter was demonstrably interested.

The new outdoor imagery in prints may possibly have developed in response to the taking over of the indoor field by photographers by around 1850. The *Baigneuses,* along with other works of Courbet, has been linked with certain photographs of nude models by Vallou de Villeneuve, a photographer who began his career, like so many others in his profession, as a lithographer.[10] Delacroix himself noted that Courbet's picture was an image synthesized from an outdoor landscape sketch and an indoor nude, and there is documentary evidence for supposing that Courbet used Vallou's photographs in painting *The Studio* in 1855. The photograph reproduced here seems to me a more likely candidate for the majestic bather than the one Scharf has chosen, the pose and lighting system corresponding a little more closely. And one other possibility suggests itself: could Courbet have derived his grandiose and "meaningless" gesture from such an image as this by merely omitting the support against which the model steadied herself for the long exposure needed in the 1850s? It would go far to explain Delacroix's difficulties. The rhetorical nude photographed in the flesh, ancestress of the twentieth-century pin-up, was in full form by the 1850s, and appears elsewhere in this volume in connection with Manet's *Olympia.* That work, it should be noted, shares with the tradition I have been tracing its indoor setting, its rhetorical character, and the black-white polarity of maid and mistress. Its relation to this tradition undoubtedly owes something to Courbet's example, which Manet surely knew, if not on its own merits, then through common friendship with Champfleury, who was Courbet's mentor in the world of the popular print. Parenthetically, neither Courbet nor Manet ever faced squarely the Realist's dilemma, in representing the nude, with respect to pubic hair versus the classical (or hairless) alternative, and *that* versus the true representation of the female anatomy. The popular image-makers, not being realists, of course had no such problem.

It is somewhat ironic to reflect that Courbet's seeking out of the popular image was inspired by notions of social reform along egalitarian

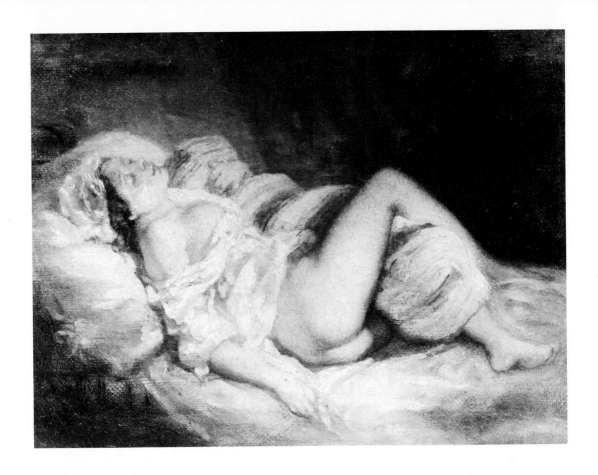

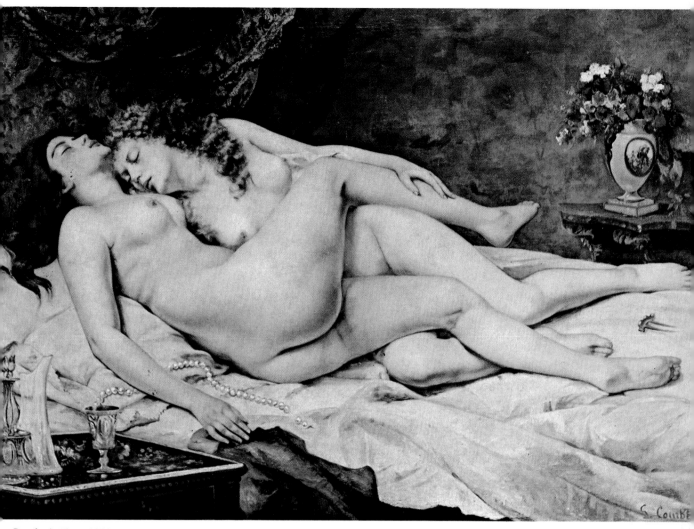

Courbet's *Sleep*, 1866,
Petit Palais, Paris.

Achille Devéria: *The Girl Friends
Discovered*, lithograph, ca. 1830.

Upper left: Octave Tassaert's
Woman on a Bed, Louvre, Paris.

Courbet's *The Hammock*, 1844,
Reinhart Museum, Winterthur.

lines, while the popular image itself–in the case of erotica–represented an aspect of society not only untouched by new ideas, but even retrograde. Women's lib was a long way off. Courbet did however seek to dignify the image by lending it realism and the clothing of high art (oil paint on a large framed canvas, and the look of the old masters). The result was to disguise its rhetorical source, to reduce the erotic aspect of its message–and to baffle Delacroix. The tradition of this erotic and very French lowbrow imagery was in effect claimed for high art by Realist painters–notably Courbet and Manet, and later Degas. One thinks of the "moral" in the epilogue of the *Beggar's Opera* of 1728: if MacHeath had not been reprieved from hanging, " 'twould have shown that the lower sort of people have their vices in a degree as well as the rich, and are punished for them." By the end of the nineteenth century this imagery was the common coin of the Intimistes, including such specific images as that of the cross-legged stocking-donner, who appears as I have noted in Bonnard, also in Matisse, and even in Marcel Duchamp. Matisse's odalisques are descendants of the generally passive "display nude" of Ingres, but his *Le Luxe* can be related to the bathing

Detail of Courbet's *The Bathers.*

nude of Courbet's picture, adoring maids and all, plus the bouquet from *Olympia*–but now miraculously purged by high art of all association with the taint of the nineteenth-century porno-erotica from which it sprang.

Courbet's *Baigneuses,* while perhaps not so purged nor so fully integrated as art, is at least understandable given the right tradition with which to associate it. And in a deeper sense than even he would have claimed, it "translates the customs and the ideas of my epoch" through its cryptic closeness to truly popular imagery of a kind unthinkable at the Salon, but smuggled in under the disguise of high art. It was one of the early subversions in the revolution of subject matter of high art that lasted for the rest of the century and on into our own.

Portions of the research incorporated in this paper were carried out under a grant from the Samuel H. Kress Foundation, which I wish to acknowledge with thanks.

[1]Eugène Delacroix, *Journal,* April 15, 1853, as translated and quoted in Lorenz Eitner, *Neo-Classicism and Romanticism 1750-1850,* II, Englewood Cliffs, N.J., 1970, pp. 117-118.

[2]The Emperor is said to have struck the ample backside with his riding crop, while the Empress in mock-innocence, having just looked at Rosa Bonheur's *Horse Fair,* exclaimed, "Oh, more percherons?"

[3]As quoted in Linda Nochlin, *Realism and Tradition in Art, 1848-1900,* Englewood Cliffs, N. J., 1966, p. 33.

[4]See Meyer Schapiro, "Courbet and Popular Imagery," *Journal of the Warburg and Courtauld Institutes,* IV, 1941, pp. 164-91; Linda Nochlin, "Gustave Courbet's *Meeting:* a Portrait of the Artist as a Wandering Jew," *Art Bulletin,* XLIX, 1967, pp. 209-222.

[5]Linda Nochlin, "Gustave Courbet's *Toilette de la Mariée,*" *Art Quarterly,* XXXIV, 1, 1971, pp. 31-54.

[6]There appears to be a relationship between this print and a composition of the English painter James Northcote, the *Death of Edward V and his Brother,* reproduced in Prof. Nochlin's article of 1971. The Devéria may be dated ca. 1830-35.

[7]Linda Nochlin very kindly brought the "traditional" aspect of this imagery to my attention, with specific reference to the painting by Auguste.

[8]See Eugenia Parry Janis, *Degas Monotypes,* Fogg Art Museum, Cambridge, Mass., 1968, especially nos. 38 and 40.

[9]Castagnary, in an unpublished manuscript, said specifically that this image is not of Sara la Baigneuse or a souvenir of Hugo's *Orientales* but is of a contemporary *bourgeoise* instead. (See *Courbet raconté par lui-même et par ses amis,* Geneva, 1948, p. 78.) The fact that he mentions Hugo's poem at all however, means that Courbet's image called it inescapably to the mind of a contemporary.

[10]See Aaron Scharf, *Art and Photography,* London, 1968, pp. 98-100, especially fig. 88.

Photograph by Vallou de Villeneuve of a posed model, ca. 1850, reminiscent of the main figure in Courbet's *The Bathers* (1853). Bibliothèque Nationale, Paris.

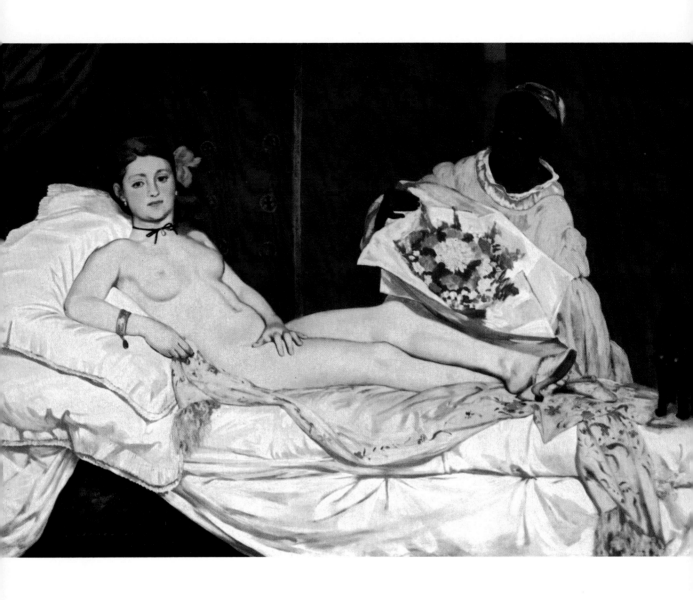

Manet, 'Olympia' and Pornographic Photography

Author: Gerald Needham teaches art history at Douglass College, Rutgers University. He has written articles for various magazines and encyclopedias and is presently completing a book on Monet.

"A woman 'more or less naked and leering at the spectator with a conscious impudence...brutal vulgarity and coarseness...as surprising as it is disgusting...' "

This reads like one of the hostile comments made when *Olympia* was first exhibited at the Salon of 1865, and which have been so often reprinted. In fact the quotation has nothing to do with *Olympia,* but is from the English *Saturday Review* of 1858 describing contemporary nude photographs. The *Review* complained that, "there is hardly a street in London which does not contain shops in which pornographic photographs and especially *stereoscopic* photographs, are exposed for sale."[1]

I would like to suggest that an important source for *Olympia* was the contemporary pornographic, stereoscopic photograph. The derivations of *Olympia* in the fine arts tradition are well known. Michael Fried has proposed that French Romanticism was an initial inspiration, later supplanted compositionally by Titian's *Venus of Urbino,* as has long been recognized; the relation of Manet's painting to the Titian has been extensively discussed by Theodore Reff.[2] However one of the most important aspects of *Olympia* was her modernity–the introduction of a conception quite different from that of the Titian. The contemporary critics did not mention Manet's debt to the sixteenth century in their comments; it was the immediacy, the contemporaneity of *Olympia* that overwhelmed them. As Reff points out:

Manet: *Olympia,* 1863, 51 inches high. The Louvre, Paris.

For Titian's ideal of a natural sensuality, conscious of its charm yet somewhat chastened, Manet substitutes a contemporary ideal of artificiality, perversely attractive in its very lack of warmth.

It is this transformation that makes Manet interesting, and separates him from the many dull painters who borrowed from Titian. We find, investigating this change, that important features of *Olympia* are identical with those of the pornographic photographs that were so widely distributed in the major cities of Europe. The *Saturday Review* writer quoted above speaks of nearly every street in London possessing stores that sold the pictures, undoubtedly an exaggeration, but indicative of an immense production. This needs to be emphasized, as very few of the photographs are known today–for obvious reasons.

The mixture in *Olympia* of an exotic odalisque setting with the very real, unexotic woman is typical of the photographs, which often sought a veneer of respectability by borrowing trappings from the nude paintings that proliferated in the Salon. This combination can be seen in a photograph by Durieu of the 1850s, with its pictorial drapes and very unpic-

Titian's *Venus of Urbino,*
ca. 1538, a basis for the
composition of Manet's *Olympia.*
Uffizi, Florence.

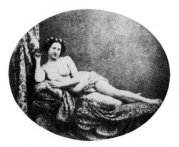

Eugène Durieu's photograph of
the 1850s, with its pictorial
drapes borrowed from Salon
paintings and very unpicturesque
nude, has the same mixture of
themes found in Manet's *Olympia.*

turesque nude. A piquancy was given by the contrast between the suggested luxuriousness of the setting and the everyday reality of the model, usually from the lower ranks of prostitution, and displaying the shamelessness or impudence deplored by the *Saturday Reviewer.* This suggestiveness is emphasized in photographs where undressing is used for erotic titillation. We reproduce two pairs of stereoscopic photographs that illustrate this type of picture, and one half of a stereoscopic daguerrotype of the 1850s. In the latter we see what the reviewer was probably talking about when he referred to the women as "more or less naked and leering at the spectator." In these days of hard-core pornography few of us would react so violently to a picture of a woman undressing, but it is clear from the Victorian responses that early photography had an enormous impact. It had a reality that was only gradually blunted by familiarity. The erotic imagination was especially stimulated by the thought that the photographs were posed by an actual woman, and not the purely fanciful figure of the erotic drawing.

Manet, of course, was not interested in any excess of vulgarity, but *Olympia* is shameless enough to have inspired Paul Valéry (scarcely an academic critic) to describe her as:

an animal vestal vowed to complete nakedness, she forces us to reflect on
all the primitive barbarism and bestial ritual in the habits and activities of
prostitution in our big cities.[3]

In addition to this similarity of content between the Manet nude and the photographs, there is a remarkable visual resemblance to the stereoscopic pictures. Unfortunately this cannot be illustrated except by looking into a stereoscopic viewer. No nineteenth-century home of any pretensions was complete without a viewer and a collection of photographs. The stereopticon was one of the major optical devices of the century, which were so widespread, and which played such an important part in the changed vision of the latter part of the century.[4] The characteristic of the stereoscopic photograph is to create an illusion of actual depth, but each object in the picture appears flat–a cardboard cutout. The flattening in *Olympia,* which is such a revolutionary stylistic element (the "playing card" as Courbet called it), is thus extremely close to the effect of the main figure in the stereoscopic shots.

Manet's acceptance of such a composition undoubtedly owes something to Japanese prints. Photography and Japanese art often contained very similar effects that inspired a number of innovations adopted by the Impressionists in the '60s and '70s. It is perhaps because these ideas came from more than one source that they were so rapidly and wholeheartedly taken up by the avant-garde artists. The characteristics of Japanese prints ceased to be curiosities when they were backed up by the evidence of the "truth" of photography.

In the case of *Olympia,* I believe that the correlation in both visual effect and subject matter between the painting and the photographs is such that the influence of the latter is far more important than that of Oriental art.

One of the most significant comments on the influence of photography

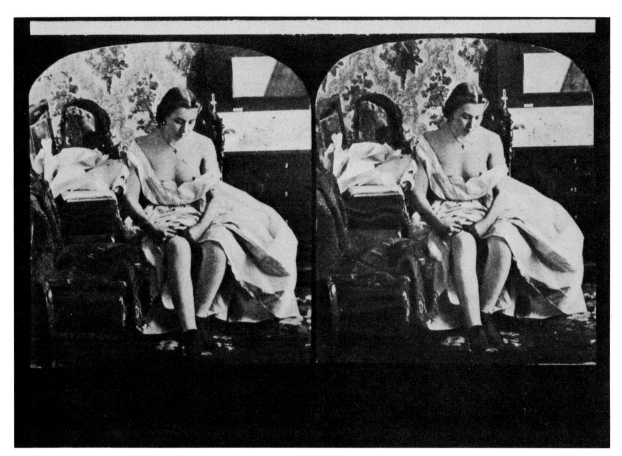

Stereoscopic photograph of the
1850s: undressing used
for erotic titillation.

on figure painting is Delacroix's *Journal* entry of May 21, 1853, when
he complains of the unbearable anatomical inaccuracy of some of
Raimondi's prints that he had looked at immediately after examining
Durieu's photographic figure studies. This diary entry reveals that Dela-
croix, who had used the nude model all his life, could only see the
human figure accurately when he had studied photographs of it. His
previous perceptual *Gestalt* was formed by the Renaissance/Baroque tradi-
tion. It required the photograph to create a new visual conception of
the human body. Delacroix himself could not break from the tradition
he had grown up in; his own paintings from photographs are prettied
up–the angles rounded off, the awkward proportions modified.[5]

What Delacroix perceived is exemplified in a very elaborate photo-
graph taken in a mirror with objects on a dresser top, drawn from
the same painterly tradition as *Olympia*, but adding by the use of the
reflection a suggestion of the camera lens as peephole. The attempted
arrangement of the flowing curves in the odalisque manner is con-
tradicted by the angularity of the arms and the sharp face. It was this
reality that Manet absorbed from the photographs and that he incor-
porated into *Olympia*. He saw that by emphasizing the angularity of
the human body he could give *Olympia* that immediacy and reality that
so startled the people who saw it.

If we accept that Manet was influenced by these types of photographs
in the creation of the painting, then the furor that greeted *Olympia*
is even more understandable. Not only did she upset the spectators

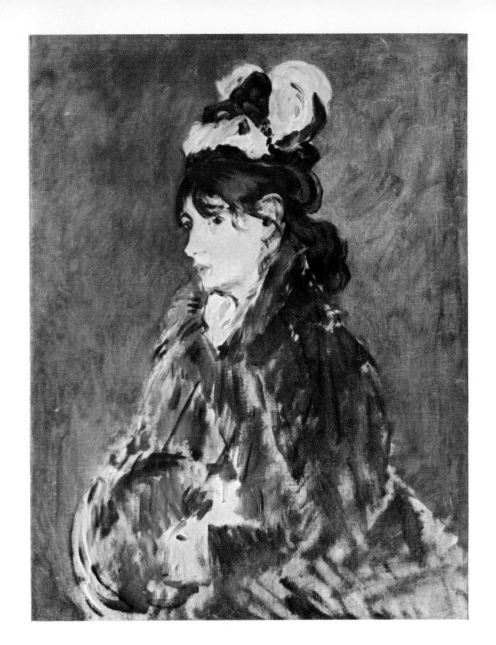

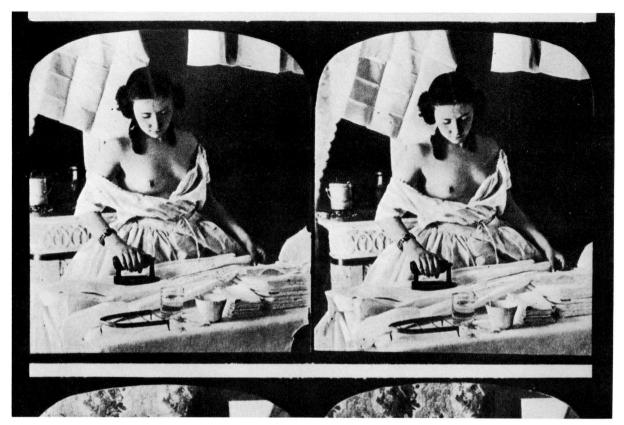

Stereoscopic photograph of
the 1850s: eroticism
in mundane activity.

Manet: *Berthe Morisot with
a Muff,* 1869, 29 inches
high. Cleveland Museum.

by her shameless suggestiveness, but she was also directly reminiscent
of the pornographic photographs that the male audience at least would
have gloated over.

In this connection, further evidence of the widespread distribution
of these photographs in Paris comes from Manet's friend Baudelaire.
In his famous section on photography in his *Salon of 1859* he wrote:

A little later a thousand hungry eyes were peering through the eyepieces
of the stereoscope as if they were the portholes of the infinite. The love
of pornography, which is as alive in the natural heart of man as the love
of himself, was not to let escape such a fine opportunity for self-satisfaction.
And do not think that it was only children coming back from school who
took pleasure in these follies; everyone was infatuated with them.

There is thus clear evidence that Manet would have been very familiar
with the type of nudes that we have illustrated.

The popularity of the prostitute as an artistic theme among the avant-
garde of the 1860s was extraordinary. Manet's literary contemporaries,
Zola, the Goncourts and Huysmans, all wrote novels centered on a pros-
titute. Degas' brothel scenes are well known and exemplify only too
well his attitude toward women. The artists' motives for this choice of
theme were probably complex. The Realist justification advanced by
the Goncourts was that all themes of human life were equally valid,
and that the lives of the people of the "lower depths" had been neglected
in novels, and that they were simply repairing an omission. However
the artists, while claiming a virtuous purpose, seem to have at least part-
ially succumbed to the erotic excitement of prositution and pornography,
which combined the allure of the forbidden with a freedom from personal

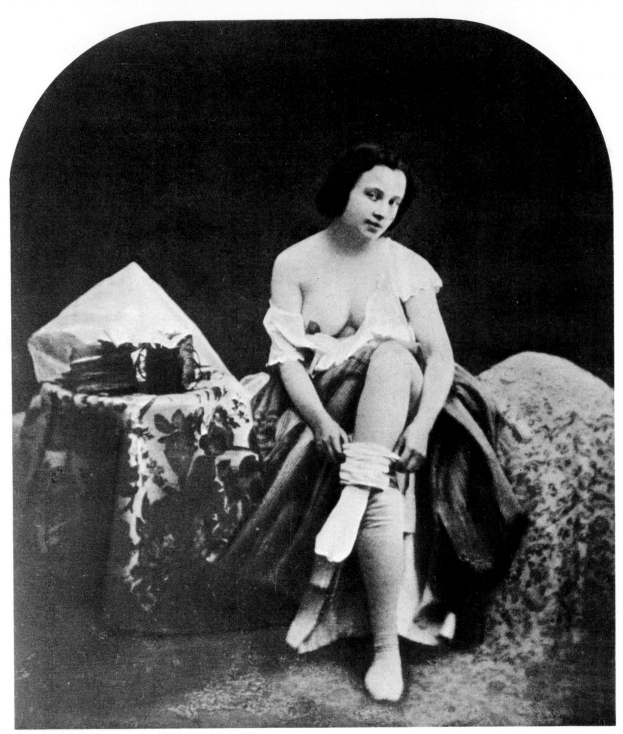

Half of a stereoscopic daguerro-
type of the 1850s, of the kind
deplored in the English
Saturday Review of 1858 for
their display of women "more
or less naked and leering at
the spectator with impudence."

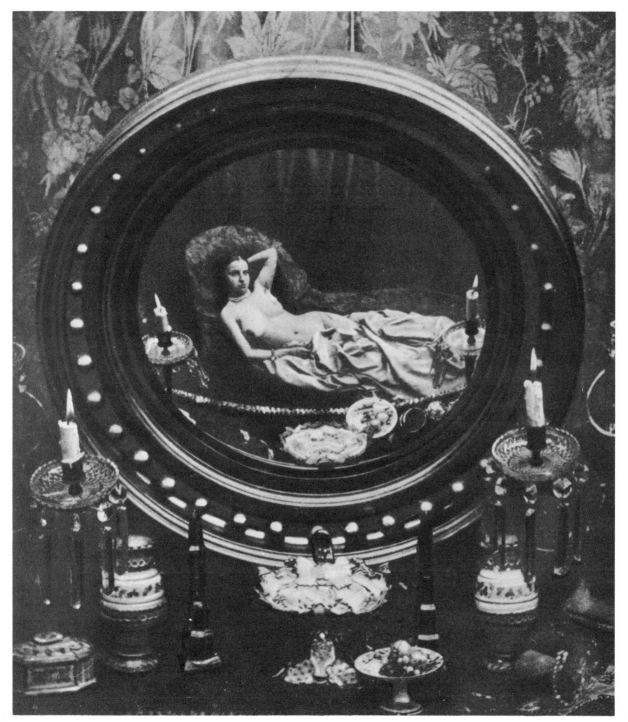

This very elaborate photograph
taken in a mirror, with its
contrast between the flowing
curves of the Odalisque manner
and the angular arms and sharp
face of the model, presents a
reality absorbed by Manet
and incorporated into *Olympia*.

Delacroix studied photographs of the nude and sent models to the photographer Durieu to pose for them. His *Small Odalisque,* 1854-57, painted from a Durieu photograph, has the angularities of the body rounded off, the awkward proportions modified. Niarchos Collection, London.

responsibility. This theme continued in the work of artists like Lautrec and Bonnard to the end of the century, as well as in the work of lesser artists, showing that an advanced attitude in art was no guarantee of freedom from conventional sexual attitudes.

Manet is fascinating in part because after two early works, *Le Déjeuner sur l'herbe* and *Olympia,* which exemplified the woman as sex object, albeit temptress, he scarcely painted the nude again. In spite of its importance as a painting, *Olympia* was not a model for Manet's subsequent development, either in content or style. Manet moved away from the Baudelairean world, and a new concept of femininity appeared in his later pictures of women when the artist was close to the Impressionist group. In the later '60s and '70s, the Impressionists maintained close contacts and worked on similar themes; they frequently painted women, but seldom nudes. Even Monet and Pissarro, whom we think of as landscapists, painted a large number of women at this time: either women together, as in Monet's *Women in a Garden* or Pissarro's *Road to Versailles, Louveciennes,* or women and men, for example Monet's own *Luncheon on the Grass* (in part a criticism of Manet's painting), or his numerous scenes of people in gardens, at the beach, or on the riverbank. The Impressionist vision of life with its delight in the pleasures of everyday living, strolling the streets of Paris, the cafés and theaters, excursions to the nearby resorts along the Seine, or railway trips to the Normandy coast, stressed openness and directness, a lack of class consciousness, an uncomplicated happiness. The painters shunned the nude with all its furtive connotations in nineteenth-century art and life. As Barbara White points out in her essay in these pages, Renoir painted very few nudes before the middle '80s. Even for Degas the nude was a relatively rare theme in the '70s.

As Manet was drawn into the Impressionist orbit he presented a world where men and women mix easily and naturally, and where women portrayed alone have both charm and dignity (as in *The Milliner* or the horsewomen). These paintings reach their height in the portraits of Berthe Morisot, and one wonders if her personal qualities counted as much as the atmosphere of the Impressionist group in inspiring this new vision in Manet's work. This concept of radiance, beauty and openness is fully sexual, but never an exploitation. Contrasting completely with *Olympia,* it points the way to the "new woman" of the 1890s with her intelligence and independence.

[1] This quotation (my italics) is from Cyril Pearl's *The Girl with the Swansdown Seat,* Signet, 1958, a delightful account of nineteenth century demimondaines and of the underworld of sex. I am also indebted to Nancy Warfield for conversations on the importance of photographs to Manet's painting.

[2] Michael Fried, "Manet's Sources: Aspects of His Art," *Artforum, VII,* 7, March, 1969. Theodore Reff, "The Meaning of Manet's *Olympia,*" *Gazette de Beaux-Arts,* LXIII, no. 1141, Feb., 1964.

[3] Paul Valéry, preface to the catalogue of the Manet exhibition, Musée de l'Orangerie, Paris, 1932.

[4] See C. W. Ceram, *The Archaeology of the CINEMA,* New York, 1965, for a description of many of these instruments.

[5] See Aaron Scharf's *Art and Photography,* London, 1968, for comparative illustrations of Delacroix's paintings and the photographs.

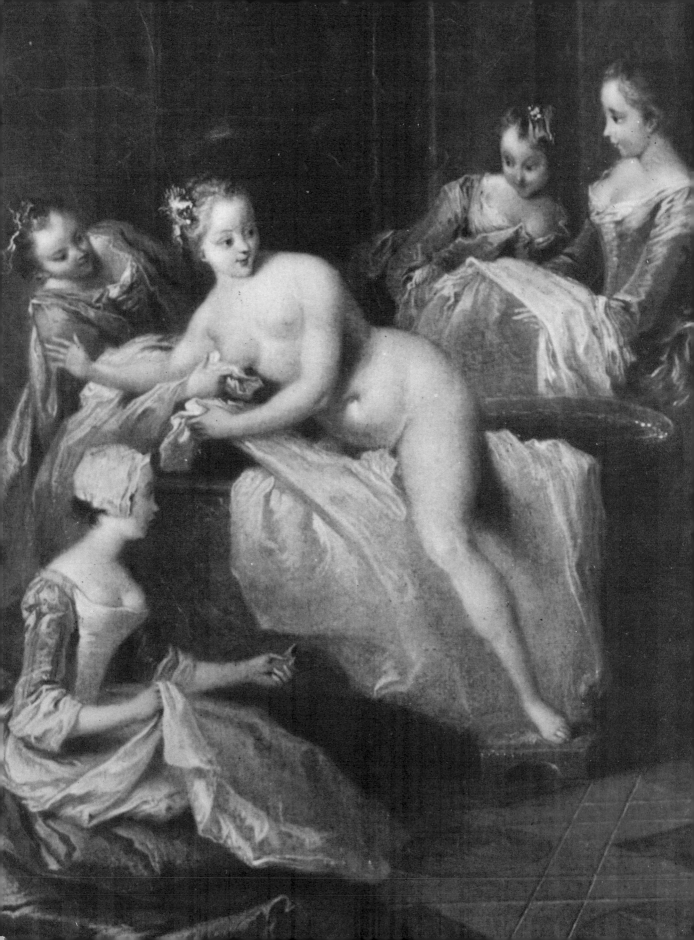

The Corset as Erotic Alchemy: From Rococo Galanterie to Montaut's Physiologies

Author: David Kunzle teaches at the University of California, Santa Barbara, and the California Institute of Arts. He has published monographs on the history of the comic strip and on the modern poster of protest.

1. Rococo: 'Essai du Corset'

During the Renaissance and Baroque periods, the erotic, half-draped and undressed female was depicted in certain mythological and biblical contexts, in the persons of Diana, Susanna, Bathsheba, etc., who aroused the lustful male by taking a bath. Usually this bathing scene was situated in a landscape or patio whose classical associations were echoed in the natural simplicity of the bather's robes. In the age of the Rococo, the bibli-classical heroine becomes a woman of fashion, who moves indoors to take her bath, dress and undress. As Susanna loses her historical associations, the simple piece of cloth with which she hastily improvised protection from a lecherous gaze becomes the fashionable costume of the age, designed not to conceal, but to reveal the body, not for protection but seduction. Ancient chastity develops into modern allurement. As the motivation for the bathing changes, so does the costume; and with the costume, so the body itself. No longer could the artist in the eighteenth century pretend that clothing, whether more or less classical, more or less fashionable, was mere covering for a body of ideal, classical proportions; he must come to terms with the fact that contemporary clothing served to mold and recreate the body on lines which were anti-classical and decidedly erotic.

In the transitional or early Rococo phase, a dual code of feminine beauty prevailed, according to whether the figure was clothed or not. Watteau painted a classical nude, an Antiope, according to a classical (or modified Rubensian) code of proportions, while the clothed ladies who people his *fêtes galantes* are of a new, fashionable, unclassical slenderness. Watteau's principal pupil, J-B. Pater, combined the two ideals in one painting and in a manner which would surely have struck his master as an esthetic impropriety; but improprieties, both esthetic and moral, were Pater's specialty. It is not by accident that the "dual code" is most blatantly illustrated in a composition in which the bathing takes place indoors (the typical Pater *baigneuses* disport themselves out of doors in what may be termed *fêtes galantes aquatiques*). The lady rising out of the tub has a torso of Rubensian proportions; her maid, fully clothed, is of quite impossibly delicate make, especially about the waist, the volume of which cannot be half that of her mistress.[1]

The rationale for this dual code, in terms of the history of fashion, may be found in another branch of popular iconography, costume illustration, which demonstrated in strictly practical terms how classical or

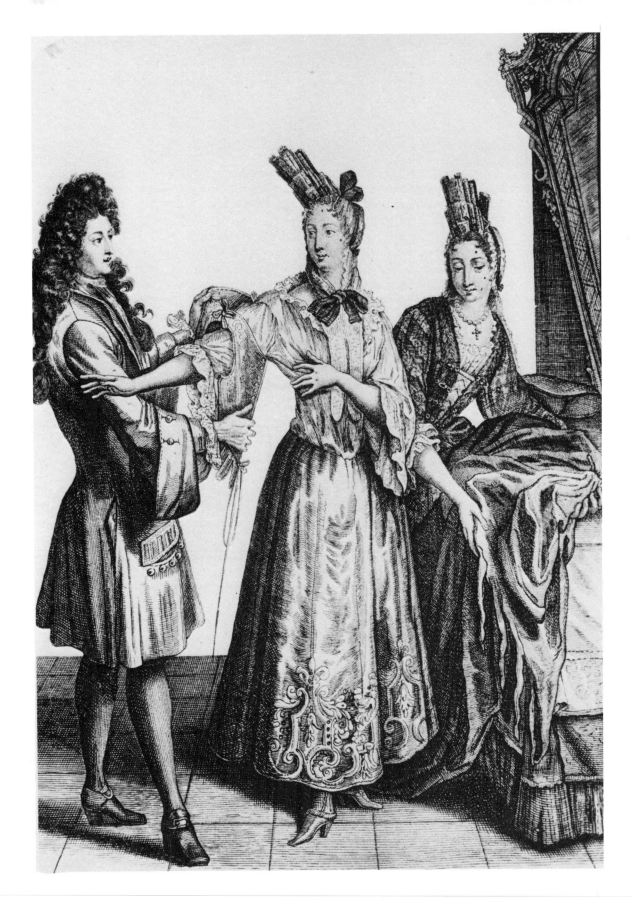

Rubensian abundance may be mechanically confined within fashionable or Watteau-like tenuity. The vogue at the turn of the century for costume books representing the typical attire of the various professions and estates (sophisticated versions of the old *Cris*) gave new status to the tailor and staymaker, the latter having recently (ca. 1675) split off to constitute a new guild, calling themselves *"tailleurs de corps de femmes et enfants."*[2] The staymaker was required to "educate" the body of the young into the newly fashionable slenderness.[3] His appearance at the eve of the new century is strictly utilitarian. In Nicolas Arnoult's engraving, he stands formally, at a distance, passing the stays over his client's arm, while a maid busies herself nearby with some drapery. From his dress, be it noted, this craftsman, who "knows how to correct the faults of nature," is of a superior kind: he must be a gentleman to serve so fine a lady. Only in the caption-verse is there a hint of the amorous role he is to play. By the age of Pater the gentleman-staymaker has become more familiar; he presses closer to his client, burying his knee into her skirt, and taking the measure of the busk with his top hand actually touching her breast, while the maid watches attentively, perhaps admiringly, from behind. The verse makes no bones about the increase in erotic content, expressing the lover's envious identification with the tailor, and his readiness to suffer in silence, could he but entertain the hope "of taking her measure as I crave."[4]

The tailor as lover-substitute was a not uncommon literary figure of an ambiguous, picaresque kind. In order to introduce himself to his mistress' home, a lover might adopt all sorts of disguises; that of physician or tailor allowed him to take peculiar liberties with the person of the beloved. In life, be it noted, staymaking like tailoring was a male preserve; the *couturières*, permitted to form a separate guild in 1675, were expressly forbidden to do anything to stays but embroider them. The Parlement recommended their admission to the craft on the grounds that some ladies did not like to be dressed by men, which suggests that staymakers were feared to be in the habit of taking liberties with their clients while fitting them.[5]

The status of the staymaker rose steadily in the course of the eighteenth century, so that by the 1750s he could rival the dressmaker and coiffeur in reputation and wealth. He became moreover the center of a controversy which surpassed by far the kind of technical disputes and professional jealousies suffered by most guilds from time to time, and which since Rousseau's *Emile* (1762)[6] took on radical moral dimensions. Rousseau, following various German physicians who wrote extensively against fashionable corsetry in the 1750s, saw in the stays worn by women and children an instrument of unnatural social conditioning; but the more prestigious staymakers were artfully engaged in concealing the "oppressive" purpose of their creations by lending them the aura of a work of art, and accusing their rivals of being mere mechanical instrument-makers, and dangerous ones at that. Costume historians have been struck by the sheer complexity and subtlety of the means used by the mid-eighteenth century to give stays their peculiar, delicate pre-formed cur-

Nicolas Arnoult: *The French Tailor*, 1697. "He is honorable, he is discreet, he skillfully conceals the faults of nature, and he knows how to keep the secrets of an amorous adventure."

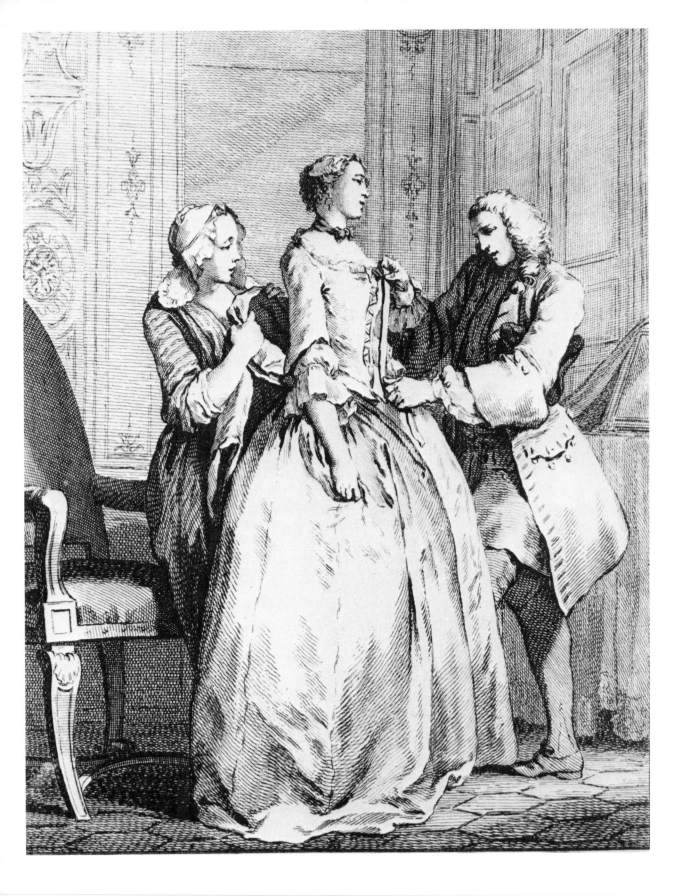

vature.[7] The staymaker was an artist; but from the moral, Rousseauist standpoint, a corrupt one, serving to inflame the desires–a Boucher of body-sculpture. The boudoir was his workshop, where he transformed, with amorous skill and amorous intent, the true subject of his art–Woman.

With deliberately feigned, almost comically eloquent prudishness, the young artist and critic Henry Fuseli takes Rousseau to task for his candor on sexual matters in general, and on the provocations of undress and corsetry in particular:

What, in the name of mutiny, what consequences will it have for wenches, to know that there are kisses, out of family. . . to know that stays paint to the eagle eye of love here their luxuriance of bosom and milky orbs of rapture, and there the slender waist and rising hips; and that with the perfumes of their toilet contagion spreads, that aprons will invite Hamlet to build tabernacles between Beauty's legs, and petticoats appear to Romeo the gates of heaven–what will be the consequences of all this?"[8]

The consequence, in art, was the emergence of the *toilette galante* with its subsidiary, the *essai du corset*, as a major iconographic theme of the last third of the century. A possible consequence, in life, was the increased prominence of corsetry in the seduction process. Casanova, visiting a twelve year-old schoolgirl in a nunnery with the object of seducing her, points out to the mistress in charge (a party to the plot) that the girl's stays are too tightly laced, that she could not possibly have so slender a waist naturally. "You are wrong, Sir," says the chaperone, "you could place your hand inside it!" "I do not believe it," replies Casanova. "Try it!" Which of course he does.[9] The autobiographical confessions of Restif de la Bretonne, whose foot and shoe fetishism is well-known, reveal him also to have been erotically sensitive to stays, the action of which is both incentive to, and in a curious way symbolic of the act of love. Restif notices that the waist of the scullery-maid Jeanneton "which was usually thicker below than above, had grown more slender while I was taking my pleasure," and in order to celebrate her seduction by a gentleman, which marks her initiation to the fashionable world, Jeanneton begins to wear fashionable stays. Elsewhere Restif describes the adventure of Gaudet whom the beautiful Jacquette, the attorney's wife, "got to lace her up in the absence of her husband and her maid, and when her dainty waist had been constricted and the pressure of the corset had pushed out an alabaster bosom, he, Gaudet, burning with desire, and devouring with his eyes charms which he was almost touching, had been on the point of pushing her on her back and telling her: 'I shall have you or die.' "[10]

The illustrations to Restif's works, engraved by Louis Binet from designs more or less dictated by the author, are also eloquent of his taste for a female body of exaggerated delicacy about the middle and at the extremities.

By around 1760, the staymaker has abandoned all pretence at professional decorum. Lacking entirely the tools of his trade, the *tailleur*, identifiable as such only from the title engraved below, stands behind the lady in her stays, his hand hovering over her breasts, gazing down upon them hungrily. By the next decade the gallant, as if in dissatisfaction

C.N. Cochin: *The Woman's Tailor,* 1697. "How gracious is your trade, O tailor, how I envy you! You may freely feast your eyes on Sylvia's charms. I would silently suffer the pains she causes me, if I were but sure of taking her measure as I crave."

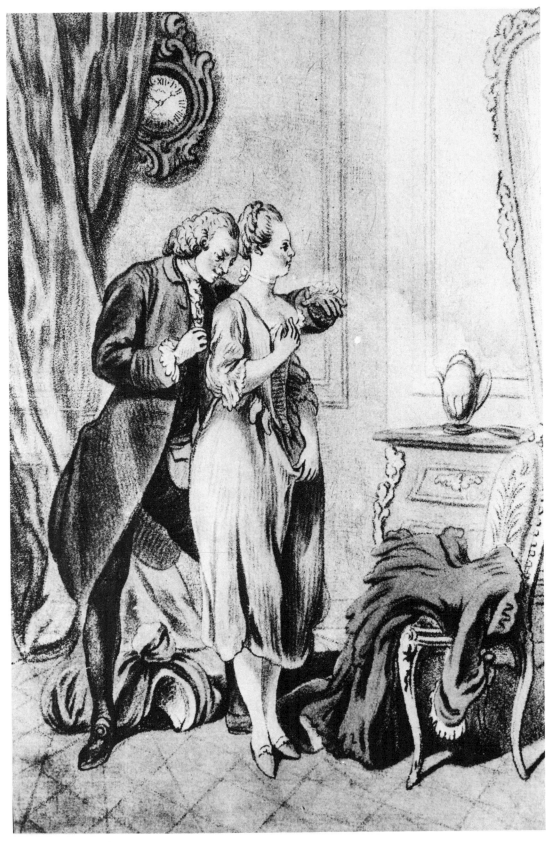

Louis Bonnet: *The Tailor,* pastel and engraving, ca. 1760.

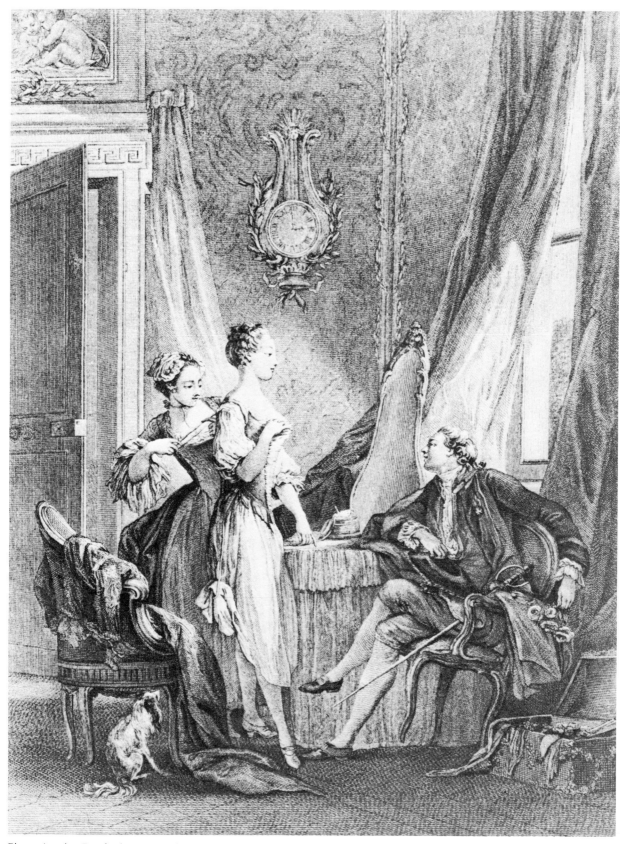

Pierre-Antoine Baudouin (engraved
by N. Ponce, 1771): *The Toilet*.

with a vicarious, voyeuristic role, makes a direct appearance, thus merging *Essai du Corset* with *Toilette Galante.* The latter did not of course represent an inherently immoral situation. It was not at all improper for gentlemen friends to be present (although they would not normally, like Restif's friend, assist physically) at the final stages of a lady's *toilette*; the *lever,* as this daily event was called, was indeed considered an appropriate time for receiving not only friends, but also artists, musicians, poets, etc. (as in Hogarth's *Marriage à-la-mode,* scene 4; his satires are always founded upon social fact). The gallant has come to admire the artist—or rather his work, literally incarnate in the mistress of his heart. The gallant, connoisseur of art, is also an artist—in the practice of love. Baudouin imbues the whole scene with an elegance both nonchalant and warm. The apparent nonchalance of the gallant is merely a cover for his erotic desire, which cannot moreover brook any male rival: it is the maid who laces the stays, not a staymaker. The lady gazes into the mirror standing before her–or into her lover's enraptured eyes. The forward pitch of his body, the roses (female symbol) in his hand near the sword-hilt (male symbol), all bespeaks as sure and graceful an intended capture of her body as that of the stays "*épousant,*" i.e. already "married" to her body.

Baudouin, heir to a clientèle for erotica formed by his father-in-law François Boucher, took another, closer angle upon the female form in stays, viewed almost frontally, and as if in an oval mirror. The male does not intrude upon the sacred, iconic space, but he is symbolized in a dove flapping his wings upon the mirror frame. Setting and paraphernalia of this toilette are much reduced in order to maximize the purity of line and mass formed by the interlocking of breast and stays.

The delicate eroticism with which Baudouin had suffused the theme of the *Essai du Corset,* and which was characteristic of the *Toilette Galante, Coucher de la Mariée,* etc., in the 1770s, later turned to open eroticism, the semi-pornographic, the anecdote and satire. In a design by P.A. Wille, the staymaker returns in the role of the maid, and helps fit the stays, not merely by lacing them, but by firmly settling them in place, one hand clasping the lady's waist, the other fingering her breasts, which are now bared to show an inch or two below the nipples. The forward motion of his body and the parting of his lips convey more than professional satisfaction at a perfect fit, and the older man, seated right, may reveal some sad sense of this. His expression is one of admiration mixed with wistful longing, with the latter surely uppermost. That he is unfit for amorous tasks may be indicated not only by his apparent age, but possibly also by the position of his cane which stands not on his side, but next to the younger man, and follows the inclination of the latter's body.[11] Unlike Baudouin's fortunate gallant, that of Wille sits both below and behind the lady, beneath the range of her dreamy gaze.

As we approach the very end of the century, the theme reaches its most vulgar and lascivious stage: the *tailleur* is now a grinning abbé, tugging mightily on the laces, his skirts hitched up for greater freedom

of movement, and to reveal a provocatively well-muscled calf. The other gallant is a young man making a facile gesture which may express at once invitation and command, while the young lady smiles, turns towards him and accepts a glass (and, by extension, the sexual invitation). By this time, however, the *Toilette Galante* had become at the hands of the English caricaturists, the *Toilette Grotesque*, which may have indirectly affected the Monsiau print. As we turn to developments across the Channel, we are at once confronted with a paradox: it is in the land of comic art, and in the work of the leading comic artist of the Rococo age, that female stays are subjected to the most sober theoretical and esthetic critique.

2. Line of Beauty

Not the least curious and paradoxical feature of Hogarth's *Analysis of Beauty*, 1753, a treatise designed as a theoretical defence of Nature over classical concepts of Decorum and false notions of Art, is that the artist chooses to illustrate the practical quintessence of his theory, his "Line of Beauty," not upon the naked female form, but upon a series of pairs of stays. His verbal description, moreover, reads both as praise of the staymaker's art (the technical development of which we have already noted), and as a unique tribute to the superiority of fashion over natural form. In approaching this remarkable passage, we should bear in mind that Hogarth was very sensitive to the peculiar esthetic and moral appeal of stays, even (or especially) when discarded. Stays are the subject of beautiful "still-lifes" in *Rake's Progress, III* and *Marriage à-la-mode, V*. In the former they are placed in center foreground, in deliberate counterpoint to the lovely and abundant forms of an acrobatic performer called Posture Nan; in the latter, their abandonment by the owner symbolizes her dishonor, her abandonment of the social decencies; and in the *Harlot's Progress*, the change in the shape of the stays worn by Moll Hackabout between the first and second scenes embodies the all-important shift in her status from simple country girl to sophisticated courtesan, and her corresponding moral decline.[12]

"A still more perfect idea," writes Hogarth in the *Analysis,*[13] "of the effects of the precise waving-line, and of those lines that deviate from it, may be conceived by the row of stays, where number 4 is composed of precise waving lines, and is therefore the best-shaped stay. Every whalebone of a good stay must be made to bend in this manner: for the whole stay, when put close together behind, is truly a shell of well-varied contents, and its surface of course a fine form." This is not just a matter of contour or silhouette, but an invitation to the eye to conceive of line in a three-dimensional movement: "so that if a line, or the lace were to be drawn, or brought from the top of the lacing of the stay behind, round the body, and down to the bottom peak of the stomacher; it would form such a perfect, precise, serpentine line, as has been shown round the cone." One imagines the artist running the staylace around his wife in the manner described. There was no comparable Line of

Sa taille est ravissante
Et l'on peut déjà voir
Une gorge naissante
Repousser le mouchoir, &c.

Beauty to be found in the male form, naked or clothed; and it is Hogarth's altogether remarkable, not to say bizarre, conclusion that the existence of this line in female stays "proves how much the form of a woman's body surpasses in beauty that of man." A visual, quasi-theoretical defense of this thesis appears in a painted sketch in which the comic, awkward and angular posture of the staymaker is juxtaposed with the dignified, graceful and fluid lines of his client.[14]

Hogarth's determination on a comparative basis of the perfect shape of stay may conceal a subtle polemic against a minor tendency in fashion at this time (unnoticed by historians) to impose straighter and flatter forms. A writer, who evidently had advance knowledge of Hogarth's treatise, wrote a few days before it was delivered to subscribers: "But the worst reason for coming to London that I ever heard in my life, was given me last night at a visit by a young lady of the most graceful figure I ever beheld; it was 'To have her shape altered to the modern fashion.' That is to say, to have her breasts compressed by a flat, strait line, which is to extend crosswise from shoulder to shoulder, and also to descend, still in a strait line, in such a manner, that you shall not be able to pronounce what it is that prevents the usual tapering of the waist." The writer, Adam Fitz-Adam, goes on to cite "the nicest observer of our times (Hogarth), who is now publishing a most rational Analysis of Beauty and has chosen for the principal illustration of it, a pair of stays, such as would fit the shape described by the judicious poet (Prior); and has also shewn by drawings of other stays, that every minute deviation from the first pattern is a diminution of beauty, and every grosser alteration a deformity."[15]

Hogarth, whose oeuvre constitutes a unique source of information for the minutiae of contemporary dress, and who probably would have written extensively upon costume had his *Analysis* not been dismissed with contempt by influential critics, was a staunch proponent of feminine sartorial artifice. He was the first art theorist to submit the quirks of fashion to sympathetic formal analysis in the context of a general esthetic theory. He used hoops, which had traditionally been regarded as either wicked or ridiculous or both, as the embodiment of the principle of quantity as an esthetic factor, just as stays demonstrated variety. But there were strict limits beyond which artifice, in its relation to the human form, was castigated as an absurdity. Hogarth was an enemy of steel orthopedic and posture machinery, which was a specialty of the French, to judge by that ludicrous contraption in the quack doctor's office *(Marriage à-la-mode, III)*. This is inscribed with the approval of the French Royal Academy of Sciences as a means of correcting uneven shoulders (the very complaint, incidentally, which the dress-reformers claimed was induced by the wearing of stays in childhood). Hogarth's opinion on such topics is also known from a contemptuous reference to "steel collars and other iron machines" used for making children hold up their heads.[16]

The French themselves recognized the superior lightness and flexibility of the English stay,[17] but it was the English themselves, entering that period known as the Golden Age of Caricature, who turned all the

Pierre-Antoine Baudouin (engraved by Le Beau, 1776): "Her figure is ravishing, and one may already observe the budding breast press back the kerchief."

P. A. Wille (engraved by Dennel,
ca. 1780): *Trying on the Corset.*

Nicolas Monsiau (engraved by R. Delvaux, 1796): *An Abbé
Lacing a Lady's Stays* (perhaps an illustration for Rousseau).

artifices of fashion to objects of ribaldry, and the *Toilette Galante* into the *Toilette Grotesque,* and the *Essai du Corset* into mechanical farce.

3. Toilette Grotesque

During the 1770s, tight-lacing as a fashion polarized[18]: advanced, Rousseauist mothers abandoned stays altogether and permitted their daughters to grow up without, but in aristocratic and socially ambitious bourgeois circles, stays were laced tighter than ever, certain young girls being notorious for their voluntary addiction to extremes of the practice. In 1777, at least four distinct tight-lacing caricatures were published in England. French galanterie is totally banished from these scenes. In one broadsheet the young girl has become an old hag, clinging to a four-poster and tugged in by an equally old and ugly maid. Another shows a cobbler giving his wife a strapping as a punishment for her vanity and extravagance: "But ah! when set aloft her cap / Her bodice while she's bracing, / Jobson comes in and with his strap / Gives her a good tight lacing." A third broadsheet shows a smithy, in which blacksmiths are hammering out all-steel stays, while a customer in an enormous headdress is being measured for them.[19] All-steel stays were, of course, an exaggeration, probably inspired by a newspaper report which was also picked up by Horace Walpole: "There has been a young gentlewoman overturned and terribly bruised by her *vulcanian stays.* They now wear a steel busk down their middle and a rail of the same metal across their breasts."[20] The only satire of the year to show a young and pretty woman being tight-laced is by Hogarth's principal follower, John Collet; this was well enough known to be adapted by Gillray in 1793, when the fashion had declined, but when the political situation offered a fortunate verbal accident. The cartoon has a cleverly punning title based in part on Collet's "Fashion before Ease—or—a good constitution sacrificed for a fantastick form." It satirizes the radical Tom Paine, author of the *Rights of Man*, who had once exercised the profession of staymaker and who is here shown tugging at the laces of stays worn by a fair but pained and reproachful looking Britannia.[21]

About 1781 an actress, Eliza Farren, who was evidently very tight-laced for her role in a play called the *Fair Circassian*, became the occasion of a caricature[22] which illustrates, for the first time to my knowledge, the fantasy which has haunted twentieth-century cartoonists and fetishists (in England): the complete separation of the body in the middle, as the logical extreme of the tight-lacing mania. But the most famous as well as the most cruel tight-lacing caricature is surely that of Thomas Rowlandson, whose etching of 1791, titled "A Little Tighter," shows a monstrously fat and ugly old woman being pulled in by a very thin but energetic gentleman. At this time the practice was universally on the decline among the fashionable; the old coquette (that eternal butt of the caricaturists) is trying to recapture the charms of her youth.

French caricature after the Revolution ridiculed the English for clinging to old modes of dress, as of politics; at some time probably in the

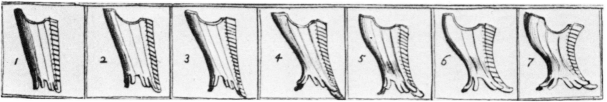

Hogarth: Progression of stays, from *The Analysis of Beauty,* 1753.

early '90s a French publisher of popular prints, Basset, issued (as it were in response to Gillray) a satire on aristocratic tight-lacing which is English in form and anti-English in spirit. This is the earliest representation known to me of a mechanical aid to lacing: an elderly beau hauls in the lady's stays (which, for the convenience of the artist, are made to lace in front); beau and belle are both dressed in the style of fifteen years earlier. A better known version of the "windlass theme," as we may call it, is that of Heath in 1820, a print which inspired several similar ones both in England and on the Continent[23] at a time when tight-lacing was feared to be reviving with vengeance.

Caricature of the secrets of the toilette, although never grosser than in England at this time, was not always so gross; Gillray renders the *Progress of the Toilet* in an almost documentary rather than satirical spirit. The prints are exceedingly dull,[24] but deserve special emphasis at this point because the idea of a "progress" which allows for comparison of first and final stages is in itself a novelty, and is to form the kernel of Montaut's systematic *"physiologie"* of the corset. Remarkable too, from the perspective of later developments, but antithetically so, is the very lack of apparent difference between the first and last stages of the toilet. This is presumably the point: "Empire" fashions were found ridiculous and immodest because of their resemblance to underwear. The fashionable silhouette after ca. 1785, and up to the time this series of prints was published (1810), threw tremendous emphasis, especially in profile, upon the breasts, which were squeezed up and thrown out by means of the prodigious busk depicted by Gillray at the moment of its insertion. This "pouter-pigeon" effect returned, almost exactly a century later, once again as an intermediary between excessively corseted and relatively non-corseted periods. It may be identified with one extreme, no. 7, of Hogarth's schematic "progress," the other extreme being the flatness of no.1, fashionable around 1700. Viewed over the long haul, Hogarth seems to have projected a century-long series, from the past into the future, with the artist's present lying at almost exact chronological midpoint (1753). We may go further and note that Hogarth's sense of the graceful slenderness of no. 4 as the perfect esthetic mean formed the bastion for the fashion-mongers' defence of the cuirasse style of the 1870s, as also for the tight-lacers' defence of their addiction; and it was the latter who explicitly hailed the Line of Beauty as a welcome return to a basic esthetic standard in dress, in abeyance since the exaggerated fullness of the crinoline and the high-waisted line of the later '60s. Finally we may add that "Line of Beauty" became a popular trade-name for the new cuirasse corset.

4. The Romantic Age

From 1825, as Neo-Classical ceded to Romantic fashions, what Rousseau

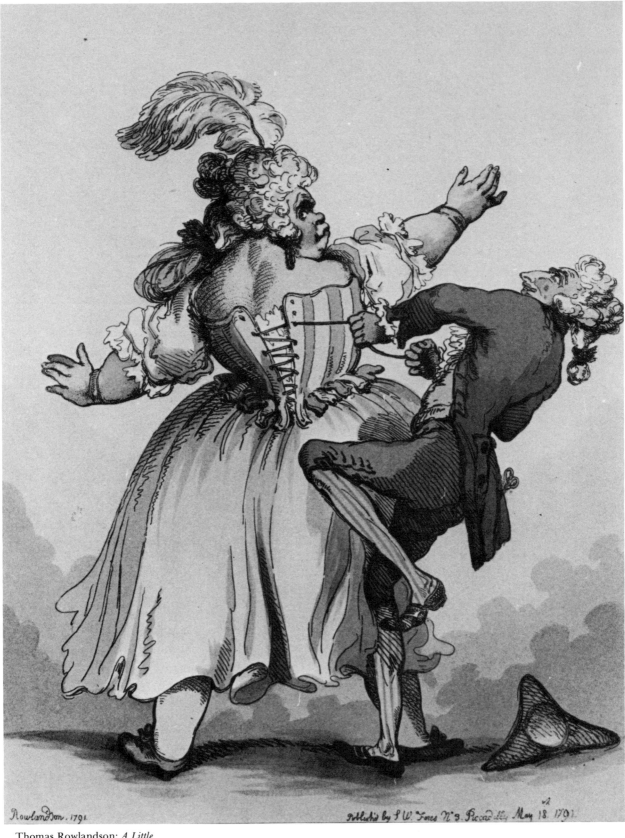

Thomas Rowlandson: *A Little Tighter*, colored etching, 1791.

James Gillray: "Fashion before Ease; or—a good
constitution sacrificed for a fantastick form," 1793.

had called the "Gothic" custom of tight-lacing revived; and with it, the medical opposition. The iconography of the corset diversifies into three groups: the medical, the satiric and the sentimental-erotic. Popular reformist medical articles against tight-lacing often fell back upon the "classic" contrast between the waist of fashion and the torso of Venus, which had first illustrated Soemmerring's tract of 1788; and if the diagrams tended to be schematic, skeletal rather than organic, and reluctant to enter into too much anatomical detail, the verbal accounts of the carnage wreaked by corsets were horrific. Moral tempers rose on this "indelicate" subject. The cartoonists, for their part, fell back on the old "windlass theme" either conventionally, as in Grandville, or in new and even more fantastic variants, such as Le Poitevin's devil grinding away the fashionable lady's waist with a grinding-wheel.

But it was the erotic exploitation of the corset by the sentimental lithograph which is most characteristic of the Romantic 1830s. Numa Bassaget reverts to source in the early eighteenth-century series of "Professions," by titling his print *"La Marchande du Corset"*. The *corsetière* (for by now women had taken over the profession) kneels before her client in humble admiration, substituting for the male who would prostrate himself before his idol. [25] Another, anonymous lithograph of the period seems, in the first instance, to be intended as a straightforward advertisement for a newly patented system of instant unlacing, indispensable for those of fragile constitution; but setting, lighting and mood all indicate that the print was intended to have a broader esthetic-erotic appeal. The lady's attitude with her back to the spectator may in this case be explained by the technical-commercial necessity of demonstrating how the lacing functions; but this rationale disappears as the erotic factor is strengthened. In a Vallou de Villeneuve lithograph the young lady appears to be struggling with the laces at the back, as if in mute appeal for our help. In Devéria[26] the girl faces us, smiling in gentle invitation, holding the lace in her hand; in another Bassaget print she actually offers the lace to her beloved, who is seated but opens his legs to receive her; the title, *La Lune de Miel,* leaves no doubt as to the symbolic significance of this nuptial delacing.[27] Two themes distinct in the eighteenth century, *Le Coucher de la Mariée* and *l'Essai du Corset,* are thus merged. Finally we have another anonymous, but exquisite, lithograph in which the ardent lover is engaged in the unlacing, like a medieval knight transforming the servile task into a peculiar sexual privilege. It was with a single stroke of the dagger that the Circassian bridegroom slashed the corset of his bride; the French romantic lover is all tender, trembling fingers as he unweaves the chastity belt.

In all these prints there is no suggestion that the corset does anything but veil, protect and repeat the perfect forms beneath. The persistent undercurrent of the Neo-Classical esthetic, as well as considerations of propriety, prevented the artist from representing *naked* forms of a romantic slenderness which violated all the canons of antiquity. Being both clothed and unclothed, the corsetted woman was placed ambiguously between two contradictory esthetic realms: that of classical sculp-

ture and that of the fashion-plate. But the Romantic sense of irony welcomed this kind of ambiguity and embraced the contradiction. The crass, moralistic juxtaposition of "natural" (classical) and "artificial" (modern) form, which first appeared in Soemmerring's polemic, is resolved by Octave Tassaert with wit and humor. The living goddess stands modestly with her back to us as she holds the tape about her breast, but she does so as if to enhance her romantically wasp-waisted and slope-shouldered contour. The stone goddess is proven to measure the same about the bust, and the classical thickness of her waist is masked by the hands of the attendant. But all this is mere playful pretence; the dualism is reconciled only in a momentary and fragmentary way. The artist, whom we may imagine concealed behind the canvas to the right, must choose between the two models: between his mistress and the Venus between the living and the dead. The choice in favor of the former was not finally to be made and affirmed until the age of Baudelaire and Montaut.[28]

5. Realism (Daumier, Baudelaire)

As Romanticism merged into Realism, the women in popular lithographs became more brazen and cast off their air of calculated sexual vulnerability. In a design of ca. 1845-50, Gavarni shows the lover engaged in unlacing his mistress, who asks him mockingly: " *'Dis donc, petit, tu aimes les huîtres?' 'Oui, . . .mais j'aime mieux les femmes.' ' . . .sais-tu les ouvrir?' '!!!' "* In another Gavarni lithograph, a change in the style of lacing knot arouses the husband's doubts as to his wife's fidelity: the lock of the chastity-belt has been tampered with.[29]

By mid-century, in keeping with the burgeoning spirit of realism in arts and letters, caricaturists became increasingly conscious of the sad truth behind the gaudy artifices of fashionable dress. The exaggerations of the crinoline provided the necessary pretext. In a striking juxtaposition, Marcelin, future founder of *La Vie Parisienne*, shows an unprepossessing young lady sitting in her shift beside a stand which holds an immense crinoline gown and wig, to the caption: *Le Matin du Bal–"Voilà pourtant comme je serai ce soir!"*[30] But already in pre-crinoline days a caricaturist signing Lefils had decomposed the process of transformation into six stages, from the somber reality of morning undress to the relative splendor of the evening ball-gown, via bust-improvers, false teeth, face cosmetics and false hair.

This kind of cynicism flourished in another iconographic field, which returns to view after having lapsed, or merged into the *Toilette Galante* in the early eighteenth century–the *baigneuse*. Her prominence in the caricature of the '40s and '50s may also be connected with an increase in the number of Parisians using the public baths and learning to swim. The evolution of the bathing-scene can be followed in the work of Honoré Daumier alone. In a 30-plate series of *Baigneurs*, 1839-42, only two females are included, although they are ugly enough. When the male takes advantage of a peep-hole between the male and female sections

of the bath, he remarks of a woman who remains unseen: *"Regarde donc la grosse Fifine qu'on aurait juré que c'était une Vénus...ah, ben en v'là un déchet"* (Look at the fat Fifine who always looked like she was Venus... well, there's a ruin for you"– *Le Charivari,* Oct. 4, 1839). In the 17-plate *Baigneuses* of 1847, several designs convey the essential ugliness of woman, once she is stripped of her social finery, the ironic spirit of the whole endeavor being summed up in the caption to D. 1644: *"Faisant toutes partie de la plus belle moitié du genre humain."* In D. 1630 an enormously fat woman confesses to a thin one that *"Dans l'été ce n'est ici réellement que je me trouve bien* (i.e. relieved of her corsets–and revealed in her grossness). Conventional social flattery becomes both hollow and grotesque: a totally shapeless woman is described as having *"encore une jolie taille"* (D. 1643). Daumier, who consistently and (compared with his contemporaries, exceptionally) avoids the device of the narrative sequence, does not depict the same woman in contrasting before and after states, but conjures up the situation indirectly. The natural undress of the bathing suit acts as a human and social degradant in its profoundest sense, exposing the ungainly waddle natural to the species, which is held by the swimming instructor like a monkey on a chain (D. 1633). Unmasked, too, is the fundamentally proletarian character of Madame la Baronne (D. 1631; a similar joke in D. 2416 of 1853). In 1858, Marcelin revived the theme of the ugly *baigneuse* in the *Journal Amusant.*

The sagging flesh representing the inner reality behind the outward magnificence is unveiled in another, more direct and simultaneous way by that *rara avis,* the caricaturist in three dimensions. The sculptor Jean-Pierre Dantan made a statuette of a crinolined lady which, when turned around, was cut apart to expose the ugliness of her naked form.[31] This trick ultimately derives from the *Vanitas* transformation image,[32] the spectator lifting the skirt printed on a separate flap of paper, to reveal a skeleton beneath. The *Vanitas* or Dance of Death transformation was employed by another sculptor, Ernest Christophe, in a statuette showing a skeleton dressed up for a ball. This was fully described by Baudelaire in his *Salon* of 1859[33] and inspired some stanzas reprinted there after having been published two years before in *Les Fleurs du Mal:* "...*Vit-on jamais au bal une taille plus mince?/...O charme du néant follement attifé! /Aucuns t'apelleront une caricature,/Qui ne comprennent pas, amants ivres de la chair,/L'élégance sans nom de l'humaine armature!"* (Did you ever see a more slender waist on the dance-floor? O spell of nothingness, crazily bedizened! Some will call you a caricature, those whose drunken love of the flesh hides from them the nameless elegance of the human scaffolding). The reference to an unparalleled slenderness of waist, the royal amplitude of the skirt, human armature and, not least, caricature, all bespeak acquaintance with contemporary pictorial satire, upon which, as is now well known, Baudelaire was (with Champfleury) the leading authority. The *Danse Macabre* of artificial beauty casts its spell upon other poems as well. The bones of the human skeleton are to the flesh as those of corset and crinoline are to the sensuous stuffs of outer dress;

Basset: "New Method of Lacing à l'Anglaise, for Slender Waists, by Milord Bricklinghton [sic]," 1790s.

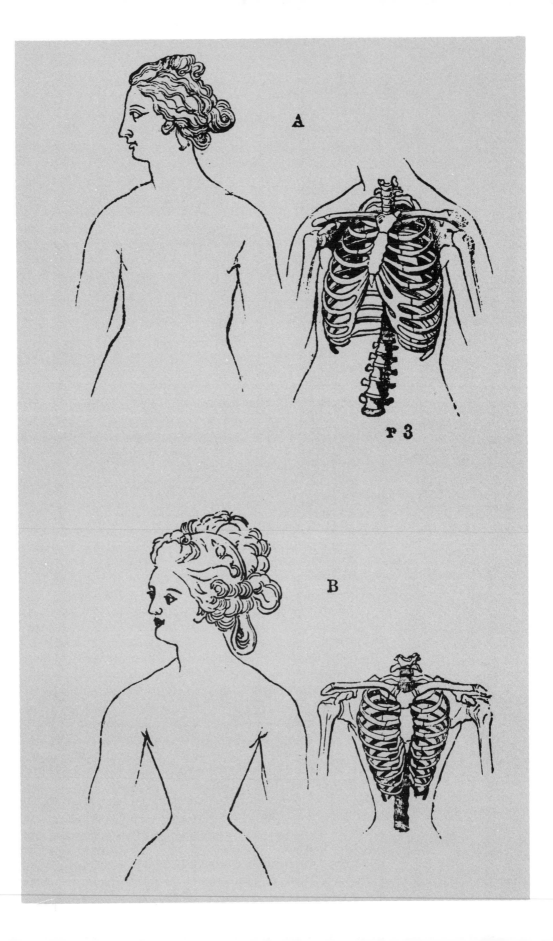

A

P 3

B

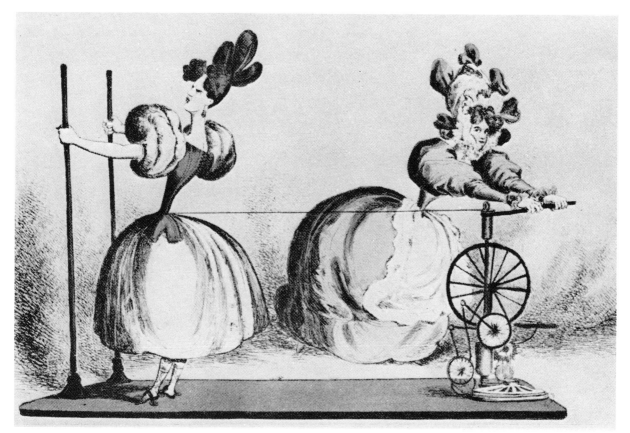

William Heath: *New Machine for Winding up Ladies*, 1828.

Classical Venus and Fashionable Lady, illustration for Soemmerring, *On the Effects of Stays*, 1788.

both stand as a deeper, stranger reality than that of the externally visible. Elsewhere in *Les Fleurs du Mal*, Baudelaire enlarges upon the "unspeakable elegance" of the armature of fashionable dress by describing the brutal prison it imposes on the flesh *("le corset brutal emprisonnant tes flancs")*[34] and the manner in which the busk crushes the soft breast, revealing woman as a physiological and social contradiction, as a perversely cultivated, sado-masochistic illusion, fascinating, dangerous, fatal: " . . . *pétrissant ses seins sur le fer de son busc, /(elle) laissait couler ces mots tout imprégnés de musc .6 ."* (kneading her breasts on the steel of her busk, (she) let flow these words impregnated with musk . . .". Imposed as we may suppose it to be by the exigencies of a very rare rhyme, the association of "musk" and "busk" is entirely characteristic of the poet, who loves to juxtapose the hard, tactile, sado-masochistic sensation, with the intangible, aromatic and gentle one. Other images in this poem (*Les Métamorphoses du Vampire*), a *"pièce condamnée"* which altogether carries woman to a demonic apotheosis, are replete with sado-masochistic and contradictory associations: "twisting like a snake,"[35] "mouth as red as strawberry," "triumphant breasts . . . yielding to biting kisses . . . smothering man in my fearful arms." She is the devouring female who from a splendid, visually ecstatic, living ("blood-filled") dummy, suddenly metamorphoses into a heap of old bones; and the soft cushions of the breasts turn into "a wine-skin with gluey sides, all full of pus."

Without daring to approach Baudelaire's sovereign sense of physical disgust and moral outrage, disillusioned contributors to *La Vie Parisienne* will ask, what is woman when she has discarded her outer clothes and

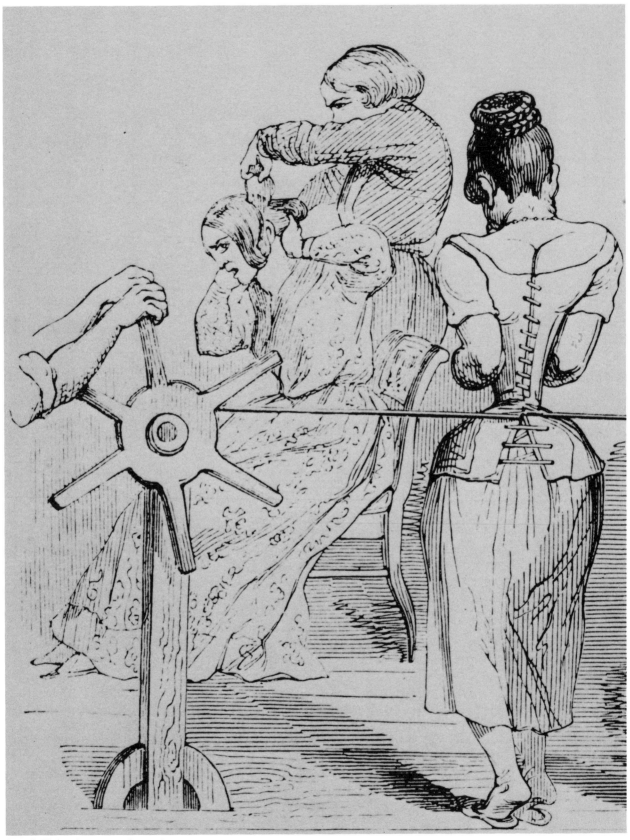

Grandville: *Tailors, Bootmakers and Corsetiers Are
the Executioners of Fashion*, engraving, 1844.

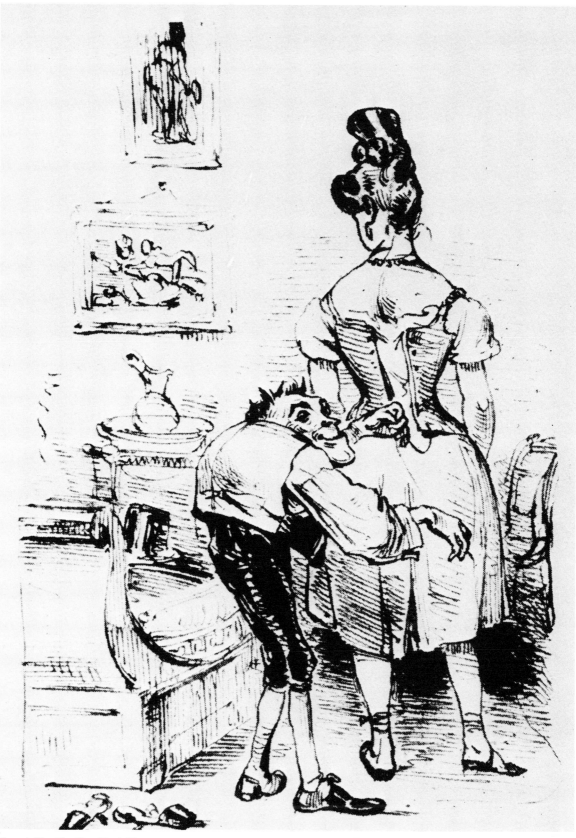

Grandville: *The Hunchback Mayeux*
Lacing a Girl's Corset, drawing, 1830s.

her physical (and moral) degeneracy stands exposed? What is that supreme artifice, that alter ego, the corset, when left lying in an untidy heap of old bones, its satin shrivelled and dank with sweat? Working at a time, the later 1870s and 1880s, when Baudelaire was acceptable to a much wider public than in 1857 (the date *Les Fleurs du Mal* first appeared), the contributors to *La Vie Parisienne* could switch from a presentation of female artifice as a kind of super-sensuous and super-seductive reality, to the true, inner reality which it concealed: one which was sordid and repulsive.

In his *Peintre de la Vie Moderne*, Baudelaire proposed a "rational and historic theory of Beauty, in opposition to the theory of the unique and absolute beauty." *"Toutes les modes sont charmantes"*–even the grotesque, in which the poet saw a kind of ideal ugliness. The ideal, always the aim of art, was simply redefined according to the needs of each age: "Fashion should therefore be regarded as a symptom of the taste for the ideal . . . as a sublime deformation of nature, or rather as a permanent, successive attempt at reforming nature." The poet's own feminine ideal is wilfully corrupt, sinuous in shape and bestial in her movements, fascinating rather than beautiful in the classical, plastic sense.[36] Verbally, the conception of her is akin to the poet's own pictorial versions of ca. 1857-ca.1863.[37] The latter in turn are close in form and spirit to the highly artificial and corrupt ideal to be developed in the pages of *La Vie Parisienne*.

The poet's correspondence for the years 1862-65 reveals that he was negotiating for a regular spot in the new magazine, but he succeeded in placing only two pieces, a prose-poem and an article on cosmetics.[38] Baudelaire's poetic *devise, "luxe, calme et volupté,"* might have stood at the masthead of *La Vie Parisienne*, which also seems in so many ways to meet the poet's demand for *"peinture de la vie moderne."* Constantin Guys, Baudelaire's choice as the artist who most nearly fulfills the role, never (as far as is ascertainable) contributed to *La Vie Parisienne*, and it is paradoxical indeed that Guys, a much overrated artist who owes his fame principally to Baudelaire, should be so much better known than such *Vie Parisienne* illustrators as Hadol, Marcelin, Roby, Sahib and Montaut, all of whom offer a richer panorama of Parisian life. It is unlikely however that Baudelaire could have appealed to the mass of the journal's readership. He might have counted himself fortunate to have his article on cosmetics printed at all. *La Vie Parisienne* joined in the general abuse hurled at the women who by brazenly painting their faces, indulged in a "filthy barbarity."[39] Not so Baudelaire: for him, it was make-up which rendered woman mysteriously passionate, superior to nature, divine. His eulogy of *maquillage* represents, by extension, a unique theoretical defence of all "unnatural" practices of fashion which were so heavily under fire in the press at this time.

6. La Vie Parisienne

The early caricature journals had paid scant attention to fashion chroni-

cle, apart from sporadic satires on particularly outrageous styles. It was Marcelin in the later 1850s who introduced to *Le Journal Amusant* a new kind of non-satirical, but fanciful and often theatrical fashion illustration, together with a more or less regular and practical fashion commentary, which he signed Madame la Vicomtesse de Marcelinville.[40] The various attempts made in the nineteenth century to launch magazines concerned with fashion as an art-form, in a matrix of literary and social criticism, were rarely successful for long, despite the collaboration and/or editorship of such outstanding talents as Gavarni *(La Mode,* 1830; *Journal des Gens du Monde,* 1833-34) and Mallarmé *(La Dernière Mode,* 1874); only the *Vie Parisienne* offshoot, Montaut's *L'Art et* (or *de) La Mode* (1880ff) was able to hold out. Gavarni, and to a lesser extent Henri Monnier did however establish that connection between fashion-illustration, theatrical costume design and social satire, all of which were to become synthesized in, and the essential dynamic of *La Vie Parisienne.*

The impulse received from the preceding generation was not that of any artist or group of artists but that of a novelist of towering reputation, one who counted most of the leading caricaturists of the age among his friends, collaborators and protégés: Honoré de Balzac. It is entirely in the spirit of Balzac that *La Vie Parisienne* attempted to codify, in terms both literary and pictorial, the true *physiologie de la toilette.* Poetic nuances may have been derived from Baudelaire, and, later, a certain pitiless physical realism perhaps from Zola;[41] but the basic purpose is still that of Balzac. It would be absurd to pretend that *La Vie Parisienne* presents a *"comédie humaine"* on the scale of Balzac's, but it does offer a unique *"comédie socio-érotique féminine,"* and a repository of graphic *"physiologie de la femme du monde"* unparalleled in its age. *La Vie Parisienne* attacks the subject of woman with something of the scientific optimism of Balzac, who believed that artistic analysis led to moral knowledge, and thence to social improvement.

Clothes were an art, and interpretation of this art in its relation to the sister arts[42] and all the other social phenomena represented a severe intellectual challenge–especially so far as women were concerned. *La Vie Parisienne* was written by men for women and for the male *"gourmet de la femme."*[43] Woman represents the illusive, the ephemeral; she is the mirror (if not the agent) of the perpetual transformation of society; by constantly changing clothes[44] and style of clothes, she expresses the evanescence of social habit and the capriciousness of human nature. To seize this evanescence on the wing, to pierce the deceptions of the social mask, to uncover the grim reality within the glittering erotic shell, was the task of caricaturist, fashion analyst and social critic, united, often in one man, in the pages of *La Vie Parisienne.* *"La toilette est la préface de la femme, quelquefois le livre tout entier"*; *"la toilette est à la femme ce que l'expression est à la physionomie"* (VP, 1886, 54, and '74, 110): these are sentiments voiced by Balzac time and again in his novels, where elaborate descriptions of the clothing worn by beautiful young women are offset by a notable lack of precision when dealing with their facial expression and physiognomic type. The faces of Montaut's females are

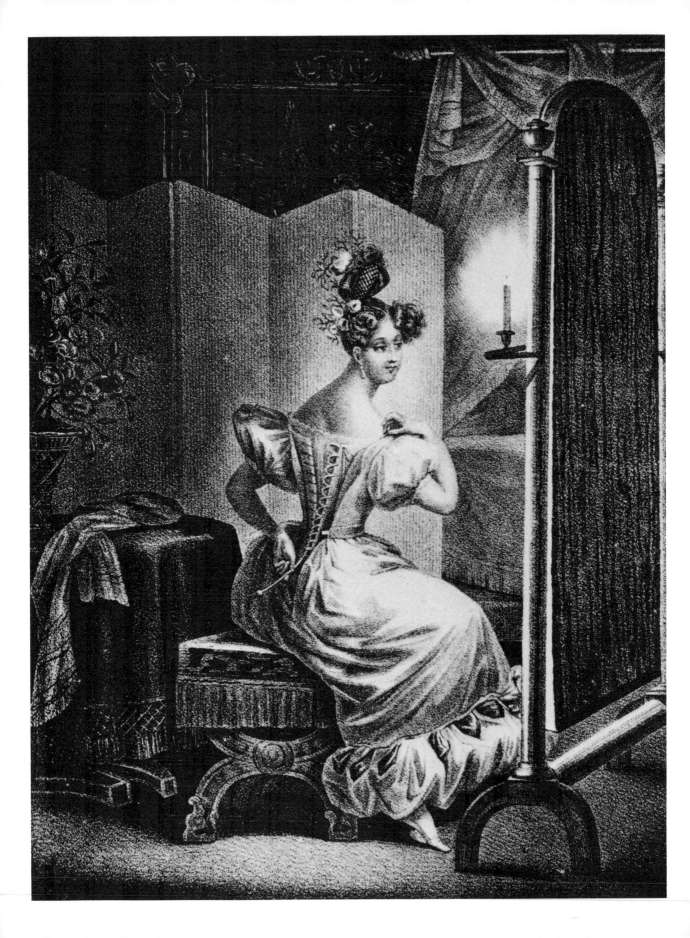

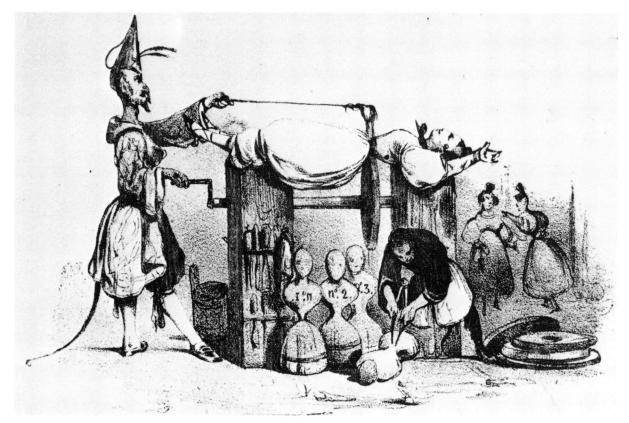

Le Poitevin: *The Devil's Grind-stone,* from the *Diableries,* 1830s.

as conspicuously blank as their bodies and their clothes are expressive.

La Vie Parisienne has been characterized only superficially and inadequately by historians of the press: "Never did a journal deserve so well its title and subtitles: *Moeurs élégantes, Choses du jour, Fantaisies, Voyages, Théâtres, Musique, Beaux-Arts, Sport, Modes* . . .It was the very image of a carefree world where only brilliant, worldly and amorous distractions and amusements seem to count . . . a frolicsome world which evolves gracefully without ever entering deeply into any subject; an amused smile reigns . . . a universe composed of dandies, salon officers and elegant women of the world, and bourgeois swells."[45] This judgment is incomplete, for beneath the frivolous surface there lay hidden a seriousness which is due to the collaboration of some eminent men of letters, headed by the philosopher Hippolyte Taine, the principal editor who wrote under the pseudonym of Frederick Thomas Graindorge, and was still contributing in the 1870s. During the later '60s Champfleury was a regular contributor, and such literary eminences as Henri Monnier, the Goncourts, Arsène Houssaye and Théophile Gautier sent in pieces from time to time.

The preface to the first volume gives a kind of manifesto: "an amusing and truthful depiction of the contemporary mores; notes and sketches done from the life; in a bold form, with the utmost honesty, human nature in the raw." *"Peinture crue":* the literary level of the 1860s may not have been maintained (it is not known who wrote the articles in the later decades), but with Montaut the graphic realism increased. After the death of the founder-director Marcelin in 1887, the quality declined all round. In the '70s and '80s, while appearing on the surface to be

Patented Method of Instant Unlacing, anonymous advertisement, 1830s.

bent on recreating Second Empire luxury and frivolity, *La Vie Parisienne* subtly recognizes that this luxury has become tarnished, a thin veneer for a social corruption which the revolution of 1870-71 exposed but did not eliminate.

"La Mode" appears last in the list of sub-titles, but was the most seriously treated of all subjects. *La Vie Parisienne* differed from all other fashion magazines in that it eschewed the formal fashion engraving, and showed fashions as worn in their social context–at the races, in the ballroom, in the foyer of the Opéra, in the boudoir. Unlike the regular fashion magazine (and there was a tremendous proliferation of them during the last third of the century), *La Vie Parisienne* does not attempt to chronicle, week by week, simply what is being worn and what is new. Unlike the regular caricature magazine, of which there was also a tremendous proliferation over the last third of the century, *La Vie Parisienne* is not content to deliver the occasional *charge* upon some peculiar fashion of the day. Writers and illustrators alike attempt to walk a thin line between the satirical and the documentary, the absurd and the imaginative, the ridiculous and the provocative. Comment is oblique and creative; criticism and prescription are based not only upon what is good taste and what is not, but also on what is curious, exotic–and erotic.

Like Gavarni and Monnier before them, Marcelin and Montaut specialized in the design of theatrical and fancy-dress costumes; but their blend of inspiration, laced as it was with the super-erotic and bizarre, remains unique. It is doubtful whether a single one of the innumerable *bal-masqué* designs created by Marcelin and Montaut could have been readily translated into reality, unlike those of Grévin, which were sold in portfolios for couturières and grisettes to work from, and used by professional theatrical costumers. Two years after Marcelin's death in December 1887, regular signed fashion commentaries began to appear under such headings as *"La Mode"* or *"Modes du Jour."* They are pedestrian and banal, and signal the end of *La Vie Parisienne* as supreme interpreter of the erotic psychology of fashion.

7. Henri de Montaut and the Centerspread

The *clou* of the magazine and an innovation at the time was the illustrated centerspread carried through the gutter, to which the reader usually turned first. During the early years the centerspreads consisted of vignettes on such topics as the Opéra (dancers in the wings, audience in the foyer), balls, dinners, concerts, the military and the races. During the '70s they emphasized social occasions which provided for displays of bizarre or fancy-dress, especially on the beach and on the floor of public dance halls. In the '80s we enter the boudoir, the arena of semi-dress and undress. In the '90s, nudity or near-nudity becomes more common. The whole nineteenth-century period thus reveals a major shift of graphic interest from ballroom to boudoir and from social dress, via déshabillé, to the naked body. The peak of psychological and fetishist interest lies in the central years, 1873-82, which are those when the

illustrations of Henri de Montaut were most dominant (cf. Appendix).

Starting in the issue of December 18,1880, and continuing at more or less monthly intervals through to June 11 of the following year, Montaut runs systematically through the gamut of feminine underclothes in a series called *"Etudes sur la Toilette,"* which comprises, in turn, the chemise; the corset; *pantalons,* stockings and shoes; décolletages; stockings ("and how to use them"); *"Dessus et Dessous";* and *postiches* (bustles and bust-improvers).[46] *"Dessus et Dessous"* is a review of feminine artifice, a summation contrasting reality and appearance. Such was the demand for this collection that a special edition consisting of 100 drawings was printed on de-luxe paper and sold in a satiné box for five francs. By 1892 this was in its nineteenth edition. Its extraordinary success[47] (no other drawings from the magazine were sold in collectors' editions) inspired Montaut to launch his *"Etudes sur la Toilette–Nouvelle Série,"* which started on October 22, 1881 with *Les Bains* (in which, for the first time, and encouraged no doubt by the recent relaxation of the censorship laws, Montaut reveals the nipple). This second series stalled, however, probably because Montaut feared to repeat himself, and was only taken up again almost a year later, September 9, 1882, with a new angle on corsets, followed by a centerspread on perfumes (p. 622). Once again the project was shelved, to be patched together ex post facto in 1884, after Montaut had left the magazine, when advertisements began to appear for *"Les Femmes d'Aujourd'hui: Nouvelles Etudes sur la Toilette."* This comprises twelve centerspreads, culled apparently somewhat at random and with no systematic connection, on corsets, perfumes, hands, flowers, fans, Dianas, fencers, bathers, *Intimités* i.e., *"toilettes d'intérieur offensives et défensives"* (1883, 308), hippic beauties, international titbits and postiches. Some of these were not by Montaut, who published his last drawings in January 1883.

During 1880-81, then, Montaut gives a kind of overview of underwear fetishism, such as he had presented only spasmodically during the preceding decade. The timing of this exceptionally provocative series must be related to the relaxation of the censorship laws in July 1881, which the artist appears to have anticipated, possibly to his cost (cf. Appendix). But more important, Montaut reflects a new consciousness of the subject of underwear among his readers, and the fact that the fashion industry during the '70s had turned its attention in this direction. Having been always regarded as essentially invisible and utilitarian, corsets, lingerie, etc. became fashion-objects, an artistic cult in their own right.

Montaut's extremely fussy, frilly drawing style, with its limp lines and powdery shading, exudes a shimmering insubstantiality worthy, in a way, of the Age of Impressionism within which his work falls; and it is a style well adapted to convey the delicate workmanship and ornamentation of the new underwear. It did not survive him, for a new manner, with firmer lines and more heavily contrasted shading, ushered in by Sahib from 1882 and then firmly established by Gerbault and Vallet, is characteristic of the '90s. By this time a new team of illustrators had

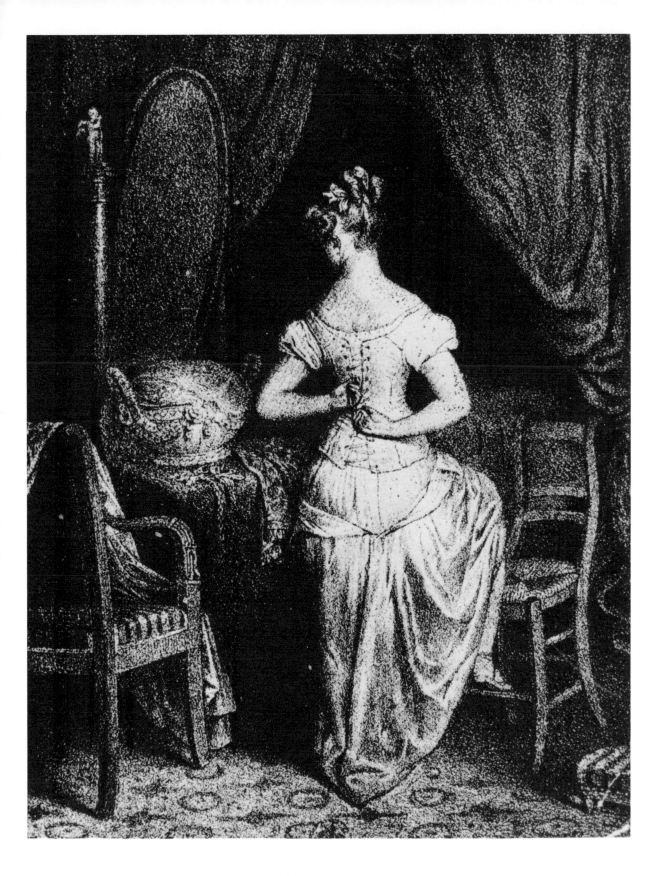

taken over who were prepared to abandon the obsessive detail of the previous generation in favor of Art Nouveau simplifications. It is not only the fetishistic intensity but also the scientific spirit of the physiologie which disappears at the fin-de-siècle, and an attempt in 1896 to launch a series of *"Nouvelles Etudes sur le Corps de la Femme"* foundered almost immediately.

The underlying intention of Montaut's underwear and toilette centerspreads may be divined from the wider context of centerspreads not concerned exclusively or ostensibly with clothing, but rather with body-movement. The artist tried to illustrate what Balzac had termed "the cut of a woman's walk."

Montaut's *"A Trouville–Comment ces Dames entrent dans l'eau"* (1873,504) is a study of characteristic attitudes adopted by women conscious of their physical advantages and disadvantages; *"Eaux Sérieuses"* ('76,486) examines behavior in a public shower according to the motivation for taking it, and the physical type; neither is merely a pretext for undress. "How they wake up" ('77,146) is a study of the various ways women stretch, yawn and climb out of bed, as much as of nightwear; it is also a study of the interrelationship between clothing and movement. A feature on croquet ('77,624) analyzes the expressive variety of the human body in twisting, bending and kneeling motions–a whole gamut of postures projected onto an identical situation, in which the erotic role of the hip contour or the décolletage may be a vitalizing factor, but not the sole raison d'être. *La Vie Parisienne* illustrates the Balzacian-Baudelairean system of "correspondances," those mysterious but objective formal relationships between man and every artifact with which he surrounds himself, from the clothes he wears to the furniture he chooses, from the shape of his moustache to the style of his carriage. A handbag or a pet bird, a fan or a bed, perfume or letterhead express not only a woman's artistic taste, but also her physical and moral character. "Like man, like dog" had long been a stand-by of cartoonists, but a history of caricature would do well to single out Henri de Montaut as the artist who pioneered this form of social analysis on a wider basis. He plays the caricaturist's favorite game in a new and profounder way, for he is not content to show *how*, but asks *why* a certain type of woman can be likened to a certain type of bird ('77, 696 and '80, 250) or horse ('81, 428 and 666) etc., and vice-versa. Nor does he limit his system of comparisons to living creatures. One of his most ambitious and in a way curious efforts is called *"Les Nouvelles Toilettes en Étoffe à meuble, ou les Femmes-Fauteuils,"* a tour-de-force which relates female physique and physical behavior patterns to toilette and simultaneously to the preferred types of chair. (It is also possible that Montaut intended to convey in veiled form a sexual idea, by which the reader identifies with the chair and the sensations of being sat upon in various positions.)

The increasing nudity in the drawings of the 1880s is accompanied by a more explicitly sexual tone in the magazine as a whole, and both reflect the growth of cultural permissiveness following the relaxation of censorship in 1881. Openly sexualized, woman becomes less idealized

Vallou de Villeneuve: *The Corset,* lithograph, ca. 1829.

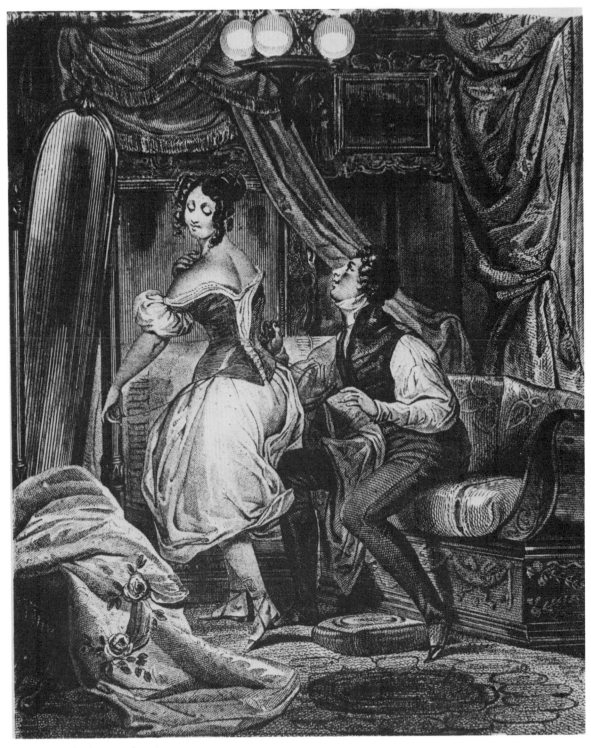

The Lover as Lady's-maid,
anonymous lithograph, ca. 1830.

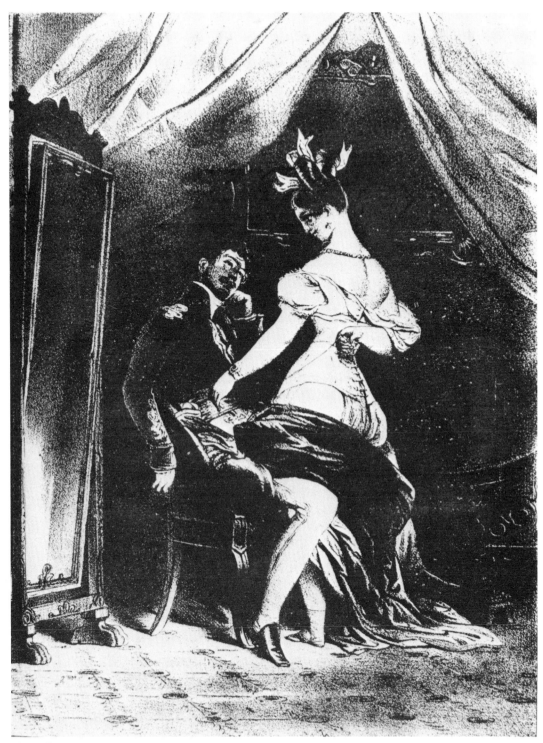

Numa Bassaget:
Honeymoon, 1831.

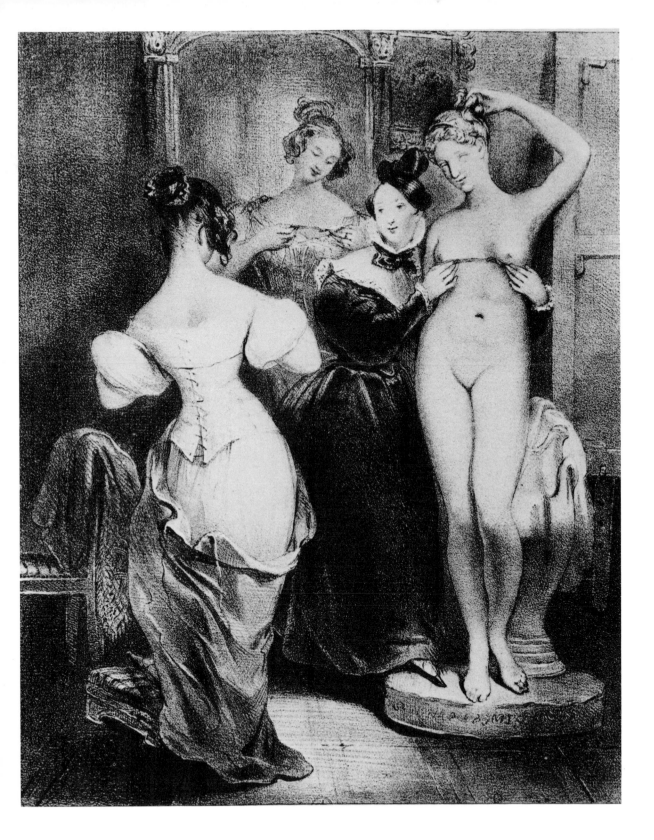

and more and more a subject of moral and esthetic disillusionment. The signal was given by the notorious "How They Eat Asparagus" (1879, 330), which is said to have caused trouble with the censors.[48] "How They Eat Grapes" (1886, 598) is no less filled with sexual overtones, even if the fruit itself is less obviously phallic. With the advent of the bicycle mania, it is "How They Inflate Their Tires" (1897).

8. Corset idealized: The World of Mme. Billard

No effort is made to hide the fact that much fashion comment in the magazine is closely bound up with commercial interests. The three regular fashion features all have a strong commercial "where to buy it" bias: *"Choses et Autres"* is a discursive miscellany of practical information, *"Modes du Jour"* and *"Petite Chronique"* mix observation of what people are doing and wearing with publicity for certain clothing firms. Such advertisements are often heavily editorialized, tend to vary in form and try to give the impression of having been written in bursts of personal enthusiasm by an editor or regular contributor. These "puffs" (as they are best designated–the French called them *"réclame racontée"*) are, like everything else in the journal, the work of men. Most fashion and women's magazines of the time credited the fashion chronicle to female names, but *La Vie Parisienne* leaves no doubt that recommendations even (or especially) on the more intimate aspects of female clothing are made by men on behalf of the women readers, and on behalf of other men who might assume a creative and critical role in their wives and mistresses' toilette. *"Si j'étais femme, j'irais tout-de-suite chez Madame . . ."*

The corsetry puffs are by far the most imaginative, the footwear puffs come a poor second and lingerie an even poorer third. The corsetry puffs are particularly revealing of the personal relationship which some staff member enjoyed with the trade or, rather, with one particular firm. Making their first appearances rather before Montaut's first graphic corset physiologies were published, these puffs set the verbal background to them. The marriage between *La Vie Parisienne* and the corset trade was a strictly monogamous affair. After two years of comparatively prosaic homage to Mesdames de Vertus, from 1865 to ca. 1882 the weekly or bi-monthly puffs were monopolized by Madame Billard.[49] Over the last two decades of the century, Madame Billard cedes her place of honor to corsets Léoty (Ernest Léoty, son of the founder, is the author of the first historical monograph in French on corsets and owned a fine collection of period garments).

During her heyday, which coincides with that of the magazine as a fashion-fetishist organ, there was no poetic extravagance too outré to express the quality of her corsetry. Unlike the other puff-advertisements, which are more prosaic, vary little in form and show every sign of having been paid pro rata, Mme. Billard's are at one with the fanciful editorial spirit of the magazine. Her copywriter must have been an habitual visitor to her shop, and conversed at length with her and her clients. He was permitted to examine special orders before they were delivered, and

Octave Tassaert: *Exactly the Proportions of Venus*, ca. 1830.

Madame n'est pas jolie, mais elle est toute mignonne... le matin.

Elle ne manque pas de tournure... crinoline.

Ses dents sont des perles enchâssées par William Rogers.

Elle a un teint de roses.

Et des cheveux abondants.

Aussi fait-elle beaucoup d'effet, le soir, dans un salon.

may even have made suggestions for improvements. The frequent articles in dialogue form under such titles as *"Chez la Couturière"* and *"Chez la Corsetière,"* although not ostensibly connected with Madame Billard, are redolent of connections with the trade, and are rich in trade-jargon as well as precious bits of social gossip. A maternity corset was a clear give-away of an Event which might not be publicly announced until much later (it was in blue, not pink satin, so Madame wanted a boy). A trivial detail became matter for scandalous speculation: why was the blue corset of the Princesse de M. returned to her corsetière with a white instead of a blue lace? Was it just the clumsiness of a new caomériste which broke the original one ('63,379)? *La Vie Parisienne* was privy to all sorts of indiscretions. There was the Russian princess who, in fits of rage, threw corsets at the head of her corsetière if they did not fit; and the Parisian aristocrat of fantastic extravagance who wore out a dozen corsets in a month, because she wanted them too light in construction for the tightness to which she laced them.

Was Madame Billard's copywriter a relative, or a business-associate? Perhaps. Whether he stood to gain financially or not, he reveals himself as committed as ever Baudelaire or Mallarmé to his mistress' hair, to the corset as love, as art, as philosophy. At one time he might possibly be identified with Emile de Villars, who contributed many of the early semi-fetishistic texts; at another with X., who writes on corset-lore during the middle period; later on, he may even have been Montaut himself.

The "world of the Billard corset" which follows, is a mosaic, each piece of which derives from thirty to forty different paragraphs rarely exceeding a half-dozen lines, spread over the whole period of her reign. The permutations seem to have been inexhaustible.

"The Parisian corset is a world, a composition, a work of art, a strategic plan." It is also the key to the understanding of society. It is by the corset that a girl becomes a woman, it is the change in corset which marks the stages of her initiation into social life. By changing her corset, a woman undergoes a necessary change of identity.[50] If the corset marks the passing of the years in a woman's life it also marks the passing of the hours in the typical day of the mondaine: from the *brassière d'ablutions,* made of net and lined with surah for the shower, to the lightly boned morning corset worn from 10 A.M. to 1 P.M.; from the true, afternoon corset, two inches smaller in the waist, to the ultimate persuasions of the satin evening corset, in which Madame finds she has "melted" four inches since rising.

The wedding trousseau of a society lady comprised at least a dozen corsets. At the most decisive moment in her life, the nuptial night, the corset played an essential part in the erotic preliminaries: "Trembling, content, your husband unlaces you with an ill-assured and clumsy hand, and you mischievously laugh at him, joyously noting that his confusion is caused by the sight of your beauty. You are happy to feel your omnipotence: you take good care not to help him undo the knots or to find his way about the lace-holes; on the contrary, you enjoy the feel of his groping fingers, which tickle you deliciously . . ." (1884,271). Balzac's

Lefils: *An Artificial . . .and Artful Beauty, Le Journal Pour Rire,* April 9, 1852. "Madame isn't pretty but very dainty . . .in the morning. /Her bust is full . . .of padding. / Her teeth are pearls . . .set by William Rogers./She has a rose-tinted complexion / and abundant hair. / Thus she causes quite a sensation in the evening, in a drawing-room."

Plate 14 of Daumier's
Les Baigneuses, 1847 (Delteil
1642). "She looks fine now, but
wait till you see her come out."

Valérie Marneffe good-humouredly and coquettishly mocks her lover, Count Steinbock, for his slowness and clumsiness in lacing her up; and it is at this critical moment, as if caught in the very act of love, that they are surprised by the rival Baron Montes, who thereupon determines to murder her.[51] It is perhaps surprising that Montaut does not exploit graphically the erotic associations of lacing and unlacing. Possibly, the theme was simply considered banal since its heyday in the Romantic lithographs of a generation earlier.

"Blind is the man who does not see that the form of the corset explains the pattern of social custom" ('68,744). In an age when there was a *physiologie* written on everything, a physiology of the corset was lacking. But who will write such a *"chapitre croustillant"*? The corset is a religion, a mystery, with secrets, inner depths and memories. Through it, chaos is harmonized. One may admire its effects, without attempting to divine its causes, which are unfathomable; it is a charming Sphinx upon which even Oedipus would have wasted his Greek, and the arcane mischief of whose intentions defy the most inquisitorial examination.

God created woman, and Mme. Billard created the corset to perfect her. The corset is an instrument of salvation, and has the eternal value of a religion impervious to heresy (i.e., dress reformers). "One may destroy a religion, overturn a government, the corset is inviolable . . . Hail, o corset! Thou art blessed by all women . . . thy kingdom has come . . . may thy glory never cease to grow, and thy name be glorified over all the earth for ever and ever, Amen!" ('86,127).

The corset is art, the corsetière the artist. The corset is the sonnet of the toilet, light in form, deliciously cadenced. Mme. Billard is the grammarian who spots between the shoulders a syntactical error. She will correct the solecisms and orthography of breast and shoulders, and suppress where necessary question and exclamation marks. Like the genial satirist, Mme. Billard *"castigat ridendo mores."* She is the teacher with no other will than that of the pupil; she is more, she is the discreet confessor who guesses more than he questions, is embarrassed at nothing, and always comforting. The corsetière is the *Deus ex Machina* of plastic beauty.

With the flexible whalebone as her perfectly obedient tool, she carves and chisels the marble, or moulds and kneads the clay of the bust, which thus becomes like Galatea, animated sculpture, with voids and volumes perfectly harmonized. Such sculpture is worthy of the Parthenon and would have been admired by Phidias and Praxiteles; or (in contemporary terms) Pradier[52] and Clésinger. The sculptor Millet said to a client of Mme. Billard: This is my marble, into which life has been blown ('82,700). A great foreign princess of our times thought that Billard corsets had to be ordered from Athens direct, because they were evidently modeled by an antique sculptor; letter after letter to Athens failed to arrive, until finally one reached the proper quarter, under the address "Madame Billard, Greek sculptress, Paris."

By the corset primitive form is civilized, the fruit is grafted into perfection, the eglantine is transformed into the rose. The gentle sheath of

a Billard corset is to a woman as the alveolus to the flower. "The shoulders emerge gracious and perfumed from the satin alveolus, like a rose from the calyx at the moment when the budding dawn spreads over the countryside its diamond-studded casket" (sic–the corset is also a precious casket containing precious jewels). The corset forms a luxurious, mossy nest, softly cradling the bosom, the waist becomes as slender as that of the willow, aerial spirit, Castilian dancer or dragon-fly (never wasp); it sways in the breeze like a reed.

The body becomes a smiling landscape, composed of charming slopes and gracious valleys. Mme Billard is a "*paysagiste*"; "by means of undulations of the ground she relieves the monotony of a desert plain; by judicious smoothing out, she improves terrain compromised by exuberances too rich. To align the hill-tops, fill in the valleys, separate the little knolls by creating gulleys, to prevent landslides, etc.–this is child's play to the skilled corsetière . . .As she graduates the slopes, she permits no crags, no sudden dips, no saber strokes to remain."

To contemplate this landscape is a voyage of discovery. "I shall certainly not organize a scientific–or rather, artistic expedition around corset-country. And yet, what a world in miniature, what an enchanted land to explore; how you would sigh as you disembark, at the prospect of such fabulous excursions! Tourists returning from Billard country describe the geography of the corset: constant beauty, with diversity . . ." ('74,477). "And yet there are so-called explorers, armchair Livingstones (dress-reformers) who leave us accounts of travel around a world they have not even seen, each copying the other!" ('82,700)

Mme. Billard's eulogist brushes the objections of the medical fraternity easily aside, as so much fuss about a thing of the past. Not content with admitting the errors of the past, he glories hyperbolically in the tortures they inflicted. The wasp-waist of the Romantic era is gone, as the last vestige of medieval barbarity. "How women of previous generations are to be pitied, enclosed in their brutal corset like ancient knights in their rough steel cuirasse armour ('70,374)." This straitjacket, this géhenne, as bad as any inflicted upon criminals, this *carcere duro* which puts the epigastrium to the torture and leads to consumption, was invented by medieval prudery, by Anne de Bretagne, and not even abolished under Louis XVI, who prohibited many other forms of torture.

Mme. Billard has performed the Revolution of 1789 by liberating woman from this Bastille. Jeanne d'Arc took the (male) cuirasse in order to be rid of the female one; Achilles threw off women's clothes because male armor was easier to wear. "Examining the other day a corset of the old school, I trembled as if I were confronted with an ancient instrument of torture. The brutal busk must have caused an agony equal to that of the question, when the executioner cracked the bones and lacerated the flesh of the victim" ('74,102).

As they humorously dramatize their case, the puffs distort and reverse the historical perspective. The corset of the '60s, the "*Ceinture Régente*" (a name patented by the Vertus Sisters–"not a tutor but a friend who

offers his arm"), had been a shorter, lighter affair designed for the high Empire waist which returned momentarily to fashion. The contemporary corset was a much more solid object, more reminiscent of eighteenth-century "tortures" than the stays characteristic of the Romantic period.

9. Corset-cuirasse

During the crinoline era and the later 1860s the fetishistic emphasis in *La Vie Parisienne* was decidedly on the feet. By the mid-'70s it moved with even greater decisiveness to the corset, this time in a new and powerful form known as the *"corset-cuirasse."* It became necessary to defend this article against accusations of resemblance to "medieval" and "Romantic" instruments of sartorial torture, especially since its effects were exhibited as never before. As the skirt shrank, the waist lengthened, and for the first time in living memory–arguably in Western history–the natural hip-contour was clearly and systematically defined and exposed. New techniques in cutting and seaming ensured absolute precision of fit, and the new anatomically compressed outline was heightened by the use of artificial dyes and glaring color contrasts, with excessively complicated ornamentation on the swaths wound tightly around the legs. Having touted the corsetière as sculptor, *La Vie Parisienne* was able to hail the emergence of the *Femme Statue:* "After 12 years of struggle against bad taste, we have at last attained the supreme goal–the statue woman of serpentine slenderness, molded in her dress like warriors in their cuirasse . . .sculpted in an armor revealing a hip contour which, they say, cost our ancestor Paradise." The constriction and immobilization is accompanied by expansion: "under the tight gussets, the breast swells, opens out . . .aloft! For some, it is like a stall-ledge *(éventaire)*. Women push and press into their kidskin sheath as if it were a pair of gloves. The legs are clasped the full length, the skirt is tight, woman is impeded in her movements, one can feel the ribbon fettering all from behind . . .Knees touch, visibly . . .woman sits down sideways, she cannot do otherwise and this uncomfortable attitude is not ungracious . . .Beneath this sheath, undulations must be soft and slow, almost imperceptible . . .Now, one can see the whole body breathing; previously the eyes judged the movements of the heart by the breasts alone." For the first time in hundreds of years the form of the belly was exposed to such a degree that it registered small respiratory movements. X. observes that the chemise is being abandoned to reduce bulk (shaped undergarments were being developed with the same end in view). One writer ends on the curious insight that, immobilized, "woman is obliged to observe herself" (1875,152). The wasp-waist (the term had long been taboo) is brought back triumphantly by the cuirasse and "pushed to its extremest limit," up to the point where "everything is forced upwards, so as to form as it were an avalanche over an abyss" ('75,152; '77,96 and 333).

Sculptured and armored: the fact that the very dress was corset-boned and often laced as well for stretch fit, the fact that the inner armor

Baudelaire: *"Quaerens quem devoret"* ("seeking whom she may devour"), drawing of the poet's mistress, Jeanne Duval; ca. 1858.

LE CRAPAUD CAPITONNÉ. — Une petite boulotte est absolument exigée, ladite boulotte toute en peluche bronze, capitonnée par un treillis de cordonnet de soie gris argent ; le long des manches une rangée de petits glands. Meuble absolument confortable, pour un repos complet ; je suis convaincu qu'une fois là on doit avoir bien de la peine à se lever.

was now worn outside as well, provoked comparisons with the medieval knight, actual exhibitions of whose accoutrements, such as that on the Champs Elysées in November 1874, were duly commented and illustrated. It was about this time that Jeanne d'Arc became a popular operetta heroine, complete with "lemon-squeezer" steel breastpieces and steel cuirasse. The armor which had failed to prevent defeat of the French cuirassier by the Prussians, was now given to the French *cuirassière*, ever victorious in the arena of fashion. In a humorous dialogue *"entre cuirassières"* one of the speakers criticizes the "costume-machine," all the "armor-plating and padding which might make people think that she had weak points" (or sides, pun on *côtés*; '74,713). Woman is likened to the warrior who after leaving the field of battle, retires to her tent to take off her salon armor, and put on her peignoir and corset-brassière. By 1878 she is felt to be tired of being perpetually "under arms." X., a regular corsetophile contributor at this time, asserts that the super-clinging (*"extra-collant"*) cuirasse dress is positively disliked by men, who become instantly jealous of the attention it arouses. The notion of woman about to burst, like some soft-bellied crustacean out of its rigid shell, is taken up in a passage of transparent insincerity: "Some woman tight-lace to a point of deformity. Truly elegant shoulders and hips can never be united by so narrow a hyphen. . .an ugly and crazy fashion. . .there is another inconvenience . . .an irresistible desire–to undress" (77,333).

From the very outset, the cuirasse bodice had met a barrage of criticism from the fashion magazines and elsewhere. While "fortified nudity" was particularly appealing to the artists of *La Vie Parisienne*, by 1877 (p. 78) when the novelty was beginning to wear thin, Henri de Montaut had fallen in with the opposition line which he garnished with a characteristic sado-masochistic relish. He claims that many cuirasses are little better than orthopedic appliances, and actually make some women look fatter. It is surely very disagreeable, he says, for even the best gloved hand of the male dancer to feel all those busks and steels "pressing into the hand and ploughing up the flesh, sometimes leaving bloody traces." Having enthusiastically illustrated the *"femme cuirassée,"* Montaut indulged in cautionary fantasies, such as the longish story entitled *"Se Faire Belle ou Mourir,"* in which a politician's wife gets herself newly outfitted from top to toe for a special state occasion–which she misses, having fainted away even before leaving her home ('79,150-52). Elsewhere,[53] Montaut ran an article which accuses women of neglecting social duties as soon as they threaten to involve the climbing of stairs: " She manages the first floor, groans at the second, emits her death-rattle at the third and expires at the fourth."

A certain "highly placed Parisienne" has become notorious for her Janus-like character; all charm and affability at home, when she leaves off her cuirasse; all arrogance abroad, when she dons it. This was the period when women spent ten hours of the day (and ten meters of lace) gradually lacing down to the exigencies of the evening; a daytime fitting for an evening dress required hours with the couturière, who would advise Madame to take it slowly: *"on s'étrangle petit à petit"* ('77,91).

Henri de Montaut: *New Toilettes in Upholstery Material,* detail, *La Vie Parisienne*, 1878, p. 712.

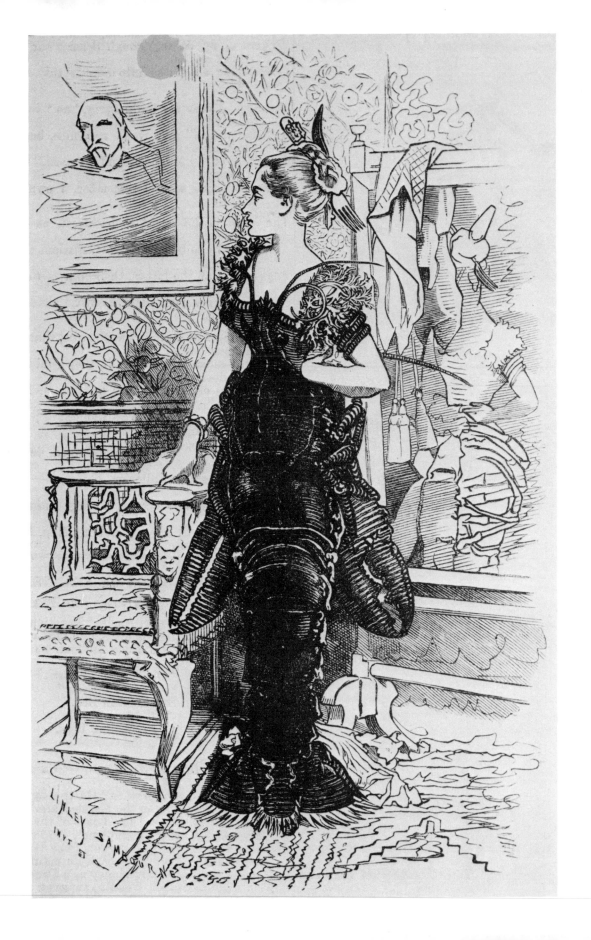

Around 1880 the externally boned cuirasse bodice gave way to the form-fitting knitted jersey (which had also started as an undergarment), but there appears to have been no relaxation of tight-lacing. (The later paintings of Manet, who is unlikely to have falsified the silhouette of his models, show remarkably wasp-waisted figures [54]). In the commercial puffs, the fiction that fashionable woman was molded like a classical statue tends to lose ground. This was probably because the proponents of "rational" and "esthetic" dress, under the banner of classicism, were becoming more vociferous. Léoty puffs of 1880 raise the famous Baudelairean battle-cry: "*Qui nous délivrera des Grecs et Romains?*" which is based on the claim that classical austerity has nothing to do with the contemporary esthetic. If there were by this time generally acceptable esthetic arguments against the classicists, simple bravado and mockery were made to suffice against the much more serious attacks of the medical profession. The open admission that beauty is bought with physical torture is all the more remarkable in that it appears in a commercial context, which in all other magazines preserved the fiction of comfort and hygiene: "Despite the constraint of her whalebone prison, and her shoes which are a torture to her, woman is becoming ever more beautiful and perfect. The dream of young girls today is for the wasp-waist of the Louis-Philippe era; and to gain this ideal, there is no torment they would not suffer. Come what may! Doctors say tight-lacing is dangerous –the girls don't care!" The Léoty corset is presented as ideal for tight-lacing; it also *happens* to be hygienic, since Mme. Léoty is both divine sculptress and expert physiologist ('84, 85 and 113).

10. English tight-lacing

With the rapid changes of silhouette following the crinoline era, and particularly during the cuirasse and jersey ("pouter-pigeon," second bustle) periods of ca. 1874-1882, the corset had become exposed in an almost literal sense as a focus of visual interest. While the pages of *La Vie Parisienne* deliberately ignore the dress reformists and pay comparatively scant attention to the subject of tight-lacing, the controversial aura and extremist character corsetry had acquired must be considered a powerful external stimulus to Montaut's physiology of the subject. Opposition not merely to tight-lacing but to all forms of corsetry was mounting in the '70s, especially in England and the United States, both countries of whose cultural peculiarities France was becoming increasingly conscious. In the U.S., in 1874, Abba Gould Woolson published *Dress Reform* and launched the first serious organization aimed at combating the evils of contemporary fashion in its very structural elements. In England, years of efforts on the part of numerous medical and lay reformers, via lectures, seminars, articles and letters to the editor of newspapers, etc., culminated in the Rational Dress Society, founded by Viscountess Harberton in 1881. Meanwhile, after suffering in silence more than a century of continuous abuse, the tight-lacers themselves had found an outlet for their viewpoint, which they displayed in all

Linsley Sambourne: *Costume du Soir–Robe en Homard* (lobster-dress), *Punch*, March 11, 1876, page 90.

its nuances, from the studiously moderate to the brazenly extreme, in the pages of a vigorous but otherwise very proper middle-class journal for young ladies, the *Englishwoman's Domestic Magazine*. During the years 1867-74, the correspondence columns of this journal were filled with literally hundreds of letters from girls and young married women testifying to the beneficial effects of tight-lacing (on their health, appearance, morale, marriage, etc.); letters also came from young men openly confessing their admiration of the practice. What had been always regarded as murderous, suicidal and utterly depraved was now empirically "proven" by the practitioners themselves, pursuing their experiments with some pretence at scientific deliberation, to be actually good for you. The esthetic advantage enjoyed by the tight-lacer over her sister adhering to "rational," "natural" and "classical" norms, was forcefully and amusingly demonstrated in a series of comparative engravings published in a collected edition (the second of its kind) of the *Englishwoman's Domestic Magazine* correspondence.

La Vie Parisienne, suddenly attentive to England after the catastrophe of the Franco-Prussian war (which had caused it to suspend publication), was quick to recognize the superiority of English male, sporting and children's fashions, but poured unremitting scorn upon the taste of the English female and her entire lack of chic (a truly Parisian preserve), especially as regards the critical realm of accessories and underclothing. In 1874, the first year of the cuirasse bodice and cuirasse corset, *La Vie Parisienne* (477) printed a special feature on the corset in London, which turns out to be the very antithesis of the elegant and persuasive French article. "It is astonishing, improbable, explains all. It does not exist; it is a single piece of coarse padded canvas, without form, without purpose, without forethought and without malice. It is a child's brassière. Whoever analyzes as a moralist, as a thinker, the corset of an Englishwoman, will understand their entire philosophy of the toilette." There was a tradition in the indictment of the English corset: Théophile Gautier describes an English governess as "stiff as a stake, red as a lobster, and tied up in the longest of corsets, the mere sight of which was enough to put love to flight."[55] The English corset had already been calumnied in a page of *La Vie Parisienne* vignettes commemorating the corset section of the 1867 exhibition, in the company of similar esthetic disasters elsewhere.

La Vie Parisienne reader A.B. de C. sprang immediately and eloquently to the defence of the English corset and English figure (1874,507), on the basis of his experience of the 12-15,000-strong English colony at Boulogne-sur-Mer–and also, one should add, on the basis of his apparent familiarity with the *Englishwoman's Domestic Magazine* correspondence. The scientific training methods he describes are precisely those recommended in the pages of that journal. His long letter (appearing by special editorial privilege, for Marcelin did not normally print unsolicited correspondence) reiterates the "classic" English position in favor of tight-lacing. The equivalent position must have existed in France, since the practice existed, although probably not to the same degree; but it was

apparently not considered necessary or desirable to make it public.[56] During the '80s, when English masculinizing fashions for women threatened to invade France, *La Vie Parisienne*, and notably Sahib, mounted a solid campaign against them, dubbing them suitable only for the thin, flat, wooden figures of English women, whose miraculously small waists (exceptionally low measurements are given) are to be regarded in the light of an inherited ethnic defect, rather than the result of the rigorous figure-training described by 'A.B. de C. Montaut's mockery of tight-lacing, and the ambivalence of his attitude to corsetry, should be viewed against a background of medical-clerical-classicist opinion vociferously opposed to "fashionable excess" and a body of private opinion tacitly in favor.

11. Henri de Montaut's Social Physiology of the Corset

It is already evident that Montaut does not share the utopian vision of Madame Billard's idolaters. He is out to prick the fetishistic bubble, or (to improve the metaphor) to deflate, gradually, the balloon of illusions, just as women could literally deflate the rubber cushions of her curves. Montaut goes to work, cautiously, progressively and relentlessly. In his first postwar contribution, made in 1873 (120), he hints at what is to become a major preoccupation. Under the title *"Le Bain de Madame,"* massage and artifices of the toilette (but not corsets) are presented as the necessary ritual instruments in the cult of beauty, which involves a multitude of servants. In a feature published a few months later (152 titled *"Madame va au Bal"*), the ritual is that of a martyrdom both social and physical, for Madame remains kneeling throughout the long journey into the country in order not to crush her dress; and after the ball, she throws off her excruciatingly tight shoes and stays, returning home a "faded rose." This reverse of the medal is however a matter of inscription, not image (Montaut always wrote his own captions).

Throughout 1874-75 Montaut was developing toilettes for all times of day and for all occasions, fanciful but credible, imagined and seen. It was his prolonged 1876 visit to Trouville that first revealed to him the disparity between the luxury and elegance of such attire, and the drab homeliness of the bathing costume, between the two types of figure contained therein, between the social illusion and the sad reality. Here is the Before and After adumbrated by Daumier and others in mid-century, and juxtaposed by Montaut with alarming thoroughness and precision, and in a heightened form which fringes upon, without actually entering, the realm of the grotesque.

The border vignettes show a dishevelled Truth being hauled out of a (wishing?) well by a little devil, while putti labor in the forge of the Vulcan of artifice, hammering at the armor of Venus. A mustachioed male figure peering through binoculars (self-portrait of the artist?) is balanced in the other corner by the artificial Venus dangling a puppet, and surrounded with the trade-jargon of her cult. Six cards, which are displayed as if fanned in the hand of some sexual gambler, show basically

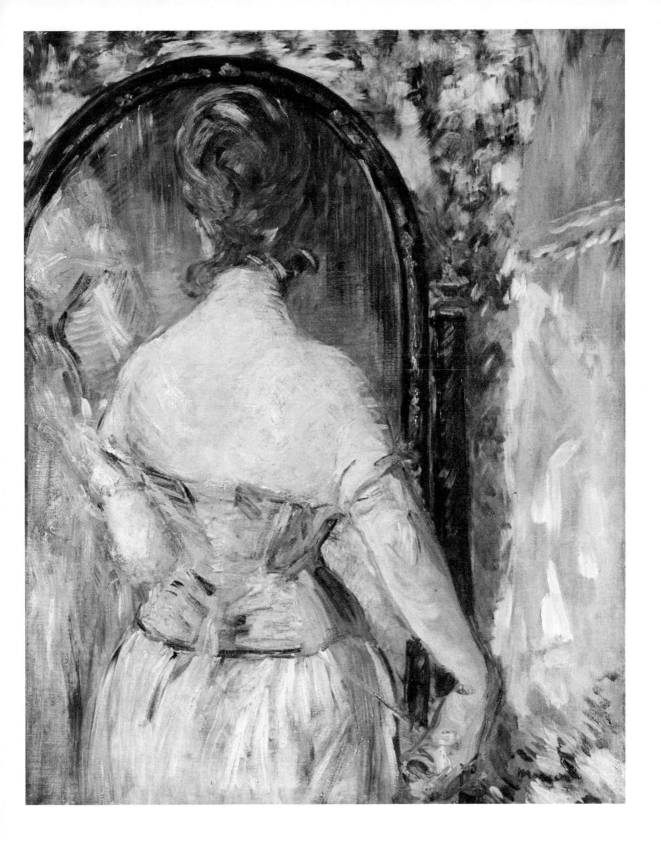

two, complementary and opposite kinds of transformation–from fat to slender, from thin to gracefully rounded. In the first category, a girl, gross-looking in her bathing-costume, manages by dint of half a day's training to confine herself within a fashionably slim, artfully armored Henri IV promenade dress; a second has managed to conceal on the hotel terrace the steatopyga she revealed at the water's edge, and a third (fourth from left) has created curves out of an amorphous mass.

In the second category, a curtain-rod (third from left) is stuffed out into shapeliness; the naturally "boat-footed", flat and droop-breasted woman (far right) proudly displays feet perched over an extreme-heeled shoe, and a well-placed, well-rounded bust; and (greatest miracle of all) the dwarfish, hunchbacked, knock-kneed goitrous monster burgeons into a wasp-waisted bird of paradise.

Shown close-up in roundels beneath, the faces undergo a similar transformation, from wan, pimpled and hollow-cheeked, by means of paint, powder *("prodige de la chimie")* and wadding, to artificial splendor.

Having shown the gold next to the base metal from which it was derived, Montaut enters the alchemist's boudoir to reveal the secrets of the process. The patron saints who preside over the miracle stand at its twin poles: Jeanne d'Arc, rigid and proud in the cuirasse she heroically donned for the glory of France *("corset Domrémy")*, and the Oriental dancer (Spanish-Moorish, or Indian Bayadère), whose lightly supported figure is all movement and flexibility. In between these opposing ideals, the Parisienne suffers various grades of martyrdom. In first place (her right as an historic archetype, by the dignity of her years, and by the literal gravity of her problem) is the gross matron, winched in English-style, massaged and compressed in six stages. Too late, alas, as it was too late for Maman Vauquer, or Mademoiselle Cormon.[57] The climax of this lady's suffering is mercifully hidden from view by her antitype, Nature's Favorite, whose corset serves to display her breasts, rather than to mortify her flesh; fortunate too the wearer of the "learned corset," which like Madame Billard's knows all the tricks, chisels the forms, ponders, enforces obedience without coercion, and creates animation everywhere.

Round the borders, we read off successively a range of corsets which include the young girl's mail-box, the boneless swath for nightwear, the defensive lock-smithery of the Middle Ages and the realistic corset (instant unlacing at the sides; according to the caption, implicitly for the adulteress). The central motif is more than motif–beside it (in scale, in significance) the others are so many lesser wings of a polyptych whose purpose is gradually to unfold, and reveal the Supreme Sacrifice of the Saint of fashion. For her, no suffering is too great, no waist too small. This is not the tight-lacing of the ancient or misshapen trying to recover youth or normality: this is the woman of fashion deliberately and recklessly deforming nature. A whole garland of putti hold on one end with the desperation born of true devotion; the entire household, from husband through maid, cook, valet to groom and pageboy, haul away at the other end. "Madame urges on the teams in the tug-of-war,

Edouard Manet: *Before the Mirror,* 1876, 36½ inches high. Justin K. Thannhauser Foundation, Guggenheim Museum, New York.

and wets the lace for supreme contraction. Her ribs cave in, her hips roll out in revolt, and her face turns purple. But she is happy. She will be able neither to sit nor bend nor laugh, but she will have the slenderest waist in the company: is there a price too high for such felicity?"

So much for the vulgar dynamics of corsetry, so much for its function as physical repressor. Next, in the course of his *"Etudes sur la Toilette,"* Montaut treats the corset as a means of socio-psychological expression. It is here that he demonstrates the extent of his familiarity with the jargon of the trade. As a social language, the corset is rich in nuances: 17 figures, all in different attitudes, all in different corsets, worn for different reasons. The polar figures stand once again in the corners: above, two corsets of historical inspiration, the one a light bust-supporter (Empire style), the other an instrument of torture, designed for tight-lacing, with contiguous boning à la Louis XV. Below, the little girl, endowed with "an unappreciated friend, whom she longs to leave for the true corset which will consecrate the maiden" and the Old Beau, who "in the past unlaced so many corsets, now laces one every morning –upon himself!" (like the vain Baron Hulot in Balzac's novel *Cousine Bette*).

In the "respectable" category, the most elegant is in white satin, the King of Corsets (left of word *Etudes*), "supple, *chatoyant,* soft to the body which it defines without excessive compression..." The least elegant in this category is the excessively *"honnète"* (second down far right), in white coutil, undecorated, unperfumed, unsuspendered,[58] and with an enormous, long, high, hard, penetrating busk. The most complex is the "true closet, into which there is always too much or too little to be put. Satin or silk cloth, white, occasionally pearl-grey; numerous busks which hide absences and disperse gatherings. A crafty corset which deceives no one, excepting when one is placed behind the wearer, and assumes that the figure thus crushed is in fact facing one." The final, exceedingly ungracious observation is rendered graphically with a delicate restraint; had Montaut been more satirist and less physiologist, he must with this idea have fallen into an absurd or repulsive exaggeration. Also respectable, because innocent, is the young girl's corset: simply decorated, and often of a poor shape which the body manages to overcome, obliging the former to mold itself upon the latter. Back lacing–50 eyelet holes each side. "All the same, more provocative than many others which try harder."

Another group is formed by the outright provocative corset which is meant to be seen, to be looked at in fact (reclining figures below and second top left). One is in white plush, another pearl-grey or very pale chamois, a third in tea-rose-leaf satin. The emphasis here is upon luxury of ornamentation, the fine lace, the jeweled clasps and buckles combined with subtlety of coloring and odor (a hint here of the Baudelairian *correspondance*). In shape, they are designed to follow existing perfection of contour, not for tight-lacing. The true *corset de combat* (lower right) gives off an odor of Spanish leather which intensifies as the body warms up; not surprisingly, a garment of such refinement

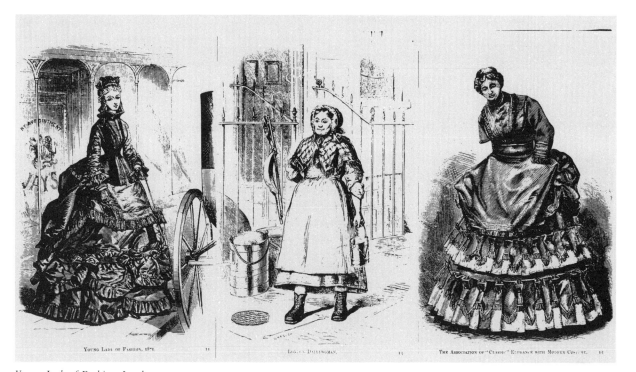

Young Lady of Fashion, London Dairywoman, The Association of "Classic" Elegance with Modern Costume. Illustrations to *Figure Training,* London, 1876.

Following page:
Louis Hadol: *At the Exposition: The Corsets (La Vie Parisienne,* 1878, p. 437, detail). "English corset for evangelical propaganda;" "Swedo-Finnish corset with drawbridge and machicolations."

cannot be entirely virtuous, for it is also described as easy to take off and even easier to put back on.

Three corsets are bad, in varying degress. One, the "antique" (standing right of center), is defensive from every angle, armor-plated, nondescript in color, lacing behind up to the neck; there is a dark suggestion here of puritanism or hypocrisy. Worse by far, however, is the sheer vulgarity of the black satin corset (seated on bed, far right), perfumed with opoponax, garnished with lace and ribbon-bows, with fan-stitch embroidery in red and blue–or, worst of all, in silver, in which case it is reminiscent of a hearse. This kind of garment is typical of the woman trying to combine elegance with economy, and ideal for the little laundress thinking of *"mal tourner."* The third bad corset, surprisingly, is the bridal one (semi-reclining, top, right of center). Made of white moiré, it is pretty "in the hand," but very long, very hard in the wearing, stiff and graceless, despite the luxury of its trimming. Fortunately worn only once, it becomes pleasurable only when it is removed. Is there here an implicit condemnation of marriage, an institution which *La Vie Parisienne* viewed with a jaundiced eye, and some allusion to the disappointments marriage always brings, or to the necessity of discarding it when it becomes too painful? Unlike the Romantic lithographers, Montaut does not mention the thrill of the groom releasing the bride, etc. (cf. above).

Enthroned above all these corsets, good, bad and indifferent, stands the classically poised figure of the truly ideal, uncorseted woman, her only covering a torrent of hair, and her anatomy defined naturally under a form-fitting vest, a maillot. But this anatomy is by no stretch of the artistic imagination a natural one: it is almost as wasp-waisted and full-breasted as the most extreme of her corseted sisters. Few are the women, says Montaut, who can afford to leave off corsets altogether; and few, one may add, are the artists brazen enough to exhibit the extreme degrees

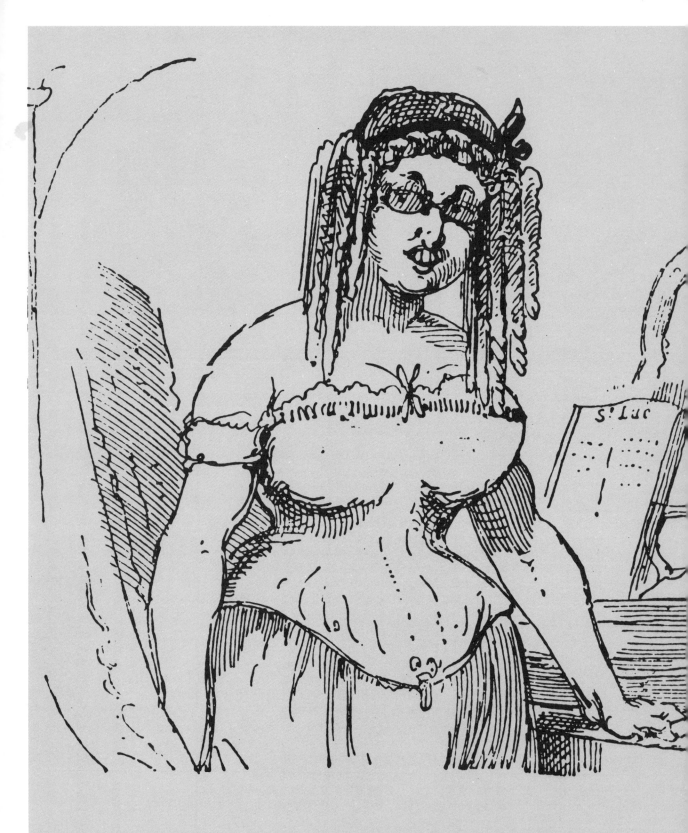

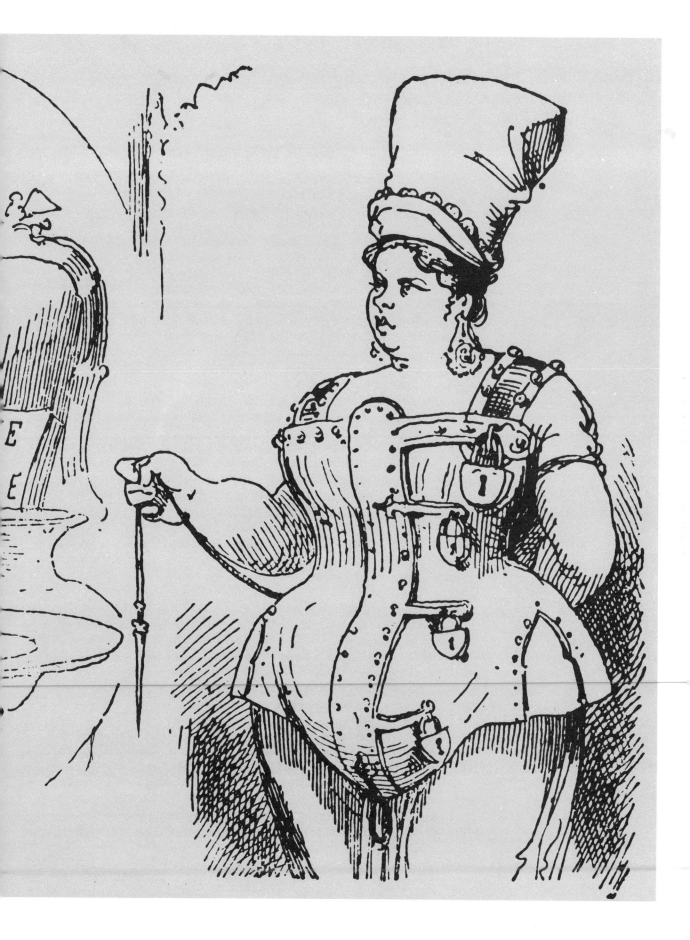

of fashionable distortion wrought by a lifetime of tight-lacing, posing as some kind of classical-artistic ideal.[59]

In his final centerspread on corsets, which was intended to launch the new series of *Etudes sur la Toilette,* Montaut returns to the "Before and After" principle he adopted in his first analysis of the subject, five years before. Having examined in detail the precise mechanism of the transformation, Montaut now places it in the broader chronological and social context, revealing in full the disparity between Nature and Art. Nature is no longer decently veiled in a bathing costume, but exposed in all the variety of its naked or semi-naked imperfection, which a loose chemise does little to hide. At the other end of the scale, Art is more perfectly stylized than ever, the bust fuller, the waist more wasp-like. The means of achieving so drastic a transformation are correspondingly severe, and in some instances repulsively so. Where in his earlier studies Montaut had balanced the "good" against the "bad," and shown beautiful figures elegantly arrayed as well as bad figures in ugly corsets, now all of the five types represented are highly imperfect, even–or especially–the central figure. All require in varying combinations and degrees, addition, subtraction, multiplication or division. The bony bottle-rack (lower left) whose only projecting parts are her shoulder-blades, which are so sharp that they chafe her when she sleeps on her back, wears the Corset Venus de Milo with perfumed rubber breasts supported by steel springs placed at the back of the waist. If a caressing arm touches her, she begins automatically to palpitate and continues to do so until the pressure ceases. The back and hip are also graciously rounded off in rubber, and provided with dimples where necessary. Even the gloves are padded. The whole is "singularly ideal and provocative; with a corset like that, one has adventures, but never a rendez-vous." For the equestrienne, false thighs and false calves are provided.

Her sister (lower right) is afflicted with a square, wide waist, pendulous breasts, protuberant belly and low, flat hips; she is hollow over the shoulders and arched at the small of her back. All this is transformed by means of a massive transverse steel bar beneath the bust and another, less solid, above; prodigious contraction of the waist and, flattening the belly, a crafty intercrossed network of whalebone and springs, which extends laterally to form the most realistic-looking *"hanches de fantaisie."* The short plump girl (top right) has to contend with a "stairway of double-chins under the arms, in which the back appears to have taken the wrong floor," which is crushed into a graceful embonpoint by means of reinforced triple springs and safety buckles.

The blonde sponging her shoulders (top left) lacks only a slender waist, which she therefore tortures into shape, adding for good measure a whalebone and spring steel armature to thrust out her bust towards her chin into the fashionable *"bosse de Polichinelle"* (pouter-pigeon effect). As a result, she becomes as stiff as a post, a graceless dummy who cannot bend or sit without effort. The central figure is that of the mature woman, magnificent still but suffering from excessive flesh, especially in the pendulous breasts and belly. The transformation here is, in a

single word–splendid! Even Cupid drops his bow in amazement. The breasts are consolidated, the riches of the belly artfully and powerfully forced away from the waist, and Madame becomes of marmorean majesty; the only disadvantage being that the extensive bust-harness prevents her from wearing any décolletage.

La Vie Parisienne, founded as a celebration of Woman as High Priestess of Society, has stripped her of her mysteries. Montaut's disillusionment with "natural woman" is akin to that of Degas, quoted in the magazine ('89,405) as saying: "At the Opera...I wear myself out showing the subscribers what the little women they come to see are really like. I do not exaggerate; they are even uglier than that, more misshapen and dirty." Montaut retains a kind of mocking detachment vis-à-vis the spectacle of art (and technology) working so valiantly to redeem nature, and questions sardonically whether the cure is not worse (i.e. uglier) than the disease. But we must remember that the corset is for Montaut only one, special and particularly vulnerable aspect of the toilette, and that the artist never experiences the kind of disgust for artificial woman that exacerbated the quasi-insane misanthropy of Guy de Maupassant at the end of his life.[60] Nascent disgust is tempered by that lightness of touch which was a by-word with the magazine; the profounder levels of cynicism are always veiled in humor and wit; the mask is as much that of Comedy as of Deceit.

Appendix–Life of Henri de Montaut

Biographical information about Henri de Montaut is exceedingly sparse. The name is often, probably incorrectly, spelled Montault. His birth-date is as yet unkown, being given as "ca. 1825" in Thieme-Becker (1931). In the brief obituary notice published in the *Chronique des Arts* January 4, 1890, p. 7, Montaut is described as *"un des plus féconds dessinateurs des journaux mondains."* In 1848 (Bibliothèque Nationale ms. *dépot légal* date) Aubert published a set of 12 plates of his design, titled *Vertus et Qualités,* in which the artist's lifelong and quite extraordinary weakness in drawing heads is already apparent. In 1849 (*dépot légal* date) F.Sinnett Sinnett in Paris and F. Gambart in London published a 15-plate set of Boucheresque and thoroughly unattractive *Enfants,* depicted in the role of eighteenth-century courtiers. In 1853 (dépot légal date) Sinnett published his voluptuous, half-dressed *Femmes de Différents Pays,* lithographed by Charles Bargue. Then the young artist enlisted for the Crimean campaign, as we know from the only album of his drawings surviving in the Cabinet des Estampes of the Bibliothèque Nationale (Qe 854,4), which, much mutilated as it is, contains miscellaneous sketches of the Crimean scene (landscapes, buildings, figures, costume studies of the local population, etc.). Page two, the top of which is torn off, is inscribed *"any* (? name barely legible, presumably intended for Henry) *de Montaut Capitaine d'Etat Major en Mission au (Crimée). Retrouvé à la Chancellerie d' Autriche à Constantinople le 26 Janvier 1857. J. B. Blosseville. Aux soins obligeants de Mr. de Bourville Alexandrie. Egypte."* Montaut may

Following page:
Henri de Montaut: *At Trouville: Those Ladies Seen during and after Their Baths. La Vie Parisienne,* 1876, pp. 476-7.

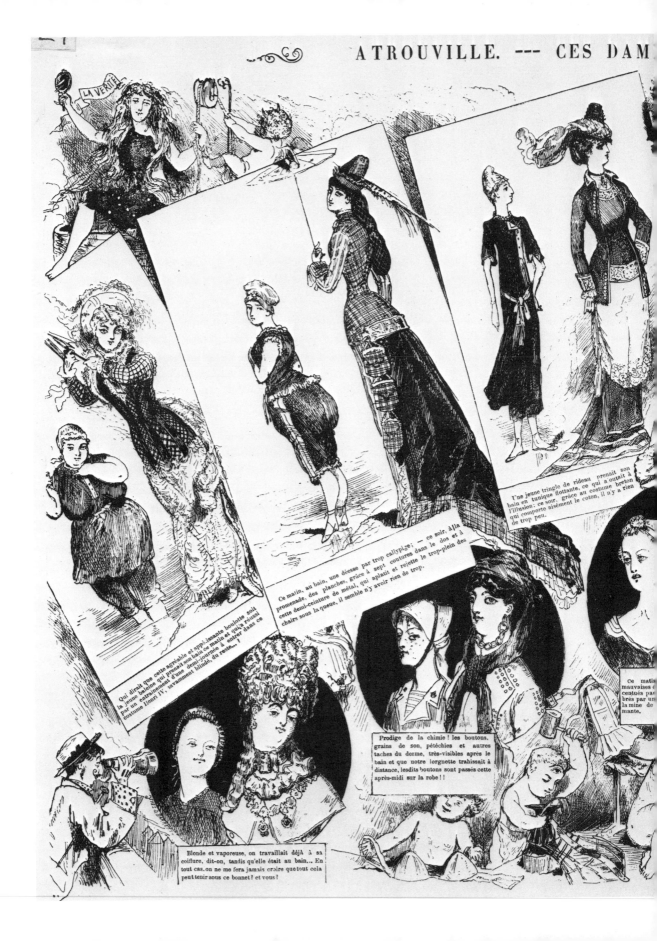

Une jeune tringle de rideau prenait son bain en tunique flottante, ce qui a outsit à l'illusion: ce soir, grâce au costume breton qui comporte aisément le coton, il n'y a rien de trop peu.

Qui dirait que cette agréable et appélissante boulotte soit la jeune baleine qui prenait son bain ce matin et quia réussi par un entrainement d'une demi-journée à entrer dans ce costume Henri IV, savamment bliudé, du reste... !

Ce matin, au bain, une déesse par trop callypige; --- ce soir, à la promenade, des planches, grâce à sept coutures dans le dos et à cette demi-ceinture de métal, qui aplatit et rejette le trop-plein des chairs sous la queue, il semble n'y avoir rien de trop.

Ce mati mauvaises centués par brés par u la mine de mante.

Prodige de la chimie ! les boutons, grains de son, pétéchies et autres taches du derme, très-visibles après le bain et que notre lorgnette trahissait à distance, lesdits boutons sont passés cette après-midi sur la robe ! !

Blonde et vaporeuse, on travaillait déjà à sa coiffure, dit-on, tandis qu'elle était au bain... En tout cas, on ne me fera jamais croire que tout cela peut tenir sous ce bonnet ! et vous !

LA VÉRITÉ

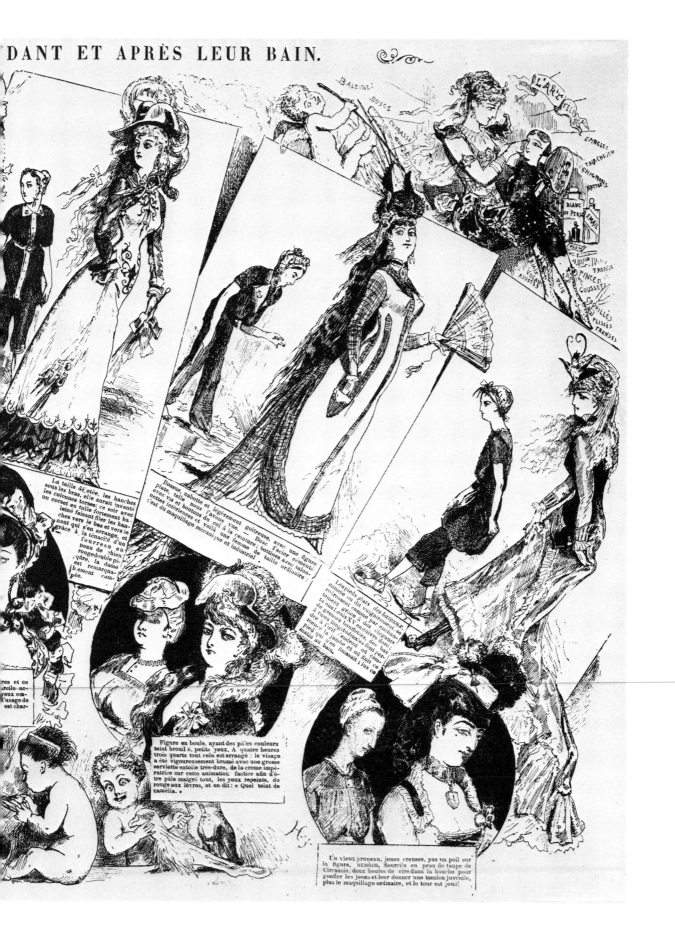

La taille dé otée, les hanches sous les bras, elle aurait inventé les colonnes torses: ce soir avec un corset en tulle invent leiné faisant fler les han- ches vers le bas et vers le haut qui s'en arrange, et grâce à la ténacité d'un fourreau en peau de rougedouble pi- qûre, la dame est remarqua- b ement cam- pée.

Bossue, nabotte et légèrement goitreuse, avec une figure plate, telle nous l'avons. Busc l'acier cimente nettes intérieures et un col à la ceinture et bottines avec talon c'est du maquillage mécanique et industriel.

Les pieds plats des nateures comme un dit vulgairement se redressent grâce à les élégant leur Louis XV en cuivre doré de grosses boufettes des bas a raies longitudinales font fer- meuve à l'œil paudru et com- pied qui n'en faisait i lus ce matin au bain.

Figure en boule, ayant des pâles couleurs teint broullé, petits yeux. A quatre heures trois quarts tout cela est arrangé : le visage a été vigoureusement brossé avec une grosse serviette entoile très-dure, de la crème impé- ratrice sur cette animation factice afin d'ê- tre pâle malgré tout, les yeux repeints, du rouge aux lèvres, et on dit: « Quel teint de camélia. »

res et de reils ac- eux or- l'usage de est char-

Un vieux pruneau, joues creuses, pas un poil sur la figure, REMBDE. Sourcils en peau de taupe de Circassie, deux boules de cire dans la bouche pour gonfler les joues et leur donner une tension juvénile, plus le maquillage ordinaire, et le tour est joué!

have imbibed a taste for life in this part of the world, for 20 years later he went to the Caucasus, whence he brought back sketches for *La Vie Parisienne* (1877,358). The artist also worked as a designer of menus and coats-of-arms.

He contributed an as yet undetermined number of drawings to *Le Petit Journal pour Rire* and *Le Journal Amusant,* where he must have met Marcelin. During the first year of *La Vie Parisienne* (1863), a fair number of his drawings appeared, in style and subject close to Edmond Morin and Louis Hadol. The first true "centerspread" (i.e., drawing run continuously across the gutter) in *La Vie Parisienne* (p. 387) is signed Henry de M. In 1864 his contribution tapers off, and he is altogether absent from the journal in 1865-72. His activities during these years remain unknown. The principal *Vie Parisienne* illustrator of the '60s is Hadol, not Morin, as stated by Roberts-Jones (pp. 66, 143-5), and it is Hadol, not Morin, whose sprightly style set the *ton* for the magazine as a whole. Hadol's numerous illustrations of women's feet, shoes and stockings may be regarded as the fetishistic forerunners of Montaut's corset physiology during the following decade. When Montaut returned to the magazine in March 1873, he appears to have lost some of the sprightly, semi-caricatural contour of Morin and Hadol, and tends to dissolve forms in a kind of perfumed haze. His manner is very hard to characterize, but is possibly unique at a time when, as Roberts-Jones (p. 146, following Béraldi) points out, the style of Morin became almost standardized in the various illustrated journals. Roberts-Jones does Montaut scant justice by merely listing him as one of the half-dozen illustrators working in the style of Morin; and the other principal historian of the satiric press at this period, Lethève (p. 34) does not mention Montaut at all. The extent to which this artist physically dominated the journal may be judged by these statistics, bearing in mind that the centerspread was the *"clou"* of the weekly magazine: 12 centerspreads in 1873, 18 in 1874, 19 in 1875, 24 in 1876, 20 in 1877, 28 in 1878, 20 in 1879, 23 in 1880, 21 in 1881, 18 in 1882, and 1 in January 1883. From that moment, it is probable that Montaut devoted himself wholly to *L'Art et la Mode,* the weekly which he had founded in August 1880. Thus for ten years he was executing about half the centerspreads, more than any other artist; and this without taking into account his numerous illustrations to articles. That a special value was placed upon his work by himself and/or director Marcelin may be gauged from the fact that for a long time his are the only signed drawings. Throughout the '70s Marcelin enforced the rule that articles should be signed with the briefest pseudonyms, preferably a single letter, and drawings, with the exception of Montaut's, remain anonymous. Roby, with whom Montaut at first shared centerspread honors, is credited only in the index, and many centerspreads are not thus credited at all. Later, in the '80s, Sahib was allowed to imitate Montaut and append his name to the drawings. Montaut was for most of his career with *La Vie Parisienne* the only centerspread artist who always wrote his own text; Roby worked in collaboration, although Sahib once again followed Montaut in this respect.

Montaut's signature evolved in a curious fashion. At first (1873-74) he signs "Hy" and "H," with index credit to "Henry" or "Henri"; he then settled for the form "H-y," and is credited "H. de Hem" in the index. In 1880 he adopted the monogram: HM, ornately interlaced, which he had used in 1863, and which he preserved for a dozen or so occasions, before reverting to H-y. In the famous *Etudes sur la Toilette* his signature is rendered more prominent, but the index credit throughout this year goes to "X.Y." Was this intended to confuse the censorship, which if it did not harass *La Vie Parisienne* directly (over the *Asperges?*), was certainly active enough with other journals during what Roberts-Jones (p. 40) has stigmatized as *"l'année pornographique"* of 1880. Was it to disorient the censorship that in early 1882 (100) Montaut hid behind the pseudonymous signature Frag (probably for Fragonard) and was indexed as "Frag et Tristan" for the highly erotic *Nuances de Sentiment?* His daring *Bains* ('81,610), with its new nakedness, and *Tattersall du Mariage* ('81,666), with the contour of pointed nipples showing clearly through the maillot, may well have aroused the censor. "Frag" also appears on the erotic *Amour et Natation* ('82,452) and the *Corsets* which we reproduce, although Montaut continues to sign "H-y" on the less provocative illustrations. Other editorial obfuscations include "par Djo" as the index credit for a semi-erotic *Types de Plage*, signed H-y (82,480).

As a tribute to the departed and surely much regretted graphic mainstay of the magazine, the artist's final drawing is credited to his real name, H. de Montaut.

[1] Pater thus exposes the dualism of an old tradition in Susanna-Bathsheba iconography (as Beatrice Farwell points out in her article included in this volume) whereby the maid is often dressed in contemporary fashion, while her mistress is classically attired.

[2] Léoty, p. 48

[3] John Locke, *On Education,* 1693 (Peter Gay, ed., New York, 1964, p. 22) protests the practice. The evidence is that tight-lacing of the waist had declined since its peak in later sixteenth-century France, where Montaigne and Paré, etc., complained of its prevalence and intensity. It appears to have undergone a revival around the turn of the century. For this, as all other matters relating to tight-lacing in these articles, I refer to my extensive forthcoming publication from Nelson's, *Fashion and Fetishism; A History of Tight-Lacing,* etc.

[4] The phrase may well conceal a sexual connotation, into which we cannot enter here. Suffice it to say that the busk was consciously experienced as a phallic symbol in the seventeenth-eighteenth centuries, being engraved (sometimes by the lover himself) with all sorts of erotic devices and verses. It was also the subject of poetic conceits not unlike the one contained in the caption of the Cochin print. Cf. Libron, p. 30.

[5] *"Ayant considéré, dit le roi, qu'il était assez bien dans la bienséance et convenable à la pudeur et à la modestie des femmes et filles de leur permettre de se faire habiller par des personnes de leur sexe lorsqu'elles le jugeront à propos . . ."* (Léoty, pp. 47-8).

[6] Pléiade ed., II, p. 265.

[7] Waugh, p. 41; whalebone in very fine flexible strips was now the rule, wood and steel being reserved exclusively for the busk.

[8] *Remarks on Rousseau,* 1767, cited by Eudo C. Mason; *The Mind of Henry Fuseli,* 1951, p. 144.

[9] Eduard Fuchs, *Illustrierte Sittengeschichte,* II, Ergänzungsband, 1911, p. 166.

[10] *Monsieur Nicholas, or the Human Heart Laid Bare,* translated and edited with an Introduction by Robert Baldick, New York, 1966, p. 208.

[11] This interpretation of the position of the cane is pure speculation, as would be a considera-

Following page:
Henri de Montaut: *Considerations on the Corset,* from *La Vie Parisienne,* 1879, pp. 224-5.

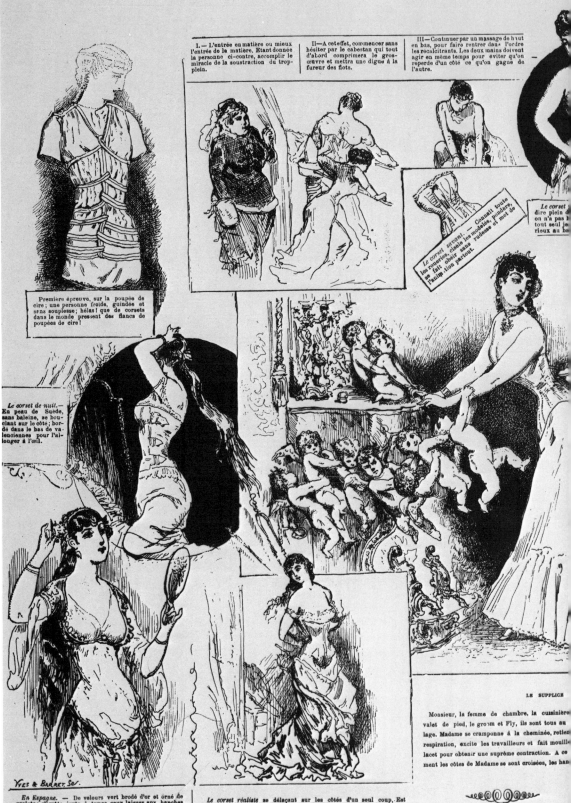

I. — L'entrée en matière ou mieux l'entrée de la matière. Étant donnée la personne ci-contre, accomplir le miracle de la soustraction du trop-plein.

II. — A cet effet, commencer sans hésiter par le cabestan qui tout d'abord comprimera le gros œuvre et mettra une digue à la fureur des flots.

III. — Continuer par un massage de haut en bas, pour faire rentrer dans l'ordre les récalcitrants. Les deux mains doivent agir en même temps pour éviter qu'on reperde d'un côté ce qu'on gagne de l'autre.

Première épreuve, sur la poupée de cire; une personne froide, guindée et sans souplesse; hélas! que de corsets dans le monde pressent des flancs de poupées de cire!

Le corset savant. — Connaît toutes les roueries, cisèle les modèles, poudre et fait obéir sans rudesse et met de l'animation partout.

Le corset de nuit. — En peau de Suède, sans baleine, se bouclant sur le côté; bordé dans le bas de valenciennes pour l'allonger à l'œil.

Le corset à dire plein de on n'a pas h tout seul j rieux au ba

YVES & BARRET, Sc.

En Espagne. — De velours vert brodé d'or et orné de grelots; s'arrête juste à temps pour laisser aux hanches toute leur souplesse. Ce n'est point un corset, mais bien plutôt le cadre d'un ravissant tableau de genre.

Le corset réaliste se délaçant sur les côtés d'un seul coup. Est habitué à s'en revenir le matin, roulé dans un journal, emportant avec lui une vague odeur de tabac.

LE SUPPLICE

Monsieur, la femme de chambre, la cuisinière valet de pied, le groom et Fly, ils sont tous au lage. Madame se cramponne à la cheminée, retien respiration, excite les travailleurs et fait mouille lacet pour obtenir une suprême contraction. A ce ment les côtes de Madame se sont croisées, les han

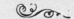

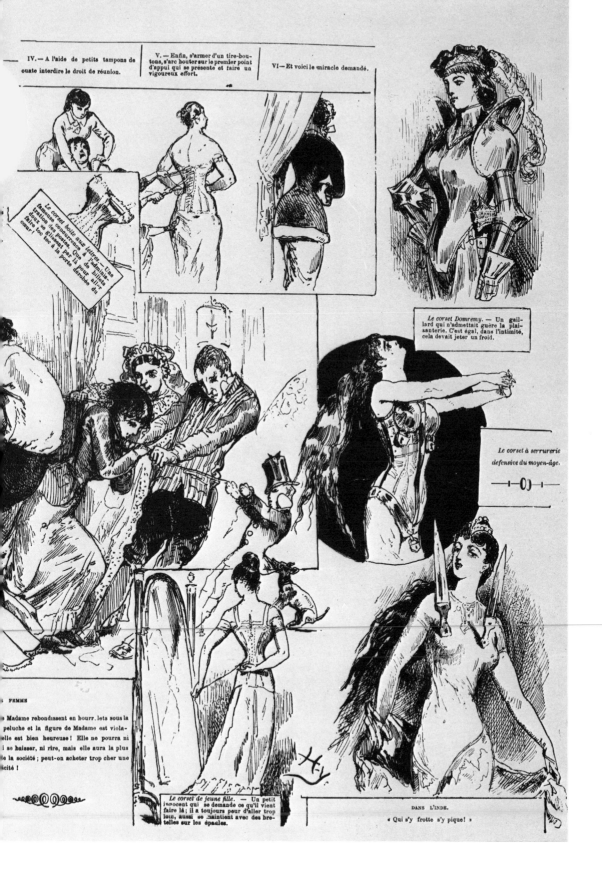

IV. — A l'aide de petits tampons de ouate interdire le droit de réunion.

V. — Enfin, s'armer d'un tire-boutons, s'arc bouter sur le premier point d'appui qui se présente et faire un vigoureux effort.

VI — Et voici le miracle demandé.

Le corset Domremy. — Un gaillard qui n'admettait guère la plaisanterie. C'est égal, dans l'intimité, cela devait jeter un froid.

Le corset à serrurerie defensive du moyen-âge.

FEMME

Madame rebondissent en bourr.lets sous la peluche et la figure de Madame est viola.elle est bien heureuse ! Elle ne pourra ni i se baisser, ni rire, mais elle aura la plus le la société ; peut-on acheter trop cher une icité !

Le corset de jeune fille. — Un petit innocent qui se demande ce qu'il vient faire là ; il a toujours peur d'aller trop loin, aussi se maintient avec des bretelles sur les épaules.

DANS L'INDE.

« Qui s'y frotte s'y pique ! »

tion of the lute, turned face down, as a symbol of the harmonies of love turning their back upon an aged aspirant. Ironically this anecdotally pointed design may derive from a morally "neutral" fashion-plate *Galeries des Modes,* 1778), showing a *"Tailleur costumier essayant un cor à la mode"* (Le Clere del., Dupin sculp., facsimile in Libron). The caption merely describes the clothing worn by the tailor and his client, but the tailor has his arm about the lady's waist, as in the Wille print, and his hand hovers near her breast, upon which his eyes are intently fixed.

[12]The change also corresponds to the difference between numbers 2 and 4 in the *Analysis* diagram. The prominence of the stays in *Rake, III* was incomprehensible to Hogarth's "memorial plagiarists" who simply omitted them as irrelevant (cf. Kunzle in *Journal of Warburg and Courtauld Institutes, XXIX,* 1966, pp. 56-7, figs. d and b). It is also noteworthy that Hogarth added a prominent pair of stays in the *Before* and *After* engravings of 1736, missing from the paintings of 1731-32. Hogarth's most amusing eighteenth-century commentator, Georg Christoph von Lichtenberg, has much to say on the possible range of symbolism of the stays in *Marriage à-la-mode, V.* The evident staylessness of the Countess in *Marriage à-la-Mode, II,* contributes to the gentle air of impropriety which she exudes.

[13]Burke ed., p. 66.

[14]Frederick Antal, *Hogarth and His Place in European Art,* London, 1962, pl. 80. This critic suggests that Hogarth may have derived his design from that of Cochin, discussed above. Whether this is demonstrable or not, it is significant that the English artist has rendered the lady even more slender at the waist than the French Rococo artists–as slender, almost, as the fetishistically idealized illustrations of Binet to the novels of Restif de la Bretonne. Hogarth may have intended a contrast between male, plebeian clumsiness and female, aristocratic grace, but the design did not satisfy him, and it was not engraved until after his death–in 1782–by Joseph Haynes, at which time there was a renewed interest in the *Essai du Corset.*

[15]*The World,* Dec. 13, 1753, no. 50, p. 301. The most sweeping philosophical-esthetic-moral lesson is drawn from Hogarth's system of stays by an attentive student and illustrious admirer, Laurence Sterne. The intelligent reader addressed by Sterne would have recognized the humor of this oblique reference to a passage and illustration from Hogarth's *Analysis:* "But need I tell you, Sir, that the circumstances with which everything in this world is begirt give everything in this world its size and shape!–and by tightening it, or relaxing it, this way or that, make the thing to be, what it is–great–little–good–bad– indifferent or not indifferent–just as the case happens?" *(Tristram Shandy,* 1760, 1843 ed., p. 108). For other Sterne "borrowings" from Hogarth, cf. William Holtz, "Pictures for Parson Yorick," in *Eighteenth Century Studies,* I, no. 2, pp. 169-184, and the same author, "The Journey and the Picture: The Art of Sterne and Hogarth," *Bulletin of the New York Public Library,* LXXI, no. 1, Jan., 1967, pp. 25-38.

[16]*Analysis,* pl. II, fig. 121, text p. 154. In a passage rejected from the published version (pp. 173-4), Hogarth refers at some length to John Bulwer's *Artificial Changeling* and that author's "shocking" description of the "most extravagant, wild and uncouth manner of covering the body in different ages and countries, and their disgustful and sometimes cruel methods of moulding and forcing the human form out of its natural figure and colour . . ." Noting that "many of his (Bulwer's) instances remain to this day," Hogarth does not get beyond Chinese footbinding, and stops short at the very point where he must have discussed tight-lacing, which Bulwer castigates briefly but violently. The artist probably felt that to enter into this area would put him in the position of treating contemporary fashion from a moralistic standpoint (which was directly contrary to his temperament), would involve him in certain contradictions, and oblige him, in logic, to end up condemning the very article he had chosen to illustrate his Line of Beauty. It should be noted that Hogarth's interest in Bulwer's book, of which there is no eighteenth-century edition (nor indeed any after the second edition of 1654), is altogether unusual for the time.

[17]It was, paradoxically, on the English model that the French developed the so-called "corset" as opposed to the heavy *"corps"* ("Lorsque la dame présentée ne peut endurer un corps, il lui est permis de mettre un corset," *Cérémonial de la Cour,* 1773, cited by Libron, p. 44). The English then took over the French word "corset" in the mid-nineteenth century to denote a garment lighter and more comfortable than "stays."

[18]The major vernacular monograph of the period, by Soemmerring, was first published in 1788; it contains an extensive bibliography indicating that the trickle of medical protestations from he beginning of the eighteenth century had thickened into a regular torrent by the time the author was writing.

[19]Waugh, Fig. 32; these four caricatures appear in the British Museum *Satires* catalogue, nos. 5452, 5464, 5444, 4552 (sic).

[20]*Letters*, X, 31, for March 28, 1777.

[21]This is not the place to deal with tight-lacing as a political metaphor. The Gillray, together with a *Punch* cartoon showing "The Effects of tight lacing on the Old Lady of Threadneedle Street" (1847, p. 115), may be regarded as antecedents of a Daumier lithograph showing the grotesque attempt to haul in a monstrously fat figure representing the Budget: "*Difficile à faire paraître svelte*" (*Charivari*, April 6, 1869, Delteil 3702).

[22]British Museum, *Satires Catalogue* 6359A (at present missing from the collection).

[23]Cf. an illustration of ca. 1825 reproduced in the German journal *Ueber Land und Meer*, 1912, no. 15 (the same design in Gec (Enrico Gianeri), *La Donna, la Moda, l'Amore in tre secoli di caricatura*, Milan, 1942, p. 24); a very crude woodcut probably of earlier date, showing a woman being strapped into stays by men armed with pincers, reproduced by Cécile Saint-Laurent, *L'histoire imprévue des dessous féminins*, Paris, 1966, p. 106; and "The Effects of General Emancipation. Mrs. Kentelo's new machine for winding up the ladies 1833," an American print which I have not seen, mentioned by Frank Weitenkampf, *Social History of the United States in Caricature–How the Comic Artists Saw Us*, New York, 1953 (typescript deposited with the New York Public Library).

[24]*The Works of James Gillray* (1851), Blom ed., 1968, nos. 570-572. These etchings were made by Gillray at a time when his mental and physical health were on the decline; the designs were dictated by an "amateur."

[25]Facsimile reproduction in Libron.

[26]Reproduced in Grand-Carteret.

[27]Balzac's rich old maid, Mlle. Cormon (*La Vieille Fille*, loc. cit. note 57 below) tight-laces herself in order to impress a gentleman she hopes to marry, and faints when she hears he is already married. She is carried to her bed, and Josette, her maid, "armed with scissors, cut the excessively tight corset." She is revived by Du Bousquier, a suitor she had just refused, but whom she subsequently feels obliged to marry in view of the fact that, having had "water brutally thrown over her and over her bodice which gushed forth like a flood of the Loire . . ." she had "been seen by a man for the first time, her belt [i.e. of virtue] shattered, her lace broken, her treasures violently cast out of their casket." It is evident that it is not merely the fact of being seen in her undress, semi-naked, which makes her feel deflowered; but that the chastity belt she put on as a symbol of her desire to marry had been violently forced by an accident which she interprets as a sign from heaven.

The lacing up of a corset could also be symbolic of deflowering or intent to deflower, as seems indicated by a Grandville drawing in which a hunchback, probably intended for Mayeux, greedily pauses with the end of the lace in his hand, before poking it through the first hole of a corset worn by the comely female before him. A picture on the wall of the room depicts a rape.

[28]Other prints of the period include one by N. Maurin, *Le Lacet*, in which the girl stands admiring herself in a mirror, holding up a loop of lace not unlike a Diana stretching her bow, the lace continuing down in an immense length to the floor, where a cat is playing with it as if it were a ball of wool. In others the invitation to the spectator to unlace is conveyed by the wearer crooking her thumb into the lacing at the back, and holding up the loop with the other hand (e.g. Devéria's *Le Coucher* and *Le Corset*, and Weber's *La Toilette*). At the coarsest level, we find the kneeling attitude of the groom before the altar paralleled to the similar position he adopts a few hours later, with a lascivious smile, to unlace his smirking bride. A good collection of such prints may be found in the Musée des Arts Décoratifs; reproductions are included in Libron and Grand-Carteret.

[29]Reproduced in Grand-Carteret. The motif was revived textually by Reznicek in 1908: "*Sonderbar–heute früh war es ein Knoten, und jetzt ist es eine Schleife!*" Gavarni's *Le Corset*, 1835 (repr. Lemoisne, *Gavarni*, 1924, p. 64), is more in the spirit of the Romantic litho-

Following page:
Montaut: *Studies of the Toilette, Second Series: Corsets. La Vie Parisienne*, 1881, pp. 38-39.

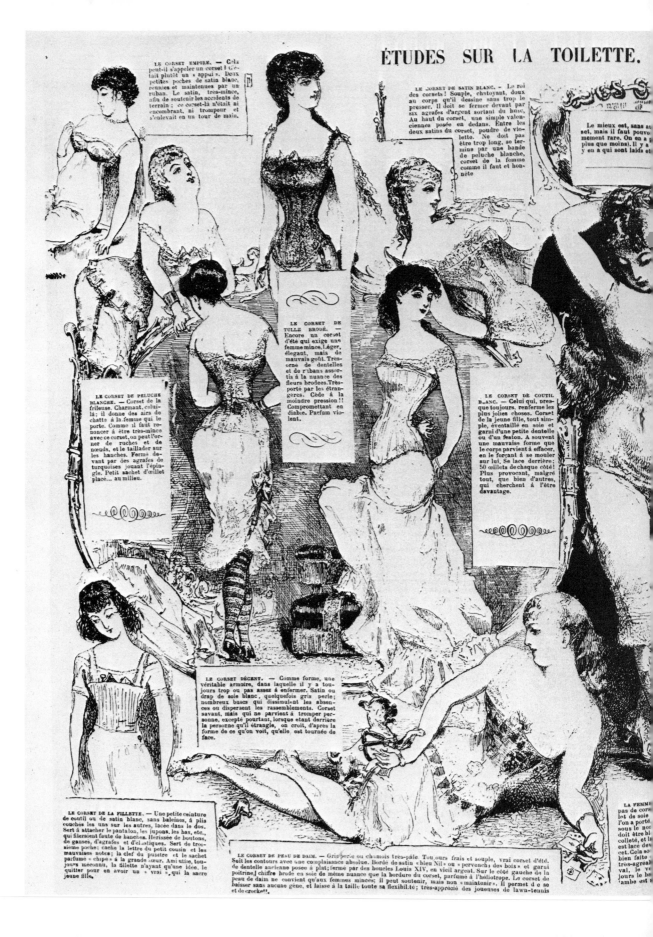

LE CORSET EMPIRE. — Cela peut-il s'appeler un corset? C'était plutôt un « appui ». Deux petites poches de satin blanc, reunies et maintenues par un ruban. Le satin, très-mince, afin de soutenir les accidents de terrain; ce corset-là n'était ni encombrant, ni trompeur et s'enlevait en un tour de main.

LE CORSET DE SATIN BLANC. — Le roi des corsets! Souple, chatoyant, doux au corps qu'il dessine sans trop le presser. Il doit se fermer devant par six agrafes d'argent sortant du busc. Au haut du corset, une simple valenciennes posée en dedans. Entre les deux satins du corset, poudre de violette. Ne doit pas être trop long, se termine par une bande de peluche blanche, corset de femme comme il faut et honnête.

Le mieux est, sans au set, mais il faut pouvo mement rare. On en a p plus que moins). Il y a y en a qui sont laids et

LE CORSET DE PELUCHE BLANCHE. — Corset de la frileuse. Charmant, celui-là; il donne des airs de chatte à la femme qui le porte. Comme il faut renoncer à être très-mince avec ce corset, on peut l'orner de ruches et de nœuds, et le tailler sur les hanches. Ferme devant par des agrafes de turquoises jouant l'épingle. Petit sachet d'œillet placé... au milieu.

LE CORSET DE TULLE BRODÉ. — Encore un corset d'été qui exige une femme mince. Léger, élegant, mais de mauvais goût. Très-orné de dentelles et de rubans assortis à la nuance des fleurs brodees. Très-porté par les étrangères. Cède à la moindre pression!! Compromettant en diable. Parfum violent.

LE CORSET DE COUTIL BLANC. — Celui qui, presque toujours, renferme les plus jolies choses. Corset de la jeune fille, tout simple, éventillé en soie et garni d'une petite dentelle ou d'un feston. A souvent une mauvaise forme que le corps parvient à effacer, en le forçant à se mouler sur lui. Se lace derrière; 50 œillets de chaque côté! Plus provocant, malgré tout, que bien d'autres, qui cherchent à l'être davantage.

LE CORSET DÉCENT. — Comme forme, une véritable armoire, dans laquelle il y a toujours trop ou pas assez à enfermer. Satin ou drap de soie blanc, quelquefois gris perle; nombreux bascs qui dissimulent les absences ou dispersent les rassemblements. Corset savant, mais qui ne parvient à tromper personne, excepté pourtant, lorsque étant derrière la personne qu'il étrangle, on croit, d'après la forme de ce qu'on voit, qu'elle est tournée de face.

LE CORSET DE LA FILLETTE. — Une petite ceinture de coutil ou de satin blanc, sans baleines, à plis couches les uns sur les autres, lacée dans le dos. Sert à attacher le pantalon, les jupons, les bas, etc., qui glieraient faute de hanches. Hérissée de boutons, de ganses, d'agrafes et d'élastiques. Sert de troisieme poche; cache la lettre du petit cousin et les mauvaises notes; la clef du pupitre et le sachet parfume « chipé » à la grande sœur. Ami intime, toujours meconnu, la fillette n'ayant qu'une idée: le quitter pour en avoir un « vrai », qui le sacre jeune fille.

LA FEMME pas de corse t de soie l'on a porté sous le no doit être bl collette, et est lacé da cet. Cela bien faite très-agréa val, le v jours le be amb e est

LE CORSET DE PEAU DE DAIM. — Gris perle ou chamois très-pâle. Toujours frais et souple, vrai corset d'été. Suit les contours avec une complaisance absolue. Bordé de satin « bleu Nil » ou « pervench » des bois » et garni de dentelle ancienne posee à plat; fermé par des boucles Louis XIV, en vieil argent. Sur le côté gauche de la poitrine, chiffre brode en soie de même nuance que la bordure du corset, parfume à l'héliotrope. Le corset de peau de daim ne convient qu'aux femmes minces; il peut soutenir, mais non « maintenir ». Il permet de se baisser sans aucune gêne, et laisse à la taille toute sa flexibil.té; très-apprécié des joueuses de lawn-tennis et de crockett.

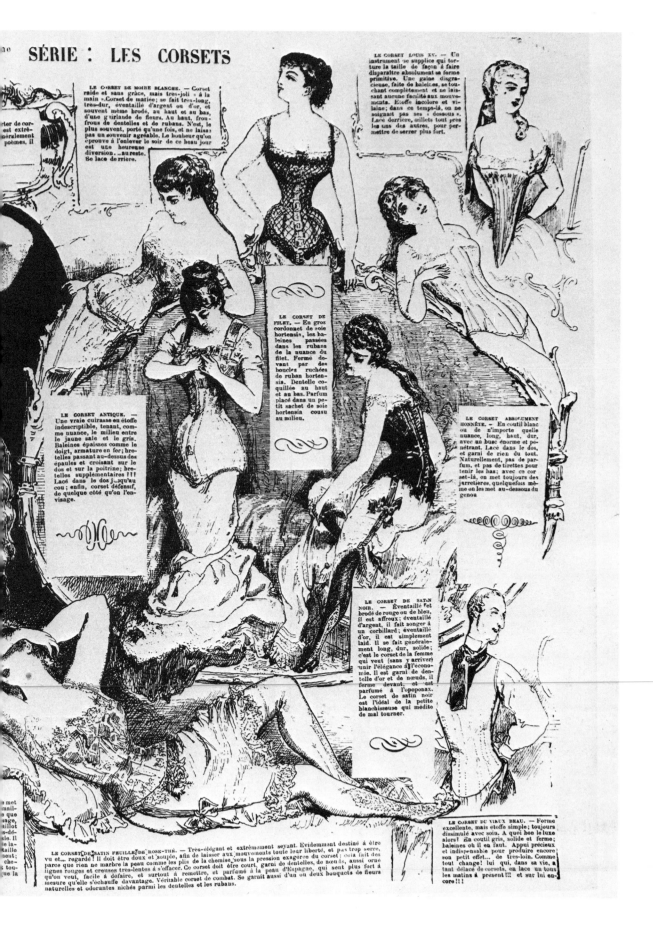

SÉRIE : LES CORSETS

LE CORSET DE MOIRE BLANCHE. — Corset raide et sans grâce, mais très-joli : à la main « Corset de mariée; se fait très-long, très-dur, éventaille d'argent ou d'or, et souvent même brodé, au haut et au bas, d'une guirlande de fleurs. Au haut, froufrous de dentelles et de rubans. N'est, le plus souvent, porté qu'une fois, et ne laisse pas un souvenir agréable. Le bonheur qu'on éprouve à l'enlever le soir de ce beau jour est une heureuse diversion... au reste. Se lace de rrière.

LE CORSET LOUIS XV. — Un instrument de supplice qui torture la taille de façon à faire disparaître absolument sa forme primitive. Une gaîne disgracieuse, faite de baleines, se touchant complètement et ne laissant aucune facilité aux mouvements. Étoffe incolore et vilaine; dans ce temps-là, on ne soignait pas ses « dessous ». Lacé derrière, œillets tout près les uns des autres, pour permettre de serrer plus fort.

LE CORSET ANTIQUE. — Une vraie cuirasse en étoffe indescriptible, tenant, comme nuance, le milieu entre le jaune sale et le gris. Baleines épaisses comme le doigt, armature en fer; bretelles passant au-dessus des épaules et croisant sur le dos et sur la poitrine; bretelles supplémentaires !!! Lacé dans le dos jusqu'au cou ; enfin, corset défensif, de quelque côté qu'on l'envisage.

LE CORSET DE FILET. — En gros cordonnet de soie hortensia, les baleines passées dans les rubans de la nuance du filet. Fermé devant par des boucles ruchées de ruban hortensia. Dentelle coquillée au haut et au bas. Parfum placé dans un petit sachet de soie hortensia cousu au milieu.

LE CORSET ABSOLUMENT HONNÊTE. — En coutil blanc ou de n'importe quelle nuance, long, haut, dur, avec un busc énorme et pénétrant. Lacé dans le dos, et garni de rien du tout. Naturellement, pas de parfum, et pas de tirettes pour tenir les bas; avec ce corset-là, on met toujours des jarretières, quelquefois même on les met au-dessous du genou.

LE CORSET DE SATIN NOIR. — Éventaillé et brodé de rouge ou de bleu, il est affreux; éventaillé d'argent, il fait songer à un corbillard; éventaillé d'or, il est simplement laid. Il se fait généralement long, dur, solide; c'est le corset de la femme qui veut (sans y arriver) unir l'élégance à l'économie. Il est garni de dentelle d'or et de nœuds, il ferme devant, et est parfumé à l'opoponax. Le corset de satin noir est l'idéal de la petite blanchisseuse qui médite de mal tourner.

LE CORSET DU VIEUX BEAU. — Forme excellente, mais étoffe simple; toujours dissimulé avec soin. A quoi bon le luxe alors ? en coutil gris, solide et ferme; baleines où il en faut. Appui précieux et indispensable pour produire encore son petit effet... de très-loin. Comme tout change! lui qui, dans sa vie, a tant délacé de corsets, en lace un tous les matins à présent !!! et sur lui encore !!!

LE CORSET DE SATIN FEUILLE DE ROSE-THÉ. — Très-élégant et extrêmement seyant. Évidemment destiné à être vu et... regardé ! Il doit être doux et souple, afin de laisser aux mouvements toute leur liberté, et pas trop serré, parce que rien ne marbre la peau comme les plis de la chemise, sous la pression exagérée du corset; cela fait des lignes rouges et creuses très-lentes à s'effacer. Ce corset doit être court, garni de dentelles, de nœuds, aussi orné qu'on veut, facile à défaire, et surtout à remettre, et parfumé à la peau d'Espagne, qui sent plus fort à mesure qu'elle s'échauffe davantage. Véritable corset de combat. Se garnit aussi d'un ou deux bouquets de fleurs naturelles et odorantes nichés parmi les dentelles et les rubans.

graphs, and does not appear to have a satirical bearing.

[30]*Journal Amusant,* Dec. 27, 1856.

[31]Reproduced in John Grand-Carteret, *Les Moeurs et la Caricature en France,* p. 347, fig. 217. Dantan may have taken the idea from Hogarth, who in *Taste in High Life* (engraved 1746) depicts on a painting on the wall the Venus de' Medici attired in a hoop cut away at the back.

[32]This type of print, common enough in the seventeenth-eighteenth centuries, lent itself, as one can readily imagine, to the nineteenth-century taste for obscenity. The notion of the natural human form as obscene, although as a matter of esthetic rather than sexual pathology, is implicit in the caricaturists' rendering of the theme.

[33]Baudelaire, *Art in Paris* (Mayne, Phaidon ed. 1965, pl. 62 and p. 211).

[34]*"A une Malabaraise."*

[35]In a poem by José-Maria Hérédia *(Les Trophées,* 1893), it is the corset-lace which evokes this image: *"Et je crois voir se tordre en sifflant le lacet / Comme un serpent lascif sur le flanc qui se cabre."*

[36]E.g. that of Théophile Gautier, whose esthetic may be regarded as normative in the 1860s: *"Que tu me plais dans cette robe / Qui te déshabille si bien ... / cette robe qui semble faite de chair."* Curiously enough this poem, published the same year as *Les Fleurs du Mal ("A Une Robe Rose"* in *Emaux et Camées,* 1857), was inspired by one of Baudelaire's chief muses, Mme. Sabatier (cf. Joanna Richardson, *The Courtesans,* 1967, p. 128), who was proud of her classical figure, and on the evidence of numerous portraits, probably seldom wore a corset. In the passage cited Gautier is admiring the ideal unity of her body and clothes; Baudelaire seeks out the contradictions between the two. Baudelaire seems to have rejected the sexual advances of Mme. Sabatier, who represented for him a kind of unattainable purity; his sexual attraction was rather for the "ugly" creole Jeanne Duval, the erotic power of whose hair is evoked in supra-fetishistic fashion in the celebrated sonnet *"La Chevelure."* It was on a Baudelaire drawing of Jeanne Duval that Mme. Sabatier contemptuously scribbled *"Son idéal!"*

[37]Cf. Jacques Crépet, *Dessins de Baudelaire,* 1926, who stresses the wasp-waisted character of many of the figures.

[38]A *petit poème en prose* called *"Les Projets"* was printed in 1864 (p. 464), and *"Le Maquillage"* appeared the same year (p. 235) in an abbreviated version of that first printed in *Le Figaro.*

[39]E.g. 1864, pp. 213, 524.

[40]1858, etc.; he also seems to have persuaded Bonvallet, the manufacturers of a new type of *"corsets plastiques,"* to take out what appear to be the earliest regular illustrated corset advertisements to be printed in a humorous journal. As a class, such journals depended very little on commercial advertising.

[41]One of Zola's early pieces, *La Vierge au Cirage,* which is concerned with hair-fetishism, appeared in the 1865 volume of the magazine *(Oeuvres Complètes,* Miterrand ed., IX, pp. 205-209). La belle Lisa, one of the two principal characters in a novel of Zola's maturity, *Le Ventre de Paris* (1873, *Les Rougon-Macquart, I,* Pléiade ed. 1960, pp. 637, 666, 675, 736, 756, 874) is replete with fetishistic symbolism. The owner of a very successful pork-butcher's near the Halles, Lisa is very beautiful, strong, plump and bursting with physical energy and sexual health; she is also very self-possessed and the epitome of bourgeois hygiene. Working surrounded by the bleeding flesh of animals, she is always impeccably clean, an immaculate priestess presiding over the sacrifice. The expanse, stiffness and whiteness of her linen are proverbial in the Halles: "her starched linen collar tightly clasped about her throat, her white sleeves reaching up to the elbow, her white apron hiding the points of her shoes..." The whiteness of her apron vied with the whiteness of the plates in her home; and the transparent pallor mingling with the tender flesh tints of her powerful breast and shoulders are those of the fats and hams she sells. Her emotional self-discipline and physical-sexual self-control are expressed in the way she is compressed in her clothing, and above all in her corsets. On at least half a dozen occasions she is referred to as tight-laced; in a remarkable anticipation of the cuirasse style which was not to come in until the following year, the "musculature" of her corset becomes in itself a symbol of controlled physical power: "Raising the cleaver with her

solid, naked wrist, she delivered three sharp blows. With each blow, the back of her black merinos dress rose slightly, while the whalebones of her corset stood out against the taut material of the bodice." At this moment she is watched in delight by her admirer Marjolin, and she plays upon the provocation by reproaching the boy for going about with that "grasshopper" of his girl friend.

La belle Lisa tight-laces as a matter of social discipline, and in rivalry and opposition with la belle Normande, an aggressively and rather vulgarly beautiful fish-vendor. Whenever their rivalry and quarrels begin to reverberate around the Halles, Lisa tightens her corsets still further. The fish-vendor, who went uncorseted, accuses the pork-butcher of being *"blindée"* (armored and as *"ficelée"* (tied-up) as her sausages. The former is all-too-soft and overflowing, sexually; the latter, although also voluptuously built, is too hard, too clean, too cool in her icy-smooth corsage. Her treatment of her unfortunate and confused brother-in-law (the hero of the novel), although perfectly correct socially speaking, is lacking in natural human warmth. Both la belle Lisa and la belle Normande are typical products of a saturated bourgeois materialism, both represent what Zola calls *"L'égoisme du ventre"* (egoism of the belly), the one masked and disciplined, the other naked and shameless. True social strength is incarnated in the former.

[42]It is noteworthy that *La Gazette des Beaux-Arts,* from its inception in 1859, devoted a large proportion of articles to the study of historic costume. Founder-editor Charles Blanc was himself a keen student of contemporary fashion, and developed novel theories on the subject in his *L'art dans la parure et dans le vêtement,* 1875. In the first volume of the *Gazette* (p. 256) Blanc wrote: *"Le Costume est quelquechose de plus que l'habillement de l'homme, c'est aussi le vêtement de ses idées."*

[43]This phrase was used of Gavarni (cf. Paul Lemoisne, *Gavarni,* 1924, p. 103).

[44]Four times a day was considered a minimum; twelve times a seldom attained ideal.

[45]Roberts-Jones, p. 6.

[46]1880, p. 746; 1881, pp. 38, 109, 196, 286, 316, 344.

[47]Roberts-Jones, p. 73, cites a paragraph from a publication of 1881 which, without mentioning *La Vie Parisienne* by name, seems to describe with shocked enthusiasm a Montaut underwear centerspread.

[48]The evidence is unfortunately lacking in the histories of the satiric press (Roberts-Jones, Lethève). Earlier, *La Vie Parisienne* had suffered from the *"censure préalable"* of suppressed drawings (1872, pp. 588-9, with the spaces left blank). Cf. Appendix.

[49]It is possible she was the exclusive property of *La Vie Parisienne,* for a limited check of other journals does not reveal her name. Her principal rival, Plument corsets, were heavily puffed in at least three journals: *le Bon Ton, le Caprice* and *la Revue de la Mode.*

[50]Cf. the novelette by Paul de Kock, *La Dame aux trois corsets,* which went through ten editions between 1866 and 1884, and the high point of which comes when the heroine's lover convinces all his friends that he has three different mistresses: one of ordinary shape, one wasp-waisted and one full-bosomed. When the friends discover the ruse, the lover abandons his mistress forthwith. (She is not alone for long, however, before she encounters a rich gentleman: "it so happened that at the time Violette was wearing the corset which gave her so slender a waist, and it was this that M. Biche-tout particularly sought in women.")

Cf. also a cartoon by Frédéric Bouchot for an Aubert series of 1843 called *"Les Petits Mystères de Paris"*: *"Couturière: Vous le voyez Madame, pour cette robe de Mademoiselle, j'ai tenu, suivant vos précédentes recommandations, à mettre partout beaucoup d'ampleur." "Oui, mais désormais, je vous recommande au contraire de serrer le plus possible, nous avons maintenant des vues sur un autre épouseur qui, bien différent du premier, aime les formes très sveltes."* A Daumier lithograph of the same period (1840, D. 711) shows an elderly man musing before a store front which displays four very different shapes of corset: *"C'est unique! J'ai pris quatre tailles juste comme celles-la dans ma vie; Fifine ma première! Cocotte, cette gueuse de Cocotte! La grande Mimi, et mon épouse là-haut dans le coin."*

Corsetry as a progressive series of initiation rites is most tellingly rendered in a short story called *"Mon premier corset"* by a Parisienne (*La Vie Parisienne,* 1870, pp. 464-5). The narrator goes to extraordinary lengths (feigning deformity) in order to get advanced from the flimsy little girl's corset to a more substantial curvilinear one, in time for her

Following page:
Henri de Montaut: *Studies of the Toilette,* New Series, I: *Before and after the Corset, La Vie Parisienne,* 1881, pp. 522-3.

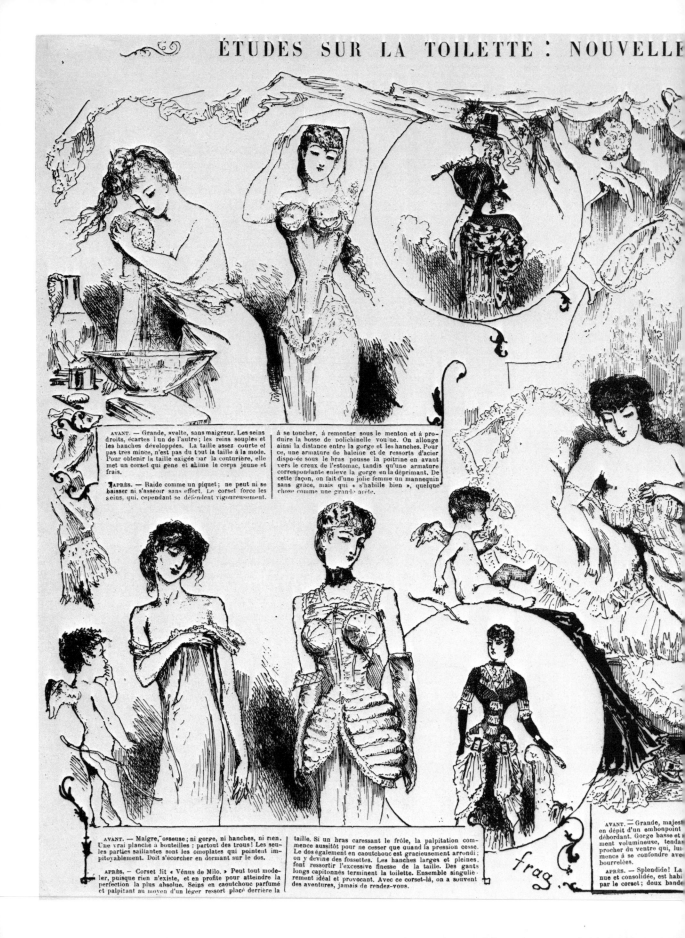

AVANT. — Grande, svelte, sans maigreur. Les seins droits, écartés l'un de l'autre ; les reins souples et les hanches développées. La taille assez courte *et* pas très mince, n'est pas du tout la taille à la mode. Pour obtenir la taille exigée par la couturière, elle met un corset qui gene et abîme le corps jeune et frais.

APRÈS. — Raide comme un piquet ; ne peut ni se baisser ni s'asseoir sans effort. Le corset force les seins, qui, cependant se défendent vigoureusement.

à se toucher, à remonter sous le menton et à produire la bosse de polichinelle voulue. On allonge ainsi la distance entre la gorge et les hanches. Pour ce, une armature de baleine et de ressorts d'acier disposée sous le bras pousse la poitrine en avant vers le creux de l'estomac, tandis qu'une armature correspondante enleve la gorge en la déprimant. De cette façon, on fait d'une jolie femme un mannequin sans grace, mais qui « s'habille bien », quelque chose comme une grande arête.

AVANT. — Maigre, osseuse ; ni gorge, ni hanches, ni rien. Une vrai planche à bouteilles : partout des trous ! Les seules parties saillantes sont les omoplates qui pointent impitoyablement. Doit s'écorcher en dormant sur le dos.

APRÈS. — Corset dit « Vénus de Milo. » Peut tout modeler, puisque rien n'existe, et en profite pour atteindre la perfection la plus absolue. Seins en caoutchouc parfumé et palpitant au moyen d'un léger ressort placé derrière la

taille. Si un bras caressant le frôle, la palpitation commence aussitôt pour ne cesser que quand la pression cesse. Le dos également en caoutchouc est gracieusement arrondi ; on y devine des fossettes. Les hanches larges et pleines, font ressortir l'excessive finesse de la taille. Des gants longs capitonnés terminent la toilette. Ensemble singulièrement idéal et provocant. Avec ce corset-là, on a souvent des aventures, jamais de rendez-vous.

AVANT. — Grande, majest en dépit d'un embonpoint débordant. Gorge basse et ment volumineuse, tendan procher du ventre qui, lu mence à se confondre ave bourrelés.

APRÈS. — Splendide! La nue et consolidée, est habi par le corset ; deux bande

frag.

AVANT. — Petite, houlotte, la gorge est ballonnée, les hanches étalées ; la distance entre le dessous du bras et la taille semble une succession de doubles mentons étagés. Le dos a l'air de s'être trompé d'étage.

APRÈS. — Un corset de coutil renforcé à triples ressorts avec boucles de sûreté a raison de tout cela. Les doubles mentons disparaissent, se dispersant on ne sait où ; le ballonnement de la gorge devient une aimable rondeur ; le dos s'aplatit, la raie qui le partageait s'efface grâce à un appareil refoulant, et on n'a plus devant les yeux qu'une femme douée d'un gracieux embonpoint.

sent pour la soulever et se serrent le dos au moyen d'une boucle. Cela ffillir et donne l'illusion du marbre. abile et vigoureuse pression force hesses du ventre et des hanches à adre et à dégager la taille. Impos- avec une robe décolletée dans le cause du système destiné à faire r la poitrine. Ce corset est affec- des beautés imposantes aux- s les grandes fraises et les costu- ouis XIII vont à ravir.

AVANT. — La taille large, carrée, la gorge tombante ; es ...c..es b ses et à peine marquees ; les côtes sor- ies ; le dos cre x aux épaules et bombé aux reins ; le ven e gros.

APRÈS — Le corset inflexible remet chaque chose à a place et lui donne la valeur voulue. Une barre d'a- er transversale semblable à la « planchette » des Ita- iennes, soutient et élève la gorge, tandis qu'une autre plus souple l'arrête dans son ascension, et la comprimant, lui donne une apparence de fermeté. Prodigieusement serrée, la taille diminue de volume et prend une certaine élégance. Un réseau de baleines et de ressort savamment entrecroisés aplatit le ventre qui s'étal sur les côtés et forme des hanches de fantaisie qu peuvent très bien être prises pour des hanches vérita bles.

First Communion. She thereafter becomes obsessed with her bridal corset: "in my head marriage was indissolubly bound up with a satin corset." Finally: "and to think that I profited from my marriage in order to leave them [corsets] off altogether!"

[51]*La Cousine Bette*, 1846, Pléiade ed. 1950, p. 494.

[52]To mention Pradier in this connection is to pay lip-service to his considerable reputation. He was a cold, academic sculptor scorned by Baudelaire (*Salon de 1846*, xvi, and would have found comparison with a corsetière both ridiculous and offensive. He was known for his detestation of the corset, as the following anecdote testifies: Alphonse Karr was invited by the sculptor to view the most beautiful model he, the sculptor, had ever met. Karr agreed she was quite perfect. Suddenly Pradier contracted his brow. "Oh you wretch, etc. etc." he cried, swearing volubly. The girl tried weakly to defend herself, having immediately understood the reason for the sculptor's sudden anger: "No, no, I assure you, Monsieur Pradier, you are making a mistake . . ." "A mistake, a mistake? You must be more stupid than–all I have just said. Do you imagine I can't tell . . ." Karr was stunned, unable to grasp the cause of all this fury. Pradier finally explained: "What a shame that such beautiful bodies are given to such foolish hussies! Like giving the plumage of a swan to a donkey who would go and dirty and trample it in the mud! No way of preventing them from wearing that abominable apparatus they call a corset! They want to be slender, to be held in the ten fingers of their lovers! And in order to be more slender, they dishonor their hips, they ruin their breast, they atrophy their belly! All that for some rogue, some dance-hall creep!" Pradier was seized again by a violent anger. He threw the model her clothes. "Go and dress, I don't want to see you again, get out!" (Léon Treich, "*Le Corset à travers les siècles*", in *Paris-Caprice*, n.d., numéro spécial, "*Les Corsets.*")

[53]*Le Salon de la Mode* 1879, pp. 14-15.

[54]Notably the doll-like Mme. Michel Lévy (National Gallery Washington, 1882), who is the very incarnation of *La Vie Parisienne;* and the barmaid in the *Bar aux Folies Bergères* of the same period. Nana, in her sky-blue cuirasse corset, was painted in 1877, that is, two years before Montaut published his "*Considérations sur le Corset,*" and one year after the same artist's analysis of the difference between the natural deformity of the bather and her perfection of form when corseted. The painting of Nana was refused at the Salon on moral grounds, and enjoyed such a succès de scandale when exhibited in a fashionable shop on the Boulevard des Capucines, that police intervention was required.

That Manet should have chosen to paint a courtesan in her cuirasse corset may be regarded as a personal response to the new provocative fashion. It is easy to think of Manet, in his own person of almost dandy-like elegance, very fashion-conscious in his paintings (especially towards the end of his life), very much the mondain in his behavior, as a subscriber to *La Vie Parisienne.* It would certainly repay the specialist art historian of this period to examine this magazine for cross-currents, and even "influences." Around 1872, for the first time in a decade, Manet returned spasmodically to the nude and undressed female, and together with Degas moved towards casual-looking study of those more intimate aspects of life (women taking baths, tying garters, etc.), which Montaut was simultaneously beginning to "physiologize." The voyeurism of the gentleman watching Nana dress is akin to that introduced even more brazenly by Montaut (the men look through binoculars and slaver at the mouth). The fact that Nana is putting on lipstick might be taken as a homage to Baudelaire, that lonely defender of maquillage, and contributed essentially to the moral outrage voiced by the critics. A pastel painting of 1878 (Copenhagen) showing a woman tying her garter by bending forward over her corset (evidently cuirasse style again, with "pouter-pigeon" uplift) might almost be an illustration to the Baudelaire line cited in context above, "*pétrissant son sein sur le fer de son busc.*" It is noteworthy that Degas in his dance-rehearsal scenes of this period becomes more conscious of the indentation in the silhouette caused by the corset (not of course a cuirasse, but a no less wasp-waisted, shorter and lighter "Swiss belt" with rubber inserts).

Insofar as the "painting of modern life" was only in its infancy at the time *La Vie Parisienne* was born, one could well make a case for the magazine as pioneer not only in fashion illustration and caricature (as we have tried to demonstrate above), but also in "high art"–opening an uncharted, monochrome but piquant trail to those dazzling boudoir, opera, dance-hall and racetrack scenes of the Impressionist and Post-Impressionist painters. Beatrice Farwell's forthcoming intensive study of erotic iconography of the early

Second Empire, centering upon Manet's Olympia, should too throw light on this whole neglected area; I have profited from advance knowledge of her discoveries, and would like to take this opportunity of thanking her for reading and offering helpful criticisms of my text.

[55]*Militona*, 1847 (Work of T.G., transl. by F-C. de Sumichrast, 1907, vol. 21, p. 64).

[56]French costume historians are silent on the subject. The only French-language defence of tight-lacing known to me is the pamphlet by "Miss Seeker," *Monographie du Corset,* Louvain, 1887, 22 pp. There was however one French physician, the illustrious orthopedic surgeon Henri Bouvier, who became notorious (in medical circles) for condoning fashionable extremes of corsetry. In England, on the other hand, the pro-tight-lacing view was propagated continuously in various popular journals and little handbooks throughout the turn of the century.

[57]Balzac, *Le Père Goriot* (1830), Lévy, 1891 ed., pp. 220, 223; and *La Vieille Fille* (1836), Pléiade ed., IV, pp. 301-4.

[58]Suspenders (garters) were a novelty at this time, and considered "fast," Cf. 1879, p.588 for a full analysis of the two alternative methods of suspension.

[59]Dress-reformers of the late nineteenth century were wont to accuse certain sculptors of having succumbed to the corrupt ideal of fashion, and often picked on Carpeaux' *La Danse,* 1867, on the façade of the Opéra. This group was much criticized at the time for its "vulgarity," and it is instructive to observe how *La Vie Parisienne* in a centerspread travesty of the group (1875, p. 90), is able to clothe the naked forms in sexy fancy dress without much alteration to the proportions given them by Carpeaux. Needless to say, Carpeaux' principal figure is relatively classical compared to Montaut's.

[60]"Women and girls with overdeveloped breasts and hips, rouge-plastered complexions, charcoal daubed eyes, blood-red lips, laced up, strangled, rigged out in outrageous dresses, trailed the crying bad taste of their toilettes over the fresh green sward . . ." *(Paul's Mistress* [*La Femme de Paul*], Maupassant, *Short Stories,* Dunne, New York and London, 1903, II, p. 258).

Bibliography (includes only those works cited more than once in text):

Grand-Carteret, John. *Le Décolleté et le Retroussé. Quatre Siècles de Gauloiserie* (1500-1870), Paris 1887.

Léoty, Ernest, *Le Corset à travers les âges,* Paris 1893.

Libron, Fernand et Henri Clouzot. *Le Corset dans l'Art et les Moeurs du XIIIe au XXe siecle,* Paris 1933.

Roberts-Jones, Philippe. *De Daumier à Lautrec,* Paris 1960 Soemmerring, Dr., *Ueber die Wirkungen der Schnürbruste,* Berlin 1788 and 1793.

Waugh, Norah. *Corsets and Crinolines,* London 1954.

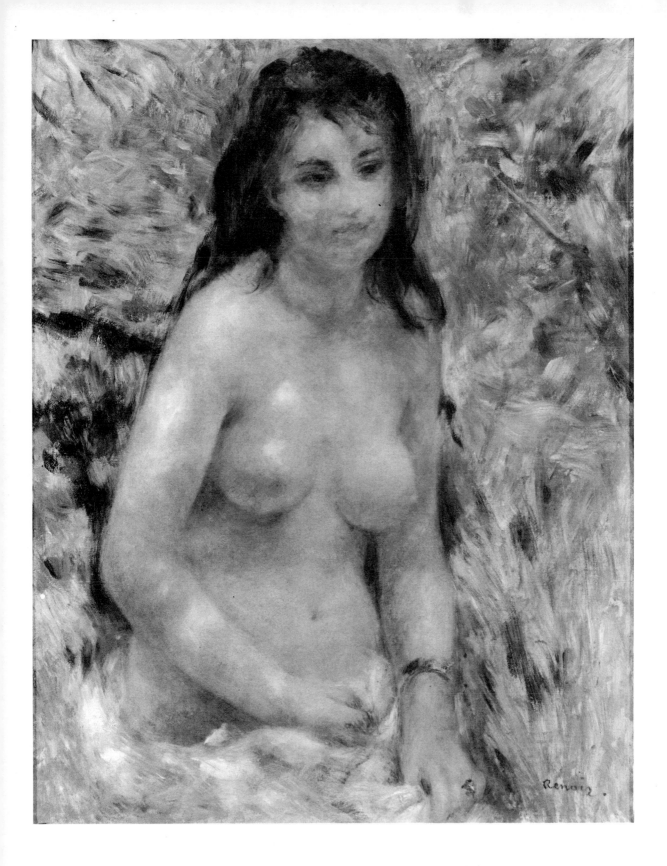

By Barbara Ehrlich White

Renoir's Sensuous Women

Author: Barbara Ehrlich White
has taught at Queens College,
Boston University and Tufts. She
has written for *The Art Bulletin*
and other journals. Currently
she is writing a book on Renoir's
development and editing an
anthology of Renoir's letters.

Renoir may be the last of the great sensual painters of ideal women, continuing in the spirit of Rubens, Fragonard and Ingres. His attitude towards the nude woman changed as he aged; however throughout his life, Renoir painted nudes from a man's point of view, as a source of delight for men's eyes. In essence, Renoir created an art about women for men to enjoy.

A photograph of the artist taken in 1919 and his painting of bathers from around the same time show striking contrasts between the artist and his work. Renoir was then 78 years old and badly crippled with rheumatoid arthritis. He was unable either to walk or to move his hands. He painted with twisted fingers gripping his brushes. He complained that he was a "disgusting object," and that he suffered day and night.[1] Physically he was emaciated and crippled below the neck, yet his creative mind and alert eyes were vibrant with sensuous thoughts.[2] In complete contrast, his nudes are small-headed, mindless and unexpressive above the neck. What counts is below. The bathers are young fat creatures with warm bodies whose skin glows with light. This group of healthy relaxed women thrives in a fertile landscape. The female nudes call to mind women giving sexual pleasure to men and bearing men's children.

In the 1870s, during his Impressionist years, Renoir was a healthy man in his 30s. He led a sociable existence as part of a group of young artists–Monet, Pissarro, Sisley, Cézanne and others–who painted together in Paris and in its suburbs. His genre scenes, such as the *Moulin de la Galette,* 1876, portray his male as well as his female companions. During these years, he was very poor but he was free to enjoy different women's company. He had affairs with several women who were also his models (Lise, Margot and others). Contemporary descriptions of Renoir as well as his *Self-Portrait* of 1875 reveal him as an intense man of delicate build and exceedingly shy. He called himself the "timid one."[3] His brother Edmond wrote a description of the artist in 1879, when Renoir was 38 years old, stating that he was a thinker, a dreamer, a serious, forgetful, disorganized man who was only really alive when he was painting.[4]

Nude in Sunlight, ca. 1876, 31¾ inches high. Louvre.

Renoir considered himself a lower-middle-class workman painter. He was aware that he annoyed certain upper-class patrons. For example, Mme. Émile Blanche, wife of a prominent neurologist, complained to her husband that Renoir had slovenly clothes, muddy shoes and bad table manners: he ate slowly and made clicking noises. In addition, she found him intolerably nervous: he rubbed his nose with his index finger

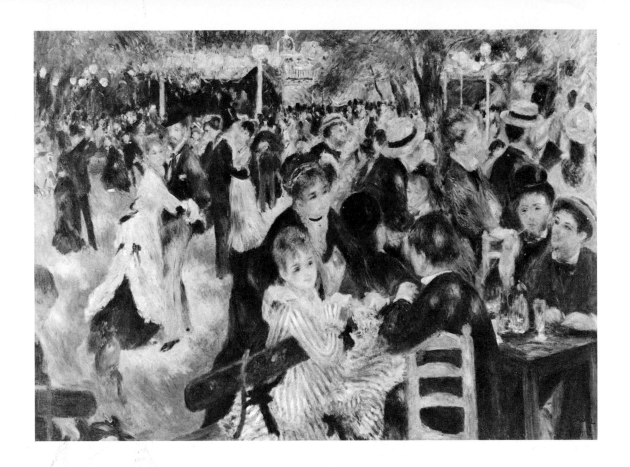

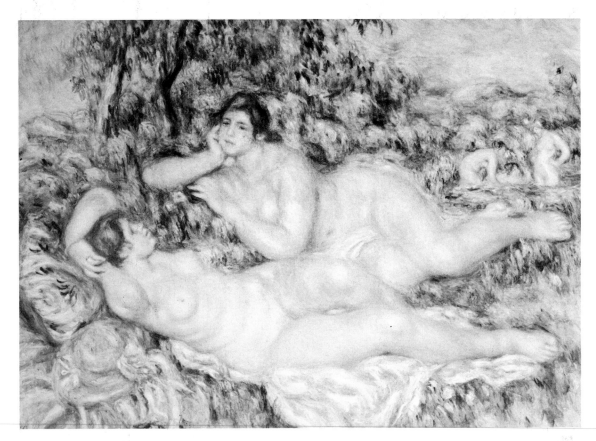

Renoir's *Self-Portrait*, 1875,
15½ inches high. Clark
Institute, Williamstown, Mass.

Renoir at 78, photographed in
1919, the year of his death.

Upper left: *Moulin de la Galette*,
1876, 30⅞ inches high.
Collection John Hay Whitney.

Left: *Bathers*, ca. 1918,
43 inches high. Louvre.

and fiddled with his jacket lapels.[5] Other patrons and his friends, however, accepted the artist without ridicule.

Renoir's personal tenseness is transformed into convivial relaxation and radiant delight in *The Loge* of 1874 and in *The Swing* of 1876. A free sociability enables men and women to relate to one another in a joyful, unpossessive manner. One senses equality between the sexes.

To characterize Renoir's Impressionist woman, Renoir's friend Théodore Duret wrote in 1878: "I doubt that any painter ever interpreted woman in a more seductive manner . . . Renoir gives his women gracefulness, lightness and freedom . . . These painted women are bewitching and enchanting . . . They would be ideal mistresses–always sweet, gay and smiling . . . the true ideal woman!"[6]

Renoir made only about a dozen paintings of nudes during the 1870s. The *Nude in Sunlight*, ca. 1876, captures the eighteenth-century Rococo spirit of Fragonard's *Bathers*. Renoir's nude woman is provocative, alluring, but unattainable. She moves through the grass and is dissolved by the sunlight. She is intangible and elusive–like perfume.

The 1880s–especially the mid-1880s–were a time of great change in Renoir's life and art, and brought him much anxiety and difficulty. In 1881, the artist turned 40, and he worried about approaching middle-age.[7] A financial depression hit France in 1882 and, as a result, Renoir was extremely poor from 1883 through 1887. Often he felt lonely, since the Impressionist group had split apart and the old friends worked far from one another. Two important events occurred that affected the future course of his life and art. First, in 1881, he went to Italy and his painting subsequently changed to become idealized, classical and conservative.[8] Second, in March, 1885, Aline Charigot bore him a son, Pierre, who was named after his father.[9] The painting of *Aline Nursing Pierre* was done when the child was about a year old.

For Renoir, paternity at the age of 44 meant a permanent commitment to live with a woman who was very different from himself. Aline, 26 years of age when their first child was born, was a peasant woman from Burgundy. While Renoir was very thin, she was fat.[10] While he was a nervous, intense, unpredictable artist, she was an unruffled country girl. His commitment to parenthood with Aline marked a change for him from public, urban sociability with male friends to increasing amounts of time spent in private, rural domesticity in a woman's world.

We have seen that in the 1870s men were frequently present in Renoir's paintings. After 1885 men disappear from his scenes. Instead of being participants, they move out of the paintings to become observers. Indeed, a male spectator is always implied as the viewer of Renoir's women.

After 40, Renoir became increasingly conservative in his attitudes and in his art. In the 1880s he wrote against modernity, against industrialization,[11] against the rising tide of feminism. Today we might consider him a well-meaning male chauvinist. He believed that there was a great difference between men and women. He believed that men should be thinkers, artists and intellectuals, while women should be sources of pleasure for men–in sex, in mothering, in homemaking. When his

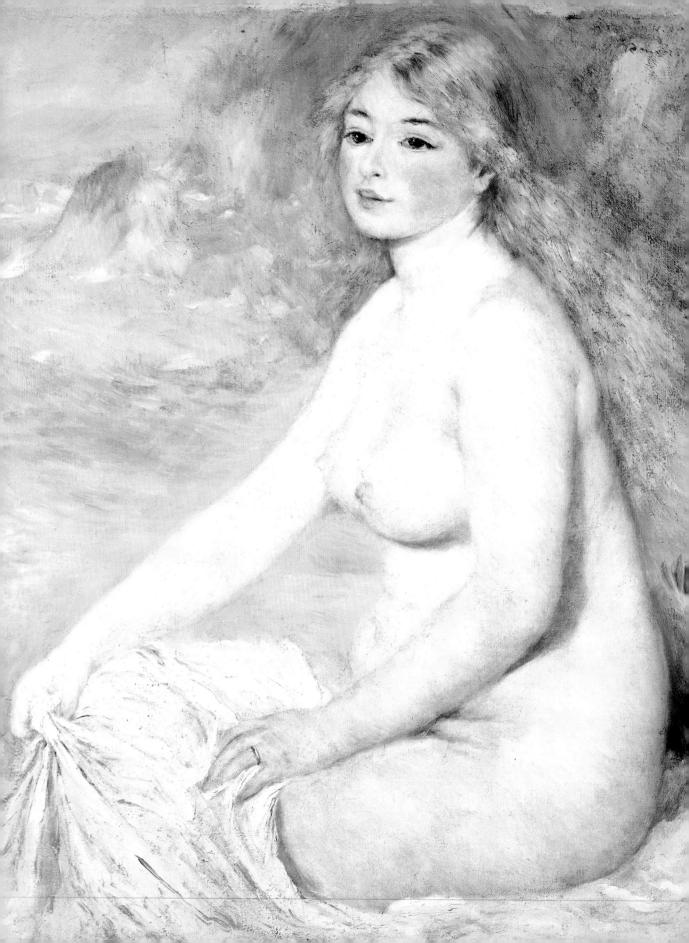

Fragonard: *Bathers*, ca. 1755.
25 inches high. Louvre.

Blonde Bather, 1881, 32⅛
inches high. Clark Institute,
Williamstown, Mass.

friend the poet Catulle Mendès asked Renoir's opinion on feminism, Renoir wrote in a letter of April 8, 1888: "I consider that women are monsters who are authors, lawyers and politicians, like George Sand, Madame Adam, and other bores who are nothing more than five-legged beasts. The woman who is an artist is merely ridiculous, but I feel that it is acceptable for a woman to be a singer or a dancer. In Antiquity and among simple people, women sing and dance and they do not therefore become less feminine. Gracefulness is a woman's domain and even her duty. I know very well that today things have become worse, but what can we do? In former times, women freely sang and danced in order to be winsome and pleasing to men. Today they must be paid off; the charm is gone."[12]

Reflecting this attitude, by around 1885 Renoir's young carefree girls disappear; they are replaced by mature peasants who are isolated in the country where they nurse and kiss children, wash clothes and fix their hair in various stages of undress. In three painted versions and numerous drawings, Renoir portrays Aline nursing Pierre. In each painting, Renoir focuses on his wife's exposed breast and upon the little boy's naked lower half.[13] Renoir here limits himself to the purely physical relationship, not the emotional relationship of nursing.

In a painting of ca. 1886, a washerwoman kisses her child in a stiff, possessive manner with locked fingers, while the child seems quite unaf-

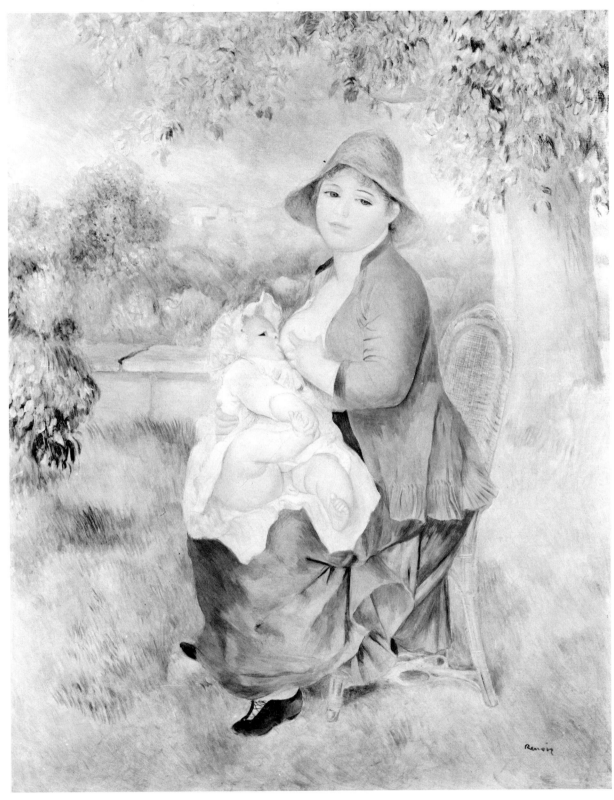

Aline Nursing Pierre, ca. 1886, 31½ inches high.
Acquavella Galleries, New York.

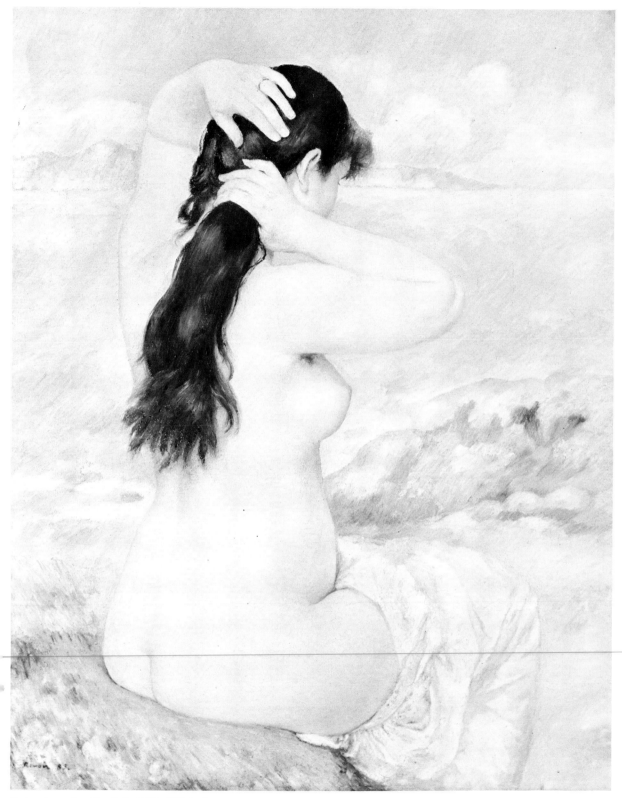

Bather Arranging Her Hair, 1885, 36¼ inches
high. Clark Institute, Williamstown, Mass.

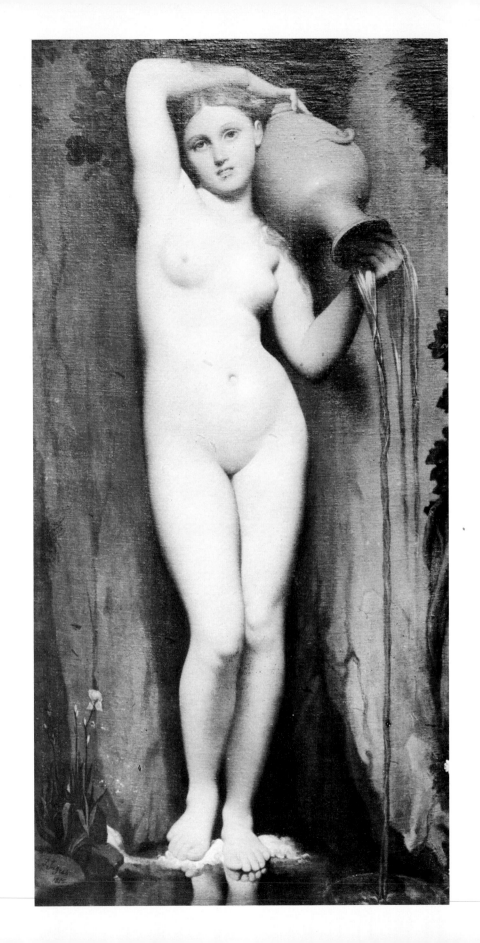

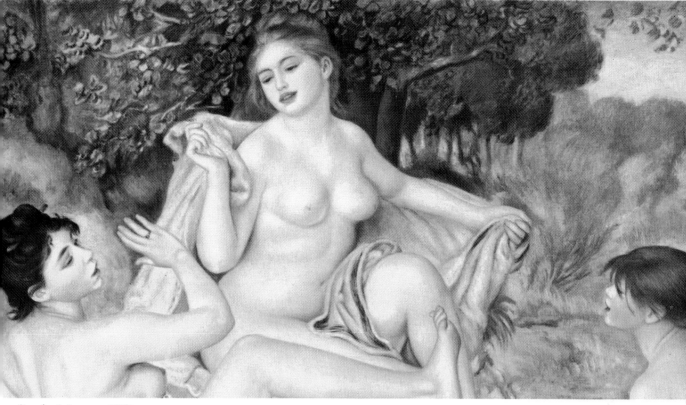

Grandes Baigneuses, 1887,
45½ inches high (detail above).
Philadelphia Museum.

fected; in the background other women hang out laundry. In a painting of ca. 1885, a buxom woman braids her hair; her partially exposed breast is meant to be sexually provocative but her face is devoid of expression or feeling and her body is hard–like sculpture.

From 1885 through 1887, Renoir's paintings of the nude also contain this quality of a woman being all body and no mind or feelings. Indeed, there is a great change from the elusive Impressionist woman of the 1870s to the formal, physical woman of the mid-1880s. The *Bather Arranging Her Hair* of 1885 shows a traditional debt to Ingres' *The Source*. Before 1885, Renoir had painted few nudes. However in January, 1886, he told Berthe Morisot that nudes seemed to him one of the essential forms of art.[14] And, beginning in 1885, the idealized nude woman becomes Renoir's most common theme.

Renoir's treatment of nudes from 1885 through 1887 is curiously strained and contrived. This is evident both in such single versions as *Bather Arranging Her Hair*, 1885, and in groups of bathers–like the renowned *Grandes Baigneuses*, 1887. The nudes are isolated from nature because of a stylistic difference between the Impressionist setting and the classical figures with their linear form and structured composition. Also, the nudes appear enormous in size compared to the landscape. Renoir tries to make the bathers sexually alluring and provocative. He manipulates the figures to call attention to breasts, bellies and buttocks. However the womens' poses are self-conscious and stiff, lacking freedom and vitality. His overworked, unsuccessful canvases have a sterile eroticism. These nudes are sex objects devoid of convincing sexuality.

To venture into the area of psychological causation to help explain

Ingres: *The Source*, 1856,
64⅜ inches high. Louvre.

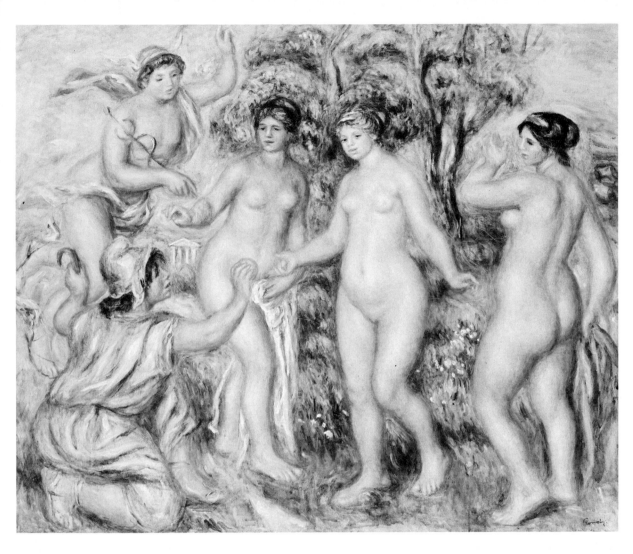

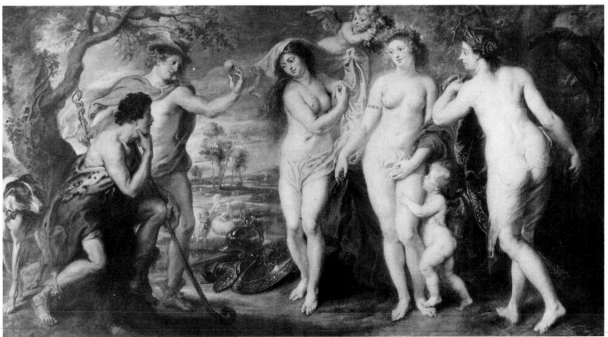

artistic change is difficult, especially as Renoir's letters are always guard-edly impersonal. Furthermore, Renoir's feelings were puzzling even to his friends. As Pissarro wrote in 1887, "Nor can I understand what is in Renoir's mind–but who can fathom that most variable of men?"[15] Nonetheless it is important to pause and consider the following questions: What was the effect of having a son in 1885 on the 44-year-old Renoir? Why did he concentrate on the nude from 1885 onwards? And why were the nudes of 1885 through 1887 so contrived and so lacking in feeling? We might speculate upon several possible answers to these ques-tions. As Jean Renoir wrote, "the birth of my brother Pierre was to cause a definite revolution in Renoir's life."[16] We know that from 1883 through 1887 Renoir was extremely poor and having a child and wife to support compounded his problems. He may have felt displaced by having a baby who demanded so much of Aline's attention.

There may have been other sources of anxiety since Renoir kept his son's very existence a secret from such close friends as Berthe Morisot and her husband Eugène Manet until 1891, when Pierre was 6 years old.[17] A possible explanation for this strange behavior is the fact that Aline was a peasant and that the Manets were wealthy and knew rich people who were potential patrons. Hence Renoir may have had some anxiety about Aline's social class. Finally, although it is impossible to prove, it is interesting to hypothesize that Renoir could have been trou-bled by woman-envy–specifically envy of a woman's ability to give birth to children. By 1885, Renoir had been prolific in producing images of people for over 20 years. However, as a male he could not produce humans in the flesh. While this is only speculation, it may be one reason why Renoir went through a crisis when Aline bore his first child. As we have said, during the two years following Pierre's birth, Renoir worked very hard to create a sensual art, but without success. However, if he did feel woman-envy, this was transformed into woman-veneration after 1887.

By 1890, as in *After the Bath,* ca. 1890-95,[18] Renoir's nudes lose the self-conscious, artificial character of the mid-1880s and from 1890 until his death in 1919, Renoir created relaxed, voluptuous nudes. After 1890, the classical figure and the Impressionist landscape are fused in what could be called Renoir's unique classical Impressionism.

For the last three decades of his life (when Renoir was in his 50s, 60s and 70s), he was plagued with progressive physical pain and deterio-ration. His facial paralysis and first signs of rheumatism started in 1888. Crippling rheumatism in the joints began in 1894. In 1899 he wrote that his physical condition rendered him more nervous than usual. In 1904 he acknowledged awareness of his worsening state. In 1905, the artist was confined to a wheelchair. By 1910, he no longer could walk. Two years later, his hands could not pick up anything. At the end of his life, the artist, immobilized, suffered continuously.

Beginning in the 1890s and until his death 30 years later, Renoir was increasingly dependent upon his wife, his models and maidservants for his daily existence. During his last 10 years he had to be dressed,

Renoir: *Judgment of Paris,* ca. 1914, 28¾ inches high. Collection Henry P. McIlhenny.

Rubens: *Judgment of Paris,* ca. 1638-9, 78⅜ inches high. Prado, Madrid.

Three Bathers, 1897,
21½ inches high (detail above).
Cleveland Museum.

Woman and Child, ca. 1895,
46 inches high. California
Palace of the Legion
of Honor, San Francisco.

fed and carried. As an invalid, he became more like an infant in relation
to the mother-figures that helped him. Perhaps as an optimistic heroic
counterbalance to his pitiful physical infirmity, his nudes become increas-
ingly sensuous and idealized. He worships the nude female body as
a strong life-sustaining being.

In 1911 Renoir wrote a preface to a translation of the late 14th-century
treatise of Cennino Cennini in which he deplores the loss of the ideal
in modern art. He expresses veneration for the noble and harmonious
in art, from Pompeii to the divine Raphael, to Titian, Poussin, Ingres
and Corot.[19] It is within this framework that we can see Renoir's nudes
following time-hallowed ideas of order, hierarchy and tradition.

For example, the *Judgment of Paris,* ca. 1914, is classical in theme,
erotic in content and follows closely in the ideal tradition of Rubens.
In his painting Renoir used female models for all the figures–including
the two males, Paris and Mercury.[20] At this time, Renoir was totally
immersed in a female world. His sensuous bathers are lusty in their
warm red-orange color and their nudity. Renoir has synthesized classi-
cism in the form and composition and Impressionism in the free stroke

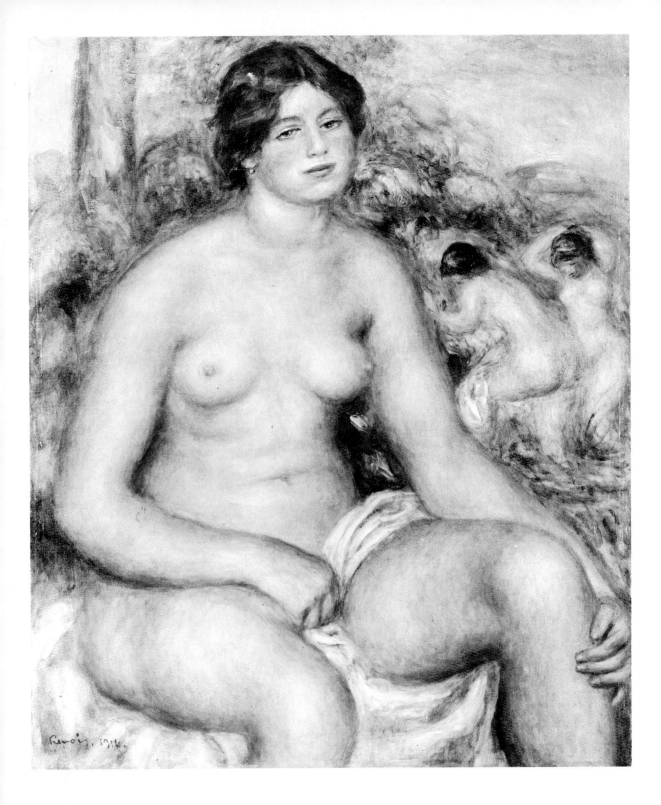

and shimmering light. To Renoir, the nude woman is sexuality, maternity and comfort. The late bather could be called "mother nature" or "mother earth." The nude is a fertility goddess–the ultimate symbol for the continuity of life.[21]

Research for this paper was partially supported by the Sameul H. Kress Foundation, the National Endowment for the Humanities, and the Tufts University Faculty Research Fund.

[1]Jean Renoir, *Renoir My Father,* Boston, 1962, p. 453.
[2]*Ibid.,* pp. 205-206.
[3]See letter to an unnamed friend, Palermo, Jan.14, 1882, in Barbara Ehrlich White, "Renoir's Trip to Italy," *Art Bulletin,* LI, Dec., 1969, p. 349.
[4]*Edmond Renoir's letter of June 19, 1879,* published in *La Vie Moderne,* cited in Lionello Venturi, *Archives de l'Impressionnisme . . .,*II, Paris, 1939, pp. 337-338.
[5]B.E. White, *op. cit.,* p. 340, n. 69, n. 70.
[6]Théodore Duret, "Les peintres impressionnistes," Paris, 1878, reprinted in Théodore Duret, *Histoire des peintres impressionnistes,* Paris, 1922, pp. 27-28.
[7]See Renoir's letters to Durand-Ruel, L. Venturi, *op. cit., I,* pp. 116, 122.
[8]See B.E. White, *op. cit.,* pp. 333-351.
[9]The couple was officially married five years later. The marriage contract of April 14, 1890, states that the couple had *"déclaré reconnaître pour leur fils en vue de la légitimation devant résulter de leur mariage, Pierre, né à Paris, le vingt et un mars mil huit cent quatre-vingt-cinq, inscrit le surlendemain en la dix-huitième Mairie comme le fils de Pierre Auguste Renoir, et de Aline Victorine Charigot."*
[10]Berthe Morisot, letter to Mallarmé, fall, 1891, cited in Denis Rouart, *Correspondance de Berthe Morisot,* Paris, 1950, p. 163.
[11]See Renoir's platform for "La Société des Irrégularistes" that the artist included in a letter to Durand-Ruel of May, 1884, cited in L. Venturi, *op. cit., I,* pp. 127-129.
[12]Letter quoted in François Daulte, *Auguste Renoir Catalogue Raisonné,* I, *Figures 1860-90,* p. 53. Similar male-chauvinist pronouncements are recollected by Jean Renoir, *op. cit.,* pp. 69, 88-89, 373. Compare the artist's attitude with the content of Linda Nochlin's article, "Why Have There Been No Great Women Artists," ARTnews, LXIX, Jan. 1971, p. 22 f.
[13]Prof. Meyer Schapiro has pointed out that Renoir shows a child naked below the waist in *Le Premier Pas,* 1880, illus. in F. Daulte, *op. cit.,* pl. 347. Also in Daulte, see illustrations for two other versions of *Mme. Renoir Nursing Pierre,* pl. 485 and 497; *Washerwoman and Child,* pl. 509; and *Braid,* pl. 458.
[14]Berthe Morisot's diary entry of Jan. 11, 1886, D. Rouart, *op. cit.,* p. 128.
[15]Pissarro letter to his son Lucien, Eragny, Feb. 23, 1887, cited in *Camille Pissarro: Lettres à son fils Lucien,* John Rewald, ed., Paris, 1950, p. 134.
[16]Jean Renoir, *op. cit.,* p. 250.
[17]D. Rouart, *op. cit.,* p. 161.
[18]F. Daulte, *op. cit.,* pl. 617.
[19]Cited in Michel Drucker, *Renoir,* Paris, 1944, pp. 172-173.
[20]As his son recalls, "The nudity of women seemed natural to him, whereas he was embarrassed by the naked male body." Jean Renoir, *op. cit.,* p. 355.
[21]See also Barbara Ehrlich White, "Renoir's Girl Outdoors, a Stylistic and Developmental Analysis," *North Carolina Museum of Art Bulletin,* Sept. 1970, pp. 12-28.

Seated Nude, 1916, 32⅛ inches high. Chicago Art Institute.

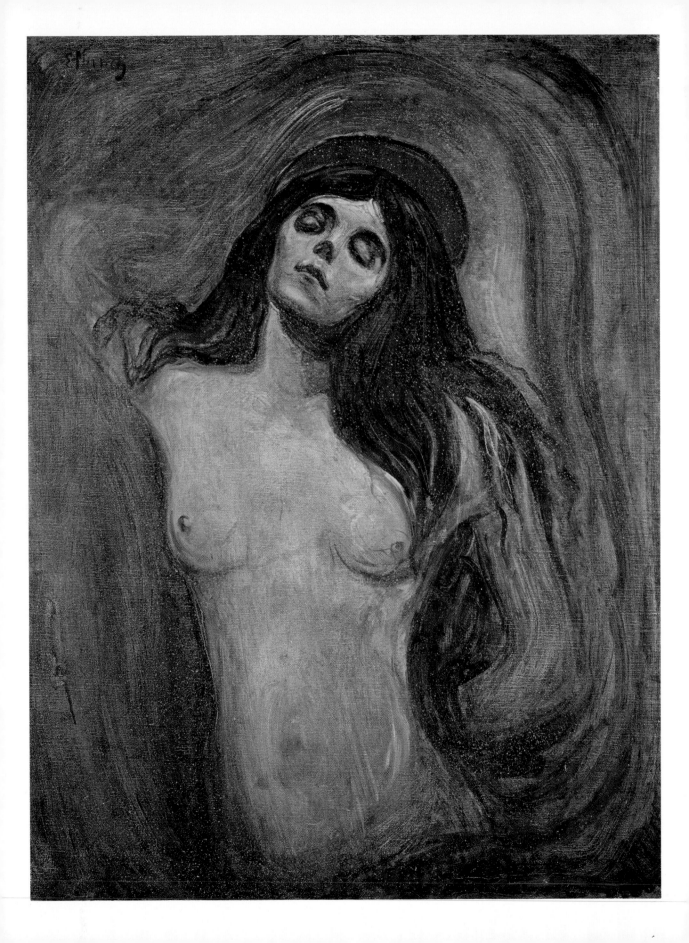

The Femme Fatale and Her Sisters

Author: Martha Kingsbury is a professor of art history at the University of Washington, Seattle; she recently organized and wrote the catalogue for an exhibition of the art and architecture of the '30s in the Pacific Northwest.

Toward the end of the nineteenth century, a particular configuration or group of attributes was so widely and consistently identified with the femme-fatale type of woman, that implications of the type could be carried into less obvious contexts by the use of that same configuration. A degree of erotic content, which certain types of portraits or genre scenes could share with more obvious images of female sexuality, can now be and apparently was also then recognized by means of this imagery. Popular art–cartoons for example–as well as "high art" participated in the image. The configuration is essentially ambivalent and stemmed from two sorts of traditions, making its widespread use easier and its insinuating or suggestive quality stronger. The configuration in question is that of a woman seen frontally; her upright and frequently taut posture is combined with a thrown back head and lowered eyelids. Concentric patterning (either through handling of the medium itself or through depicted accessories, such as hair) frequently reinforces the image. The upright carriage projects power and control, over self or others as the case may be, and has its roots in such widely-known types as Gustave Moreau's Salomés. But the thrown-back head and lowered eyes (sometimes accompanied by a slack jaw, loosed hair or raised arms) seem to signal both abandon and acquiescence, and have precedents among the Odalisques of earlier decades (Delacroix, or Renoir of 1870, for example).

In its clearest expressions this configuration was frequently intensified by mythic or religious implications. Klimt's *Judith* or Munch's *Madonna* are excellent examples. Their erect postures signify a threatening power, but the suggestion of ecstasy in their heavy eyelids and thrown-back heads signifies a loss of control in their moment of triumph. (The emphasis is different in each, of course.) Such a femme fatale often seems to exercise her power through the hypnotic fascination she actively compels, and also, paradoxically, through abandoning herself to her role in total self-forgetting passion. The separate components of the configuration are often in themselves ambiguous (the gaze from under heavy lids can imply cold calculation in *Judith*, or delirium in the *Madonna*), and combinations of attributes make them doubly ambiguous.

By the last years of the century the femme-fatale configuration was widespread under the guise of vaguely symbolic or allegorical figures. For example, Franz von Lenbach's paintings of women nude above the hips with loose hair streaming against a dark ground, titled *Voluptas* (1895) and *Ecstasy* (1903), employed the configuration quite directly.

Edvard Munch: *Madonna*, 1893-94, 35½ inches high. Munch Museum, Oslo.

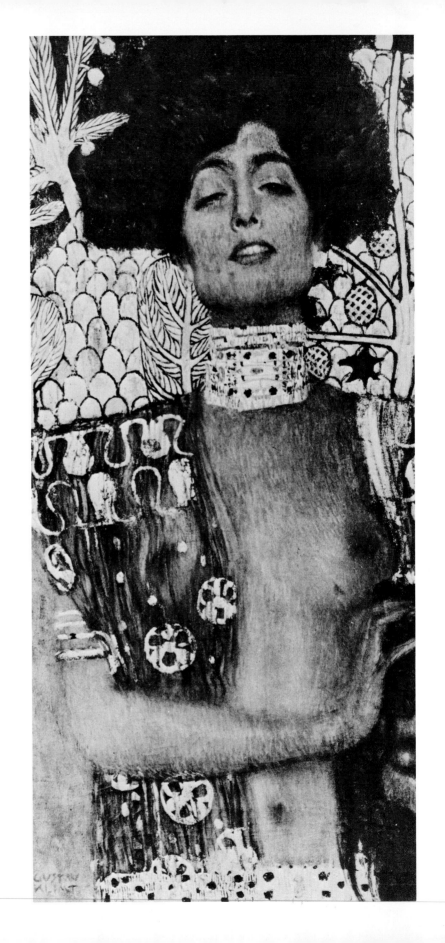

Delacroix: *Woman with Parrot,* 1824, Musée des Beaux Arts, Lyon.

Gustave Moreau: sketch for *The Apparition* (Salomé, "tattooed" version), ca. 1875. Moreau Museum, Paris.

Gustav Klimt: *Judith,* 1901, 33 inches high. Osterreich- ische Galerie, Vienna.

In portraits of his wife and daughters or of himself, the image occurs more subtly: though his self-portrait as St. John in the Lenbachhaus, Munich (his own head portrayed on the charger carried by Salomé), is a blatant transferral of such meaning to a personal level, a portrait of his wife of 1901 merely alludes to the configuration through posture, expression and the absorbing dark ground. By about 1903 the same female types and related postures had spread as far as Japan, where they occur frequently in paintings of mythic import by Aoki Shigeru.

The group of attributes was quickly adapted to non-literary subjects. Entanglements of this mythic femme fatale with a real individual or with an unspecified, generalized figure occur in works of Edvard Munch. The visual characteristics of his *Madonna* (1893-94) are obviously related to his lithograph of Eva Mudocci of 1903; and in the lithograph of the same year of *Salomé*, Eva Mudocci merged with the femme fatale while Munch's self-portrait merged with the sacrificial figure of John. In many works such as his lithographs, *Lovers in the Waves*, 1896, or *The Kiss of Death*, 1899, the woman is less specific and represents by implication all women or any woman both seductive and destructive. The power of feminine sexuality is latent, soon to be released, in the taut body and compelling face of the virginal figure in Munch's *Summer Night (The Voice)*, in several versions from the mid-'90s; it is more freely if subtly manifested in the lithograph of a *Woman Resting,* leaning back with raised arms, as late as 1919-20.

The live rather than literary individuals most frequently touched by the femme-fatale configuration, with its implication of compelling sexual power, were actresses. Because they exerted a compelling fascination for the public, their popular personalities already had something in common with the femme-fatale image. The stage roles with which an actress might become identified, in an era when Salomés were so popular in operas and plays, could be a factor. But more basic was the way in which an actress seemed to exert her power through a passionate and energetic projection of her personality even while, paradoxically, playing a role in which her own identity might be endangered or lost. This assertion of power through loss of self on the stage was analogous to the simultaneous threat and sacrifice of sexual passion, through which the femme fatale both overpowered and submitted to her victim. An actresse's power was considered to reside in the real woman rather than the stage character. A series of portraits by John Singer Sargent of theatrical personalities illustrates this. His *Ellen Terry as Lady Macbeth,* 1889, is a full-length portrayal of the costumed figure at the mad aggres- sive moment she crowns herself. The tall figure with raised arms and crazed glance seem to loom above the viewer, but all is explained by the role. His 1890 portrait of a popular Spanish dancer, Carmencita, has much in common with Manet's earlier *Lola de Valence* but the head is higher, the back more arched, and the expression less blunt and more contemptuous. It is as dancer, not as simple woman, that Carmencita flings her challenge. On the other hand, in Sargent's portrait of the great Eleonora Duse, ca. 1893, no special dress or particular role are

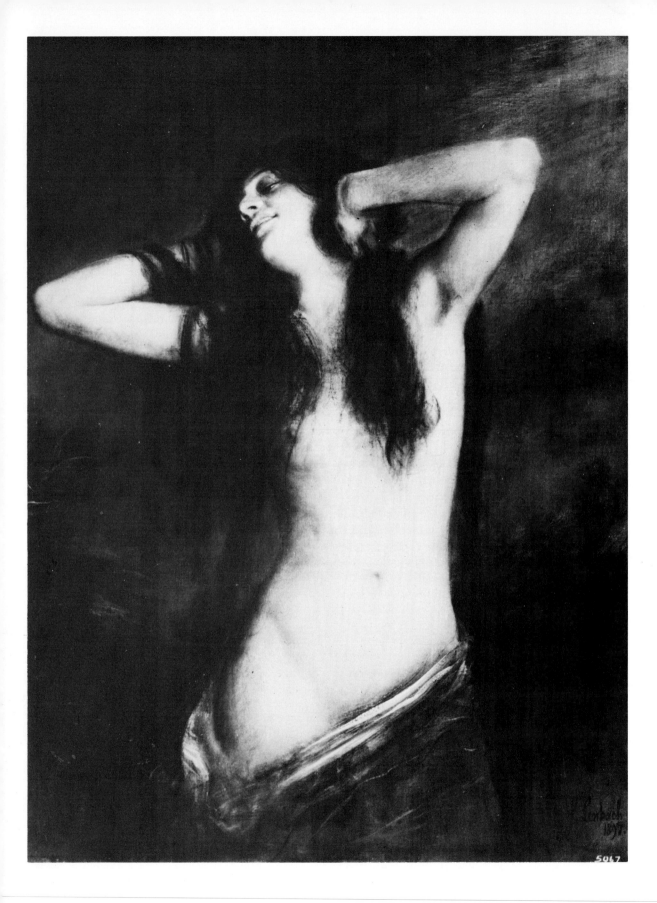

Franz von Lenbach: *Portrait of the Artist's Wife,* ca. 1900, 39 inches high. Frye Museum.

Franz von Lenbach: *Voluptas,* 1893, 43 inches high. Frye Museum, Seattle.

indicated: the briefest suggestions of posture and gesture, and the paint itself focused concentrically on her head and eyes, suffice to create a portrait with both individuality of characterization and the generalized power of the femme fatale. In portraits of Elsie Swinton, an American opera singer, Sargent's manner was less extreme, but nevertheless the raised head, haughty gaze, and upright bearing convey something of the confident threat of the femme fatale–without costume or situation or even knowledge of the sitter's stage personality. (A full-length oil portrait was done in 1896; a charcoal head in 1908.) Such examples make clear that the power and the threat resided not in any particular mythic individual or any narrative situation, but in the nature of female eroticism itself.

This imagery was reserved almost exclusively for women, touching men only on rare occasions when they too exhibited a kind of mastery or power simultaneously with submersion of themselves. A portrait by Sargent of his artist friend Paul Helleu (pastel, ca. 1889), or Munch's self-portrait (a lithograph, 1908-09) include aspects of the configuration

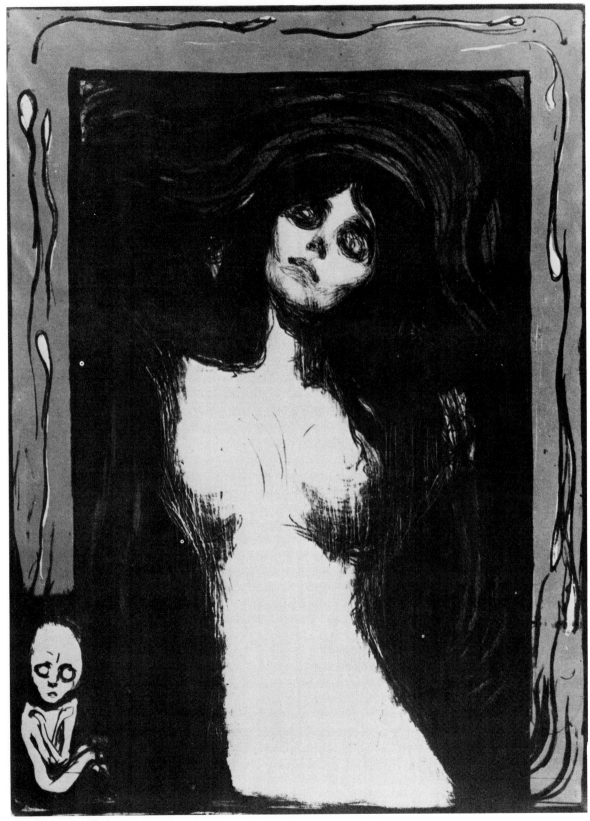

Munch: Lithograph version
of the *Madonna*, 1895-1902,
24⅝ inches high.

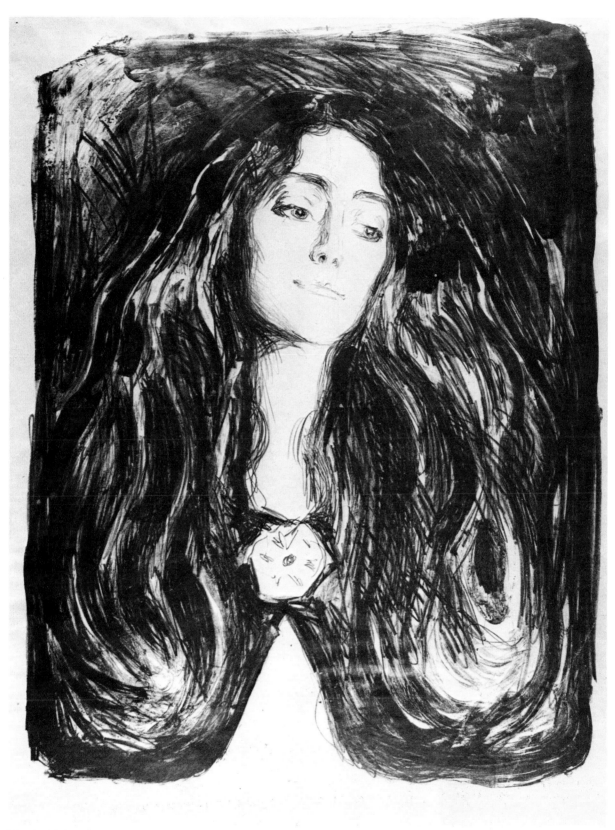

Munch: *Madonna* (Eva
Mudicci), lithograph, 1903.
21⅞ inches high.

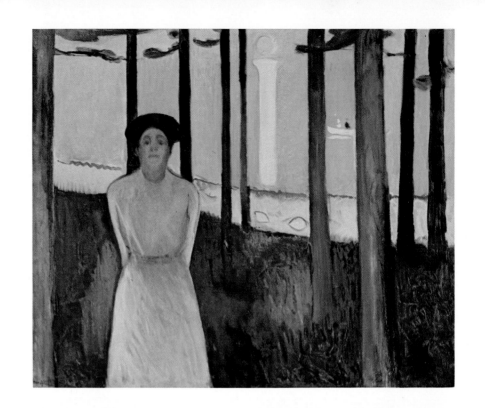

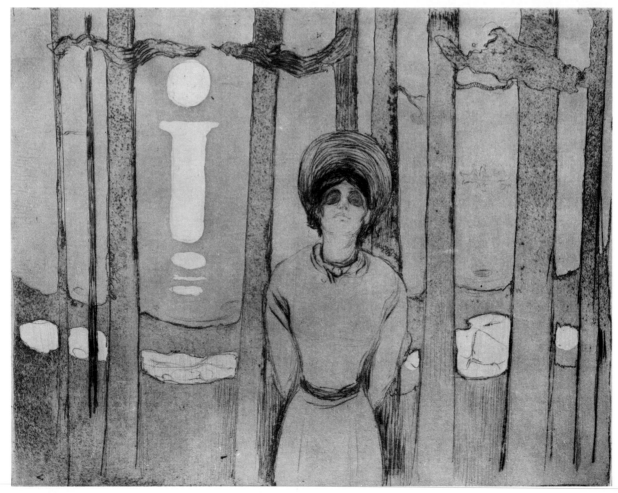

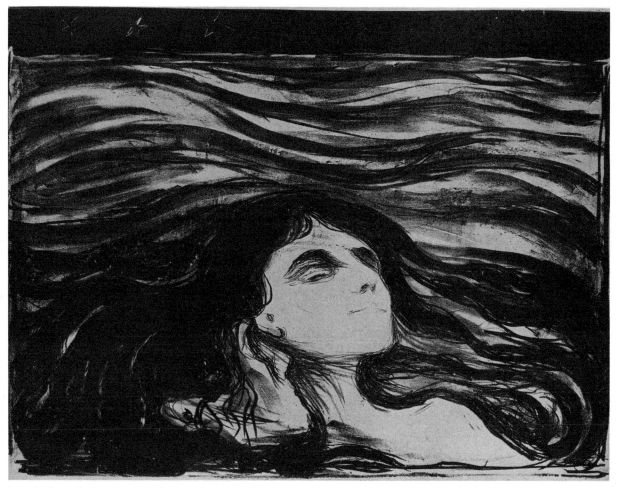

Munch: *Lovers in the Waves*, 1896,
lithograph, 12¼ inches high.

Munch: *Summer Night (The Voice)*,
1893, 34⅝ inches high.
Museum of Fine Arts, Boston.

Munch: *Summer Night (The Voice)*,
1895, drypoint and
aquatint, 9⅝ inches high.

–leaning back, chins lifted and eyes lowered, bodies absorbed into
the background or by encircling forms. In both instances, the men's
smoking cigarettes is significant (Munch's is usually called *Self-Portrait
with Cigarette Smoke*) and both can be taken as characterizations of unusu-
ally sensitive men (artists) in deep reveries. The male artist in the exercise
of his special creative power also seemed to have something in common
with actresses or with woman in general, in his absorption by the passion
he originated. Thus Carrière assimilated such imagery to portray Rodin
or himself (Rodin, at work, 1900; himself in a head and shoulders self-
portrait ca. 1895).

The threat and the attraction of the femme fatale emanated in the
mid-'90s not only from literary characters and great individuals but
even from popular types, exemplified most obviously in the drawings
of Charles Dana Gibson. The Gibson girl shared with her sisters in
high art the dual characteristics of inexorable power over others and
vulnerability (to Cupid's arrows, to her own passions). In particular situa-
tions she invariably exhibited a willful independence, yet over-all a con-
siderable degree of conformity to type emerged. (Was she, after all,
one girl, all American girls, or all women?) The Gibson girl was domineer-
ing and manipulative; she got what she wanted–yet she seemed the
puppet of a stronger force and submissive to its dictates. (Especially,
it was implied, beyond the relatively free years of maidenhood.) She

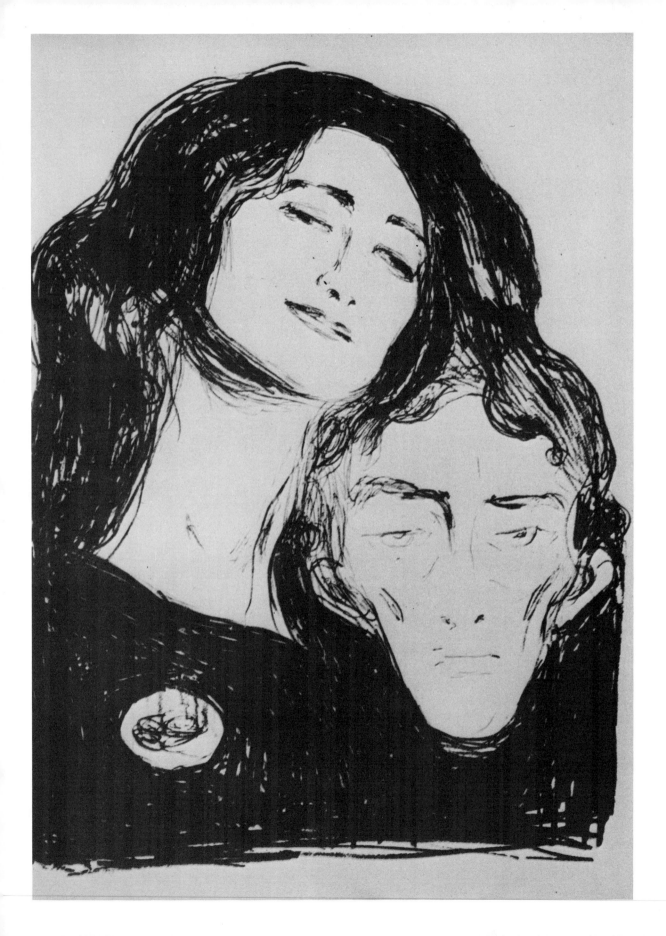

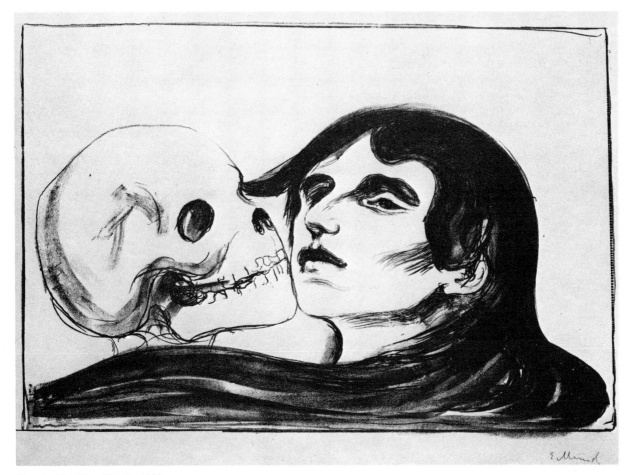

Munch: *The Kiss of Death,* 1899,
lithograph, 11⅝ inches high.

Munch: *Salomé,* lithograph,
1903, 16 inches high. The head
of St. John the Baptist is
a self-portrait of the artist.

shared many characteristics with the women in George Bernard Shaw's
Man and Superman (1903), in which the drive of the Life Force to become
conscious of itself through superior breeding seemed to win over its
drive to consciousness through individual effort (to oversimplify: the
erotic feminine instinct triumphs over the masculine instincts). Gibson's
and Shaw's girls shared in the aggressive and dangerous selflessness
of the femme fatale. They all seemed to draw upon the energy of the
Life Force or Nature, in a way impossible to men. The Gibson girl
appeared at home in the elements (*A Northeaster,* or the *Picturesque America*
views of mountains and shores populated by the beauties of feminine
America); or even at one with them, diffused as a vision in the wind
with her hair streaming across the sky in a manner related to her Euro-
pean sisters in high art. On occasion her aggressiveness extended to
mockingly taking over the male role (as in Gibson's series of leap-year
reversals).

It is but a step further to fashion plates and advertising posters of
the period, in which a more generalized image of woman was projected.
These sources, like the Gibson girl, used some of the imagery of female
power, but in a more restricted way; in fact, they now can be seen
to emphasize, through constrast, the strongly female and erotic content
of the true femme fatale and her sisters (including the Gibson girl –except
in Leap Year, of course), since fashion plates tended to rely on a superfi-

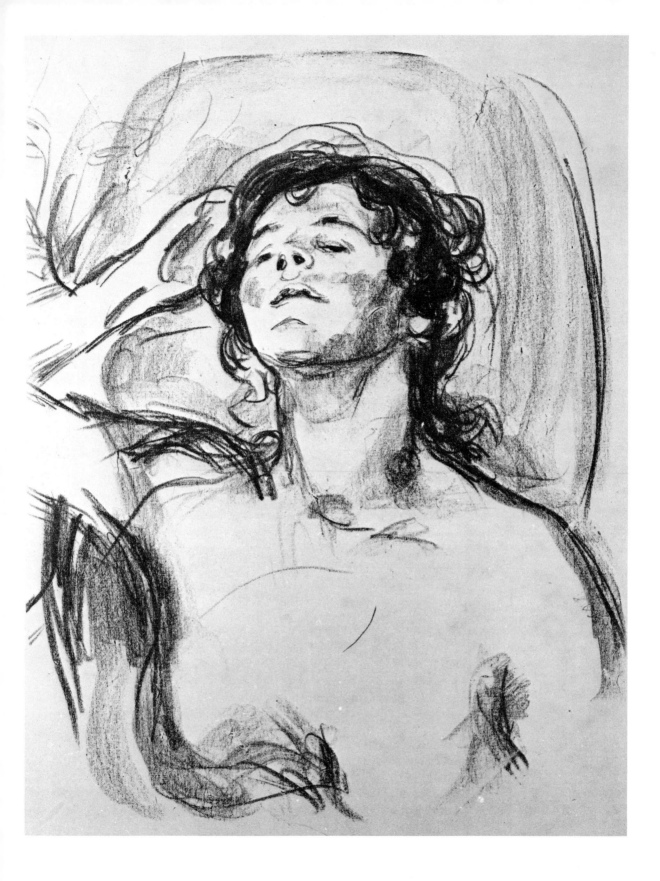

Munch: *Summer Night (The Voice),*
1898, woodcut, 9⅞ inches high.

Munch: *Woman Resting,* 1919-20,
lithograph, 22⅞ inches high.

cial borrowing of mannish details. Through the '90s, skirts became increasingly narrow in front and on the sides, with the fullness trailing behind. Above such a slender straight-hung skirt, the torso became larger in proportion. Broad shoulders and large sleeves accented the already swollen bosom, which appeared (at least in illustrations) somewhat monolithic through the incorporation of the two breasts into one great mound welded to the underlying chest. All this, worn with strikingly upright posture and thrown-back shoulders, represented a degree of mannishness in women's fashions. The invention of the simply-tailored shirtwaist for women, and the affectation by women of sailors' costumes, neckties and other such details of male attire, accompanied the general change in silhouette. The proud and powerful carriage appropriate to such costumes had much in common with the bearing and posture of the femme fatale. The Gibson girl epitomized much of this, but she parted company with most fashion plates and advertisements in carrying her chin so high that she gazed coolly down from a pinnacle at the men seeking her. This free, aloof air allied her with the powerful abandon of the femme fatale, and separated her from her fashionable contemporaries who generally carried their chins level or the backs of their heads high, and wore a pert or coy expression–certainly a more demure and implicitly acquiescent attitude than the Gibson girl's. (This fashion-plate look of modesty and discretion was further enhanced by broad hats which shadowed the face, with brims or plumes that frequently fell forward at one corner, or by tiny hats perched atop elaborately piled hair with forward brims pinned down toward the forehead and tails arching up:) Such fashions represented girlishness flirting with mannishness; but the Gibson girl and the femme fatale represented mature female eroticism.

In general it was not through encroaching on the male role but through her femininity itself that the Gibson girl dominated. She ruled her father's life as the daughter he must marry off *(The Education of Mr. Pipp* series, and many individual cartoons) and ruled her many suitors as the goal they so desired *(The Weaker Sex* series, and many individual cartoons). Clearly it was with an astounding, alluring, but nearly unattainable sexual power that she commanded or obsessed men. Once married and a mother she disappeared from consideration (unless she had the good fortune to become a widow, or the bad fortune to marry an impotent old man and remain frustrated in her eroticism, in which cases cartoons were still devoted to her). Women dominating their husbands or children were seldom present in Gibson's works, except as nagging old wives. The implication seemed to be that a woman's erotic power was extinguished by its very fulfillment–indeed, a femme fatale with children is unimaginable. (A possible exception is Medea, but the children did not survive to tell the tale; as usual it is "the exception that proves the rule.")

In most interpretations, as in Gibson's, that blatantly sexual power and its potential danger, which the femme fatale or the more aggressive Gibson girl manifested, did indeed disappear through the fulfillment

Munch: *Self-Portrait with Cigarette Smoke*, 1908-09, lithograph, 22¼ inches high.

John Singer Sargent: *Portrait of
Eleonora Duse,* ca. 1893,
23 inches high. Private collection.

One of Gibson's more vulnerable
girls, stricken by Cupid's
arrows. Illustrated in *Life,* 1900.

Charles Dana Gibson: *A North-
easter: Some Look Well in It,*
from *Life,* 1900.

or the demands of motherhood. But occasionally the eroticism and sen-
sual possessiveness of the femme fatale were depicted as present even
in motherhood–shifted or latent, perhaps, but still operative, and evi-
denced in postures or gestures related to the configuration that ran
through the examples above. In the late nudes, portraits and genre
scenes of Renoir, for example, this may be glimpsed. (Barbara Ehrlich
White's characterization, elsewhere in this volume, of these works as
erotic is certainly to the point.) The broad forms and circling shapes
of Renoir's late figures are passively sensual in a material way; their
expressions are actively seductive as their eyes gaze languorously from
under heavy lids. The women's great size bodes power as well as heavi-
ness, and they often radiate a cool sense of control. Their relaxation
seems to result from confidence in that power, as well as from languor.
The bright frank gazes of large-eyed girls which occurred in many
Renoirs of the '70s, gave way through the '80s to this more provocative
type (*Girl in a Straw Hat,* ca. 1884). Sometimes a figure participated
in the configuration of the femme fatale to a considerable extent, like
the central nude in the *Bathers* (1884-7, Philadelphia) who draws a cloth
across her back, with head thrown back and arms raised and extended.
A confidently seductive air is quietly present in Renoir's portraits of

A fashion plate showing country
dresses, from *The Queen*, 1895.

1900 fashion plate: tailor-made
costume and outdoor costume.

Renoir's *Maternity,* ca. 1918 (late version of a theme begun in the mid-1880s), 20 inches high. Private collection.

Auguste Renoir: *Portrait of Tilla Durieux,* 1914, 36½ inches high. Metropolitan Museum.

Gabrielle; it is more evident in his 1914 portrait of the German actress *Tilla Durieux,* with her great bland smile, or in his 1918 *Maternity,* with the nursing mother seated under a tree gazing out serenely from beneath a straw hat. The relaxed and knowing smiles by which these women so often relate to the viewer suggest that their power could be directed at that viewer (not only at the child they may be holding) and that its basis is erotic as well as nurturing.

A mingling of maternal themes with erotic content, through an obsessive and compulsive attracting power of a femme-fatale sort, is more evident in Eugene Carrière's variant than in Renoir's. Carrière's figures are often very close to the femme fatale in their posture and manner of presentation; they gaze out of half-closed eyes, their backs arched and their heads thrown back, and a swirling murky dark surrounds and envelops them somewhat like the patterns of hair or background in some of Munch's works. Such figures by Carrière include portraits of young girls (*Lucie,* ca. 1885-90) and of his wife (*Mme. Carrière with Her Dog Farot,* ca. 1895) among single figures; portrayals of mothers

Eugène Carrière: *Maternity,*
1892, 59 inches high.
Modern Museum, New York.

with children often share these qualities of posture or gesture and of relation to a dark ground. The women embrace their children with an anguished intensity that suggests passionate abandonment to the role of self-sacrifice. It is impossible to determine whether ferocious joy or intolerable pain is registered on their countenances. They seem to abandon themselves to their carnal role, to be absorbed into its darkness, but simultaneously they radiate out through it to encompass others' bodies and lives. The possessed are their children, not their lovers; but the pattern is similar, visually and psychologically, and its basis is the same—sexual instinct and the erotic power that is its tool. The delirium of self-sacrifice of these mothers was close to the sexual ecstasy of the femme fatale in its appearance and probably its significance at the time. Perhaps the great popularity and respect Carrière's works enjoyed was due in part to their encompassing such deep implications and fears. Certainly the frequency of this imagery in Salomés and Judiths, and the great number of their sisters and cousins who flourished in high and low art across Europe and the United States, is testimony to the deeply troubling consideration that female eroticism provoked at the time.

By the end of Carrière's and Renoir's careers and of the Gibson girl's popularity, the configuration which so pervasively insinuated its burden of dark meanings had become a cliché. By World War I, it appeared on book jackets, in frontispieces to sentimental novels, on the covers of sheet music. Thus in 1917 the image of a girl with tossed-back head and half-closed eyes accompanied the lyrics, "All the orient is in your smile/ mysterious as river Nile/ and you stole my heart/ with your cunning art/ and the Egypt in your smile . . ." Shadows of the configuration, still suggesting the erotic and the dangerous, persisted in popular imagery for a long while, in the bearing and manner of '20s movie vamps, of Greta Garbo or, more mundanely, in Dracula movies, in Charles Addams' domineering witch-glamour-girl-mother and in the pages of high-fashion women's magazines. The notion that woman's power is a dark erotic force, dangerous to herself and her victims, lingers on in these images as troubling, tantalizing or merely amusing.

Reincarnation of the femme fatale on the cover of sheet music, *There's Egypt in Your Dreamy Eyes,* 1917. Private coll.

Vampires, Virgins and Voyeurs in Imperial Vienna

Author: Alessandra Comini teaches at Columbia University and helped write the catalogue of the Klimt and Schiele show held at the Guggenheim Museum in 1965.

When the young Richard Wagner began work on *The Flying Dutchman*, he had a definite if unacknowledged model in mind: Heinrich Marschner's opera of 1828, *The Vampire*. Although that opera and its composer are now neglected, Marschner's blood-curdling work was enormously popular in the German-speaking world and was repeatedly performed during the 1830s and 1840s. The villain of the piece was *Der Vampyr* – a tall, thin, pale man whose hypnotic gaze led village girls into conveniently handy forests where, later, their bodies were discovered with blood-smeared, lacerated throats (revived in this century as the vampire in such films as *Nosferatu* and *Dracula*). Every time the male vampire victimized another virgin, she in turn was transformed into a vampire. This led to a population explosion of vampires by the end of the century–how else can we explain the curious preponderance of female vampires who later winged their way into literature and art? A splendid and scary foil to the virgin-concept, she vied with her innocent sisters for poetic and artistic attention. This thirsty lady represented what man could expect to find after the seventh veil was removed—an all-devouring femme fatale. The misogynous messages of Schopenhauer and Nietzsche had of course prepared the way for this truly overwhelming aspect of womanhood. As personal details of Nietzsche's life came to light, the Machiavellian paraphrase in *Zarathustra* acquired unexpected new meaning: "Thou goest to woman? Do not forget thy whip!" Now it was *woman*, not man, who brandished the warrior's whip; now it was *man*, not woman, who was tormented. Strindberg and Munch were devoted to this rich–and autobiographical–theme. For them as for so many other cultural spokesmen, man was artist and creator; *he* was the sensitive, bewildered, persecuted one. Woman was. . .woman, and had to be either vampire or virgin. To quote Nietzsche again: "Two different things wanteth the true man: danger and diversion. Therefore wanteth he woman, as the most dangerous plaything."

By the time the male vampire had become a mere singing *Fledermaus* in imperial Vienna, the city was reeling under a plague of femmes fatales. The situation was summed up by Secession artist Ernst Stöhr, whose drawings and poems were published in the December 1899 issue of *Ver Sacrum*. In one illustration, a wild-eyed female crouches over the prone figure of a gentleman whose verbal exclamations are stronger than his physical protests:

The vampire from *Nosferatu*, 1922, a movie directed by F.W. Murnau.

Why do you entice me to sweet lust
With your red, dark mouth?

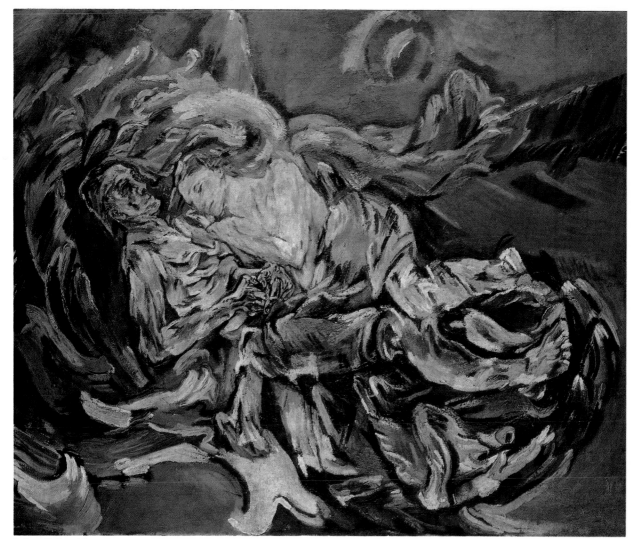

Oskar Kokoschka: *The Tempest,*
1914, 71¼ inches high.
Kunstmuseum, Basel.

Klimt: *The Bride,* 1917-18.
Private collection, Vienna.

Pen drawing by Kokoschka for
his play, *Murder, Hope of Women,*
reproduced in *Der Sturn,* 1910.

I sink onto your hot breast [the picture shows a reversed situation]
Ah! Kiss me that I may get well!
How your mouth burns as in hot fever
And blazes in wild fire!
My poor life is the price,
You drink my heart's blood.

The gruesome blood-lust of woman entered a full-scale classical arena
a few years later when Hofmannsthal and Strauss collaborated on a
magnificent and bloody sequel to their first "thriller," *Salomé,* and pre-
sented the public with *Elektra.* Anna Bhar-Mildenburg sang the sinister
Clytemnestra in the Vienna première, providing an electrifying flesh and
blood counterpart to Gustav Klimt's picture gallery of infamous women
of the past.

 Oskar Kokoschka's play *Murderer, Hope of Women* (written and pro-
duced in 1908; published in 1910 in *Der Sturm* with illustrations by
the artist), derives from this double-barreled operatic and painted presen-
tation of the femme fatale. His misgivings about the nature of woman
come as no surprise. The two main characters in the play are "Man"
and "Woman." In their struggle against each other, woman hisses:

„Was lockst Du mich zur süssen Lust
Mit rothem, dunklem Mund?
Ich sink' an Deine heisse Brust —
Ach! küsse mich gesund!"

„Wie brennt Dein Mund so fieberheiss
Und loht in wilder Glut!
Mein armes Leben ist der Preis,
Du trinkst mein Herzensblut."

Ernst Stohr: illustration (left) and poem (right) in December, 1899 issue of *Ver Sacrum*.

Photograph of Friedrich Nietzsche, critic Paul Rée and Lou Salomé, Lucerne, 1882. Lou (left) wields a whip.

With my breath I fan the blond disc of the sun.
My eye collects the exultation of men.
Their stammering lust prowls around me like a beast.
I shall not let you live. You! You weaken me–
I shall kill you. You fetter me.

Sensitivity to the omnipresent threat of woman was shared by others. Karl Kraus, cantankerous editor of the weekly satirical magazine *Die Fackel*, used his journal to print scathing comments about Vienna's budding feminist movement–contrasting "woman" and "culture" and defining them as irreconcilable opposites. In 1903 a sensational book was published, *Geschlecht und Charakter*. The author was 23-year-old Otto Weininger. He equated cultural weakness with women and with Jews and damned all three. The book became wildly popular and was an actual *vade mecum* for both Strindberg and de Chirico. But Weininger had created his own Frankenstein. Within a year, unable to cope with either his own Hebraic ancestry or the "female" qualities he discovered lurking within himself, he committed suicide. Such was the rarefied atmosphere in which the young Alban Berg grew up to produce the ultimate femme fatale symbol in his opera *Lulu*–based on Wedekind's plays.

And yet not all women were vampires or Lulus. Some were virgins or Liliths. The dualism with which woman had traditionally been regarded–the Madonna-whore polarity–was inherited by the Expressionist generation which sought to deal on a personal level with this

Klimt: *Expectation*, cartoon for
the Stoclet frieze, ca. 1905-09.
Osterreichisches Museum fur
Angewandte Kunst, Vienna.

Klimt: *Realization* (detail),
cartoon for the Stoclet frieze,
ca. 1905-09. Osterreiches Museum
fur Angewandte Kunst, Vienna.

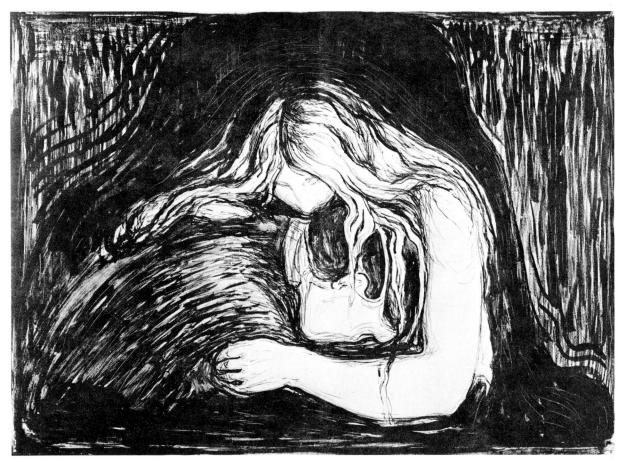

Edvard Munch: *Vampire,* 1895,
lithograph, 15¼ inches high.
Modern Museum, New York.

Schiele: *Self-Portrait with
Pants Down,* ca. 1909.
Present whereabouts unknown.

–literally–*man*-made phenomenon. In *The Dreaming Boys,* published
as a "fairy tale" in the same year (1908) his *Murderer, Hope of Women*
was performed, Kokoschka explored the theme of awakening adolescent
sexuality. His deliberately stylized illustrations mirrored the now explicit,
now metaphorical tone of the high-pitched, lyrical text. Throughout
the work little red fish of desire accompany the boy and girl who are
irresistibly drawn to each other:

And I was giddy with ecstasy when I came to know my flesh
And I was a lover of all things when I spoke with a girl.

Virginity was naturally less interesting as a permanent condition than
as a preparatory state. Klimt had recently stressed this practical concept
in his famous Stoclet frieze. A progression from virginal *Expectation* to
Realization–beautifully and euphemistically presented as the Kiss–was
shown as nature's law, intensified by a symbolic background web of
organic intertwining–the tree of life. Seen through Expressionist eyes
however the kiss frequently became, as it had for Munch, a confessional
of discontent and Angst. Apparently in these artists' personal experi-
ences, a virgin, once transformed into "woman" by medium of the kiss,
did not docilely remain woman, proceeding blandly and automatically
to fulfill her "biological destiny." No! At times she seemed downright
vampiric, demanding complete attention and jealously draining the life
blood of the male's creative ability. The kiss, the embrace, the constant
physical proximity could take on restless or nightmarish proportions
for the artist who found his thoughts urging him elsewhere (Kokoschka's

Left: Edvard Munch: *Vampire,*
1894, etching, 11½ inches high.
Chicago Art Institute.

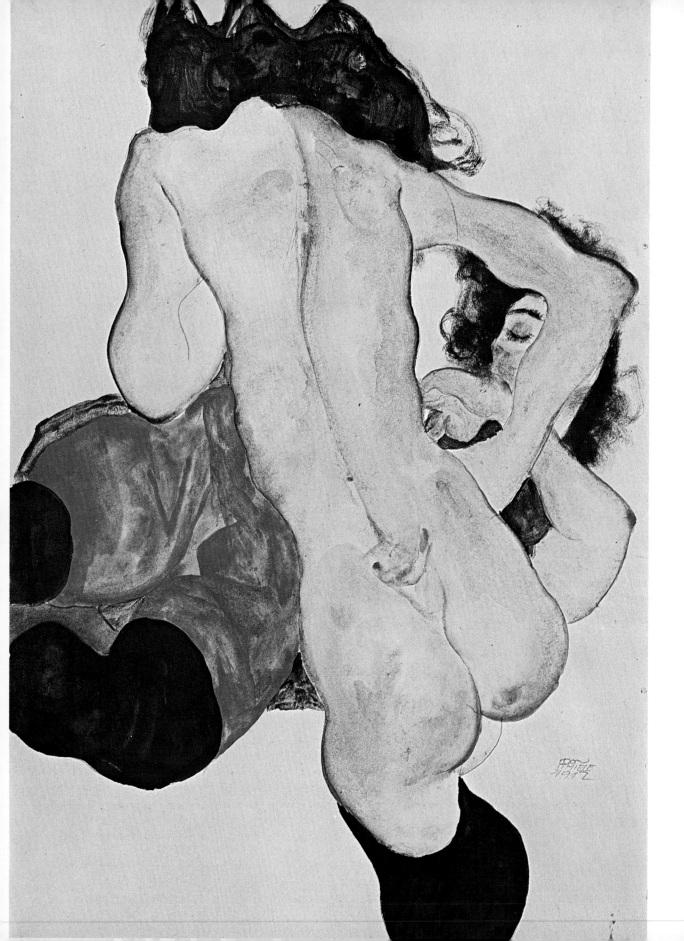

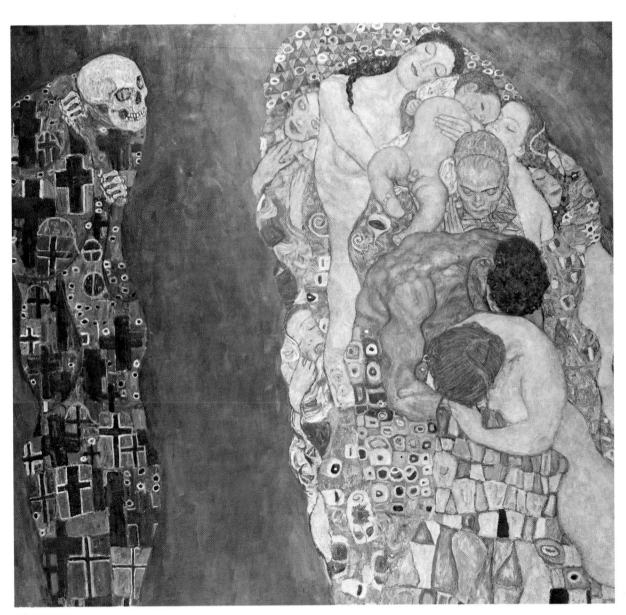

Klimt: *Death and Life* (or *Death and Love)*, before 1911, revised 1915. Private collection, Vienna.

Egon Schiele: *Two Nudes, One With Red Pants,* 1912. Collection Serge Sabarsky, New York.

Two of Richard Gerstl's *Self-Portraits,* from a series in which he documented the stages of his own suicidal depression. Above, ca. 1907. Private collection. Right, Sept. 29, 1908, ink and wash. Albertina, Vienna.

Alfred Kubin: *Self-Contemplation,* ca. 1900, pen and sepia. Private collection, Vienna.

The Tempest), or who discovered his body immobilized in the presence of a suffocating love.

As artists in Kaiser Franz Josef's Vienna dealt with the theme of virgin, a distinctly Lucullan approach took shape: the virgin was served up as a delectable tidbit for voyeurism, complete with an invitation to speculate on the ineluctable "fulfillment" awaiting her. Often the beholder, of course presumed to be male, was able to identify with the artist as the whole concept of virginity was carefully scrutinized. Following the technique of the old masters, Klimt first drew his figures nude and then, especially in the case of virgins, gradually adorned them with ornaments of repeated and suggestive shape until their bodies were defined and penetrated by a cumulative symbolic overlay. (A photograph of Klimt's studio at the time of his sudden death in 1918 shows two of the canvases on which the artist had been at work. One, the uncompleted *Bride,* reveals Klimt's "dirty old-master's" approach.)

For both Jugendstil and Expressionist artists there was plenty of voyeurism in the traditional sense–and artists like Klimt and Schiele never tired of drawing females engaged in masturbation, an apparently vacuous and mindless activity when performed by women. But for Schiele voyeurism was not necessarily a lonely vigil at the keyhole. Frequently the artist participated in the erotic acts played out before his mirror. He, like the obviously ambidextrous Goethe before him, could make love with one hand while recording it with the other. But it was precisely the attraction of the mirror that drew Schiele into a singular kind of

voyeurism–that of spying upon himself. He literally caught himself with his pants down. Fascinated by the taboo aspects of the theme, he portrayed masturbation with an unprecedented exactness. For the *male* artist, picturing masturbation by a *male*, the act was presented as a revelation of psyche–a liquid fire illuminating and flooding the corners of his most secret self. Alfred Kubin, for example, explored the motif of guilt and the fear of overindulgence, with the then generally supposed consequence of insanity.

As artists turned toward themselves, away from woman, whether as vampire or virgin, they were appalled to discover the enemy close at hand; to find within themselves those mystifying, foreign, so-called "feminine" qualities which Weininger and Freud had labeled "bisexual." What frightening landscape of the soul did Richard Gerstl see, for instance, to change so profoundly within one year's time his vision of himself from worldly sophisticate to frail, will-less somnambulist? The sudden rupture of his close friendship with Arnold Schönberg–his idol, but also his rival for Schönberg's own wife–was unbearable. Expelled from the Schönberg circle, in disgrace, his lonely reflections became a voyeuristic trespassing across the threshold of sanity. As with surgical pincers, Gerstl exposed his psychic wound to document the day-by-day suicidal course of his depression. With cold detachment he dated the final self-portraits, and soon after the date of the last one he burned the paintings in his studio and killed himself.

This was a strange and new kind of voyeurism–inevitable product of that turn-of-the-century Vienna which Karl Kraus described as an isolation cell in which one was allowed to scream. As the glorious façade that had been imperial Vienna began to disintegrate before the eyes of twentieth-century artists, revealing such disparate social specters as vampires and virgins who beckoned man to his doom, a final insight was vouchsafed to the artist; a narcissistic voyeurism in which the antipodes of man's thought about sex, woman and himself battled for resolution. For some, self-knowledge proved disastrous; for others, including Klimt, it could inspire a vision in which man and woman together faced their common heritage of life–and death.

Schiele: *Male Nude Seen from Rear,* 1910. Collection Serge Sabarsky, New York.

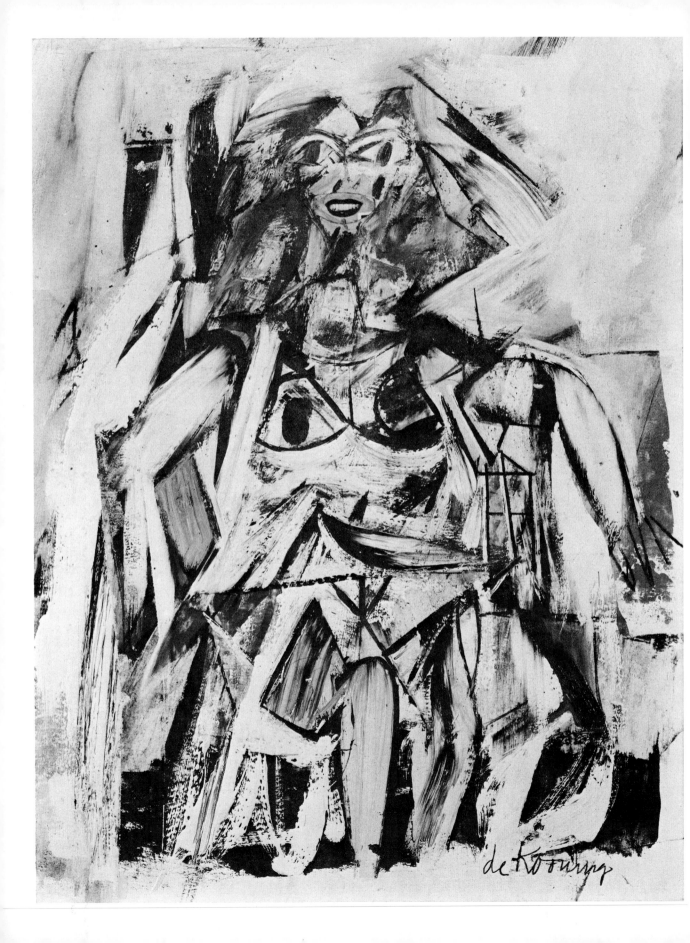

Pinup and Icon

De Kooning: Drawing for *Woman,*
ca. 1951, 18 inches high.
Artist's collection.

Ingres: *Portrait of M. Bertin,*
1832. Louvre, Paris.

Willem de Kooning: Study for
Woman, 1950; the mouth was cut
out of a cigarette advertisement.
Private collection, New York.

The image of the pinup entered modern art around 1950 through a convergence of three historical developments whose juncture, in retrospect, has an air of inevitability, but before the event it would have seemed as improbable as a public recitation by Richard M. Nixon from the sayings of Chairman Mao.

First of all, there is the pinup itself–a highly stylized photograph of a star, starlet or model, produced for a mass male audience. The image it presents has connections with the fine arts, but they are so remote that, at the time of the pinup's greatest popularity, ca. 1930-60, it seemed a phenomenon insulated from all cultural factors outside its own subcultural milieu.

The second factor, Abstract-Expressionist painting, ca. 1945-60, was vaguely connected to images of women, to erotic art and even to photography. But one would have had to unravel generations of stylistic change to find relevant filiations between the pinup and an Abstract-Expressionist image. As far as the pinup as a form of popular art is concerned, modern art–especially mid-twentieth-century vanguard painting–existed on another planet.

The third historical development concerns political and cultural forces in America in the decades that included World War II and its aftermath and how these forces affected the role of woman in society and the image that women were expected to project–to themselves, to each other and to a dominantly masculine world.

The particular situation of American women, caught up in what Betty Friedan has called "the feminine mystique," was the result of economic and psychological pressures which in turn derived from the larger cultural context of which both the commercial arts (the pinup) and the fine arts (Abstract-Expressionism) were a part. But the singular dynamics of this larger context have only become visible with the passage of time. The economic necessities of the postwar years, for example, which so strongly changed the social role of the American woman, seemed supremely unrelated to modern American art which, until the late 1950s, flourished in an underground community almost entirely cut off from the nation's economy. (In other words, none of the artists were selling.) In order to understand this curious meeting of art, commerce and politics, we must examine each of the three elements separately.

The pinup: according to Eric Partridge's *Dictionary of Slang,* the word enters the language ca. 1944-45, courtesy the U.S. Army. It refers to those photographs that were attached to the walls of barracks,

Leslie Brooks, with aircraft.
©Vitagraph photo.

Imogene Williams, ca. 1944,
holding pre-Oldenburgian
giant stuffed carrots,
wearing pre-*Playboy*
bunny uniform.

Marie McDonald, known as
"The Body," in maritime pose.

machineshops, bars, barbershops, in the cabs of trucks, on bomber noses (it is said that a famous pinup of Rita Hayworth was attached to the atomic bomb that was dropped on Hiroshima[1])–in other words they appeared where men gather without women, in more or less tribal (professional, recreational) groupings, not unlike the Mens House structures in many primitive societies.

A good part of the historical development of the pinup image is adumbrated elsewhere in these pages, especially in the articles by Gerald Needham, Beatrice Farwell and David Kunzle, who discuss the erotic print and its descendant, the erotic photograph, and also the so-called "art" photograph of a posed model, often made especially for the use of artists and art students. In such prints and photographs, the styles of Rococo, Neo-Classic, Romantic, Realist and *art officiel* painting were popularized, simplified and often hardened into stereotypical formulations. Models in erotic photographs were frequently assigned the traditional positions of Susannah surprised at the bath, the penitent Magdalen, Aphrodite Anadyomene, Diana the huntress and other clichés from Greece and Rome, the New and Old Testaments. The images are drenched with art. The artisans, hack artists and minor masters who manufactured products for the erotic-art market were prisoners of the styles of their time. And they also consciously emulated them–at the demand of the businessmen who published erotic art for profit and who knew that their clientele preferred visual formats that conformed to the fashionable imagery of a Bouguereau or a Regnault.

Plastic innovation is almost nonexistent in nineteenth- and twentieth-century erotic art, which was tailored to a middle-class market with conservative taste (the few exceptions to this are works by eccentrics and visionaries). Most artists and craftsmen accepted contemporary visual *schemata* and concentrated all their energies on subject matter.

In such an approach, the visual image is, in a sense, turned inside-out. What had been the painter's preoccupation–the expressive pose of the model and its translation to the plane of the canvas, the translation of the hue and value of flesh to the hue and value of pigment, the symbolizing of light and space–become passively accepted rules or prototypes for the maker of erotic prints and photographs. The latter focuses on what the artist all but ignores or censors out of his work: the obses-

Marie Wilson as *My Friend Irma,*
©Paramount Pictures, 1949.

Pinup idol Toby Wing, ©1934;
Paramount Productions' caption
reads: "For reducing the abdomen,
lie flat on the back at the foot
of your daybed, hands flat..."

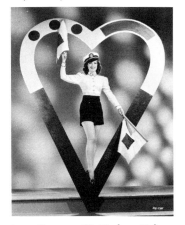

Anne Gwynne, "A Modern Valen-
tine," ©Universal Pictures, 1942.

sional, the fetishistic, the pornographic. And this inversion of emphases is what gives much of the erotic art of the nineteenth and early twentieth century its look of estrangement and sometimes of dreamlike fascination. Style has been canceled out. Subject matter has been given a strange, raw impact, often heightened when the pictures are the products of semi-primitive craftsmen or of craftsmen working with semi-primitive techniques, such as early photography, where the slowness of the film necessitated poses of muscle-knotting duration. The inviting smile in such turn-of-the-century nudes as those photographed by Charles Schenk often can be interpreted as a stoical grimace at an aching shoulder or thigh.

Thus we have the paradox of an image drenched with art, but from which the esthetic has been drained off, leaving a sediment of human sensation which, however crude or perverse, still can have more vitality to it than an academic painting executed with all the skills and tact of the Beaux-Arts. It is this element in the pornographic photograph that might have attracted Manet as a source for *Olympia,* as well as the shock-value of his allusion to an illicit and scandalous commerce, which Gerald Needham suggests was his motive. After all, for Manet, the great challenge was to break the old stylistic conventions, to go beyond the accepted esthetic in order to make fresh contact with the real.

The dual nature of the mass-produced erotic image–the scaffolding of high-art style used as a container for dangerous (tabu) emotional communications–reappears in the pinup; in this it is a direct descendant of the prints of Devéria and the photographs of Vallou de Villeneuve. But another source is equally important in its evolution—the theatrical publicity picture, whether poster, handbill or program illustration. Almost as soon as it appeared, the form reached perfection with Toulouse-Lautrec's great advertisements for the music-hall stars of Belle-Epoque Paris. Varying in size from the postcard to the giant lithograph, it basically presents in eye-stopping simplicity the image of the star, often reduced to a salient, characteristic gesture, plus stage properties associated with the act: Yvette Guilbert's gloves, Loie Fuller's veil, May Belfort's cat, and later Lillian Russell's hat, Sarah Bernhardt's tresses. Like martyrs or goddesses, they can be identified by their attributes and gestures, and once these were fixed in the public mind, the delineation of the star's actual appearance tended to become increasingly stylized and rigid.

With the advent of the movies, Hollywood took over the star system and made it a major base of its industry and art. The studio publicity photograph replaced the poster and the handbill as the audience outgrew the urban centers (where poster-displays flourish) to cover the villages of the globe. The photographs were distributed to newspapers and magazines and became so popular that special journals were published which relied almost exclusively on them for illustrations–the most famous, of course, being *Silver Screen.* Such periodicals were based in part on the formulas of older theatrical reviews, which dealt in backstage gossip and society *faits divers,* and also on semi-pornographic magazines which

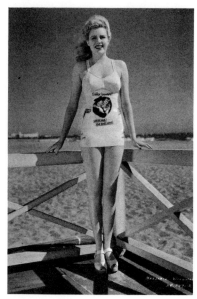

Marjorie Woodworth's bathing suit
proclaims: "Sailor beware!
Loose talk can cost lives."
United Artists, ©1942.

Betty Grable in her most famous
pinup pose, before she
became a well-known actress.

Dorothy Lamour displays an
"intricately tucked black jersey"
for Paramount, ©1945.

published photographs and drawings of nudes, such as *Tit-Bits,* founded
in London in 1881.[2]

Stars and aspiring actresses were publicized by the studios with photo-
graphs in which the poses owe as much to the erotic photograph as
to the theatrical poster. But as their appeal was aimed at the widest
popular audience, the overtly erotic content of the image was kept strictly
within the narrowest interpretations of famously ambiguous state and
municipal statutes. Despite their modesty, however, pinups were enor-
mously successful by the mid-1930s–as can be judged by the number
of magazines devoted to them, and their ubiquitousness in those places
where men work, rest or play without women.

The editors of *Tit-Bits* knew as early as 1900 that an erotic photograph
is more stimulating to the male viewer if he can extend his fantasies
and indulge in a dream-dialogue with the model. Thus the model often
was given a name: "Belles of the Halls of Mirth and Song–No.46–Miss
Mable Devere (born in France of English descent, from a family of
former Earls of Oxford, she gained a prize at a recent 'Beauty Show'
in Paris)"..."A Dancer of Pompeii–Mlle. Dugère, the famous Parisian
'première' giving her extraordinary performance before the President
of the French Republic"..."Miss Fanny Woods is now a full-blown actress
in London, but when she was only a Yankee chorus girl, she was a
divinity without skirts..."[3] (The arch prose with its heavy double mean-
ings has not changed much in three quarters of a century, from *Tit-Bits*
to *Playboy,* even though the models have been stripped of all their clothes;
the modern voyeur may see with the eyes of Mailer, Miller or Genet,
but his ears are still tuned to the cadences of Louisa May Alcott.)

The pinup models were similarly identified–as feature actresses or,
more frequently, starlets. After all, that was why, presumably, they posed
in the first place–to make their names known; the pinup, in a sense,
is an advertisement for a brand product. Such was the popularity of
the medium, however, that many of them became famous as pinup
models while remaining obscure as actresses, such as Toby Wing, or
Chili Williams, the "Polka-Dot Girl," who was so popular that the Chemi-

Martha Vickers as "Miss Danger Signal–because she has never had an accident..." Warner Bros.

Pat Clark in two-piece Indian suit; © Warner Bros., 1944.

cal Warfare service of the Army used her in posters to indoctrinate recruits on how to identify lewisite, phosgene and other poison gases. (There were exceptions, of course; Betty Grable and Marilyn Monroe overcame their fame as pinup models to become stars.)

By the 1940s, the pinup image was defined with canonical strictness. First of all, there was the "pinup girl" herself. She had to be the healthy, American, cheerleader type–button-nosed, wide-eyed, long-legged, ample hips and breasts, and above all with the open, friendly smile that discloses perfect, even, white teeth. Then there is her costume and pose. These must be inviting but not seducing; affectionate but not passionate, revealing by suggestion while concealing in fact. The legs are carefully posed so that not too much of the inner thigh is shown; the navel is covered and so are most of the breasts except for the famous millimeters of "cleavage." The body is evident beneath the costume, but not its details–the bulges of nipples or of the *mons veneris* are scrupulously hidden. There is a dialectical pressure at work, between the voyeuristic public which wants to see more and more, and that same public which, in its social function, supports codes and laws that ban any such revelations. Caught between these two forces, the image tends towards an almost Byzantine rigidity, and assumes some of the symbolizing force of an icon. The pinup girl and the Virgin in Majesty both are instantly legible visual images of the comforting and commonplace which is also ideal, and thus unattainable.

Given the rigor of the main *schema* of the pinup, it is not surprising that an enormous amount of fantasy and repressed emotion were released in those areas of the picture not controlled by the sexual dialectic. The models seem to play in a doll's house filled with Freudian toys –pre-Oldenburgian stuffed giant carrots, toy aircraft engines, telephones, scissors, arrows, columns, traffic signals and apertures of every sort through which to peer, march or glide. The sexual act takes place as if in a charade, and the model is an actress who has not been told the hermetic meaning of her role.

The model herself is a person–that is, she has a name, which the caption supplies, along with a few biographical anecdotes. But it is an open secret that it is not her real name, just as her biography is a fiction of the caption writer. She is, in fact, a man-made object disguised as a girl, just as her appurtenances are studio props disguised as vegetables, sections of machinery, fragments of landscape.

The artifice with which the elements of her anatomy are composed and photographed erases all the details and peculiarities of the model (wrinkles, moles, body hair), generalizes the body into a format and robs it of any logical scale. Thus a pinup can be reduced to an inch in a magazine advertisement for cigarettes or enlarged to 12 feet for a billboard. The symbol works in almost any conditions, in almost any context.

Such, then, were some of the characteristics of the pinup image in the late 1940s, when suddenly it entered the field of high art, under the sponsorship of Willem de Kooning.

De Kooning had painted pictures of women off and on since ca. 1940.

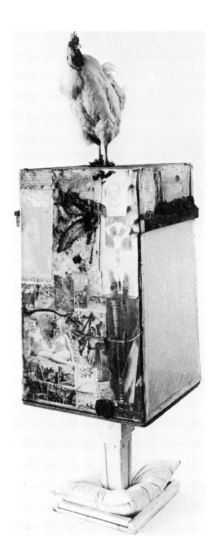

Robert Rauschenberg: *Interview,* 1955 (left) and *Odalisk,* 1955-58, with pinups pasted among brushmarks and screens. Sonnabend and Castelli galleries.

They usually were based on drawings from the model, or from photographs taken to his careful specifications, and they refer to classic precedents in art history. In 1945-50, he was preoccupied with abstract paintings, and it was on these that his reputation first rested. Then in June, 1950 he decided to undertake a large painting of a woman, and there is evidence among his many preparatory drawings and sketches that the pinup image was one of the sources for his format.

Starlets, models, erotic photographs had been subjects for artists long before de Kooning–one thinks of Reginald Marsh's and Edward Hopper's burlesque scenes, for example, or works by Pascin, van Dongen or Beckmann. But in each case, the woman's figure was part of a specific, usually exotic ambience and had a unique social character–colorful music-hall star, exploited prostitute, free-thinking bohemian, etc. The peculiarly anonymous, ubiquitous pinup must have seemed too inhuman and too artificial to appeal to artists in the '20s and '30s. It was precisely for these qualities that it appealed to de Kooning.

Primarily there were formal reasons. De Kooning has mentioned that giving his painting the objective substructure of a woman's body freed him to paint as he wanted to, while painters who use abstract shapes, he said, are forced to invent them, subjectively. Painting the woman,

Alfred Leslie: *Lady with Peaches and Grapes,* 1963, 8 feet high.

Roy Lichtenstein: *Aloha,* 1962. Burton Tremaine Collection.

he told David Sylvester, "did one thing for me: it eliminated composition, arrangement, relationships, light–all this silly talk about line, color and form–because that was the thing I wanted to get hold of. I put it in the center of the canvas because there was no reason to put it on the side. So I thought I might as well stick to the idea that it's got two eyes, a nose, a mouth and neck . . ."[4] (In other conversations, with this writer, he has continued the itemization, and emphasized the fact that his figures of women frankly exhibit their primary and secondary sex characteristics–"it's all there.")

The pinup figure, with its rigid iconic stance, is well suited to such a frontal, abstract disposition of parts.

In a number of drawings and studies, de Kooning analyzed the hieratic poses of the pinup, and in one small oil, cut the mouth from the "T-Zone" girl in an advertisement for Camels in *Time* magazine and stuck it in the face of his figure. It is the quintessential pinup smile. (There were many other pictorial sources for de Kooning's paintings of women, of course. The sketch of a figure with a mouth from a "T-Zone" advertisement, for example, is posed in the open, receptive, challenging posture of M. Bertin in the portrait by one of de Kooning's heroes, Ingres.)

It has not been remarked, I believe, that de Kooning's major paintings of Women in his great 1950-55 series are all fully clothed. And, as in the pinup photograph, the clothing reveals as it conceals. Breasts are pushed out, as if being offered to the viewer like fruit on a tray, as well as bound in by brassieres and covered with blouses. Skirts underline as well as cover the vagina. Costume becomes the primary sex characteristic.

In *Woman with Bicycle,* 1952-53, the figure stands next to her machine in the same cheerfully disengaged way that a pinup model might pose next to a life-preserver. And de Kooning's figure rejoices in two radiant smiles–one in her mouth and the other as a collar around her neck. The teeth in her throat are not noticed as a particularly violent motif because the whole image in de Kooning's paintings of women is so discordant–threatening, passionate.

It is surprising to compare the large oils with the drawings and small oils that led up to them. The latter are mild, gentle, even pretty, like the pinups. De Kooning takes an ironic position; he comments on fads and foibles, such as the figure who wears shoes that are an inventive combination of wedgies with stilettos, or the loony hats which decorate some other figures. But on the whole, the drawings affectionately present the pinup as the friendly neighborhood sex-symbol Americans had come to know and love.[5]

In his large paintings, all this is transformed. Under the pressure of pictorial necessities, the surfaces of the figure warp and buckle. The face is opened flat to the picture plane, stretching the smile to a savagely archaic mother-goddess grin. The artist concentrates on the new kind of space he is trying to bring to the painting, and the consequent distortions of his invented anatomy follow in a functional way (as I have discussed at some length elsewhere[6]), producing the awesome, furious

Roy Lichtenstein: *Girl with Ball,*
1961. Collection Philip Johnson.

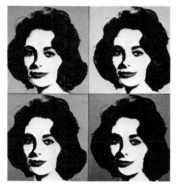

Andy Warhol: *Liz,* 1963.
Castelli Gallery.

Facing page:
Willem de Kooning: *Woman and
Bicycle,* 1952-53. Whitney Museum.

effect that so shocked the public when the Women were first shown in 1953. De Kooning himself was surprised at the audience's reaction. He thought his Women were typical, like the chatty ladies of Gertrude Stein, "as if one of them would say, 'How do you like me?' "[7] He also thought that they were funny.

Perhaps the goddesses in the paintings emerged from the pinup girlies in the drawings because de Kooning was not paying much conscious attention to either of them. His hand and eye, obsessed for over two years with pictorial difficulties, ignored the emergent figurations, which in turn tapped the artist's subconscious where, Jung tells us, such archetypal visions proliferate. Perhaps looking at the unfinished painting from June 1950 until around November 1952 made him so familiar with it that he could not foresee its effect on strangers and how, joined with the other large paintings of Women that rapidly followed the completion of *Woman I,* the impact would be overwhelming. Also the technical originality of the paintings must be taken into consideration. Perhaps it is similar to *Les Demoiselles d'Avignon* who, Picasso explained to Gertrude Stein, only seemed ugly because they were the first of their kind; the artists who came later could make them pretty.

Given all these reasons, and accepting them all, I still think it is fair to consider de Kooning's Women of the 1950s as violent intellectual and emotional criticism, in visual form, of the contemporaneous situation of the American woman as reflected in the pinup photograph.

De Kooning had recognized and accepted the pinup as part of the anonymous American mid-century urban environment. Although it was highly stylized–like the erotic photographs that had appealed to Manet–it also expressed with extraordinary candor a hidden social condition–the debasement of women, their inferior social status, their exploitation as sex objects and their simultaneous elevation, "on a pedestal" as the cliché put it, to a pantheon of goddess-dolls.[8]

Manet found a human, repressed erotic residue in the erotic photograph–an element uncontaminated by art or style. He used it as a way to liberate his own developing vision. De Kooning found a human residue in the pinup–of a repressed, cosmeticized sexuality. Manet transferred the raw emotional sensation to his Olympia; de Kooning turned the repressed sexuality of the pinup inside-out, changing the kittens into tigers. Both the de Kooning and the Manet created public scandals, not only because they allude to non-art, despicable, illicit sources (although this surely is part of the shock effect), but also because they comment on a general, shameful, social hypocrisy–Manet on the double-standard and the degradation of the prostitute by nineteenth-century society; de Kooning on the dehumanization of American women, 100 years later. Manet's *Olympia* offers to the spectator the skin of an issue, so to speak; de Kooning's *Woman* reveals the anxieties inside.

The situation of the American woman in the late 1940s and '50s has been analyzed at length by such writers as Betty Friedan *(The Feminine Mystique),* Kate Millett *(Sexual Politics)* and, more recently, Germaine Greer *(The Female Eunuch)* in books which have been widely circulated

Willem de Kooning: *Woman 1,* 1961, oil on paper with pasted head of pinup girl. Private collection.

Willem de Kooning: *Woman,* 1966-67, charcoal. Artist's collection.

and which obviously have found an enthusiastic audience. Friedan discussed the plight of the woman in the 1950s and how she was forced into a role of helplessness and ignorance: the housewife, cook, mother, laundress, etc., devoted to husband and children–to making the male happy and comfortable, amused and protected. The concept is expressed in Irving Berlin's lyrics to a ballad sung by the he-man hero of the musical-comedy *Annie Get Your Gun* (1946) in which he attacks Annie for trying to be a professional and competing with men for men's jobs. He warns her that she does not attract him seriously because she wears work clothes, talks in an assertive manner. For him, he sings:

The girl that I marry will have to be
as soft and as pink as a nursery.
The girl I call my own
will wear satins and laces and smell of cologne.
Her nails will be polished, and in her hair
she'll wear a gardenia, and I'll be there,
'stead of flittin',
I'll be sittin',
Next to her and she'll purr like a kitten.
A doll I can carry the girl that I marry must be.*

Kate Millet, in *Sexual Politics,* makes a convincing economic analysis of the reasons behind the feminine mystique of the late 1940s and '50s. During World War II, she points out, women were drafted by the hundreds of thousands into the work force, into blue-collar jobs (remember Rosie the Riveter) and throughout the professions. They filled positions which traditionally had been exclusively male prerogatives, and they received pay commensurate to their work. When the war ended and the men were discharged from the services, they wanted their jobs back, and there was tremendous pressure on women to relinquish them, to marry, move to Scarsdale, have seven children and welcome the tired wage-earner home from the 6:18 with a dry martini in a chilled glass, dressed in satins and lace and smelling of cologne, at least.

The pinup, and related figures in advertising, entertainment and the arts, reinforced and gave visual authenticity to this image of a docile, manipulatable godlet.

(A number of authors investigating the phenomenon of the success of *Playboy* magazine have added a psycho-sociological explanation to the success of the pinup image.[9] The American male, they suggest, spurred by competition in every level of the capitalist society, is filled with anxiety about failure–about not being "number one" or becoming a "weak and helpless giant," to borrow two Presidential phrases. Thus in his sexual fantasies he prefers the female who offers no difficulties or unpredictable aggressions. She should look like *Playboy's* Playmates: friendly, healthy cheer-leader types whose airbrushed contours are pleasant to contemplate, but never challenge. He need not worry about being successful with her in the flesh, for the opportunity will never come up. The pinup, obviously, is a similar projection of such masculine anxieties. Part of the scandal caused by both Manet's *Olympia* and de

*© 1946 Irving Berlin, New York 19, N.Y.

Tom Wesselmann: *Little Great American Nude, 34,* 1965, collage with Marilyn Monroe's face on a nude model. The Harry N. Abrams Family Collection.

James Rosenquist: *Untitled (Joan Crawford),* 1964. Galerie Ricke, Cologne.

Boris Lurie: Collage from "Doom Show" at the March Gallery, 1960.

Kooning's *Woman,* I may be due to the fact that the artists' figures seem arrogantly to challenge men at the point where they are least secure and, furthermore, to be sublimely indifferent about the results of the contest.)

Whether de Kooning subconsciously or consciously subverted the pinup image and its expression of the feminine mystique by consecrating the placid icon to a fiercer goddess is beside the point. Certainly he has never given public support to feminist or Women's Lib causes, and it is equally certain that he did not approach his painting with any doctrine or program in mind. On the contrary, he despises propaganda art of all sorts as well as messages, rules and formulations which oversimplify art in order to score an esthetic point. Like all great painting, his Women are ambiguous and have been interpreted as attacks on women as well as glorifications–and both interpretations have their truth to them. They also have been seen as reactionary as well as radical pictorial statements. And here, again, both positions are logical even if unconvincing when taken separately. What we are dealing with is rather a coincidence of forces–a confluence of art, anthropology and politics, as was suggested at the beginning of this article. Its immediate effect on art was to be remarkable.

Shortly after de Kooning exhibited his Women, pinups of all sorts began to appear in paintings and collages. Robert Rauschenberg incorporated them into his first ornate "Combines". They are nudes–from nudist magazines rather than from the more characteristic billboard, fan-magazine or advertisement sources de Kooning preferred–and thus Rauschenberg's image itself had a certain shock in 1955. But he treated them as collage elements in an all-over composition which emphasizes chance effects in richly exuberant, decorative surfaces. The cut-apart magazine illustrations do not lose their identity to become part of a larger "palette," as they do in Schwitters, for example. Nor do they retain suggestions of an exotic environment or of an alien, lost world, as they do in Ernst and Miro. They are simply commonplace pinups, used as easily as–and often juxtaposed with–lashings of Abstract-Expressionist brushstrokes. Woman is reduced even below the status of an object; she becomes one among many materials. She symbolizes the banality of her presence.

Alfred Leslie, in a transitional period between Abstract-Expressionism and a return to figuration, in 1963, used the pinup as a collage element in a similar way–as if he wanted to elude de Kooning's influence by going back through that master's sources to *Woman I,* and behind it to its connection with commercial photography.

The banal, ubiquitous, vulgar character of the pinup figure was, of course, inherent to de Kooning's presentation. The Pop artists adopted a similar stance; they were at once deeply influenced by Abstract-Expressionism and in reaction against its intellectual painterly approach. The pinup represented for Roy Lichtenstein the kind of "despicable" subject matter he was seeking in the early 1960s.[10] And his cool, calculated application of paint, in flat colors granulated by Ben-Day dots, underlines

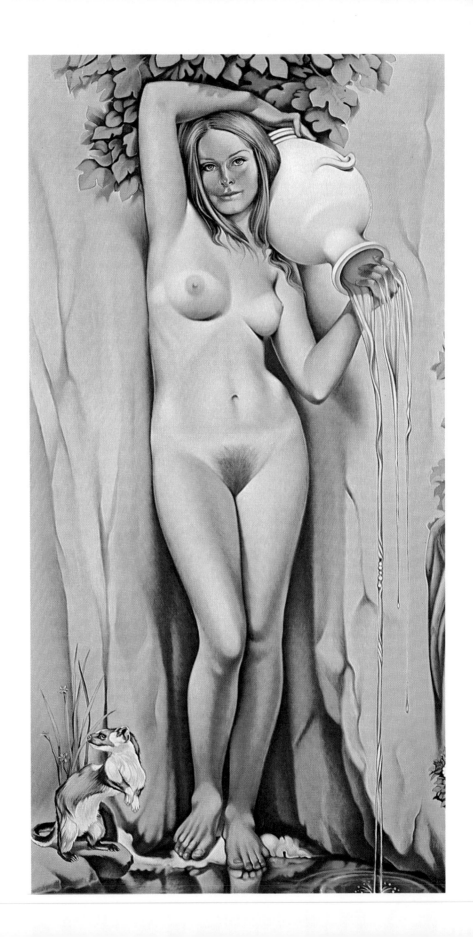

Marjorie Strider: *Triptych*, 1963. Artist's collection.

Wayne Thiebaud: *Showgirl*, 1962-63. Collection Heather Persoff.

Mel Ramos: *Ode to Ang*, 1972, Utah Museum, Salt Lake City.

the banality and everyday aspect of the girl with a beach ball or the Hawaiian bathing beauty, with their button noses and even, white teeth. With Warhol, Rosenquist and Wesselmann, the pinup is invoked over and over again as a standard part of the standard American scene–glamor that has been deglamorized and made contemptible by familiarity. In the violent protest pictures by Sam Goodman and Boris Lurie, whose "Doom Show" in 1963 was a frantic attack on American militarism and what they saw as incipient fascism, the pinup became a symbol of the capitalist state. Just as a European might have used a skyscraper or the Capitol dome or the Statue of Liberty to stand for America, they used the pinup in collages, and scrawled indignant messages and signs across the mosaic of anatomies.

(In David Smith's notebooks,[11] from the 1940s on, the pinup is also used as a symbol, but on an erotic impulse. Other motifs, such as the cannon and wheels, were developed from photographs in his notebook to drawings to shapes in steel sculpture. The nudes and bathing beauties which Smith cut from magazines, however, are more like symbols or hieroglyphs than clues to shape.)

The pinup recurs in American painting throughout the early 1960s[7] –from straight depictions in painterly neo-realism by Wayne Thiebaud in California to experiments involving the serial image and multi-dimensional canvas by Marjorie Strider in New York. The assemblage of pinups also became a cliché in 1955-65. It was used by such very different artists as draftsman-printmaker André Racz, Bruce Conner (he made them shortly after graduating from art school in San Francisco) and Arman, who supplied an Ecole de Nice version, made during a stay in New York. In the late 1920s and early '30s the Bauhaus had popularized pictures that consisted of catalogues of varying textures; a similar bowerbird instinct seems to have infected many artists in the following generation, but instead of collecting textures they sought out reproductions of girls taken from the enormous variety of sources that were available to the public in pornographic, nudist and film-fan magazines, in high-fashion and big-industry advertising, in postcards, programs and packages, and pieced them together in mosaic and jig-saw puzzle patterns. Then, suddenly, the cultural underpinnings of the image gave away and almost overnight, it seems in retrospect, the pinup was no longer a living icon, but a bit of memorabilia–a vestige from the past.

The first and strongest force to attack the viability of the image had been prefigured in the 1955 "Combines" of Rauschenberg and, by the early 1960s, in Wesselmann's "Great American Nude" series–that is, the "new morality" and the general acceptance of public nudity. The causal factors for this shift in public attitudes are beyond the scope of this text; it is sufficient to mention:

1. The systematic attack on obscenity laws by writers and publishers which, a few years after the banning of Edmund Wilson's *Memoirs of Hecate County*, saw the appearance in paperback racks across the country of such books as *Lady Chatterley's Lover*, *Tropic of Cancer*, the novels of

Larry Rivers: *Me and My Shadow,*
1970, photomontage and Plexi-
glas. Marlborough Gallery.

Ray Johnson: *Jayne Mansfield,*
1968, collage. Schwarz Gallery.

Sade, Genet and Burroughs as well as an avalanche of commercial por-
nography.

2. The exploitation by film-makers and magazine and book publishers
of the cancellation of almost all obscenity laws.

3. The pill and the new sexual permissiveness, with its connections
to the counter-cultures of the drug, hippie, hard-rock and other scenes.

By the late 1960s, the pinup of the 1950s was no longer by the stretch
of any imagination an erotic image. It could be used in a camp, nostalgic
way by such an artist as Ray Johnson–in whose collages photographs
of Jayne Mansfield and Marilyn Monroe look like entries from an old
diary–bits of a happier past–related to Ernst's use of nineteenth-century
line-engravings in his collages of the 1920s. Or it could be used straight
in its 1970s-nude form, as an erotic image, a voyeuristic fantasy, perhaps
over-life-size to increase the illusion, as in Larry Rivers' kinky *Me and
My Shadow* cutouts. Finally, in an ultimate twist of irony, the pinup
could be reborn as erotic Americana, based on sources in the old masters,
as in Mel Ramos' *Ode to Ang* in which a primitive travesty is made of
Ingres' *La Source*–an approach nicely articulated by the sad pun in the
title. Here stylistic conventions are used in much the same way as they
were by the manufacturers of erotic photographs in the mid-nineteenth
century.

De Kooning turned to abstractions in 1955-63, except for a series
of small oils on paper in 1961, which again were clued to the pinup
figure, as revealed by a collage head pasted to *Number 1* of the group.
When he returned to the figure in the mid-'60s, he developed a far
more flexible, sinuous image in which a high-speed brushstroke
dominates the format. He did a series of paintings, with related charcoal
drawings, titled *Woman on a Sign*–referring to figures on billboards or
in storefront advertisements. But these are women abstracted to ideo-
graphs; they do not have the curious dialectical tensions of the pinup
with its hot and cold signals. His later figures are pastoral nudes, often
in landscape settings–far more sensual and serene than the pictures
of the 1950s. Whatever symbolizing action there is to the image should
be sought in the interactions between the figure and the high-speed
paint strokes that constitute it– embodiments of the creative energy and
the individual's will to create, each shaping the other.

Rauschenberg has returned to the pinup theme from time to time,
but usually to suggest transience–as if we should recognize the image
as part of yesterday's news.

The motif has persisted in Europe and can be noted in the works
of such artists as Richard Hamilton, Martial Raysse and Peter Blake.
But for them, the pinup is an exotic fragment charged with meanings
and references to their ideas about America, like a Coca-Cola bottle.
To a Frenchman, a pretty girl drinking from a Coca-Cola bottle is
a gangster's moll or a hippie or some other out-of-the-ordinary person-
age. To an American, she is simply thirsty. The American pinup has
undergone a similar metamorphosis on the other side of the Atlantic.
She is an otherworldly figure–unusually dangerous or attractive. A

nymph left behind by Surrealism, as she also appears in the collages of Joseph Cornell.

But to the American painters who made the pinup a motif in their art in the 1950s and '60s, it was an image so banal that it partook of no special magic–except for a hint of the universal.

Joseph Cornell: *Big Dipper,* ca. 1963, collage. Collection Allan Stone.

Martial Raysse: *Nude,* 1963, collage. Iolas Gallery.

[1] Richard Wortley: *Pin-Up's Progress.* London, 1971, p. 63.

[2] *Ibid.,* p. 26.

[3] *Ibid.,* p. 27.

[4] David Sylvester, interview with Willem de Kooning, B.B.C. broadcast, Dec. 30, 1960, excerpts published in Thomas B. Hess, *Willem de Kooning,* New York, 1968, p. 148.

[5] For a more complete discussion of de Kooning's 1950-53 drawings of women, see Thomas B. Hess, *De Kooning Drawings,* New York, 1972.

[6] Thomas B. Hess, "De Kooning Paints a Picture," *Art News,* New York, March, 1953, pp. 30-33, 64-67.

[7] David Sylvester, *op. cit.,* p. 148.

[8] Marilyn Monroe in her last interview with *Life* magazine said: "I never quite understood it–this sex symbol. I always thought symbols were things you clashed together. That's the trouble, a sex symbol becomes a thing. I just hate being a thing..." But she went on to say: "But if I'm going to be a symbol of something, I'd rather have it sex than some of the other things they've got symbols of..." Quoted in Richard Wortley, *op. cit.,* p. 91.

[9] J. Anthony Lukas, "The 'Alternative Life-Style' of Playboys and Playmates," *The New York Times Magazine,* June 11, 1972, pp. 72,75. The author also cites Richard Schickel ("The Disney Version"), Peter Shrag *(The Decline of the WASP)* and Rollo May *(Love and Will).*

[10] Gene Swenson, interview with Roy Lichtenstein, "What Is Pop Art?" *Art News,* New York, November, 1963, p. 25: "It was hard to get a painting that was despicable enough so that no one would hang it–everybody was hanging everything. It was almost acceptable to hang a dripping paint rag, everybody was accustomed to this. The one thing everyone hated was commercial art..."

[11] Rosalind E. Krauss, *Terminal Iron Works, The Sculptures of David Smith,* Cambridge (Mass.), 1971, figs. 40, 41, 113, among other pages in the David Smith Archive.

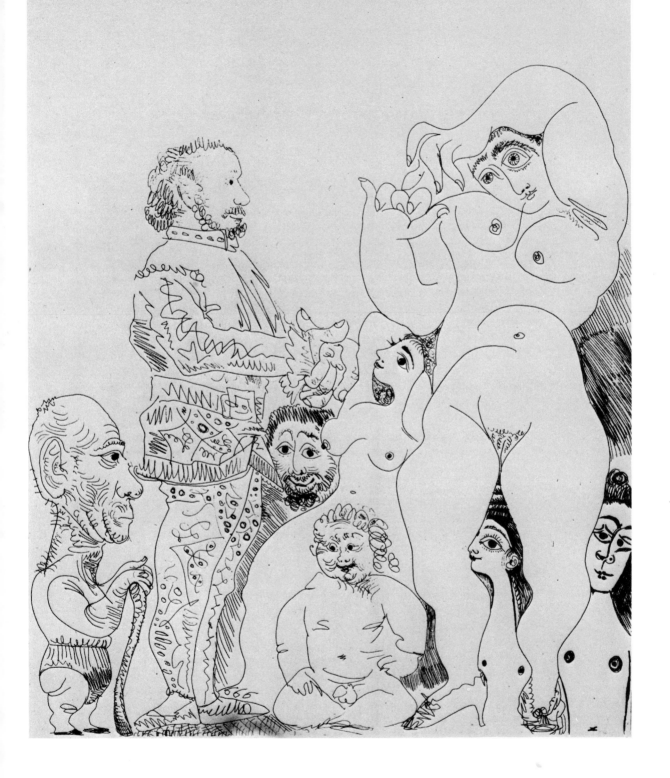

Picasso's Suite 347,
or Painting as an Act of Love

Author: Gert Schiff teaches at the Institute of Fine Arts, N.Y.U.; he has written a major volume on Fuseli and edited the *Amorous Illustrations of Thomas Rowlandson*

Picasso's *Suite 374*[1] represents, in my opinion, the most comprehensive statement ever made by the artist about his philosophy of painting, and of life. He reverts to his childhood and sees himself as the infant prodigy, attended by his future sources of inspiration. All through his career, Picasso has attempted to revive and redefine the great humanistic tradition of painting. This source of his art is represented here by the figures of Rembrandt and Velasquez. Woman, the other source of his inspiration, is present as a majestic nude prostitute with a mantilla. She is attended by an old procuress, an archetypal figure both in Picasso's œuvre and in Spanish literature. In 1903, Picasso had painted *La Celestina*, the heroine of the fifteenth-century play by Fernando de Rojas; he had portrayed her, true to the letter of the play, as a greedy, malicious witch. Now he has transformed her into a much older, almost Fate-like character, and her silent and humble presence in so many scenes of courtship and love makes it evident that he conceives of her as a life-preserving and ultimately benevolent force.

But Picasso portrays himself also as the old man who in front of "warm, fleshy, genial life" is forced into the role of a mere observer. In etching *Number 8* we see him sad and dwarfed by a dressed-up cavalier who rubs his hands in happy anticipation at the sight of a throng of healthy female animals. And Picasso puts himself a second time into the picture, as an "old child," a *putto* with a wrinkled face who squats in a Buddha-like attitude in front of the women. It is not only a symbolic self-portrait, but also a typical Picasso paradox. The meaning of the figure is a precise reversal of its appearance: it stands for youthful appetites, or for a child's delight in everything sensual, in an old body.

Picasso redefines the art of the past mostly in terms of parody. In the aquatint *Number 123* he turns the spirit of Velasquez' *Las Meninas* into its opposite. The derivation becomes obvious if one takes into account that in the original design on the copperplate the painter and his easel were on the left, as they are in the Velasquez. But Picasso transforms the courtly scene into a vision of ribald, promiscuous, instinctually innocent, primeval humanity. The reappearance of the central figure of *Les Demoiselles d'Avignon* might even designate the locale as a brothel. All through *Suite 347*, Picasso takes an obvious delight in replacing the sphere of Spanish courtly etiquette–which signifies civilization–by this vision of mankind "in the raw." Quite often he also intermingles these two spheres of high life and low life.

Etchings like *Number 248* parody a well-known iconographic model

Picasso: *Suite 347*, Number 8, March 25, 1968, 16¾ inches high, etching. All the engravings illustrated here are from *Suite 347*. The Roman numerals denote engravings made on the same day.

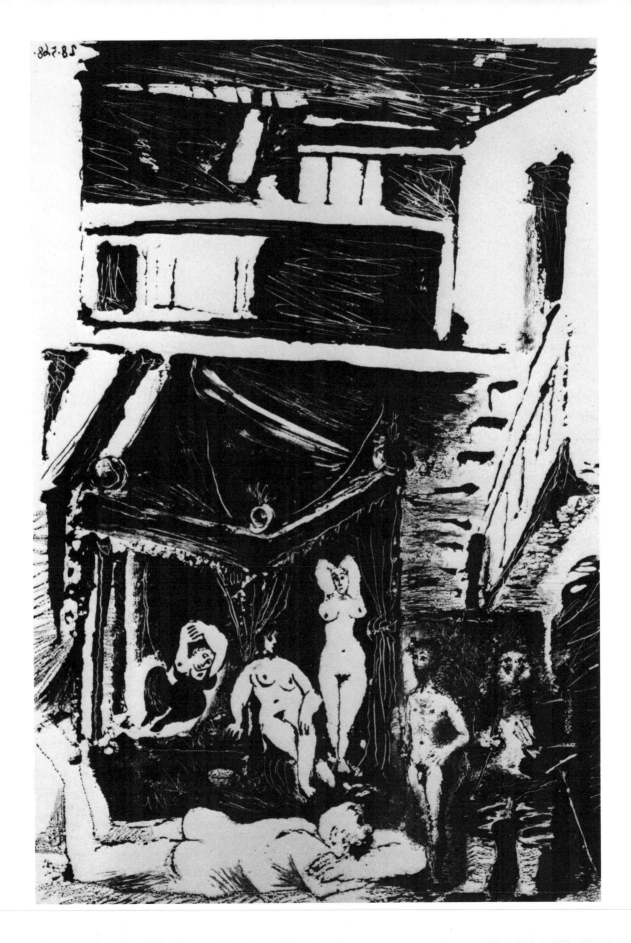

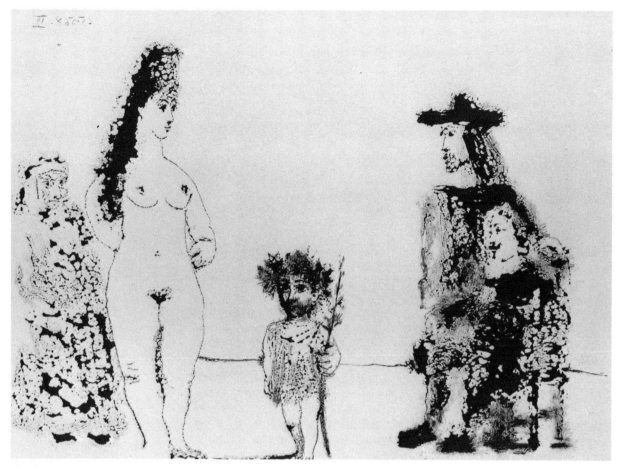

Number 111, May 25, 1968, III,
8 inches high, aquatint.

Picasso: *La Celestina,* 1903,
31⅝ inches high. Private
collection, Paris. An early
portrait which anticipates the
old procuress in *Suite 347.*

Number 123, May 28, 1968,
19½ inches high, aquatint.

from Dutch art, *The Suitor's Visit.* Such scenes, in which a well-mannered
suitor enters the boudoir of his beloved, have been painted repeatedly
by Gerard ter Borch. In the Dutch prototypes as well as in Picasso's
etchings the suitor lifts his hat and bows in front of the lady; only with
Picasso she becomes a woman of pleasure (again attended by the old
procuress). She exposes herself unabashedly and his ceremonious bow
allows the caller to focus his attention upon the center of pleasure.
This might be the right place for a brief remark about the voyeurist
element in *Suite 347* which has so shocked some critics. Its presence
and even prevalence are obvious. But then, Picasso himself would be
the first to admit this. He gave a charming proof of his superiority
in regard to his own condition in a remark to Brassaï: "Whenever I
see you, my first impulse is to reach in my pocket and to offer you
a cigarette, even though I know very well that neither of us smokes
any longer. Age has forced us to give it up, but the desire remains.
It's the same thing with making love. We don't do it any more, but
the desire for it is still with us."[2] Furthermore, since Picasso's painting
deals with man's (and woman's) most basic impulses and passions, sexual
symbolism has always been one of the principal elements of its imagery.
Encyclopedic in nature, his art omits nothing and suppresses nothing.
"Pablo never liked to overlook any anatomical detail, especially a sexual
one," Francoise Gilot remembers.[3] And the many scenes of exposure
and inspection in *Suite 347* certainly corroborate this. Yet Picasso's scenes

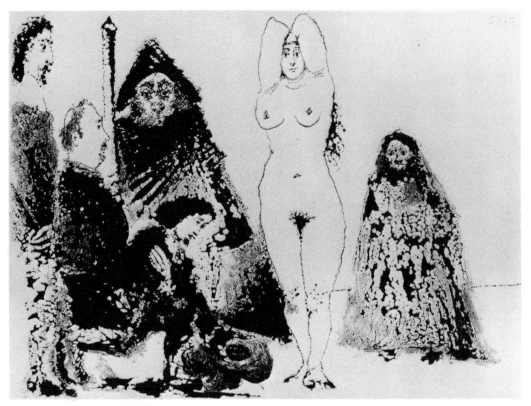

Number 114, May 26, 1968 III,
9½ inches high, aquatint.

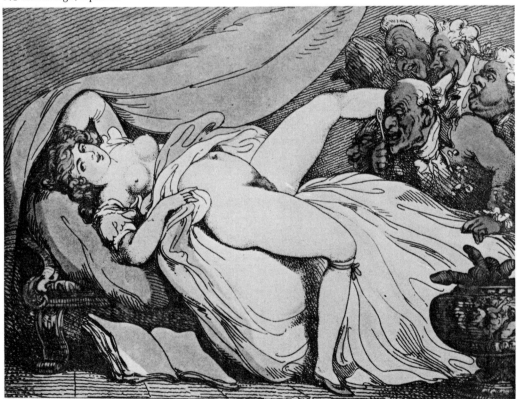

Thomas Rowlandson: *The Inspection,*
colored etching. A coarse proto-
type of Picasso's *Number 114.*

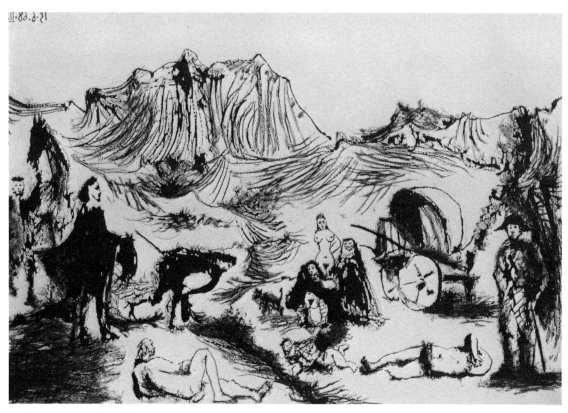

Number 161, June 15, 1968 III,
13¼ inches high, aquatint.

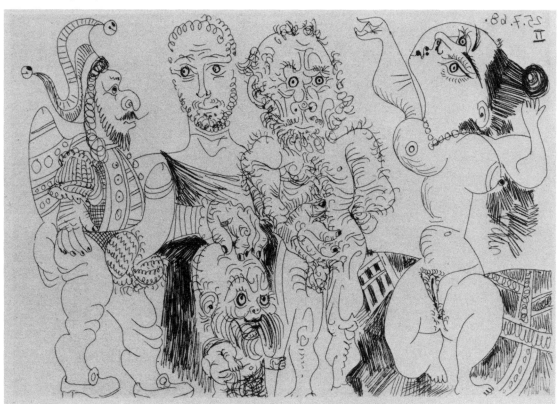

Number 216, July 25, 1968 II,
6 inches high, etching.

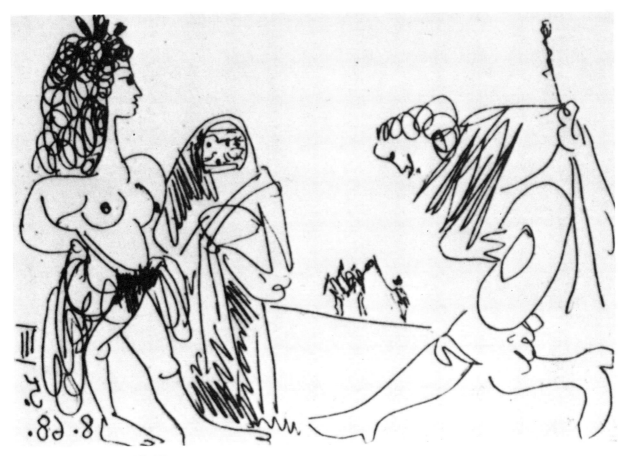

Number 248, August 5, 1968 III,
2⅜ inches high, etching.

Gerard ter Borch: *The Suitor's
Visit,* ca. 1658, 31½ inches high.
National Gallery, Washington, D.C.
This favorite theme of Dutch
genre is alluded to in *248.*

of voyeurism imply nothing of that mixture of hatred, fear and castration-
anxiety which together form the clinical syndrome. On the contrary,
they represent a fervent homage to life. In order to realize this, one
has only to compare Picasso's aquatint of a nobleman paying homage
to a prostitute with a colored etching on a similar theme by Thomas
Rowlandson, *The Inspection.* In the latter, a group of hideous old men
gaze, obsessed, at a disdainfully compliant model. Phallic shapes in a
bronze container hint at their virtually castrated condition and, hence,
at the admixture of infantile horror which Freud detected, 100 years
later, in the voyeurist syndrome. In the Picasso, however, the voyeur
is a worshipper. The nobility of his conduct could make us believe that
he had stepped out of El Greco's *Burial of Count Orgaz.* With almost
religious fervor he pays homage to the girl's radiant beauty.

At his present age, Picasso's world of sexual phantasy is, like the child's,
polymorph perverse. In some of these plates even small children appear
as prostitutes. They expose themselves, and enjoy it, as children do.
In that magnificent composition where a delegation of noblemen greets
a group of strolling gypsies, we find again sheer, animalistic pleasure
extolled, and civilization paying homage to low life.

Picasso's serene detachment from his own condition as one whom
"age has forced to give it up" permits him to comment ironically on
male frustration in front of the female. Etching *Number 216* depicts
a jester, an antique philosopher, a very old satyr and an equally old
dwarf in front of an inviting nude. The bearded philosopher seems

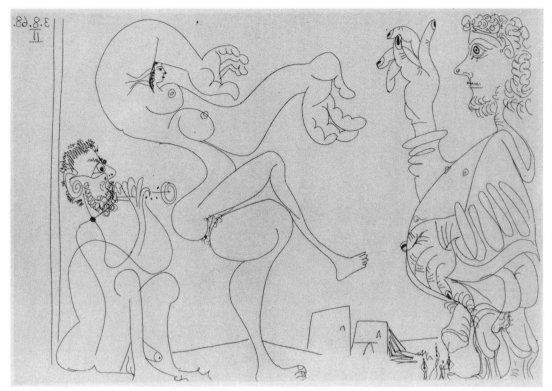

Number 237, August 3, 1968 II,
6⅞ inches high, etching.

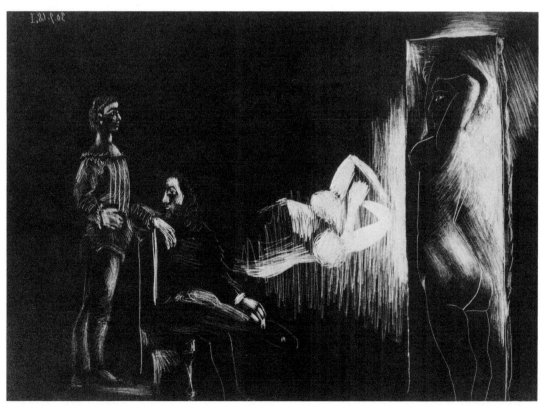

Number 344, September 30, 1968 I,
8⅞ inches high, aquatint.

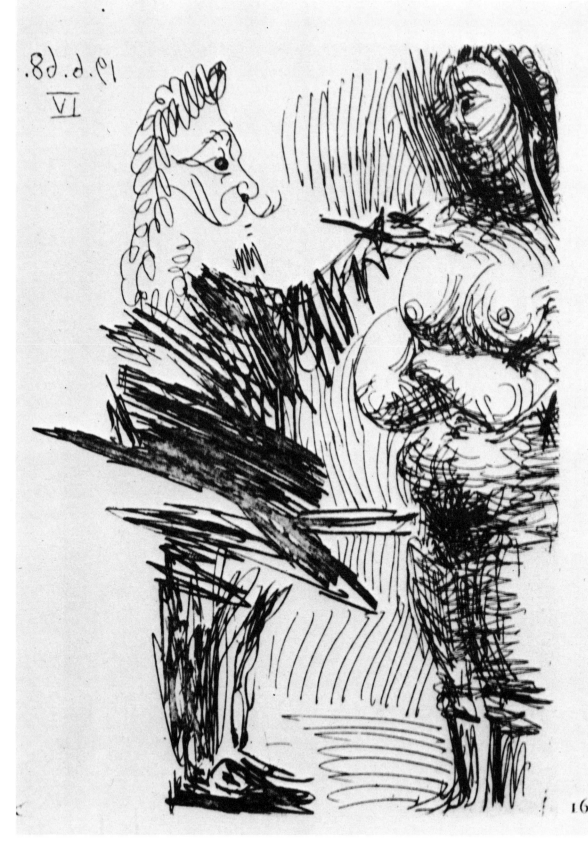

Number 166, June 19, 1968 IV,
5 inches high, etching.

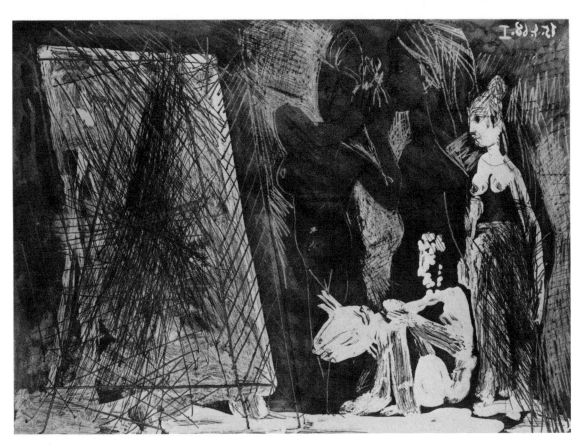

to ponder the question whether it is philosophically justifiable to follow one's desires. The hairy, withered satyr is openly embarrassed by his awareness of his faded powers. Only the bragging jester is free from self-doubt: not only does he exhibit his swelling strength, he "underlines" it by mockingly putting his hand on the head of the humble, Socrates-like dwarf. But, unlike the Greek sage, the dwarf betrays by his wistful expression that the desire is still with him also.

In another example the situation is different. A young woman dances to the pipes of Pan which are rather inappropriately played by an unattractive old pedant. In front of them stands a scolding moralist with raised forefinger. However, like so many of his kind he seems to exemplify the proverb that the right hand should not know what the left hand does. Yet, his semen generates men–an old mythological motif, best known in the myth of Uranus. Could it be that the pipe-player, like Amphion, caused the stones to move of their own accord and to form a new city? In that case the strange composition would imply that the unfulfilled desire of old age can be converted into creativity.

In those compositions which deal with his philosophy of painting, Picasso reverts several times to Balzac's *Chef-d'oeuvre inconnu* which he once illustrated for Vollard. In this story, the young Poussin is introduced by Frans Pourbus to an imaginary artist called Frenhofer. This man, the greatest painter of his age, is working on his ultimate masterpiece, a life-size female nude. He wants to incorporate all his art and wisdom in the painting. Frenhofer keeps it hidden from everybody: the nude is his "creature," "his beloved": to expose her to profane eyes would be blasphemy. Yet, when Pourbus and Poussin are finally admitted to his studio, they find the painter, who has become mad, in front of a canvas covered with senseless lines and blots of color. The two following illustrations are evidently inspired by Balzac's story, in my opinion. In the aquatint *Number 344* we find the mature master (Pourbus *or* Frenhofer) together with the young Poussin who gazes, fascinated, at the emerging likeness of the model. In *Number 39* we see Frenhofer musing in front of his senseless web of lines, surrounded by one real companion and two shadowy creatures of his imagination.

There are, I believe, two reasons for Picasso's lasting preoccupation with *Le chef-d'oeuvre inconnu*. First, the process by which Frenhofer transforms his originally naturalistic nude into a labyrinth of "senseless" lines corresponds in a certain way to Picasso's own definition of a picture as a "sum of destructions." And because of this "destructive" character of his art he has been thought by many people to be as mad as Frenhofer. Second, there is the motif of the infatuation of the artist with his work, this particular obsession which induced Frenhofer to call the woman in his painting both his "beloved" and his "creature." We may well assume that this is as much a part of Picasso's unconscious phantasies as it is of every great painter's. In works like the engravings *Number 166* and *188* Picasso finds a disarmingly simple visual formula for the Promethean, man-making activity of the painter.

In both cases he omits the canvas and shows the painter working

Number 39, April 15, 17, 1968 I/ II, 10¾ inches high, aquatint.

Number 188, June 26, 1968 I, 3½ inches high, aquatint.

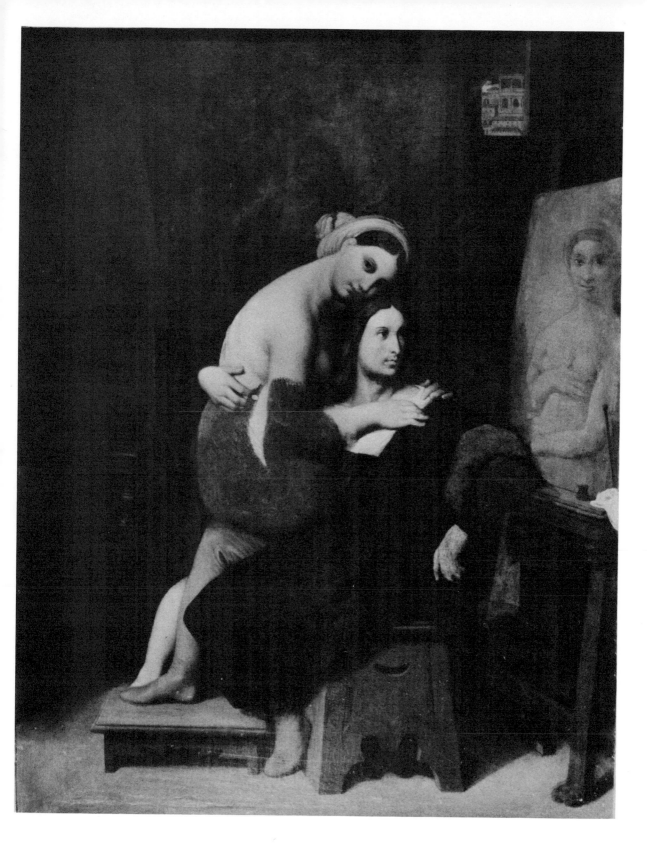

Number 314, September 5, 1968 I,
6 inches high, etching.

Ingres: *Raphael and La Fornarina*,
ca. 1860, 26¾ inches high.
Chrysler Museum, Norfolk, Va.
Number 314 is one of the *Suite's*
24 variations on this theme.

directly on his model. In *Number 166,* he adds a touch to the coloring of her bosom, in *Number 188,* his brush glides lovingly around her neck and shoulder. Here Picasso illustrates one of the greatest lines in Leonardo's *Treatise: "Si 'l pittore vol vedere bellezze che lo innamorino, egli n'è signore di generarle."* [5]

His 24 variations on Ingres' *Raphael Painting the Fornarina* bring the argument to its conclusion. Ingres shows Raphael with the beautiful girl on his knees; both are contemplating her nearly finished portrait. Picasso continues the story and follows the couple through the various *praeludia amoris* to the final consummation of their love. At each stage they are observed by a voyeur–the Pope. First we see him peeping through a curtain, then he is allowed into the room. In the example illustrated here, the additional figure of a jealous husband is included, hiding underneath the bed. Yet, as in almost every print in this series, even in the supreme ecstasy of his union with the model, the painter retains palette and brushes in his hands. He goes on painting, if only in the air. Thus painting, lovemaking and "generation" become literally one, or, in Picasso's own case, the desire, still so very much with him, now finds its gratification in painting. Painting allows him to act out his immense love of life. His is an old age without bitterness. This is why he–ivy-crowned satyr, led by the genius of youth–still has his rightful place among young revelers and majas. This is why he can foresee his own immortality. In one of the last plates of *Suite 347* he designs a monument

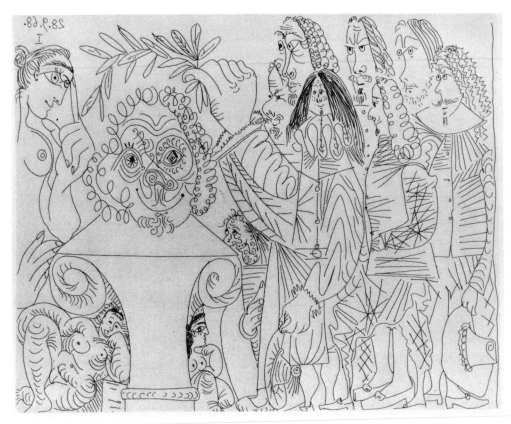

for himself, a herm with the head of a sacred buffoon. It is crowned with laurel by a delegation from the time of Velasquez–the representatives of civilization. But at its foot lounge earthy nude women, remembering him with a smile: the beautiful creatures of low life.

[1] This series of 347 etchings was executed by Picasso in Mougins, March 16 to October 5, 1968. They are fully reproduced in the following publications:
a) *Picasso, 347 Gravures 13/3/68-5/10/68* (catalogue 23, serie A), Galerie Louise Leiris, Paris, Dec. 1968.
b) *Picasso 347* (2 vols.), Random House/Maecenas Press, New York, 1970.
c) Georges Bloch, *Pablo Picasso, Catalogue of the Printed Graphic Work,* II, 1966/1969, Berne, 1971.
[2] Brassaï, *The Master at 90–Picasso's Great Age Seems Only to Stir Up the Demons Within, The New York Times Magazine,* Oct. 24, 1971.
[3] Françoise Gilot and Carlton Lake, *Life with Picasso,* New York-Toronto-London, 1964, p. 318.
[4] Cf. also *Number 138.*
[5] Leonardo da Vinci, *Trattato* 13. Translation by A. Philip McMahon: "If the painter wishes to see beauties which will make him fall in love with them, he is a lord capable of creating them." *(Leonardo da Vinci, Treatise on Painting,* I, Princeton, 1956, p. 24)

Number 135, June 1, 1968 II,
16¼ inches high, etching.

Number 342, September 28, 1968 I,
8¼ inches high, etching.

Index of Illustrations

Page numbers in italics indicate color plates

Photograph, Colorplate Credits

Cover: courtesy *Réalités*, New York. 4, 28: Mondadori, Milan.
10: Sotheby's, London. 14: Graphica Press, New York.
74: Mme Georges Duthuit, Paris. 82: George Eastman House, Rochester, N.Y.
83, 85, 86, 87: Marcel Bovis, François Saint-Julien,
Nus d'autrefois 1850-1900, 1953, George Wittenborn, Inc., New York.
89: Delacroix's album of models, Print Room, Bibliothèque Nationale, Paris.
170; Clark Art Institute, Williamstown, Mass.
182, 194, 195: Munch Museet, Oslo. 190: Museum of Fine Arts, Boston, Mass.
206: Museum of Modern Art Film Stills Archive, New York.
209: colorplate from *Oskar Kokoschka*, by F. Schmalenbach, Blauen Bücher
Verlag, Königstein, 1967.
212, 213: Oesterreichisches Museum fur angewandte Kunst, Vienna.
216, 220: from *Egon Schiele, Watercolors and Drawings*, by Serge Sabarsky,
to be published by Frederick A. Praeger, New York.
217: Marlborough-Gerson Gallery, London. 231: Chrysler Museum, Norfolk, Va.
234: Utah Museum of Fine Arts, University of Utah, Salt Lake City.